AFTERSHOCK

AFTERSHOCK

THE HUMAN TOLL OF WAR

HAUNTING WORLD WAR II
IMAGES BY AMERICA'S
SOLDIER PHOTOGRAPHERS

Richard Cahan
Mark Jacob
Michael Williams

CITYFILES PRESS

In honor of those who fought
for freedom

And those who work to make
war a thing of the past

Published by CityFiles Press, Chicago, Illinois

Produced and designed by Michael Williams

ISBN: 978-0991541881

First Edition

Printed in China

Funding provided by the
Jonathon Logan
Family Foundation

JONATHAN LOGAN
FAMILY FOUNDATION

C
O
N
T
E
N
T
S

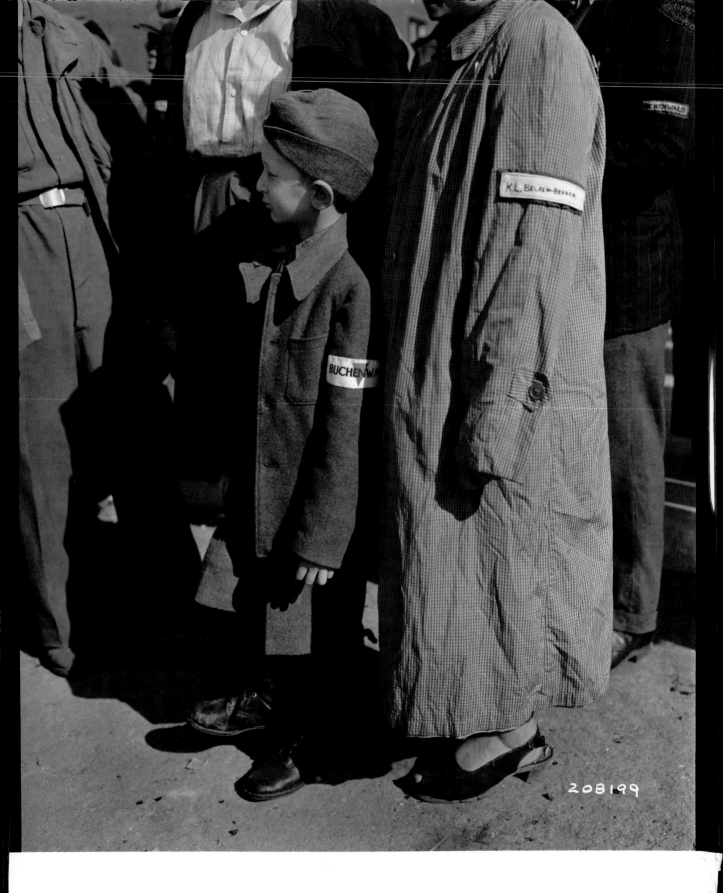

FOREWORD
Carol Guzy

Four-time winner of the Pulitzer Prize for photography, Carol Guzy has covered the impact of war and natural disasters around the world.

As a photojournalist who has covered the human face of war, I know that the experience leaves a lasting mark.

Soldiers and civilians alike endure unspeakable horrors. Journalists, too, suffer from trauma and post-traumatic stress disorder. When we leave the war zone, we too can be the walking wounded.

The soldier photographers who produced the powerful pictures in *Aftershock* went through this ordeal to capture a record for the whole world to see. These images from 1945, the last year of World War II, were a warning of the wreckage that war always brings. Yet even after they documented such devastation, conflicts continue to the present day.

The fearless war photographer Robert Capa declared, "If your pictures aren't good enough, you're not close enough." Close enough doesn't always mean standing in the flames or gunfire. Even more difficult can be breaking the barrier of intimacy and capturing the human toll. It's a different kind of courage—to stay with a story even when it's ripping at your heart.

These U.S. Army Signal Corps photographers showed that courage.

It has been said that when you make a photo, you take a piece of the subject's soul. As well, you give a part of yours. There are pieces of my soul scattered all over the earth. Indeed it's what makes me whole.

For me, covering Haiti's perpetual open wound became a mission. It was hard to witness

LEFT: A six-year-old war orphan is released along with 350 other children from the Buchenwald concentration camp near Weimar, Germany, on June 19, 1945.

injustice as the world community looked away. The people were mired in such turmoil and anarchy that kids grew up stepping over bodies near their school buses.

Kosovo's ethnic cleansing became another scar. Serb aggression resulted in suffering, death, and desperate refugees who flowed past the border to camps in Kukes, Albania.

In Sierra Leone, brutality could not extinguish the strength of the amputees. During the country's civil war, rebels cut off the limbs of civilians—even children—to intimidate the population and control the blood diamond trade. I photographed a charming little four-year-old refugee girl named Memuna, who is now a young adult with a family in Washington, D.C. One of the great honors of my life was when her new parents asked me to be her godmother. They told me my pictures were the reason they found her.

I recently worked for a non-government organization, Love for the Least, that sponsored a medical mission for refugees of ISIS. Overflowing camps with Syrians, Christians, Yezidis, Kurds—all who survived the ISIS doctrine of hate and intolerance. Persecution, genocide, lost loved ones, and desecration of holy symbols haunt their minds. Love for the Least is a grassroots Christian nonprofit helping all faiths in the region. They provide a prayer room for those who want it, and it's teeming with refugees of every religion in need of a healing touch or a comforting voice. Stoic people drop the facade of resilience for a moment and weep from the deep emotional trauma they endure.

I was so touched by the people there that

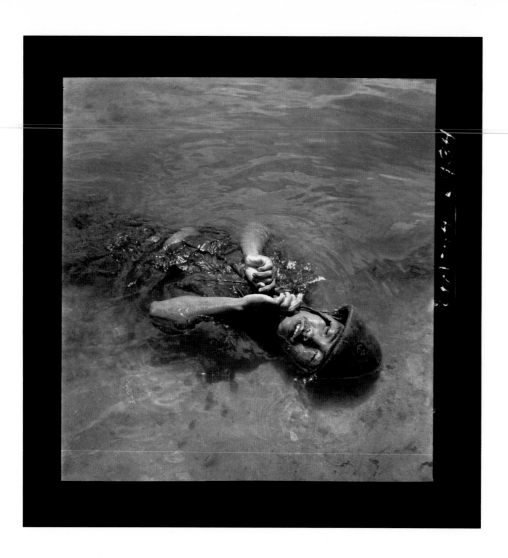

I returned to Mosul, Iraq, for the last month of the battle for liberation, and witnessed a heart-wrenching flood of humanity, wounded and weak, fleeing a nightmare of fierce fighting. Many were trapped or held as human shields. All endured a moving frontline sparked when ISIS emerged from tunnels—rubble laced with IEDs, snipers, grenades, and 130-degree brutal heat. ISIS orphans were pulled from the rubble after their parents blew themselves up with suicide bombs.

One tiny waif named Khadija kept calling for her mother, not realizing that the burns she sustained were from her own parent's suicide bomb. A little boy was found eating raw meat. Soldiers and medics believed it was from ISIS bodies surrounding him. A woman clutched the body of her child who had just died from hunger and dehydration. It was pitiful to see her holding so tightly that medics couldn't take the child away, for even a moment, to wrap the tiny body.

Empathy is a small word with epic meaning.

We've seen throughout history how selective compassion breeds hate—for the simple crime of being different. It begins when one group deems others unworthy of mercy. And when we turn away from oppression, our silence becomes complicity.

Photography is a means of confronting that hate, of finding that empathy.

While the pictures in *Aftershock* are disturbing and painful, they are vital. They provide a personal window into haunting scenes of conflict and atrocities during the last days of World War II. They also capture moments of life amid the rubble. Fear is palpable but valor endures.

"Never again" echoed after the Holocaust, yet at no time has it truly meant "never," as the human species continues to perpetuate acts of terrorism, genocide, and intolerance.

This is not a book that glorifies battle. It is a significant reminder of the horrific consequences of war on humanity. It is a book that demands peace. ☀

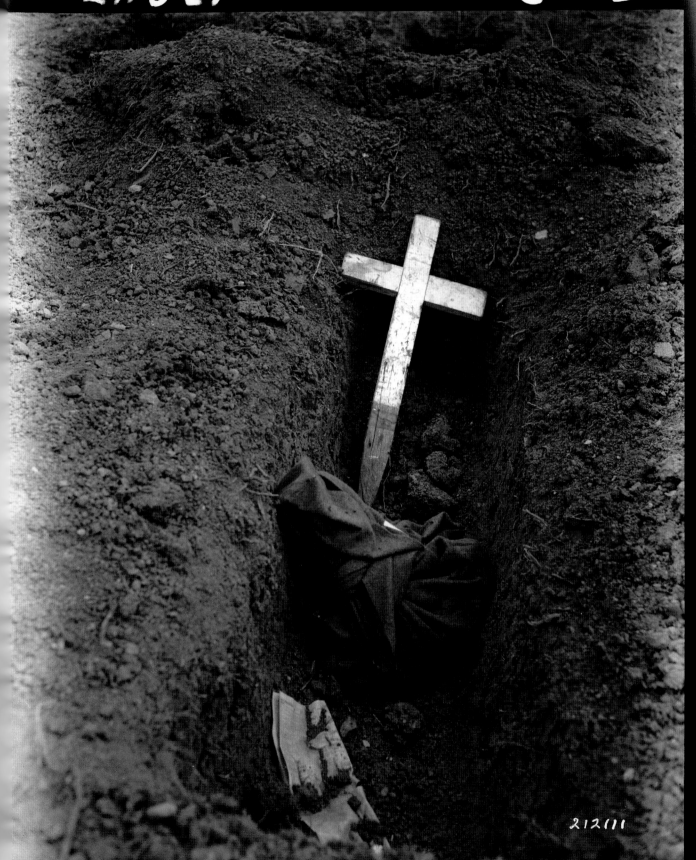

SWPA-SIGC-45-13847

212111

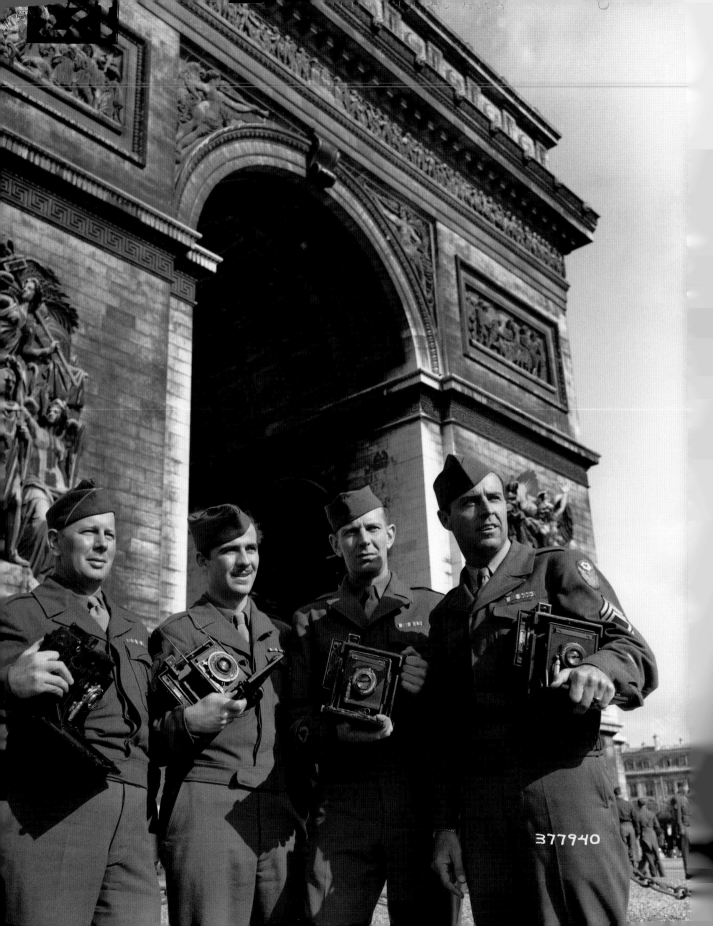

377940

SOLDIER PHOTOGRAPHERS
Documenting the Human Toll of War

They stormed ashore in North Africa, hacked their way through jungles in the Philippines, and rolled into Germany, bracing to be killed at any moment. They were armed—with cameras. Their orders were to shoot pictures of everything they witnessed, all the horror and courage and waste.

Now, 75 years after the end of World War II, their haunting images serve as a reminder of the human toll of war.

Tucked away in binders at the National Archives in College Park, Maryland, are hundreds of thousands of World War II photographs taken by American soldiers, sailors, marines, airmen, and coastguardsmen. Many images are familiar: tanks rushing across North Africa, Flying Tigers and Flying Fortresses, soldiers huddling in landing craft, the liberation of Paris, and kamikaze attacks. The work is well known and deservedly acclaimed. Their still photographs fill the pages of magazines such as *Life* and illustrate thousands of books. But historians focus on the action shots—GIs shooting it out in the Battle of the Bulge or General Douglas MacArthur wading through the Pacific toward the island of Leyte. What is often overlooked are the photographs that document the end of the war, the inventory of devastation as the howitzers stopped firing and the soldiers put down their guns.

This book focuses on photographs taken in 1945, the last year of the war, by a group of several hundred men in the U.S. Army Signal Corps. Few of these photographers were professionals, but they were a remarkably determined and skilled group. Unlike other military photographers, Signal Corps soldiers photographed all over the world—from New York City to New Caledonia. Their still images of the war's end and immediate aftermath are beautiful and brutal: cemeteries and churches, POWs and DPs, liberators and prisoners, surrenders and suicides.

We gather their photos because they are sobering and instructive. Today, some people view war as a natural and even routine option when peace talks break down. Too quickly, the havoc of war fades from memory and is reduced to a few paragraphs in history books. Each succeeding generation suffers from this forgetfulness, and plunges unto warfare over and over again, assuming that such conflicts can be contained and will never spiral out of control.

Edgar L. Jones wrote in the *Atlantic Monthly* in February 1946:

> We destroyed fascists, not fascism; men, not ideas. Our triumphs did not serve as evidence that democracy is best for the world, any more than Russian victories proved that communism is an ideal system for all mankind. Only through our peacetime efforts to abolish war and bring a larger measure of freedom and security to all peoples can we reveal to others that we are any better than our defeated opponents.

This book shows the cruelty and ugliness of total war. We hope it inspires people to take heroic measures to keep it from ever happening again.

THE WAR DEPICTED in these photographs was the deadliest in the history of the planet— "one of

LEFT: Signal Corps photographers William F. Augustine (*from left*), Sam F. Calvano, Al A. Unsen, and Edward J. Ellis return to Paris on August 25, 1945, the anniversary of its liberation. Bacon Photo

the great catastrophes of the twentieth century," as Signal Corps photographer Clifford Bell wrote. And 1945 was an especially calamitous year as the Americans and their allies rolled back the conquests of Germany and Japan to discover shocking cruelty and devastation. The war ended slowly as bombs rained down and famine spread. In the early months of 1945, Allied soldiers slogged cautiously through France and Belgium on their way through Germany to Berlin. Fierce fighting continued in Asia as the Allies struggled to take Pacific islands to make way for the invasion of Japan. By March, the fate of the war in Europe was pretty much sealed. As cities fell, soldiers began to see and understand the cost of war—even an "ethical" war. Then the gates of concentration camps were flung open and soldier photographers watched as former prisoners, fleeing soldiers, and civilian refugees rummaged for food and shelter.

The photographers who took these pictures were at the front lines—following close behind (or sometimes ahead of) the lead combat units, capturing unparalleled scenes of battle and of genocide. They created evidence, pictures that are as relevant today as the year they were taken. These photographers were simply doing their duty, but they were also creating a historical record that was a gift to future generations.

"Looking at Germany in 1945," wrote scholar Dagmar Barnouw, "they saw and photographed the bombed-out cities: houses broken up and broken open, an incomprehensibly altered cityscape in which what had been visible was now invisible and what had been invisible was now visible, in which what had been public was now private and what had been private was now public."

World War II redefined war. Combat served as cover for the attempted destruction of an entire people. The bombings of cities represented the abandonment of the idea that civilians should be spared. Most of the Signal Corps photographers were young, but even seasoned journalists would have been unprepared for the scenes that showed up in their viewfinders. What these soldiers saw was a world at total war—the mobilized population of 50

RIGHT: Howard Nickelson (*left*) and George H. Fezell examine negatives developed in a portable photo lab constructed with salvaged materials near Anzio, Italy, on March 22, 1944. Yale J. Lapidus Photo

FOLLY

FUZZY'S

377866

nations fighting with few restraints and with demands for unconditional surrender on every continent but Antarctica.

The death toll was staggering. Numbers vary wildly, but many experts estimate that 15 million soldiers and 45 million civilians died. And when the fighting was over, entire nations were left to rise from the ashes. In Europe, the postwar period was called the "rubble era." Throughout the world, the new reality was known as the "atomic age," with the deaths of hundreds of thousands of people now possible by a single human act. A new world emerged: the division of Europe and the splitting of Korea in 1945, the formation of the state of Israel in 1948, the bisection of Vietnam in 1954, and the creation of more than 40 new states from colonial Europe and the United States in the first years after World War II.

Rather than deciding that "war is war" and forgetting about the past, world leaders decided in late 1945 that the actions of individuals had been so depraved that they must be tried for war crimes. Chief U.S. prosecutor Robert H. Jackson called the Nuremberg trials of Germany's war criminals "the first trial in history for crimes against the peace of the world." The excuse of "just following orders" was no longer acceptable.

But retribution was not enough to set things straight.

Months earlier, in March 1945, President Franklin D. Roosevelt warned how difficult it would be to keep war at bay. "Peace can endure only so long as humanity really insists upon it, and is willing to work for it—and sacrifice for it," Roosevelt declared at the Yalta Conference. "Twenty-five years ago American fighting men looked to the statesmen of the world to finish the work of peace for which they fought and suffered. We failed them. We failed them then. We cannot fail them again, and expect the world to survive."

While many countries were devastated, the United States suffered relatively few military deaths—about 450,000—and hardly any civilian deaths. The war's end put America in a position to assume worldwide leadership.

For that reason, 1945 was a year of American

optimism, despite the horror at hand.

Although World War II has been cast in a nostalgic glow as a just and essential war, America's role at its start was not so clear-cut. Less than a quarter century had passed since the end of the First World War, and most Americans knew this would not be "The War to End All Wars," but rather a fight for survival against the Third Reich and its "Final Solution" and Japan and its Greater East Asia Co-Prosperity Sphere. No songs like World War I's "Over There" were played as troops left America. The romance was over.

PHOTOGRAPHY HAS LONG played a role in confirming the toll of war. The first photographs of combat were taken during the Mexican-American War of 1846–1848, only a few years after photography was invented. A photographer produced about 50 images in the field—each one made by exposing light-sensitive, silver-plated copper sheets to the light to create what was known as a daguerreotype. A few—including a view of American troops riding on horseback—still exist.

A little more than a decade later, New York photographer Mathew Brady got permission from President Abraham Lincoln to document the Union's war effort. Brady used his own small army of photographers to create more than 10,000 glass-plate negatives. In 1862, Alexander Gardner, a skilled member of Brady's team, photographed the aftermath of the brutal Battle of Antietam by showing the corpses splayed across the battlefield near Sharpsburg, Maryland. The following month, Brady displayed the work at his New York gallery, inspiring the *New York Times* to write:

> Mr. Brady has done something to bring home to us the terrible reality and earnestness of war. If he has not brought bodies and laid them in our dooryards and along the streets, he has done something very like it. At the door of his gallery hangs a little placard, "The Dead of Antietam." Crowds of people are constantly going up the stairs; follow them, and you find them bending over photographic views of that fearful battle-field, taken immediately after the action.

LEFT: Darkroom technician I. Unger develops film at Camp Amirabad in Tehran, Iran, on December 15, 1944.

Here, for the first time, was a realistic look at war, in contrast to the heroic paintings of swashbuckling generals and flag-bearing soldiers that people had been fed for centuries. "These pictures have a terrible distinctness," the *Times* wrote. "By the aid of the magnifying glass, the very creatures of the slain may be distinguished. We would scarce choose to be in the gallery, when one of the women bending over them should recognize a husband, a son, or a brother in the still, lifeless lines of bodies, that lie ready for the gaping trenches."

Here, for the first time perhaps, was an antiwar photo exhibition.

MILITARY PHOTOGRAPHY became institutionalized when it was put under the purview of the U.S. Army Signal Corps. That was a logical place since the Signal Corps, created during the Civil War as a signaling team that used flags and torches to relay commands, was in charge of army communications. The Photographic Section of the Signal Corps, established during World War I, oversaw the army's ground and aerial photography. By the end of World War I, about 100 officers and 500 enlisted men were documenting the war, sending back still photographs and motion-picture film. A century later, the National Archives possesses about 55,000 photos from the Great War.

In World War II, Signal Corps cameramen were joined by photographers from the U.S. Army Air Forces, U.S. Navy, Marine Corps, and Coast Guard, as well as war correspondents and GIs who brought along their own cameras. This book focuses solely on pictures taken by Signal Corps photographers, who left behind a remarkably complete and consistent archive. They were on the ground in each of the major theaters of war in 1945, and they created a group aesthetic, generally using the same cameras and lenses, the same types of film, and the same direct documentary style. They were taught to photograph like press photographers, producing sharp and serious photographs. Like the live-or-die, friend-or-foe, shoot-or-be-killed war itself, their photographs offer little nuance. The Signal Corps photographs of 1945 work together to form a harsh but steady narrative about the last year of the last world war.

Almost all the photographs in this book were produced by the ten Signal Photographic Companies that were overseas. In 1945, the 161st Signal Photo Company was dispatched to Dutch New Guinea and the Philippines; the 162nd to France; the 163rd to France and Germany; the 164th to China, Burma, and India; the 165th to Belgium and Germany; the 166th to Luxembourg and Germany; the 167th to France and Germany; the 168th to France, the Netherlands, Germany, and the Philippines; the 196th to Italy; and the 198th to France, Belgium, Germany, and Okinawa.

"The photographer always has a front-row seat," said Walter Rosenblum, of the 163rd Signal Photo Company. "You might get hurt in the process, but you're privileged. You're a participant and an eyewitness."

The photo companies varied in size, but each was led by a captain and a group of lieutenants who were in charge of assignment platoons. In most companies, the platoons consisted of still photographers, movie photographers, and jeep drivers. They were supported by clerks, mechanics, repairmen, and cooks. Each photo company maintained a darkroom, which could operate 24 hours a day developing and printing the still photographs gathered by the photographers. Film was couriered (by jeeps and small planes in Europe) to major photo headquarters in London and later Paris for processing. There, the photographs were reviewed, edited, sometimes censored, and sent back to the United States. Photographs deemed most important were transmitted by radio so they could appear in U.S. newspapers and magazines within a day or two after they were shot.

SIGNAL CORPS PHOTOGRAPHERS were enlisted men. They came from all across America with different ambitions and experience.

Clifford Bell was working as a clerk in a cut-rate camera store in San Antonio, Texas, when he enlisted. "I thought the army was what I wanted, especially since I would be accomplishing two things at once: supporting my country's fight against a vicious enemy and climbing out of my own personal rut," he said.

Jacob Harris, from Long Island, New York,

RIGHT: Charles J. West Jr. carries a Speed Graphic in Port Moresby, the capital of Papua New Guinea, on February 23, 1944. Hoffman Photo

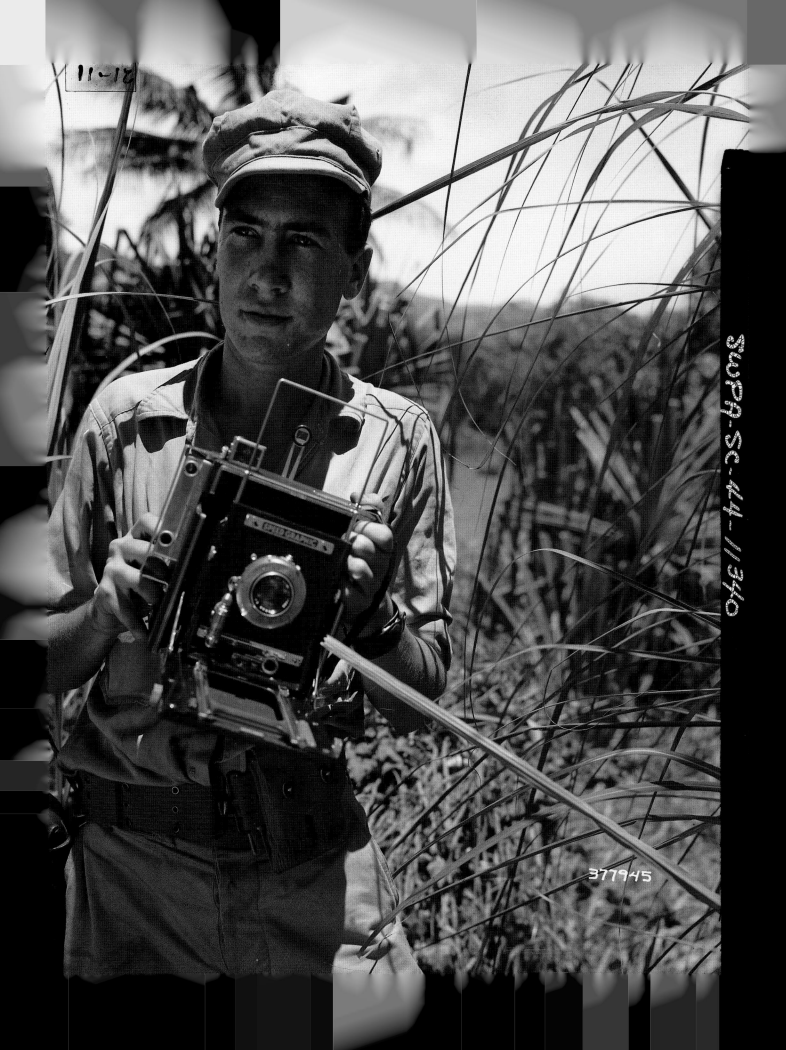

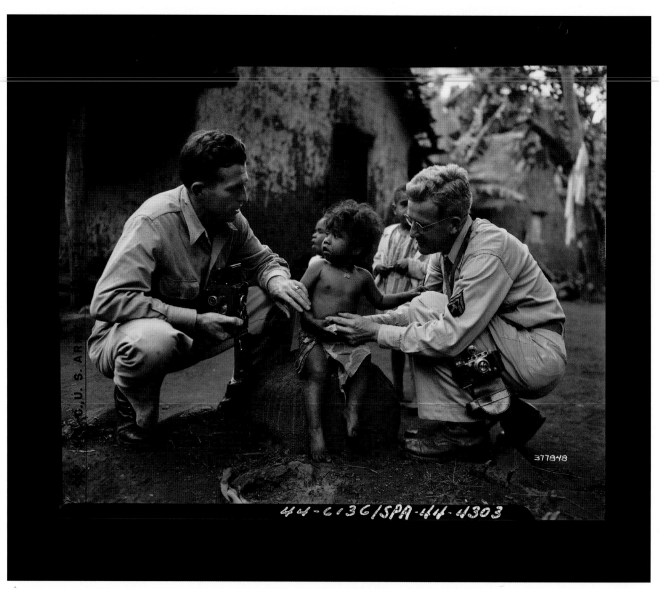

Yank magazine correspondent Lonnie Wilson (*left*) and Signal Corps photographer John W. Buckley approach a toddler at the Saint-Louis Catholic Mission in New Caledonia on September 1, 1944. Morton Photo

and J. Malan Heslop, from Ogden, Utah, were professionals. Harris worked for the Associated Press and Heslop for the *Ogden Standard Examiner.* Walter Rosenblum was a leader of the Photo League, a New York–based cooperative of professionals and amateurs who believed that photography could help cure social ills by spreading empathy.

Arnold E. Samuelson came from Tacoma, Washington, and Clare Leipnitz from Eau Claire, Wisconsin. Arthur Herz, a refugee who fled Germany to Rochester, New York, was not yet a citizen when he persuaded the army to take him. "I fancied myself a bit of a photographer," he said. Jerry Rutberg, of New York City, joined the army one year after Pearl

Harbor because he yearned to follow in the footsteps of documentary photographers Lewis Hine and Arthur "Weegee" Fellig. And Sidney Blau, a graduate of Brooklyn Technical High School, enlisted because "when I got into my teens I had a love affair with cameras."

WHETHER THEY ARRIVED as amateurs or professionals, Signal Corps photographers received the same instruction, usually lasting about 12 weeks. First came basic military training: drills, marksmanship, maneuvers, first aid, map reading, and a study of army organization and courtesy. A few men even went through traditional Signal Corps training: wire

splicing, pole climbing, telephone and radio procedure.

Men were split into sections after about a month. Photographers were taught how to use the still cameras—large-format Speed Graphics, medium-format Rolleiflexes, and small-format 35mm Kodaks—as well as the Bell & Howell Eyemo motion-picture camera. At some point, photographers decided whether to shoot still or movie cameras, but they were expected to know both. They started with theoretical training: the elementary principles of photography, optics, chemistry, negative making, contact printing, and enlarging. Then they received field training with cameras. "We were supposed to take pictures, to take pictures, to take pictures," said photographer Malcolm L. Fleming.

Assignments were practical. They photographed details—small objects, maps, room interiors, home exteriors, jeep dashboards, the front-wheel-drive assembly of trucks—and they practiced working at night. They learned to figure out the correct exposure without a light meter and how to judge distance for focus. The goal was to shoot quickly and effectively under extreme conditions.

They also learned the value of written material. Typed captions were as important as pictures. "Photographic coverage is valueless unless the pictures are completely identified by properly documented supplementary notes," the U.S. Army told its photographers. Caption cards were called "dope sheets." Identification of every American soldier—including their hometowns—was essential so that men and women stateside could relate to and support the war effort.

The still photographers got to know and rely on the PH-47 Speed Graphic, the press camera of the era. The cumbersome Speed Graphic, which weighed seven pounds, was not made for the jungles of the Pacific or the battlefields of Europe, and operating the camera was a challenge during the weeks of training and years in battle. The camera was improved in a few ways for war use: its shiny parts were blacked out and its leather was toughened to resist fungus. But it remained a complicated machine, with a fragile front bellows and tilt mechanism, cocking lever, aperture selector, and shutter speed selector. A photographer had to be especially selective because loading film was tricky, especially under stressful situations. The camera held only two sheets of film, each of which

was protected from light by metal slides until an exposure was made. Once exposed, the film needed to be covered again. Wrote photographer Robert Stubenrauch in his autobiographical novel *CAT Thirteen,* about opening the slides: "Cock the shutter, frame the picture carefully, double check the focus, check, slide out? Trip the shutter, pull the paper tab. Slide in, move to the next angle."

This was not a Brownie.

But the Speed Graphic could create four-by-five-inch negatives that were infused with photographic information. It is these giant negatives that have been scanned—most for the first time—for this book. The photographers who made these images and the darkroom technicians who processed them would likely be astonished by the rich information that lives on in those negatives.

EVENTUALLY, SIGNAL CORPS PHOTOGRAPHERS headed across the Atlantic and Pacific Oceans for destinations unknown. The journey took weeks as troop transports zigzagged to avoid detection.

They soon found out that shooting battle was nearly impossible.

"Actually, it turns out there's very little you could photograph during the daytime because most combat took place at night," said Signal Corps Lieutenant William Lueders, of the 163rd Signal Photographic Company. "Guys don't stick their necks out in the daytime."

Soldiers moved slowly, often on their bellies, and most of the action happened beyond the lens. Photographers—known as "Brownie-bearers" to foot soldiers—stood behind walls and, like infantrymen, crawled flat on the ground. That made pressing the shutter nearly impossible. "The truth was that the stark actuality of the battle front was seldom photogenic," wrote Chief Signal Officer Harry C. Ingles in 1944. Except for landings, "the most striking feature of the battlefield is its emptiness."

And, of course, photographs could not convey the full effect of battle.

"All cameramen know the disappointment and letdown in viewing a shot made at the time all hell may have been letting loose," wrote Captain Robert Lewis, commander of the 163rd. "Since bullets don't photograph and shells aren't visible and the noise of battle is missing—the rain, the dust, or the mud—all

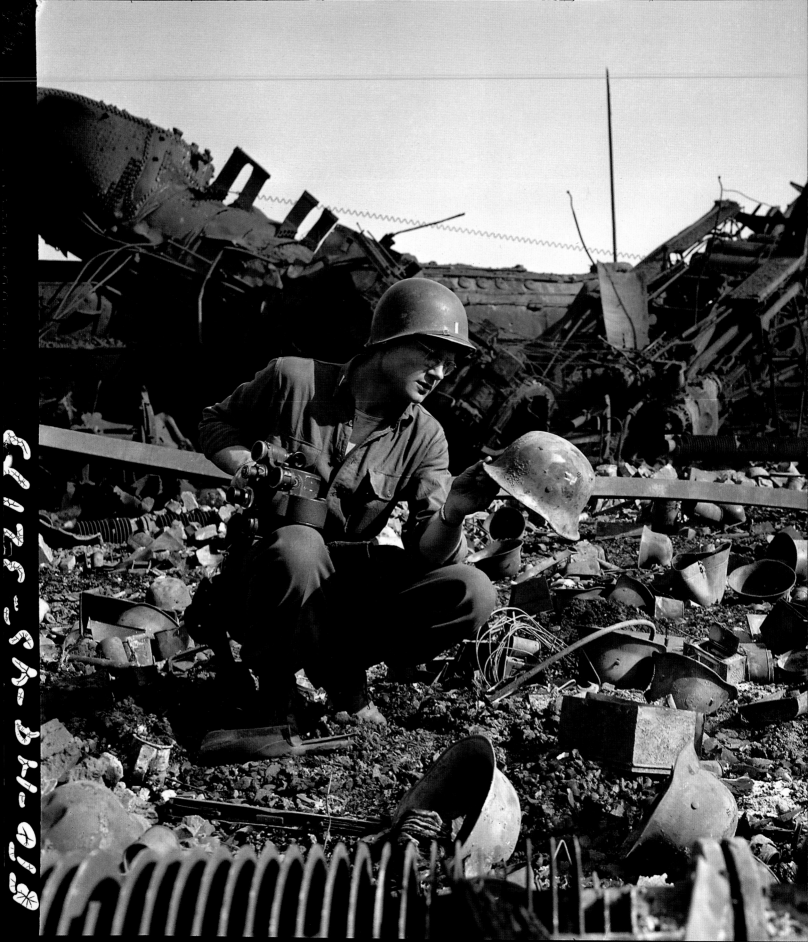

this has been reduced to one dimension."

But they could convey the horror surrounding battle. Like Matthew Brady's photographers, they could show corpses littering the landscape and makeshift graves. And they could show mothers gathering up their babies in front of oncoming troops. They could show the rubble left behind in cities across Europe and Asia, and could show hordes of refugees on their way home. They could show amputees, hangings, executions, beatings, collaborators, and schemers, and the wrecked relics of imperialist dreams. And they could show the gates of hell.

Those scenes are what Signal Corps photographers gathered in 1945. Getting to those scenes left scars on each of them.

"The sound of thunder sounds like the sound of artillery," wrote Robert Stubenrauch a half century after the war. Sydney Greenberg of the 164th was afraid of the dark after a raid on his camp in China by Japanese soldiers, and Walter Halloran of the 165th had nightmares about his time in Germany until the day he died at age 94 in 2018. His brother, Patrick J. Halloran, who rose to the rank of Air Force major general, said, "He never forgot."

What they saw was staggering.

Buried among the records of the 163rd Signal Photographic Company are reports of the daily havoc photographers encountered in 1945. Here is what photographers Fred Bornet and Robert Stubenrauch reported in early April:

> **2 April:** 42nd CP [42nd Infantry Division command post] moves to Wertheim. Town just taken in renewed division push. Civilians loot bread reserves. Team discovered camouflaged [Messerschmitt] ME 109 factory hidden in RR tunnel.
>
> **3 April:** 42nd assaults Wurzburg. Team on way to town, gets food riot at Wertheim. Civilians raid barges on canal.
>
> **4 April:** Corps and team move to Tauberbischofsheim. Wurzburg still fought for. Team crosses Main River on pontoon

LEFT: Photographic officer Don Sykes looks over scorched Nazi helmets in a bombed rail yard in Northeim, Germany, on April 11, 1945.

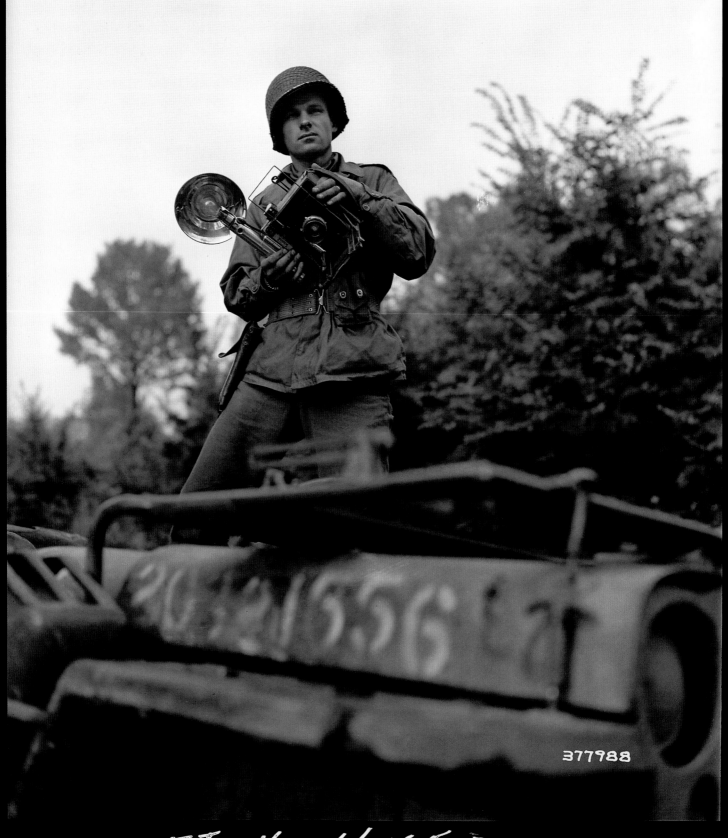

377988

ETO-HQ-44-16613

10

ferry. Picture of town, dead snipers, PWs, etc.

5 Apr: Germans counterattack during night. Repulsed by river. A regiment of the 42nd mops up every house thoroughly of snipers. Team gets pictures of old cultural town, sniper-hunt, devastated buildings.

Even victory was traumatic.

About 40 miles to the north on the following day, photographers Joseph A. Bowen and Walter Rosenblum reported on a raid that liberated the Stalag XIII-C prisoner of war camp at Hammelburg.

"The camp consisted of a large group of buildings surrounded by several rows of steel fences," they wrote. "One by one, the tanks hacked their way into the camp itself. And when they released the last barrier, a swarming mass of happy men drowned out the tanks from view. Kissing the tanks, kissing the tankers, the happiness of the PWs knew no bounds."

All of this took a psychological toll. Wrote Rosenblum: "You see men killed before your very eyes. You see the hate in the face of the Nazi soldier even while our medics are giving him first aid. And then the French and their stories of Nazi oppression. The brain isn't large enough to encompass all the suffering and hardships the Nazis have caused."

After the war, several Signal Corps photographers wrote memoirs in an attempt to deal with what they had witnessed.

Charles Eugene Sumners, of the 166th, wrote about watching an American soldier take a young German woman into a barn against her wishes. "She came out after five or ten minutes straightening her skirt, and then ran down the street crying," he wrote in his book *Darkness Visible.* "I don't know: possibly, if I had tried to stop this, I would have had to kill him or he would have had to kill me—one or the other."

Sometimes what they saw was too gruesome to record. Sumners wrote about finding a family of four lying together in the crater made by the explosion of a mortar shell. "I did not take a picture of this," he wrote, "but I still remember this whole family huddled there and covered with snow—a father

trying to shield his family from the enemy."

Clifford Bell, of the 163rd, wrote about how the war changed him—particularly after he found the body of fellow photographer Cecil Lannigan buried in the rubble of an Italian street following a 1944 strafing attack. That night, Bell watched as Allied machine gunners brought down a German warplane.

"For the first time I felt a strange exultation as I followed the flaming wreckage all the way to the ground," Bell wrote in *War through a Lens.* "A few months before, perhaps only a few hours before, I would have been surprised, and probably a little frightened, to recognize this feeling in myself. I would have been appalled to find satisfaction, even elation, at the spectacle of men dying horribly in a plummeting mass of burning wreckage."

But Bell thought about his friend who had been killed.

"I calmly accepted that my mind was beginning to give up its hold on centuries of civilization, and was yielding to the embrace of the gods of war.

" 'Burn, you bastards, burn,' I whispered hoarsely into the blackness."

THE DEEPEST SCARS came from photographing the concentration camps, but the work was essential. Supreme Allied Commander Dwight D. Eisenhower ordered a "complete pictorial record" of the camps, and by late April 1945, the *Weekly Kodachrome,* the newspaper of the 166th, wrote, "Without photos it would be impossible to convey the real truth about the concentration camps."

Nerves were frayed as the camps were uncovered. On the way to Dachau, Walter Rosenblum and Joseph A. Bowen reported witnessing a firefight in which SS officers surrendered to the Forty-Second Division on the morning of April 29.

"I guess the 42nd men were a little mad—and proceeded to shoot their prisoners," Rosenblum reported in the team history. "Bowen was forcibly prevented from making pictures. I was hiding out in a nearby building and got the sequence." A few hours later, Rosenblum and photographer Arland B. Musser witnessed another shooting of unarmed German soldiers inside Dachau (pages 130-131).

The death and cruelty in the camps overwhelmed the senses.

"Men were gagging and retching, immersed in a

choking stench unlike anything they had experienced before," wrote Robert Stubenrauch.

"We would go out and make pictures at these camps and then go back to the base to shower," wrote Charles E. Sumners. "You could wash our clothes in gasoline or burn them, but you could still smell that camp odor, and it stayed with you for some time."

Walter Halloran gave a slide presentation in 2007 to share his World War II experience, but could hardly talk about what he saw at Buchenwald. "We were hardened by years of combat. But nothing, nothing prepared us for the brutality—the sights, sounds and smells—we found there."

Said Sidney Blau, of the 163rd, "I have spent 60 years trying to forget the experience" at Dachau.

"This past week I had a ghoulish assignment," he wrote his wife after seeing Dachau. Blau wrote that he had read early reports about the camps but believed they were exaggerated. "How wrong I was. It was 100 times worse."

The sights and the stench were appalling, he wrote. "War-hardened infantry men cursed at what they saw." He saw boxcars filled with the dead, and talked to those who survived. "I spoke to some of the more fortunate ones. They told me about some of the prisoners driven mad by hunger. They cut slices of meat off the dead and ate it. And I could believe it."

IT'S UNCLEAR EXACTLY how many Signal Corps photographers were killed in action, but it is likely several dozen. The Marine Corps Photo Section had it even worse. Photographer Norman Hatch estimated that half of his unit was wounded or killed at Iwo Jima in early 1945 and more at Okinawa later that year. "The most important thing was being where the action was," recalled photographer Sumners. Wrote photographer John Cooper, of the 161st, "Some of our people would get so wrapped up in combat taking pictures that they seemed to forget they were in combat."

Unlike medics and chaplains, cameramen tended to blend in with the fighting forces. And still photographers had to make themselves visible to get what they wanted. Movie cameraman were even more vulnerable; their film cameras made noise when they were shooting.

Danger was constant. William Fred Bonnard Jr., for example, was in five amphibious assaults with the 163rd: Casablanca in 1942, Sicily and Salerno in 1943, Anzio and Toulon in 1944. "People, understandably, have no idea what being a combat photographer was all about," said Walter Halloran. "You see these movies every night on television. How many people stop to think about it: Now wait a minute, there must be someone with a camera filming this."

Photographers were given sidearms, but it was too hard to shoot both a camera and a gun. They realized they would have to choose: soldier or photographer. "A cameraman has to expose himself a great deal while 'shooting' combat action, and he can't very well operate a gun and a camera at the same time," wrote photographer Joseph Michael Zinni, of the 166th. "In our unit we lost some fine comrades, who chose to keep taking pictures to the end," wrote Joseph D. Boyle, of the 163rd.

The pressure on them to produce photographs was severe. Peter Maslowski, who wrote *Armed with Cameras,* found a 1943 diary entry from Secretary of War Henry L. Stimson denouncing soldier photographers for not getting close enough to the action. He even grumbled that Signal Corps photographers "do not seem very anxious to be killed."

Stimson's alarm must have been passed down, because photographer Zinni wrote that he was confronted soon after by a Signal Corps colonel who "asked me why we weren't able to take pictures of American soldiers bayoneting Germans, pictures of our machine-gunners mowing down groups of the enemy, pictures of our mortars landing on enemy installations and other fantastic, impossible and unobtainable pictures."

Wrote Zinni, to his wife in the States, "He wants blood!!"

BECAUSE SO MUCH was expected, Signal Corps photographers were allowed to travel just about anywhere they wanted. Late in the war, General Eisenhower signed what became known as a "blue pass" that gave free rein to each man designated as an "Official War Photographer." Unlike infantrymen, photographers could withdraw from the front at any time. They called themselves "gypsies" and "vagabonds" because they could take off in their jeeps. But they often traveled from job to job based on

Photographer Raymond Hurley looks over the damage to a British tank from a bazooka blast in Osterode, Germany, on April 12, 1945.
Jack Kitzerow Photo

orders rather than whim—being called upon to take tactical photographs.

"We were like news cameramen, you know," said William Lueders in 2004. "You look for something interesting to photograph." To help them, photographers were given advance information about troop movements. It was an unusual level of freedom for a soldier, allowing them to find and "liberate" stashes of wine in France, watch the "twistings, turnings, and wrigglings of *frauleins*" in Germany, and collect war souvenirs in Europe and Asia. But "it was a trap," wrote photographer Clifford Bell. "You had to get pictures, and the only ones worth getting were in places where the shooting was."

THE WAR ENDED in Europe in mid-1945. The company newspapers were filled with news about going home.

"Jimmy Bosen had been writing to a West Virginia gal, Pauline, ever since Camp Sutton," announced *Foto-Facto,* the newspaper of the 163rd, on June 1, 1945. "They were pen pals or something like that for he never met her. Then Jim went home on TD—and he married the girl. We have his word that it will be a til-death-do-us-part contract—providing it really can happen." (Jimmy J. Bosen married Pauline Murphy on May 10, 1945, in Salt Lake City, Utah.)

Two weeks later, *Foto-Facto* issued an extra Goin' Home edition with news that:

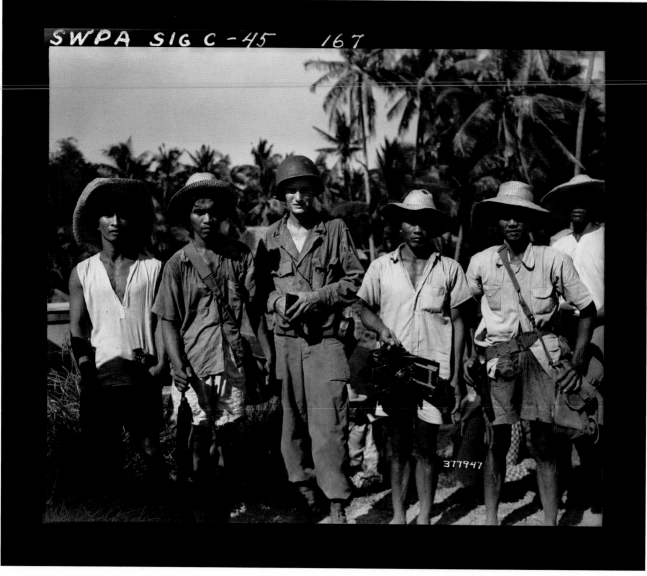

Signal Corps photographer Herbert Wolcott is joined by a Filipino family in Binmaley on the island of Luzon in the Philippines on January 9, 1945.

"Hanson retraces his steps through Fort Dix to the Bronx and Clara."

"Harvey the Hoosier Hotshot will hit Lebanon, Indiana. (Lookout Bachrach, there's a threat coming.)"

"Quinn goes back to three sons, and Syracuse, N. Y., wonders if he will be a truck driver or bartender."

For most, the war really was over. Some were told they could return to the United States but had to be ready for deployment for the invasion of Japan.

IT TOOK FIVE days for Clifford Bell to return to the United States from France aboard a troop transport ship.

"On the train I sat alone and stared out the windows as we rolled smoothly along," he wrote. "I didn't want to miss a thing, not a rock or a tree."

But everything seemed strange as he headed back to San Antonio. The train crossed bridges that were intact and cities that were filled with workers. He noticed they were not in uniform and they were not armed. Farther on, a man waved at the train. "He was offering a greeting, not making a sign asking for food or cigarettes.

"There were millions like these men, I knew. I told myself that this was right; this was the way it should be. This was the way it had been all along and

I was the one who was strange." Bell felt the clean air and considered the graciousness of America. "Life seemed extremely good, and yet for the first time it frightened me a little. For the first time I really knew just what I had here, but I was aware it could all be lost."

Only a few of the Signal Corps photographers are alive 75 years after the end of the war. Almost all were older than 20 in 1945, which means they would be at least 95 today. Like most GIs, the Signal Corps photographers seldom shared their experiences with their families. Walter Halloran's daughter Susan said, "He had four daughters, and I think he wanted to protect us from what he saw." Some took home a typewriter they had used or a Luger they had confiscated from an Axis soldier, but few were allowed to bring home their old Speed Graphics. Jerry Rutberg pinned his Purple Heart on his daughter's pajamas whenever she would take sick. But on the whole, the war was something to forget rather than remember.

Reunions were held; reunions were missed. Russ Meyer, who went on to produce "skin flicks," hosted get-togethers for the 166th at Camp Crowder in Neosho, Missouri. "It was like Russ's life started when he was in the army," said actress Erica Gavin, who played the title role in Meyer's movie *Vixen!* "He was born, he popped out in a uniform. There was no childhood." Malcolm Fleming, who became a professor of education at Indiana University, skipped get-togethers for the 165th. "I wanted to put that all behind me. I was wondering what's next."

Most members of the Signal Corps lived lives of relative obscurity after the war. Meyer was an exception, and he pulled many members of the 166th into his film projects, including Bill Teas, star of the 1959 film *The Immoral Mr. Teas,* billed as "a ribald classic in revealing Eastman color." Three movie directors who worked on Signal Corps films—Frank Capra, John Huston, and George Stevens—had long, celebrated careers in Hollywood. Stan Lee, who made Signal Corps training films, helped create Marvel Comics; and Yoichi Okamoto, who joined the 163rd in mid-1945, went on to become President Lyndon B. Johnson's official photographer.

The Army Pictorial Service, which oversaw the Signal Corps photographic work, received more than 300,000 negatives, which were deposited at the Pentagon. Those negatives were transferred from the Department of Defense Still Media Depository to the National Archives and Records Administration in 1986. They are now housed in the Still Picture unit of the archives in College Park, Maryland, along with about 4,000 color transparencies and more than 500,000 World War II prints and negatives from the U.S. Army Air Corps, Coast Guard, U.S. Navy, and Marine Corps.

Most of the Signal Corps photographs have corresponding negatives, but orphan prints exist. Tens of thousands of other Signal Corps prints— either never received or rejected by the Army Pictorial Service—are in private collections. Many were taken home by the photographers themselves, and remain with families.

ROBERT STUBENRAUCH WAS on a business trip for Goodyear with a colleague in 1984, driving a rental car through the winding roads of the Alsace countryside, when their car pulled into the tiny village of Bouxwiller in northeastern France. Stubenrauch had stayed there with his 163rd combat assignment team for two weeks during the winter of 1944 and 1945, when Nazi troops were "within a rifle shot away."

He wanted to find the woman who had sheltered them.

"The family Phalzgraf?" he asked a passing French gentleman, and was directed to a large red house only one street over.

Stubenrauch and his coworker walked into a dark foyer and found the name of Madame Phalzgraf on a brass door panel.

"We soon heard the slapping sound of slippers and saw the gleam as the glass door opened and a voice called out," he wrote.

"Qui est là?" Who's there?

"I sought the right words and called up from the darkness: *'Madame, c'est un ami de la temps de guerre.'"* Madam, I'm a friend from wartime.

"Mon dieu, c'est toi Robert?" My god, is that you, Robert?

Then she said, "I just knew it was you." ✳

About the Photographs

The photographs in this book come from original negatives taken by U.S. Army Signal Corps photographers around the world. We carefully placed each negative on a flatbed scanner and created 50-megabyte, 16-bit files at the National Archives and Records Administration in College Park, Maryland. We wore gloves.

Almost all the negatives are large: 4 inches by 5 inches. They have not been cropped, and the original markings have been left intact. In some cases, parts of the negatives were masked by black strips (which appear white on the positive images on these pages) by U.S. Army photo editors to indicate preferred cropping.

The vast majority of these negatives were created with Speed Graphic cameras, which produce negatives full of photographic information. There are also a few images created with twin-lens reflex cameras, which produce negatives that are 2¼-inches square. These cameras were much simpler to use, but they required photographers to look down toward a viewing screen. That made the GIs particularly vulnerable in battle. In a handful of cases, we scanned from a print. These photos appear in the book with a thin white border around the image.

We view these negatives as historical artifacts. We rely on them because they capture the war in 1945 with remarkable detail and tonality. Scanned and reproduced today, the pictures take on a new life. The most skillful photographic printer using an enlarger could never have created images with such sharpness and richness. Here is a different, more real war.

In this book, all images are presented edge-to-edge, including notations such as "confidential" or "restricted." They are all declassified now.

The resulting scans have not been altered or Photoshopped. In most cases the original negatives are in amazingly pristine condition, despite being developed in the field at portable labs and, in some cases, exposed in the post-nuclear wastelands that were Hiroshima and Nagasaki. We have cleaned dust and spots from the images but have not corrected darkroom flaws or signs of age, wear, or deterioration. The results are a testament to the resourcefulness of the Signal Corps lab men who processed the images, the U.S. Army and Department of Defense that housed the negatives, and the National Archives, which cares for them today.

The Still Picture Branch at the archives preserves these photographs in cold storage and allows researchers to scan up to 10 photographs a day—after the negatives have warmed to room temperature. We were assisted by Elissa McConnell, who visited the archives more than a dozen times to scan these negatives.

We are showing the exact sheet film we found—the black borders surrounding the negatives, the writing on the black borders that were added after the photographs were taken, and the small numerals

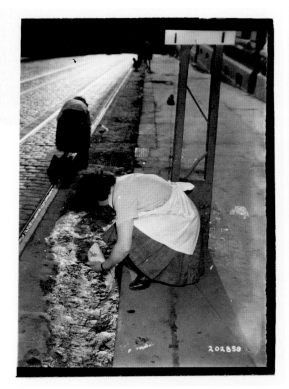

A contact print (*left*) of a 1945 image and the complete negative. An army photo editor placed masking tape on the negative to crop the image, and wrote notations on the border to indicate where the photo was taken. The Signal Corps identification number is at the bottom right.

written directly on the negatives in the bottom right corner that were added by the U.S. Army years after the war. These six-digit numbers are Signal Corps identifiers. Today, the numbers can be used to order a copy of an image.

ETO stands for European Theater of Operation, CT for China Theater, IBT for India-Burma Theater, CPA for Central Pacific Area, SWPA for South West Pacific Area, WPA for Western Pacific Area, AD for Alaskan Department, and USFA for United States Forces, Austria.

You might notice that some of the film was from Agfa, a German corporation. Agfa merged with a U.S. company in 1928 and was renamed Agfa Ansco. It produced the Superpan Press Film that was used by the Signal Corps throughout the war. The other popular film was Eastman Kodak's Safety Film, named because it was an alternative to nitrate film, which was quick to catch fire.

We have credited each photograph with the name of the photographer as written in the original caption, but in some cases no names were left behind or only a last name was recorded. We generally used the dates as they appeared on the captions.

This book comprises photographs taken by Signal Corps still photographers and stories from still photographers and filmmakers. These men experienced the war together, often working side by side. The reports that they made, as well as their photographs, were often made in tandem. This is their story. ☀

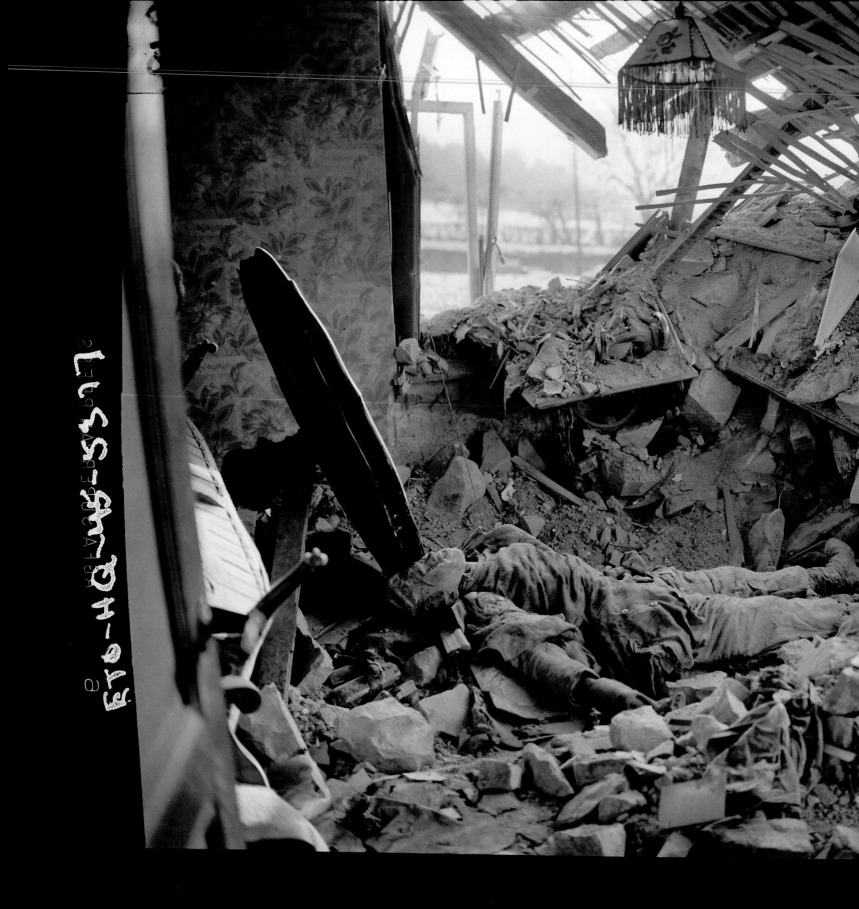

JANUARY 1 BRUCE D. HAWKINS PHOTO (167TH SIGNAL PHOTOGRAPHIC COMPANY)

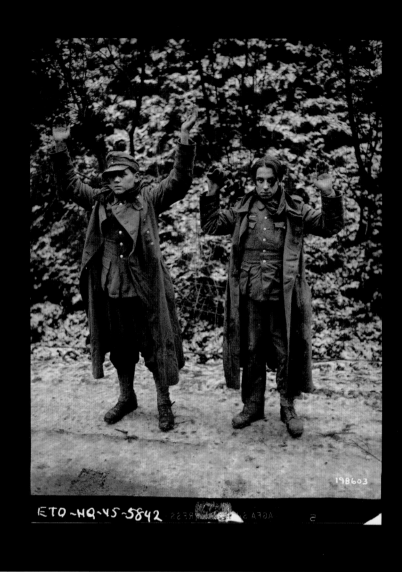

JANUARY 1

World War II was the largest, most destructive war in history. By the start of 1945, it had been wreaking devastation for more than five years. But the endgame was well underway. The German army had already made and lost its last big gamble, the Battle of the Bulge. Germans who had rounded up droves of American prisoners just weeks earlier were now the ones surrendering—including these two Germans wearing GI-issue boots and leggings in Snamont, Belgium. But fighting remained intense. "The Luftwaffe is up again," Joseph Zinni of the 166th Signal Photo Company wrote to his wife on January 1, 1945. "Artillery duels, of great proportions, are in progress. The 'chattering' of machine-guns that are not very distant is heard at frequent intervals. Mortar-fire is occasionally heard, and there is an exchange of rifle fire that is periodical—about every ten minutes or so. Aside from this, dear, things are rather quiet."

LEFT: A dead German soldier lies in the rubble of a house hit by an artillery shell in Hotton, Belgium, one of the towns where the Battle of the Bulge offensive was shut down.

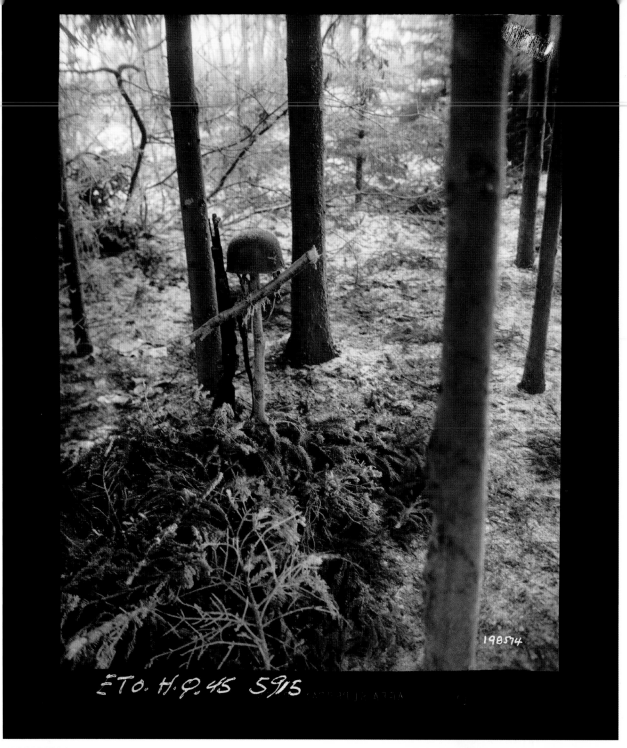

ETO. H.Q. 45 5915

198574

JANUARY 3

A German soldier's temporary grave includes his helmet and a cross made of tree branches in the woods near Bastogne, Belgium, where some of the Battle of the Bulge's fiercest fighting occurred. Eric Wiesenhutter of the 166th Signal Photo Company recalled taking cover with an infantry unit: "During a let-up in the barrage I ran across the field to join these doughboys. They would have been much happier to see me with a bazooka than with my Speed-Graphic [camera]."

RIGHT: In a battle-scarred church in Schleiden, Germany, just over the Belgian border, U.S. soldiers are trained in a fearsome weapon, the flamethrower. The U.S. Army used the incendiary device more often in the Pacific than in Europe, but it was effective in persuading Germans to surrender in the waning days of the war. Said photographer Malcolm Fleming, "Our flamethrowers were devastating."

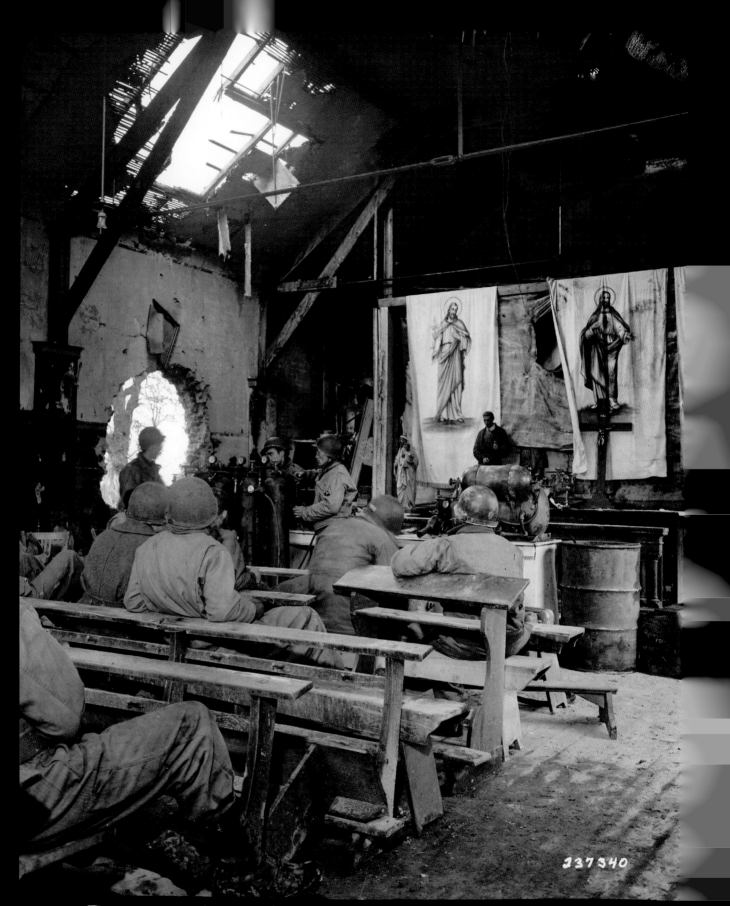

JANUARY 4 DWIGHT W. MILLER PHOTO (167TH)

"We took off from Assam for Kunming, my unit's headquarters in China. I was a raw, semi-trained second lieutenant in the Signal Corps, 22 years old and without a clue as to what was going on. Scarcely able to walk under the weight of my equipment, I struggled onto the airplane."

Barney Rosset
164th Signal Photographic Company

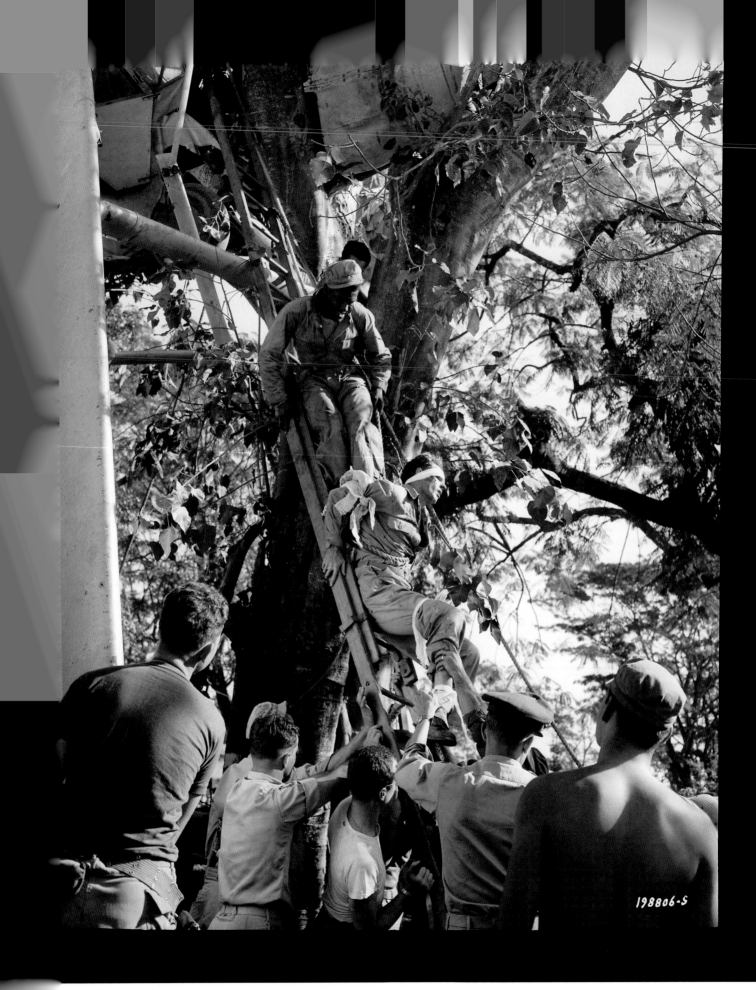

198806-S

JANUARY 11 LOUIS W. RACZKOWSKI PHOTO (164TH)

JANUARY 12 SYDNEY GREENBERG PHOTO (164TH)

Chinese workers maintain the supply lifeline between India and China along the Ledo and Burma Roads.

LEFT: Staff Sergeant Wells Latta, pilot of a "mercy ship" flying wounded soldiers from the Battle of Myitkyina, Burma, is helped from the wreckage of his plane after it encountered mechanical trouble and crashed into a tree. The three wounded men who were being transported suffered only cuts, while Latta sustained a broken ankle and lacerations. The rescuers were praised for the difficult and dangerous job of cutting away parts of the plane to free the pilot as gasoline and oil leaked from the aircraft.

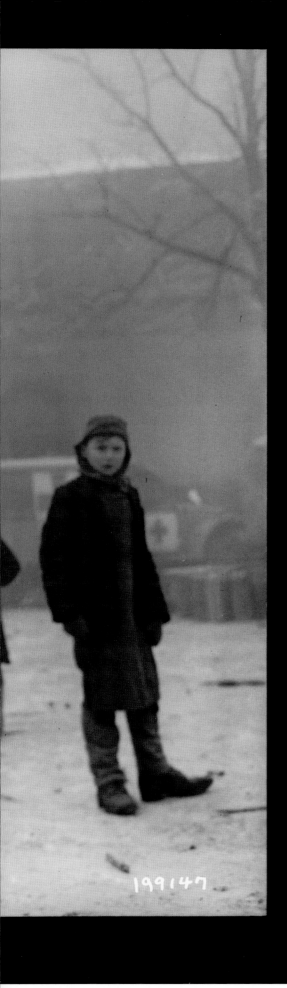

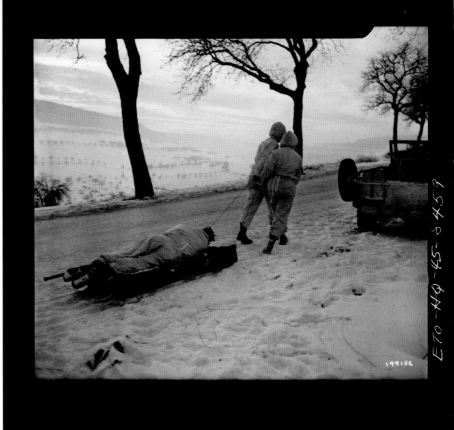

JANUARY 15 MILLER PHOTO

A wounded GI is pulled on a "ski litter" to an awaiting jeep in Ettelbruck, Luxembourg. "Our medics, our infantryman, our engineers, [were] doing things that you didn't believe people had the right to try," wrote Walter Rosenblum of the 163rd Signal Photo Company. Eric Wiesenhutter, who served with the 166th, wrote years later about the high cost of the war during 1945: "I can still see the endless lines of ambulances heading for the rear with their human cargo. There were no helicopters in those days for evacuating the wounded, and they had to travel many miles over bumpy back roads to get to medical care."

LEFT: The Alsace region, claimed for centuries by both the French and the Germans, was the scene of bitter fighting as the Allies moved toward the German homeland. A German counteroffensive around the Alsatian town of Rittershoffen caught civilians by surprise. This wounded woman, clutching her child as she awaits evacuation, was one of the lucky ones. About 100 civilians were killed in the house-to-house fighting, with many of their bodies lying in the streets as the battle raged.

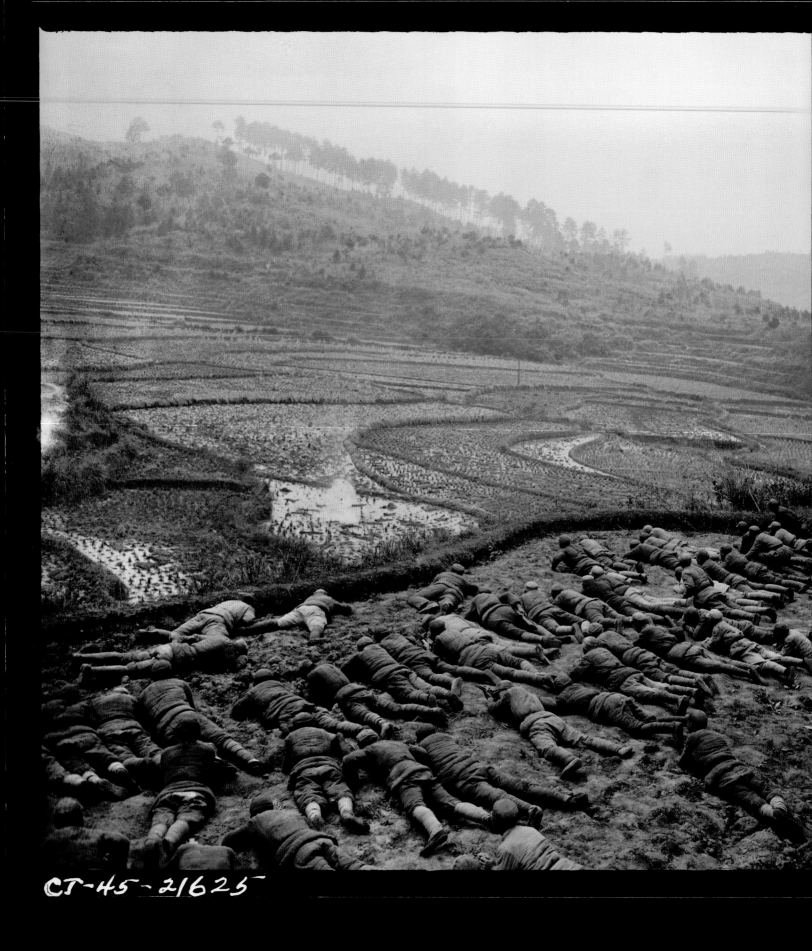

CT-45-21625

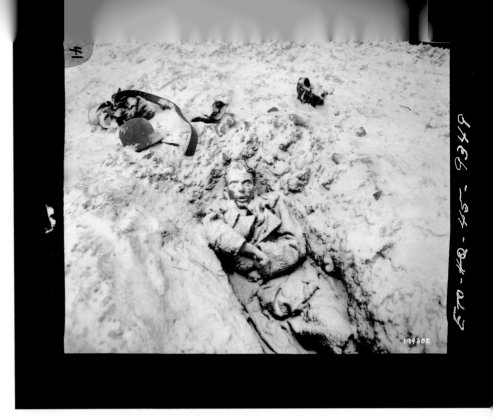

JANUARY 17 WALTER D. MᴀᴄDONALD PHOTO (167TH)

A dead German officer lies in a foxhole after his crew operating an 88-millimeter artillery piece was knocked out near Mabompre, Belgium. American troops had to be careful handling the German dead because the bodies might be booby-trapped. GIs would hook a wire to a dead soldier's leg and pull it, setting off at a safe distance any explosives that might be rigged to it.

LEFT: Half a world away, Chinese soldiers hit the dirt as they went through training with U.S. troops. When Americans tried to build up the Chinese forces earlier in the war, they encountered a huge, virtually untrained, and poorly equipped army. Most didn't have weapons or boots, and there was one blanket for every five soldiers. "It seems that some people doubt whether or not the Chinese soldiers will fight, so they urgently wanted pictorial proof," wrote Barney Rosset of the 164th to his parents. "Myself and two of my sergeants went out to get it, and if our film shows what we saw, then the whole world can know that the Chinese soldiers will fight."

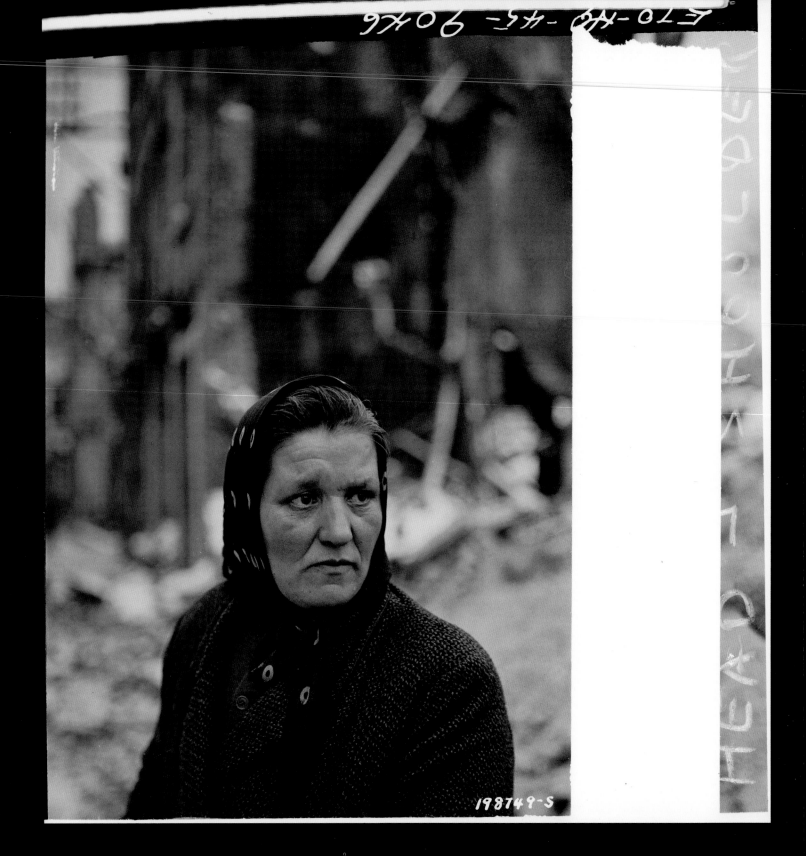

198749-S

JANUARY 18 CHARLES TESSER PHOTO (167TH)

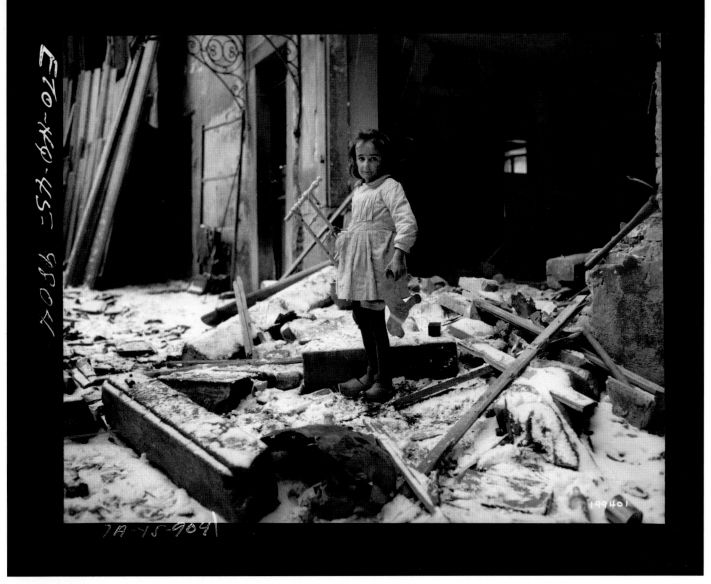

JANUARY 20

A girl has salvaged a toy from her wrecked home in the Alsatian town of Kientzheim. "The damn grim business of war has me down," wrote Gordon Frye of the 163rd Signal Photo Company to his wife. He had grown tired of photographing "poor civilians, homeless, hungry kids, blasted ruins of once beautiful villages, blasted twisted forms that were once human beings." Everything, he wrote, "is uncertain, only the bloody war is definite."

LEFT: After a U.S. Army Signal Corps photographer took a picture of this woman in La Roche-en-Ardenne, Belgium, he wrote a caption saying that "tragedy is written on face." La Roche, a picturesque town of 1,900 people that was a popular tourist attraction, had been recaptured by the Americans in September 1944, and troops planned a Christmas banquet and ball, inviting all the townspeople. But the Germans' surprise offensive in mid-December changed those plans, forcing the Americans to abandon the town as it became engulfed in the Battle of the Bulge. German artillery flattened homes, American artillery knocked down more, and then aerial bombing by the United States left La Roche leveled. The woman in the photograph survived the destruction of her home, but her child was buried in the ruins.

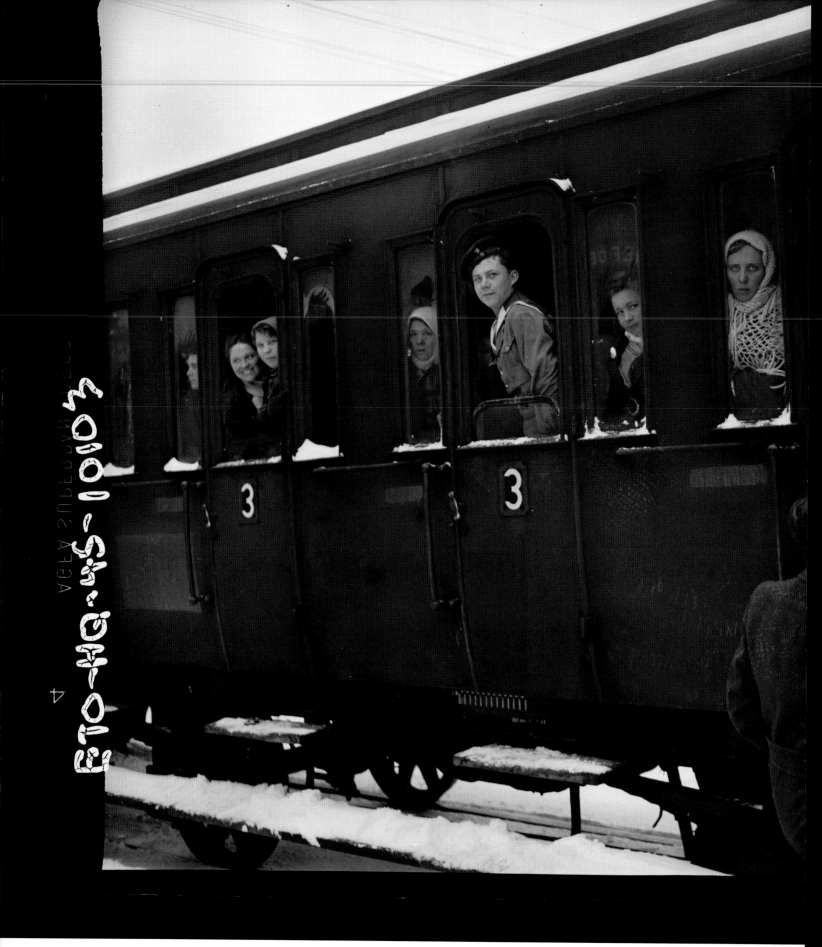

In early 1945, much of Europe was on the move. With the Germans retreating across Europe, millions of their prisoners and slave laborers were suddenly free, while refugees from the war zone tried to return to the remnants of their homes. Charles E. Sumners of the 166th Signal Photo Company described "caravans of refugees headed back to their particular towns or countries. . . . They would eat anything they could find. Some were seen to boil grass that they found along the road. I saw them picking apples in a small apple orchard where the apples were small and still green, but it did not matter to them. When they left the orchard all the apples were gone—eaten from the trees."

Shown here are Soviet "displaced persons"—known as DPs—leaving Hayange, in northeastern France, by train for a resettlement camp in nearby Thionville. While some of the DPs in this photograph seem happy and hopeful, the situation for displaced citizens of the Soviet Union was precarious. About two million slave laborers from Soviet areas were in German captivity, plus another one million who had become refugees, primarily people from the Soviet Union's smaller states who supported neither the Soviets nor the Nazis. Many of the Soviet DPs were sent back to the Soviet Union against their wishes.

The flood of refugees—in Europe and Asia—became a frequent spectacle for Signal Corps photographers. "I have seen much evidence as to the insurmountability of the human spirit," wrote Walter Rosenblum of the 163rd to his friend, New York art critic Elizabeth McCausland. "It adds much weight to our knowledge of things to come."

200337-S

CT-45-21319

JANUARY 26 DICK PHOTO

From an American perspective, the China-Burma-India theater was a backwater of the war. But it was part of the Allied strategy of pressuring Japan on all fronts. The Burma Road, built by the Chinese in the 1930s to link Burma and China, was cut off by the Japanese for much of the war. A whole new road, more than 1,000 miles long from Ledo, India, to Kunming, China, was built by the Allies to link up with the Burma Road, allowing China to be supplied from India. Shown here is the first convoy along the completed Ledo Road.

RIGHT: This young fighter from Burma's Kachin ethnic group served as a scout for American forces. The Kachins developed a fearsome reputation as guerrilla fighters against the Japanese. When they killed a Japanese soldier, they would cut off both of his ears and keep them as a way of counting the dead. This grim bookkeeping method was also a form of psychological warfare.

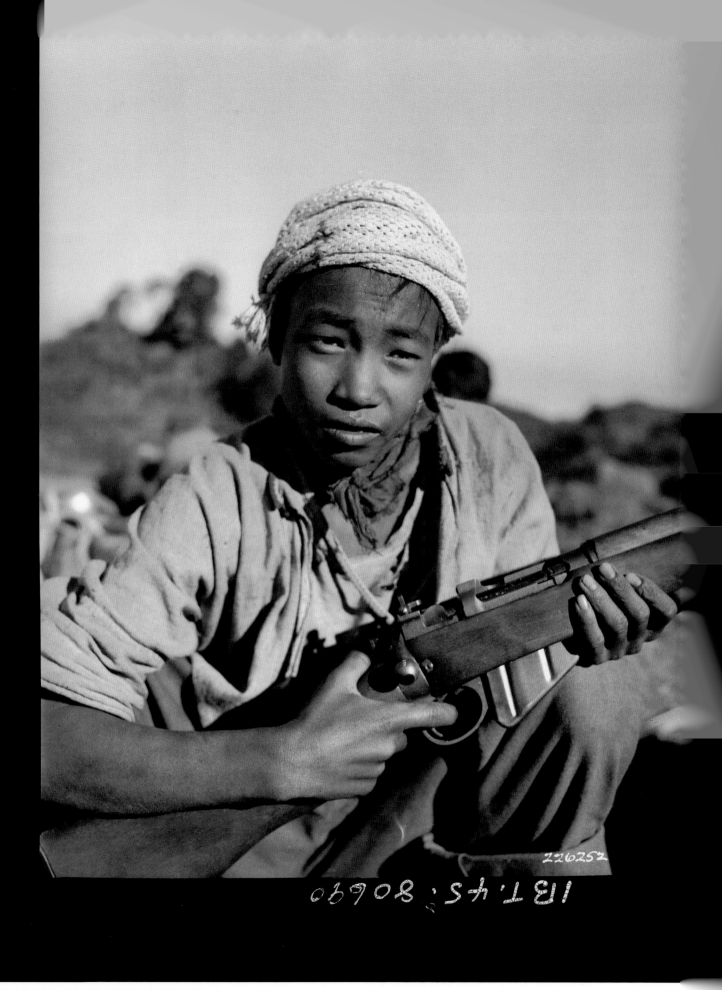

226252

117.45:8060

JANUARY 26 CLARE LEIPNITZ PHOTO

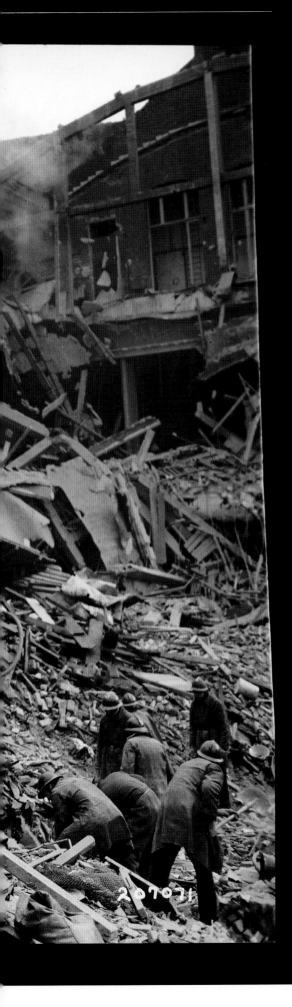

One of the Nazis' last hopes was the V-2 missile. So many V-2s battered the Belgian port city of Antwerp—arriving quietly and exploding without warning—that it was dubbed "The City of Sudden Death." Called *vergeltungswaffen,* or retaliatory weapons, the V-weapons served the propaganda aim of striking back at the Allies for their bombing of German cities. Their strategic purposes included spreading terror in Allied cities and disrupting war commerce. No city was targeted by the V-2 as much as Antwerp, not even London, whose V-2 attacks attracted more attention in the United States.

Pictured are civil defense workers in Antwerp digging through rubble and quelling lingering fires hours after a V-2 missile hit a British signal exchange and the Palace Theater. The American Red Cross officers club, in the theater, was demolished, but U.S. casualties were described as light. Just a month earlier, a V-2 had killed more than 500 people when it smashed into an Antwerp movie theater showing the Gary Cooper film *The Plainsman.* While the V-2 did not alter the course of the war, it did change the rest of the twentieth century. It was the first ballistic missile with an automatic guidance system, and its technology was crucial in the nuclear arms race and space exploration.

The key to Signal Corps work was to stay alert and safe. "War photography was just shoot what was going on," said photographer Malcolm Fleming of the 165th. Edward C. Newell of the 163rd Signal Photo Company said he "wanted to stay close to the moving action—didn't want, or almost feared, getting left out or feared something big happening."

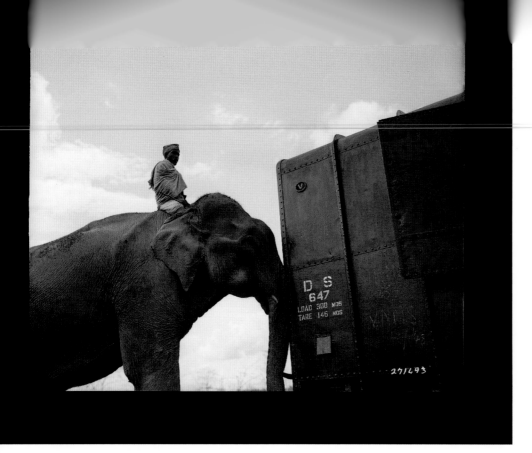

FEBRUARY 3 JAMES H. LOBNOW PHOTO

An Indian mahout, a worker who rides and tends elephants, directs a pachyderm to move a boxcar at a tea plantation outside Bogapani, India. Signal Corps photographers rode elephants to stay out of the swamps in the China-Burma-India theater.

Sydney Greenberg spent two years serving on China's southwestern border, attached to the Chinese army when he served with the 164th; he told his sixth-grade granddaughter, Isabel, about the experience decades later for a social studies project. "They call it embedded now," he said. He used a bamboo canteen to carry water and slept in a jungle hammock. "Every single day I was in combat was uncomfortable. Mosquitos. I had fleas, I had lice, I had everything." His American boots wore out. He contracted malaria and dysentery. "We became literally Chinese," he said.

RIGHT: The first convoy along the completed Ledo Road pushed through Namkham, along Burma's traditional border with China. When the Japanese retreated from Namkham, they left behind a vandalized cityscape. At the Golden Eye Buddhist Monastery, once a showpiece, ornate buildings were smashed and burned. Statues of Buddha were missing heads, arms, and hands. The statue shown here was among the least damaged.

FEBRUARY 4 JOHN GUTMANN PHOTO

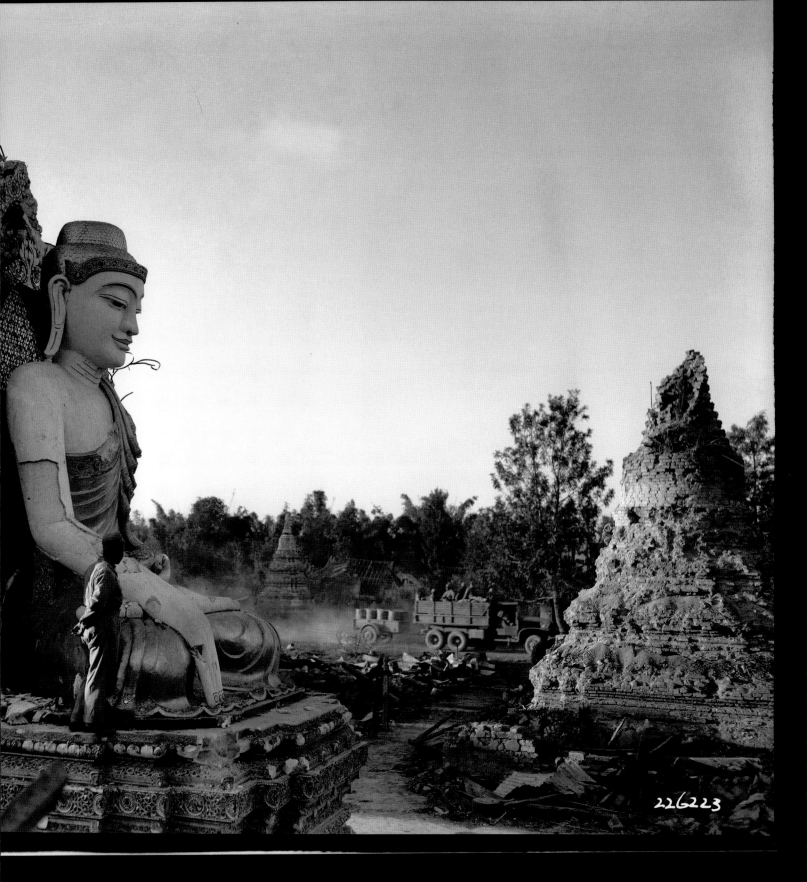
226223

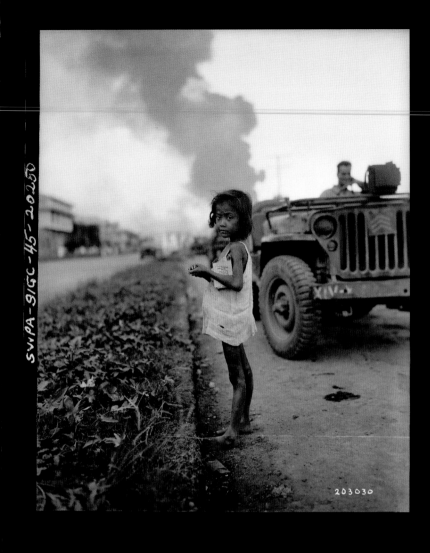

FEBRUARY 7 GAETANO FAILLACE PHOTO

A young Filipina holds her U.S. Army ration box as a fire burns behind her in Manila, the Philippines' capital, which was ravaged by fighting late in the war. The main Japanese commander in the area ordered a retreat, but a defiant admiral ordered his 20,000-strong force to stand and fight, leading to widespread devastation as American and Filipino soldiers dislodged them. "Many of us had tears in our eyes, and hatred in our hearts," said one photographer, "because that day we saw the Japanese policy, 'If we can't have it, no one shall.' "

RIGHT: The Alsatian town of Ostheim was similarly turned to ruins, and for a similar reason: Americans used firepower to break down the defenses of an enemy determined to hold its ground. After nearly two months of American shelling, the town fell.

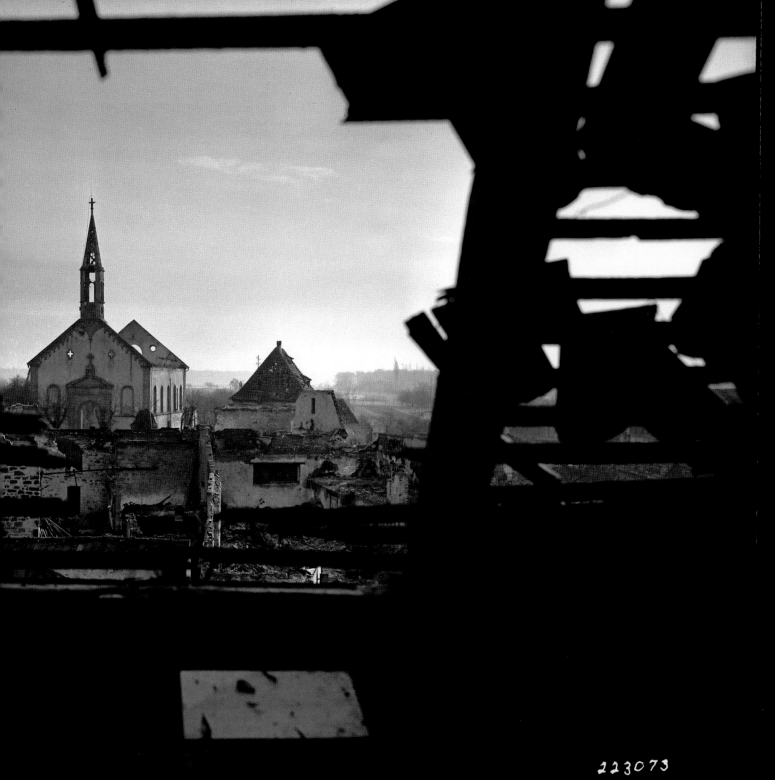

223073

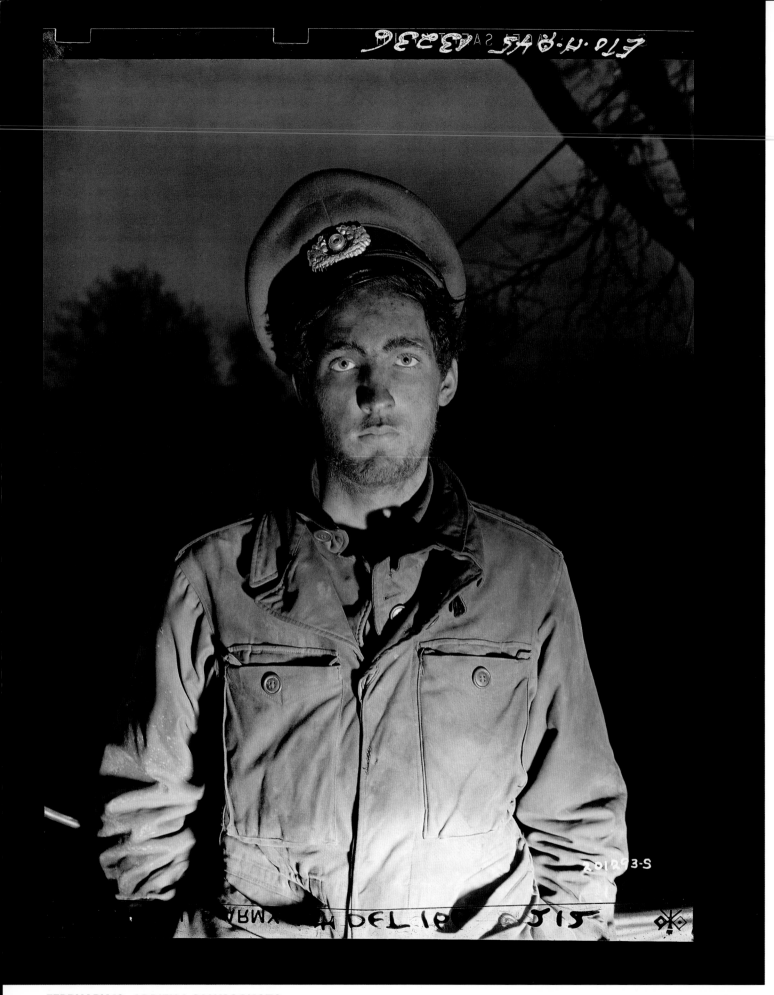

FEBRUARY 13 ADRIEN J. SALVAS PHOTO

FEBRUARY 14 ADRIEN J. SALVAS PHOTO

Some thought the Siegfried Line, shown here near Brandscheid, Germany, would be a formidable defensive position for the Germans, but that notion was mocked by a popular British song entitled "We're Going to Hang Out the Washing on the Siegfried Line." As it turned out, the Siegfried Line's "dragons' teeth" barely delayed the Allies.

LEFT: Private First Class Jack Pulliam greets American troops in Prum, Germany, with a thousand-mile stare and a German officer's cap. Pulliam was captured on his twentieth birthday in early January after a deadly battle in the Belgian village of Flamierge. "Have no idea why so many had to die for such a one-horse town," he wrote years later. The paratrooper from Pennsylvania was taken to Germany, deprived of food, forced into slave labor, and kept several nights in a dog kennel. He and a friend escaped. They were found hiding in a fruit cellar by the U.S. Fourth Infantry Division. Pulliam was wearing the dress cap from a German officer he had killed that day to avoid recapture. "I regret what followed but it had to be," Pulliam wrote. He knew he was lucky. "Captured once again, but this time in the right hands."

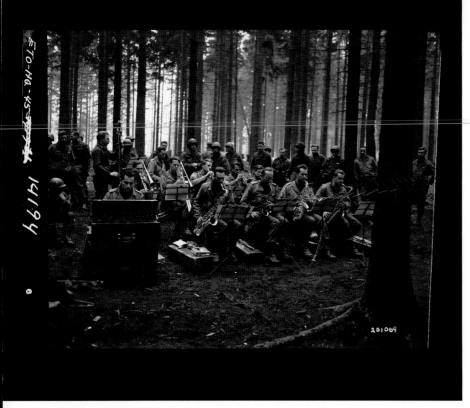

FEBRUARY 17

The First Division's Eighteenth Infantry Regiment band took a circuitous route—from Algeria to Sicily to Normandy—to get to this concert in the woods.

RIGHT: GIs pay their respects during a burial at Namphakka Cemetery in Burma. As the war wound down, the U.S. military realized that many of its dead lay in remote cemeteries that would be difficult to maintain. The more than 100 dead at Namphakka were moved to a cemetery in the Burmese city of Myitkyina by year's end, and then were moved a second time to a cemetery near Calcutta, India.

Robert Stubenrauch of the 163rd took photos of many corpses and documented the work of the Graves Registration Service, which handled the war dead. He knew the photos would not be released during the war. In *CAT Thirteen,* Stubenrauch's autobiographical novel, he wrote, "No, these negatives were not for today, but for some distant tomorrow. They would someday be reviewed by a military book picture editor. He would find an accurate record of just what happened that awful day. Right now, Bob thought, they were just part of a usual day's shoot."

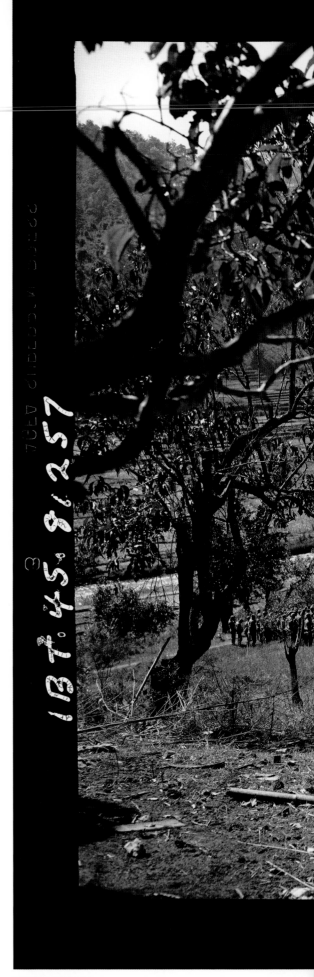

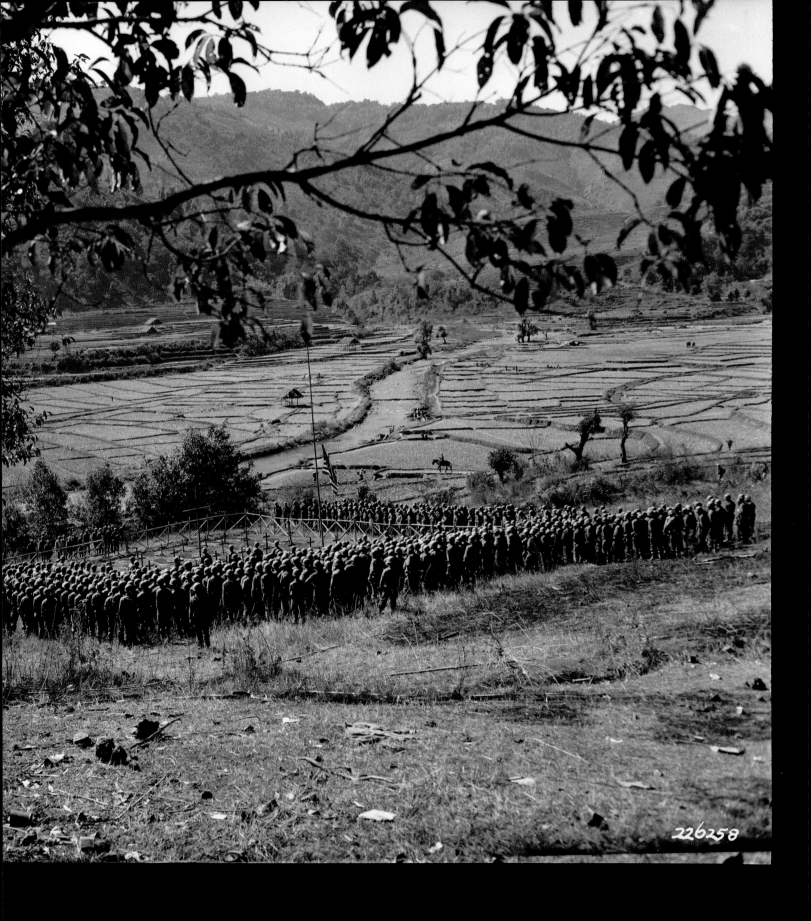

226258

L. Bennett "Elby" Fenberg
163rd Signal Photographic
Company

"Even though I carried a gun at all times, I had no desire to shoot anything but my cameras."

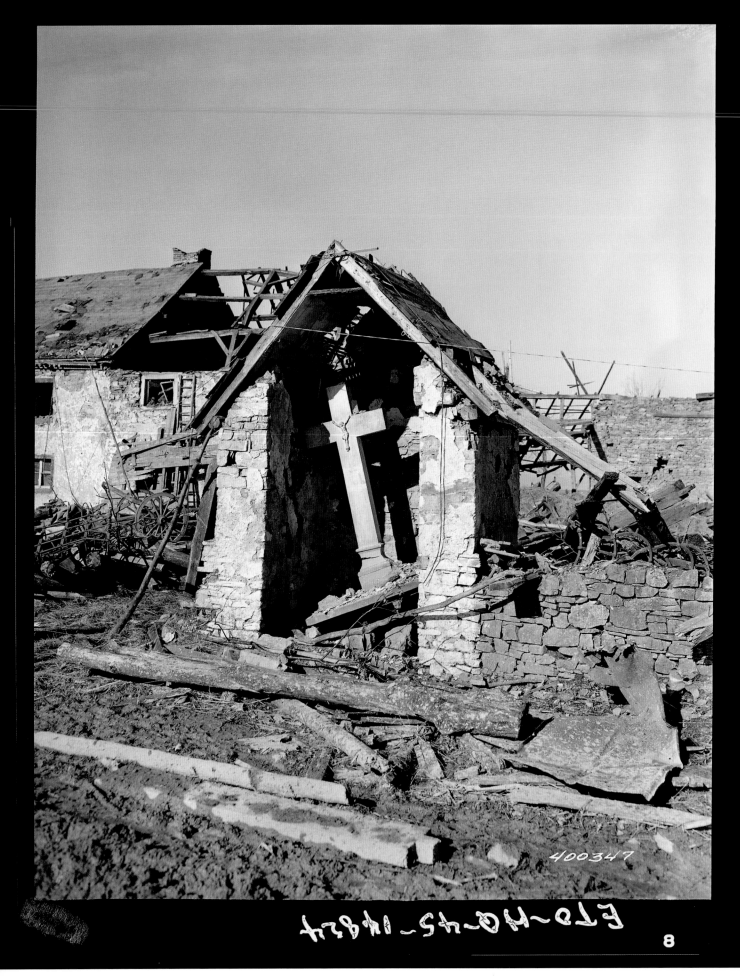

ETO-HQ-45-14824

8

FEBRUARY 22 JOSEPH LAPINE PHOTO

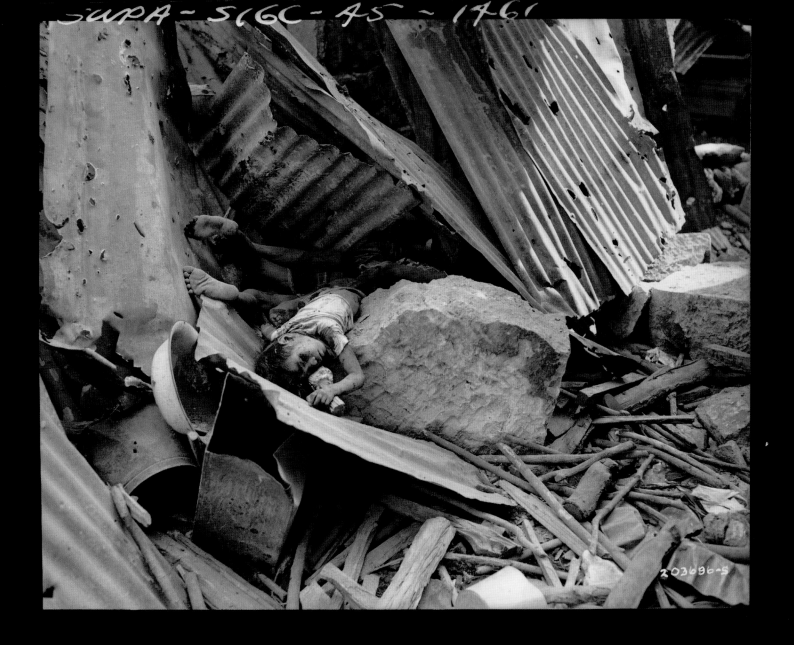

FEBRUARY 23

One of the most ravaged cities during World War II was Manila. When fighting began in the Pacific in 1941, General Douglas MacArthur declared the Philippines' capital an "open city" that he would not fight to defend. Two days later, the Japanese bombed it anyway. When the Allies tried to retake Manila in 1945, the Japanese defense was so dogged that large parts of the city were destroyed, with many civilians killed. The Signal Corps used the word "atrocity" to describe this photo of a young girl and a woman lying in rubble. Photographer Ira Lewis wrote about Manila: "It was bad because the Japanese were well trained. Very good fighters. If President Truman hadn't decided to drop the bomb, and we had to go to Japan, it would have been very bad."

LEFT: A crucifix knocked askew in a roadside shrine in Dahnen, Germany.

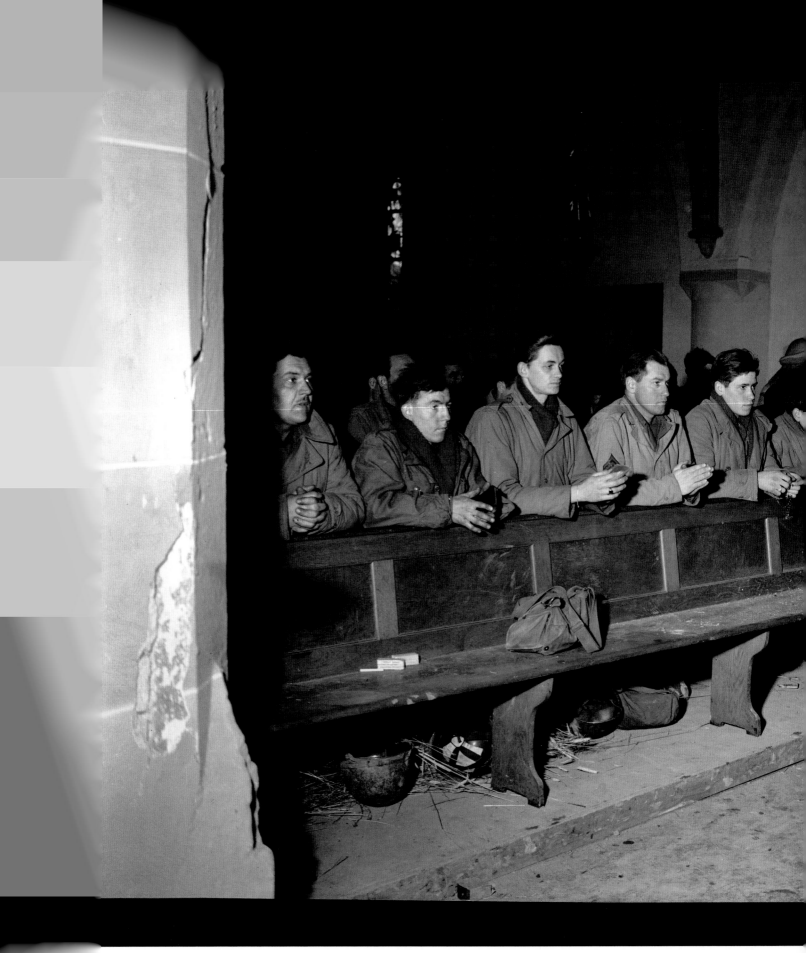

400348

Members of the Fourth Infantry Division attend Catholic Mass in Bleialf, a German town just across the Belgian border that had been the scene of American death and misery during the recently won Battle of the Bulge. Germany's initial, surprise attack had led to the surrender of thousands of American troops. But German success was short-lived, and Bleialf was firmly in U.S. hands when these soldiers worshipped. The woman on the far right was a nurse at a nearby field hospital.

This photo was taken by Arthur Herz, a native of Berlin whose Jewish family had fled Hitler's Germany. Herz immigrated to Rochester, New York, and eventually was inducted into the army. He served in the 166th Signal Photographic Company, where he stood out because of his heavy German accent. Herz recalled, "I often attempted to show pictorially the incongruity of battle and its aftermath, e.g., wounded men being treated in a battalion aid station in a crypt decorated with trumpet-blowing angels; a dead soldier in a burned-out tank with a church in the background; a little girl cradling a kitten in the smoking ruins of a farm."

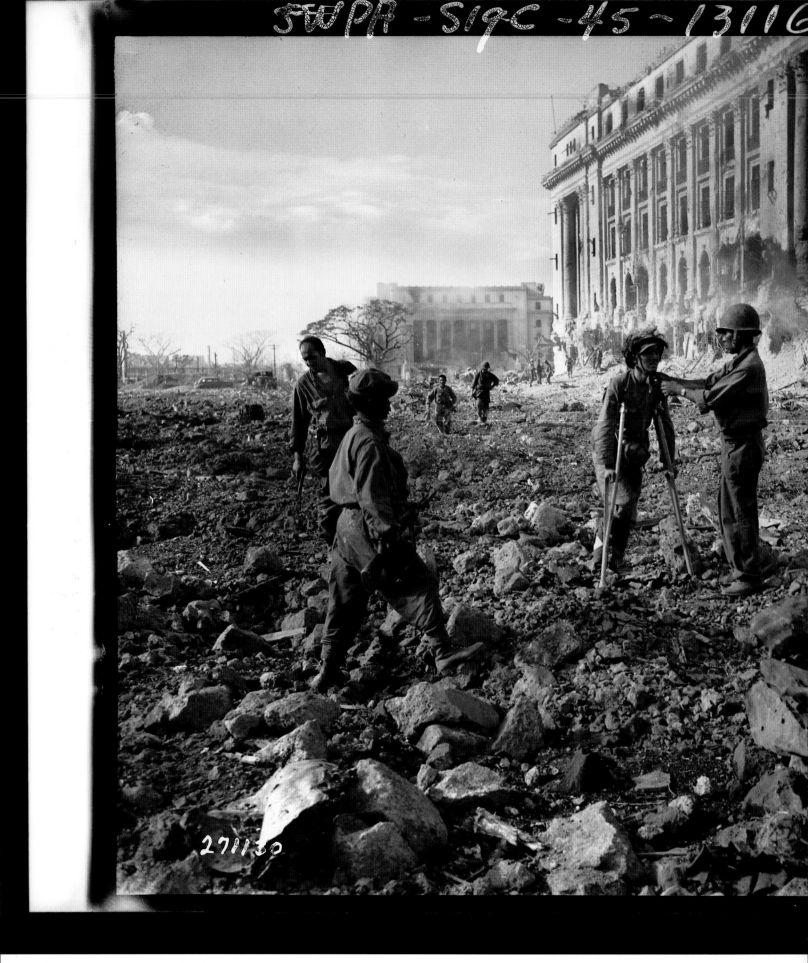

MARCH 1 KINGSLEY R. FALL PHOTO

MARCH 4 HENRY PALM PHOTO

Despite the insistence of Japanese leaders that soldiers fight to the death, a few Imperial soldiers did indeed surrender. These soldiers are eating at Manila's Bilibid Prison, a facility that was used by the Japanese as a prisoner of war camp and by the Allies for the same purpose.

LEFT: The soldier with crutches was one of only 30 Japanese to surrender to the First Cavalry Division after the Americans besieged a cluster of three structures—the legislative, finance, and agriculture buildings—within the old walled city of Manila. It took the Americans six days to root out the defenders in those buildings. Despite the rubble, the mood changed as the Allies took control. Signal Corps Lieutenant Donald E. Mittelstaedt, of the 161st, recalled heading down Manila's Avenida Rizal. "It was more than a conqueror's or liberator's reception," he said. "It was a hero's welcome."

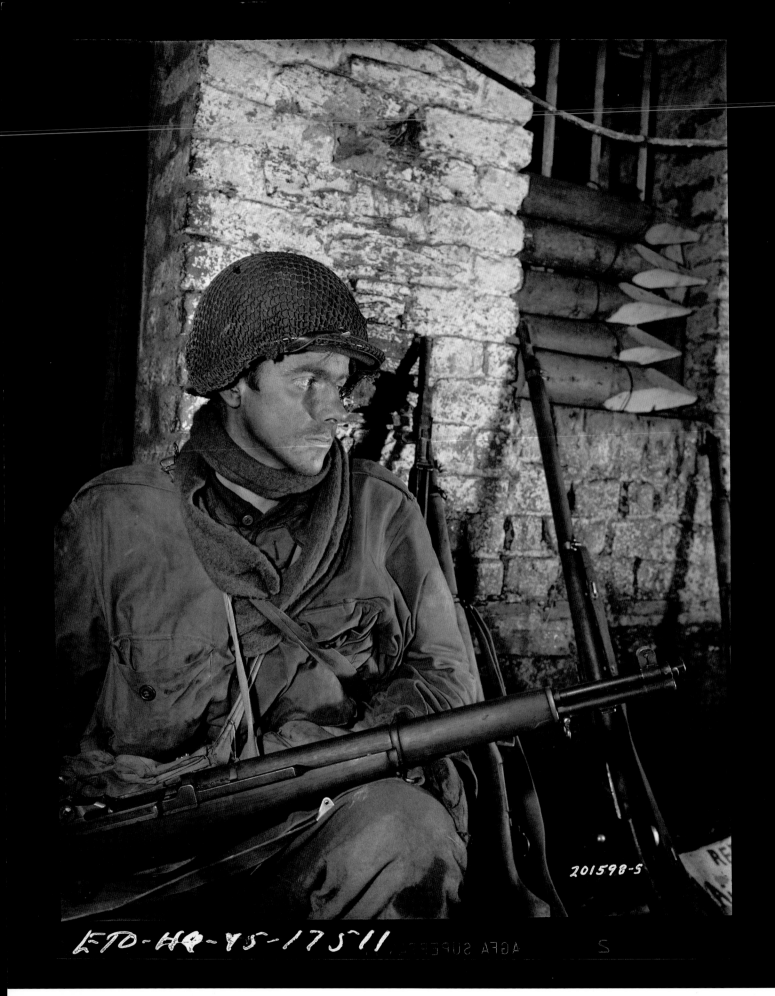

MARCH 4 CHARLES B. SELLERS PHOTO

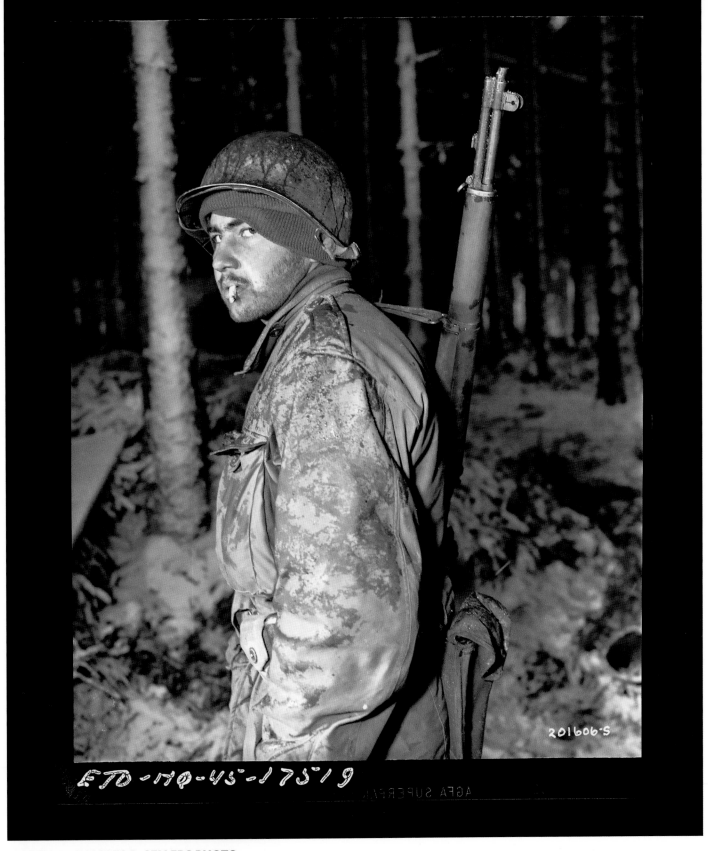

MARCH 4 CHARLES B. SELLERS PHOTO

Signal Corps photographer Charles. B. Sellers took portraits and collected descriptions from GIs in the Sixty-Ninth Infantry Division after they saw their first combat of the war, assaulting German positions along the Siegfried Line. "I was scared to death," said Private Raymond L. Roth of Mogadore, Ohio.

LEFT: Private Fred I. Green of Eaton, Ohio, said simply: "It was different from anything I ever saw."

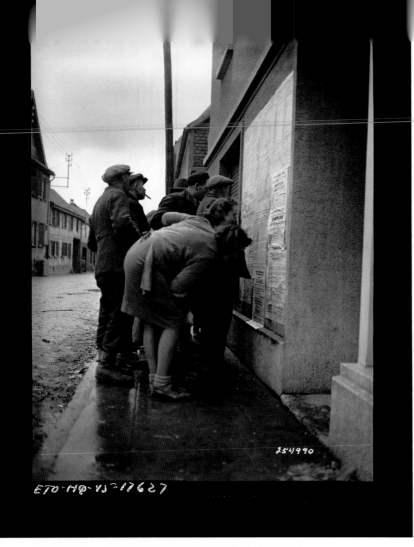

254990

ETO·HQ·VS·17627

MARCH 5 WILLIAM SPANGLE PHOTO (165TH)

Townspeople in Gross Vernich, Germany, study a proclamation from Allied authorities about the conduct of civilians.

RIGHT: German women flee the city of Krefeld in a gasoline-powered runabout after its capture by the Ninth Army. They were among the few civilians left in the city of nearly 200,000. Described as the richest urban area in the German Empire in 1890 and known as the "Velvet and Silk City" because of its textile industry, Krefeld was bombed by the Allies about 200 times, killing more than 2,000 civilians. By the time of the worst attack, over three days in mid-February 1945, most people had evacuated. "The bombs blasted the rubble and injured the corpses that were still lying beneath it," wrote historian Jorg Friedrich. During the Allied occupation, the town was run by a 21-year-old intelligence officer who had immigrated to America as a German Jewish refugee. His name: Henry Kissinger, later to become U.S. secretary of state.

ETO·HQ·VS·17606

42.

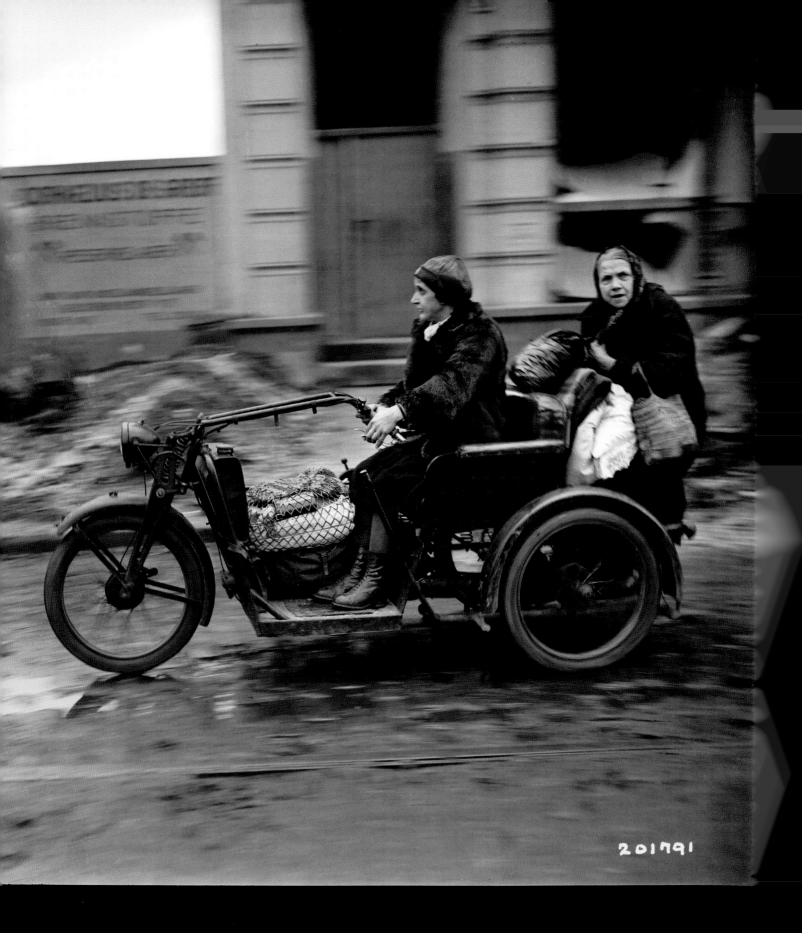

201791

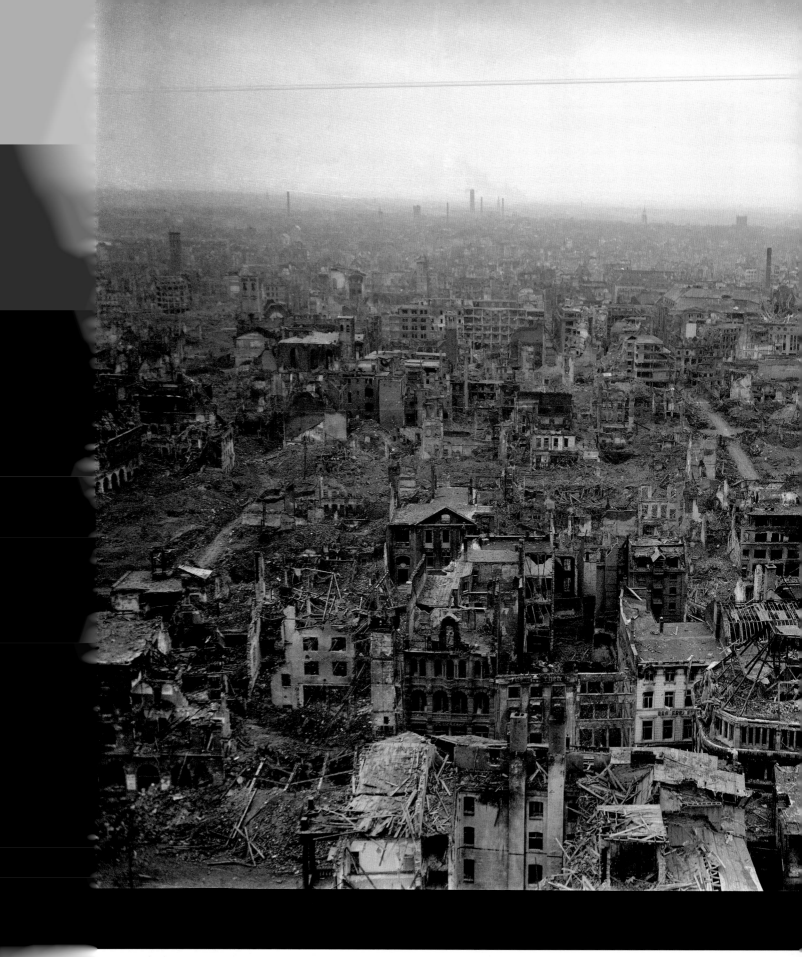

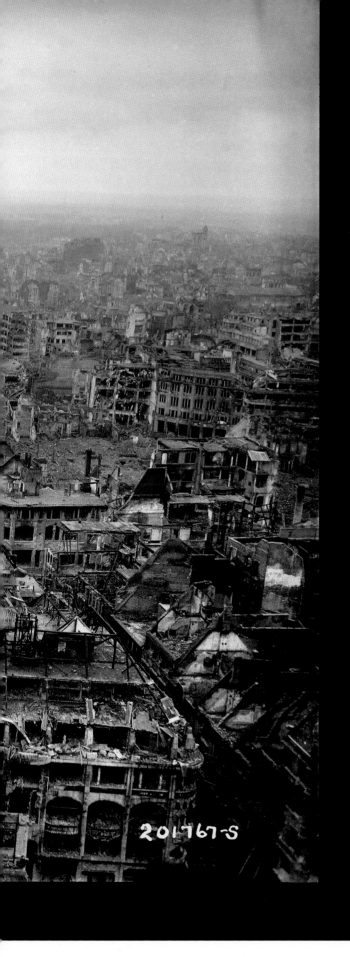

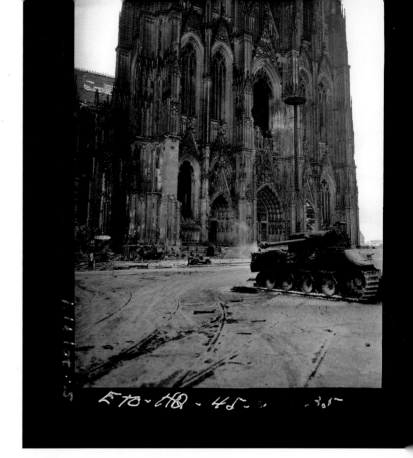

MARCH 7 JAMES E. MYERS PHOTO

An abandoned German tank sits in front of the famous cathedral in Cologne, Germany, after the badly damaged industrial city was captured by American forces. The cathedral, begun in 1248 but not finished until 1880, was considered the tallest structure in the world for a few years in the late nineteenth century. During World War II, Britain's Royal Air Force made repeated bombing runs against Cologne, including an attack by more than 1,000 bombers on a single night in May 1942. The High Gothic five-aisled basilica was hit more than a dozen times in the bombings, but remained standing at war's end.

LEFT: Vast sections of Cologne were less fortunate than the cathedral. British poet Stephen Spender wrote, "The ruin of the city is reflected in the internal ruin of its inhabitants who, instead of being lives that can form a scar over the city's wounds, are parasites sucking at a dead carcass, digging among the ruins for hidden food, doing business at their black market near the cathedral—the commerce of destruction instead of production."

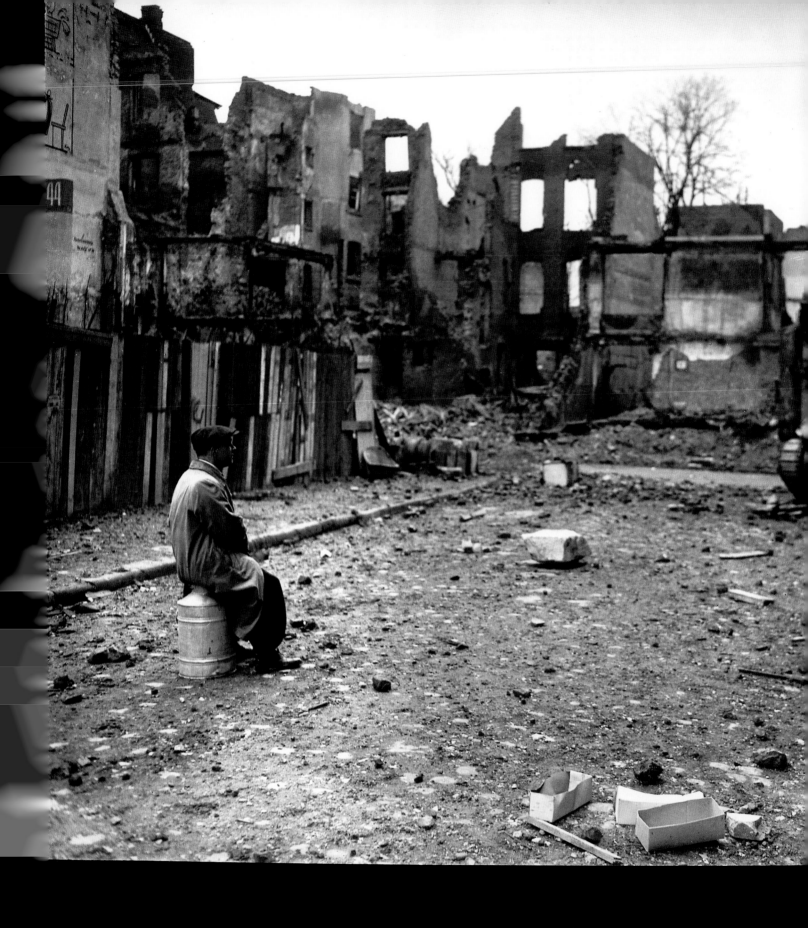

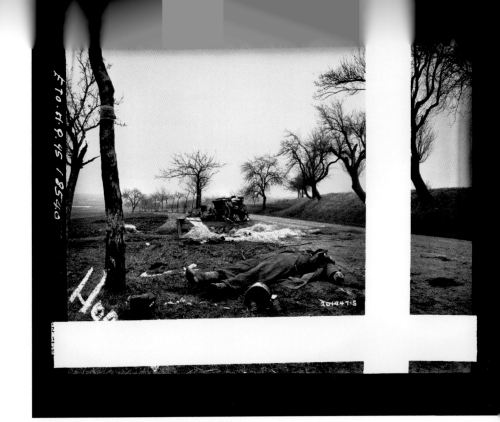

MARCH 9 R. MILLER PHOTO (166TH)

A German soldier lies dead along a road near Koblenz, Germany, an ancient town founded by the Romans in 9 BCE at the confluence of the Rhine and Mosel Rivers. General George Patton had hoped to cross the Rhine around Koblenz, but the bridges were blown. American troops found an intact railway bridge 20 miles northwest, at Remagen, and got across there. "As the last barrier to the German heartland, rich in Germanic lore, it was assumed that the enemy resistance would be fanatic," wrote Ralph Butterfield, following Patton with the 166th Signal Photo Company. For most, the crossing was anti-climactic. Wrote Jacob Harris of the 163rd, "Our division makes an un-historic, administrative crossing of the Rhine at two points. Most unimpressive, but beautiful pontoon bridges."

LEFT: A German civilian confronts an American tank amid ruins in Cologne. The caption on the Signal Corps photograph said: "Is he wondering if it's worth it?" As the Allies rolled into Germany, the grim scene was described by Joseph Zinni of the 166th: "No smiles, no flowers, no wine, no V-for-Victory signs with upraised hands, no cheering, no tears of joy or happiness, no banners with huge signs: 'Welcome to Our Liberators'—no, none of these—but instead—sneers, scowls, hatred, fear, malice." Similarly, the GIs had little sympathy for German civilians. "We had a reputation for great generosity in Italy and France," wrote photographer Gordon Frye of the 163rd, "but we have no intention of playing Santa Claus to Hitler's children."

75

MARCH 10 ERNEST E. RESHOVSKY PHOTO

French entertainer Maurice Chevalier performs for a packed house at the opening of the Stage Door Canteen in Paris. Chevalier fought in the French army in World War I and spent more than two years in a German prison camp. But during World War II, his loyalty came under question. After the German conquest of France, Chevalier supported the collaborationist Vichy government, and he performed for French POWs at the same German camp where he had been held. The Nazis exploited Chevalier's German visit as a propaganda coup, and the French Resistance targeted him for death for a time. But others were more tolerant. Chevalier, after all, had a Jewish wife and protected both her and her parents. Ultimately, he succeeded in taking a middle ground and saving both his life and his postwar career.

RIGHT: Sergeant Wilmer C. Cooper of Washington, D.C., receives a medal from Brigadier General John Ratay in Marseilles, France. Many Signal Corps photographers disdained photographing generals and their behind-the-front activities. Lieutenant Colonel John N. Harman Jr. wrote that photographers were "often un-army to the point of being impertinent."

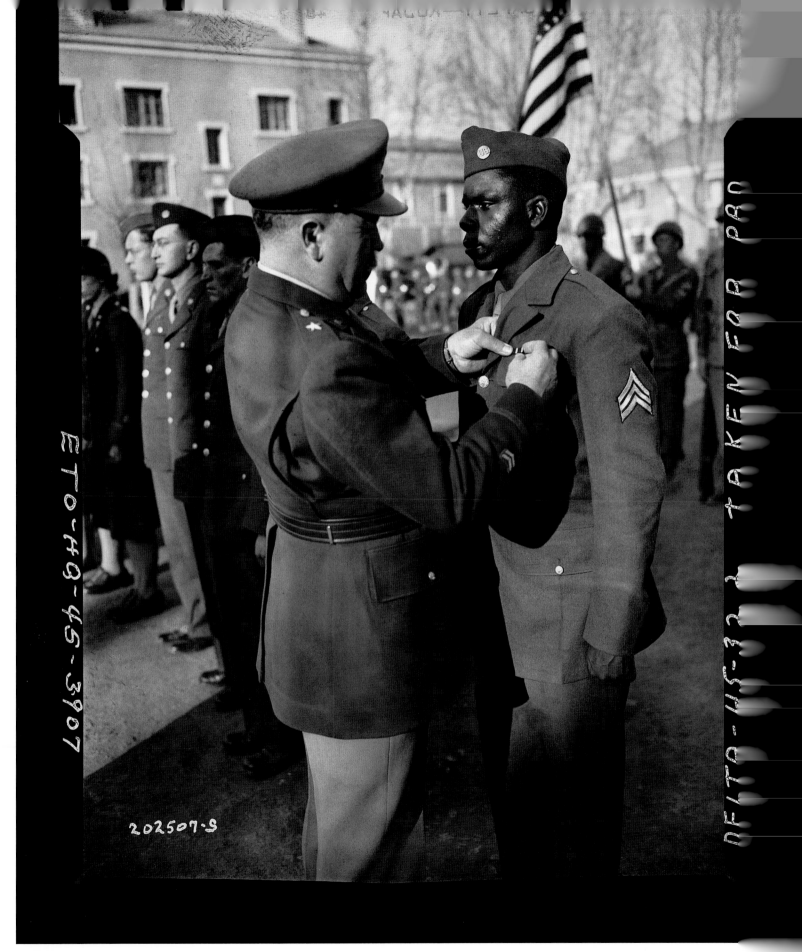

MARCH 13 BEHRMAN PHOTO

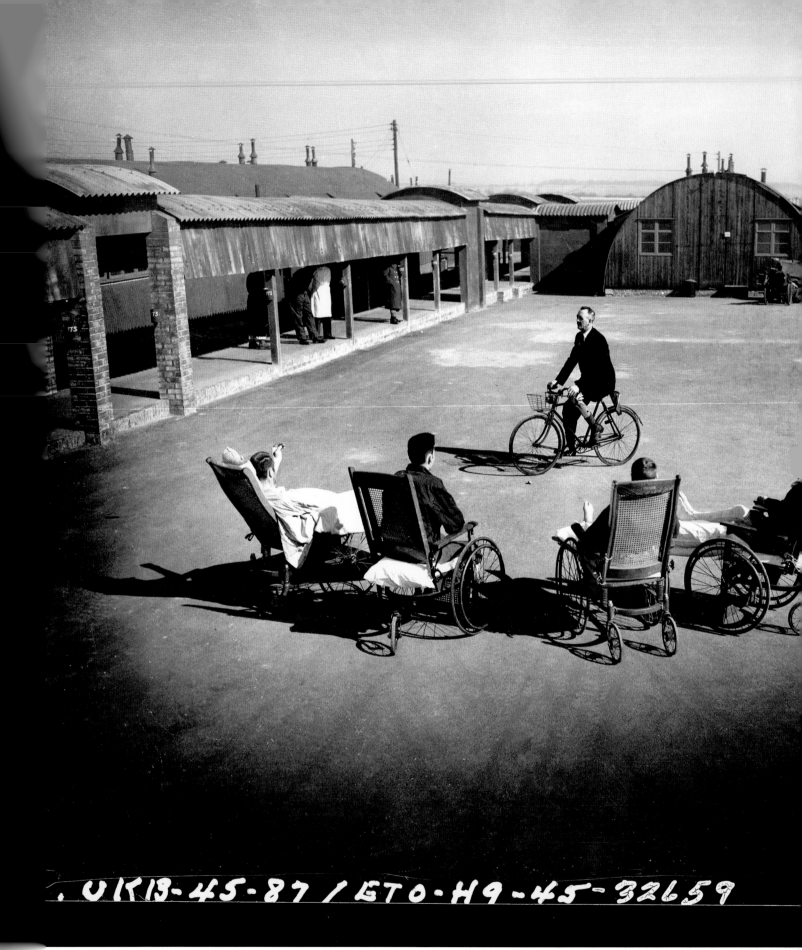

. UKB·45·87 / ET0·H9·45·32659

American and British combat veterans who had lost limbs watch as Arthur Charles Eims, of the Palmers Green area of London, demonstrates how a disabled person can ride a bicycle. Doctors treating U.S. military members in all theaters of the war performed 9,434 "major amputations" because of combat wounds, and there were an additional 10,912 "traumatic amputations" during combat as a result of land mines and other explosions. During one period of the German retreat in late 1944, more than a third of the Americans' amputations came from land mines.

Another major problem—especially during the Battle of the Bulge—was trench foot and other cold-weather damage to the body. Because of medical advances like penicillin and more effective blood transfusions, severely wounded soldiers were more likely to survive, which meant that the long-lasting impact of war injuries was inescapable. John Gill, an army medic from Madison, Wisconsin, who was wounded by shelling in France in 1944, carried around a piece of shrapnel in the lining of his heart until it was found by doctors in 1992. Maxwell Droke, in a 1945 book for war veterans called *Good-by to G.I.: How to Be a Successful Civilian,* urged badly wounded veterans to "face your handicap fairly and squarely— and then forget it." He implored them to not "let this physical impairment turn and twist your life until you are a morbid, melancholy misfit."

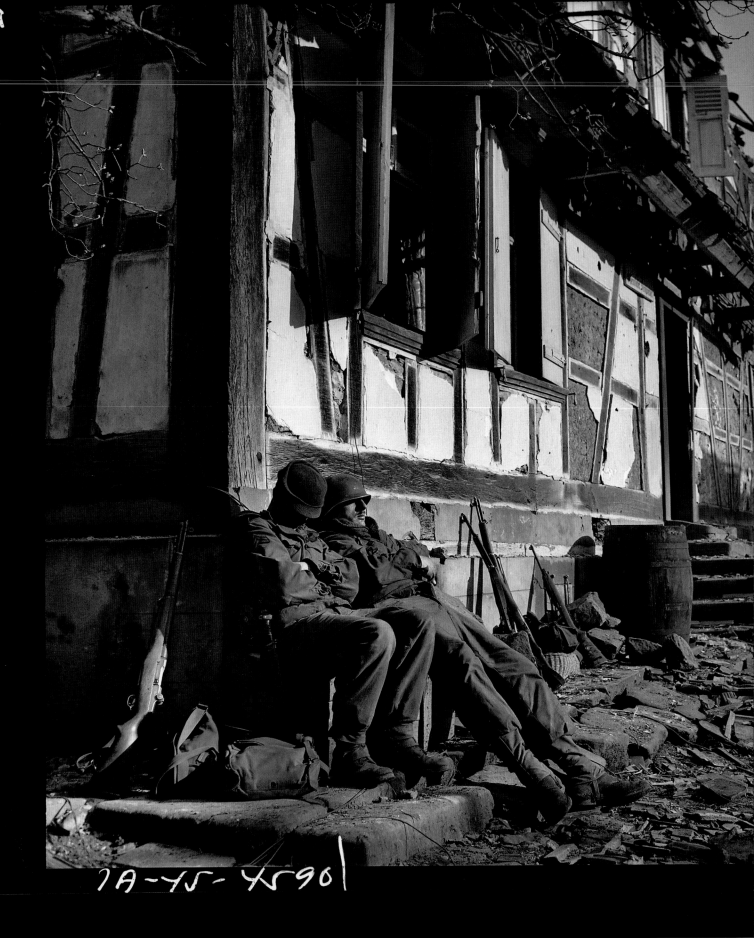

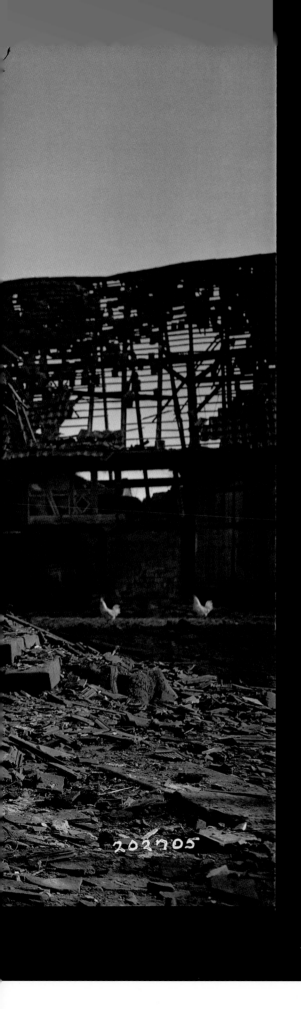

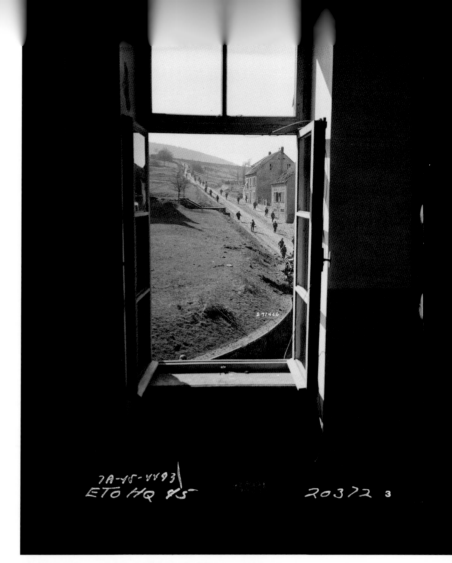

MARCH 15 JACOB HARRIS PHOTO (163RD)

Seventh Army troops move out from a German village.

LEFT: Two members of an engineer battalion with the Seventh Army snooze beside a war-pocked house in Mulhouse, an Alsatian city that had changed hands between France and Germany several times in the previous seven decades. The Germans, who called the city Mulhausen, claimed it after the Franco-Prussian War of 1870–1871. France took it back after World War I, Germany seized it early in World War II, and the Allies retook it for France in 1944. Charles E. Sumners of the 166th described the crumbling German defense: "After the Battle of the Bulge, we would go forty or fifty miles a day and meet only token resistance from the German troops. They could have prolonged the war for a good while if they had not lost all their top fighting men and equipment in the offensive."

" There were elements I couldn't walk away from because all the elements for great photography were there, and to just walk away from it just to save my neck would've been stupid."

Bill Teas
166th Signal Photographic Company

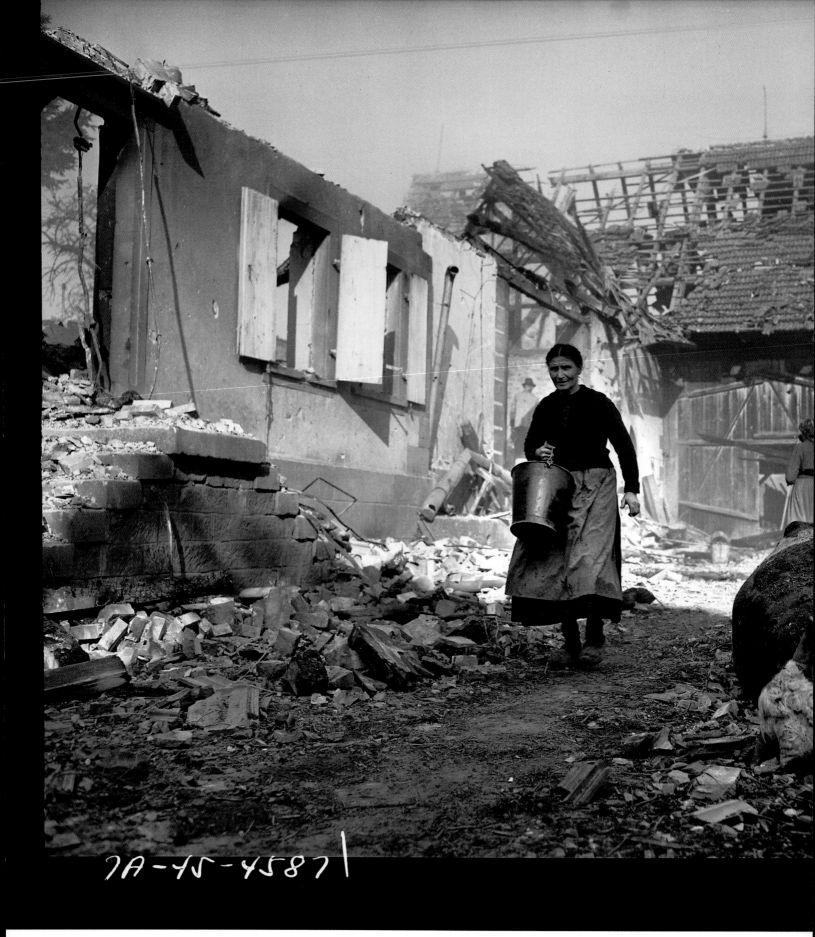

7A-15-45871

MARCH 15 IRVING LEIBOWITZ PHOTO (163RD)

MARCH 16 DWIGHT ELLETT PHOTO (165TH)

The house where composer Ludwig van Beethoven was born survived the Allies' violent takeover of the German city of Bonn.

LEFT: A woman carries a pail in Mulhouse, France, near the German border. Soon, Americans entered Germany, often using tanks to clear the way for the infantry. "When we entered the first German towns, the people looked like they couldn't believe their eyes to see the endless lines of American tanks and troops passing through," wrote Eric Wiesenhutter of the 166th. "The civilians in these towns were certain that we would kill them all," wrote Walter Rosenblum of the 163rd. "And they were the most pathetic looking figures I have ever seen. They waved white flags, and begged us not to shoot them. A very pretty little girl, about 17, ran over to [Joseph] Bowen, fell down on her knees, grasped his hand, and begged for her life."

MARCH 19 JAMES F. KILIAN PHOTO

A German woman watches grimly as refugees moved through Krefeld, about 18 miles east of the German-Dutch border.

RIGHT: In the German city of Monchengladbach, only 10 miles from the border, women try to gather a few discarded coffee beans from the mud. Presumably the beans were spilled by the newly arrived Americans, since coffee was a rare commodity indeed in Nazi-controlled Germany. It had been rationed there since the spring of 1939—even before the outbreak of the war—and became increasingly difficult to get as shipping from South America was constricted by the war. Germans drank a number of coffee substitutes using chicory, dandelion roots, and acorns. They sometimes boosted the impact of their ersatz coffee by adding Pervitin, a methamphetamine pill used by soldiers and housewives alike. Monchengladbach is near the town of Rheydt, the hometown of Nazi propagandist Joseph Goebbels.

MARCH 19 CHARLES PEARSON PHOTO

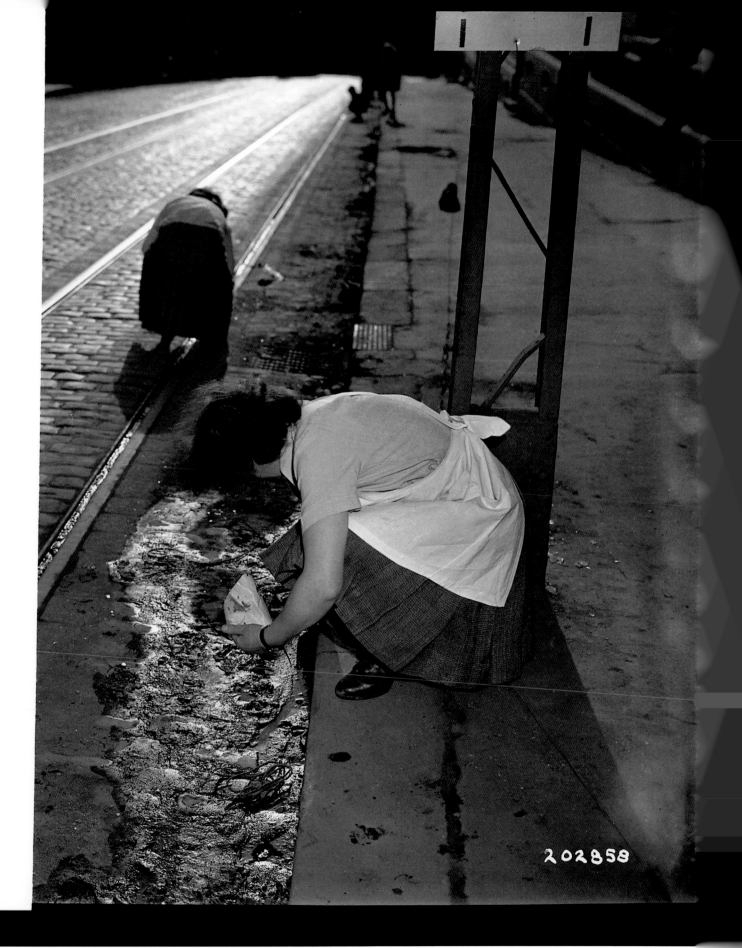

202858

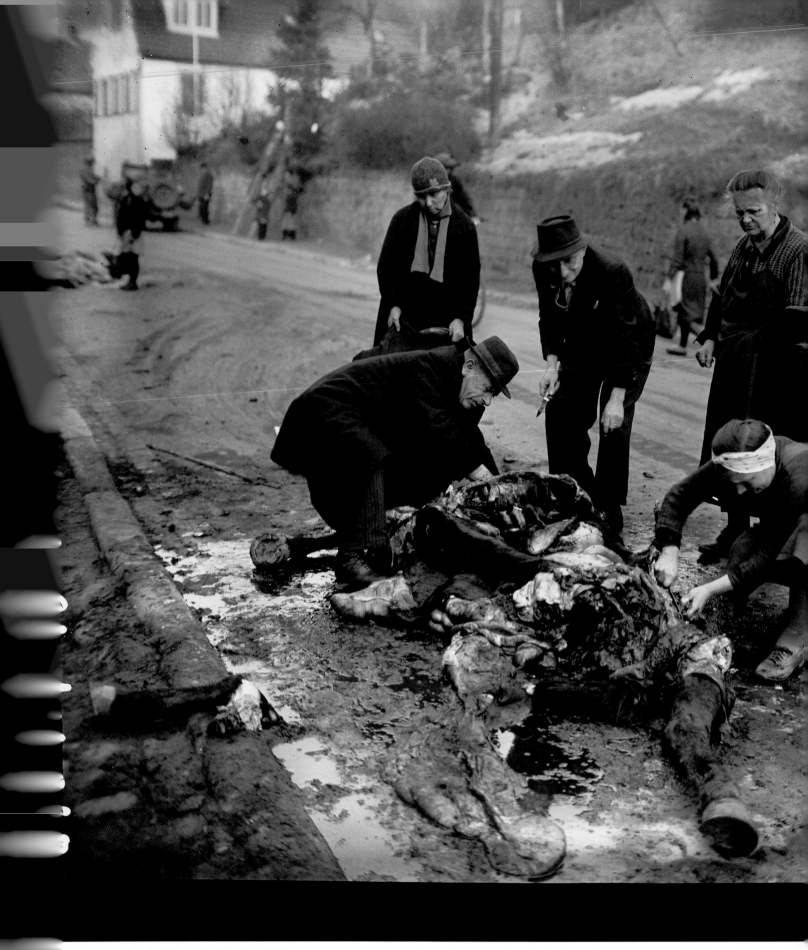

203269

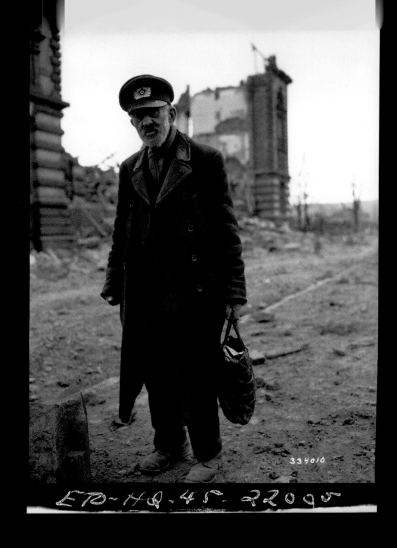

334010

ETO-HQ-45-22095

MARCH 21 **KOHL PHOTO**

This confused, elderly man in Zweibrucken, Germany, asked a Signal Corps photographer whether "the Fuhrer had sent him."

LEFT: A horse killed along a roadside in Frankenstein, Germany, provides sustenance for civilians desperate for food. "There were many people who had nothing to eat and went hungry for several days," wrote Charles E. Sumners of the 166th. "The Germans had stripped them bare of food and supplies when they had come through, and it was a while before the Americans could get food to them. They would certainly eat horsemeat or anything else they could get their hands on. It was agonizing to see the hunger on the faces of those people—especially the small children and the old folks." Sights like this were not rare; the 163rd Signal Photo Company reported "food riots" in Wertheim. Wrote James W. Todd of the 163rd: "Someone tells us this is the first day of spring. No tra la las forthcoming from this quarter."

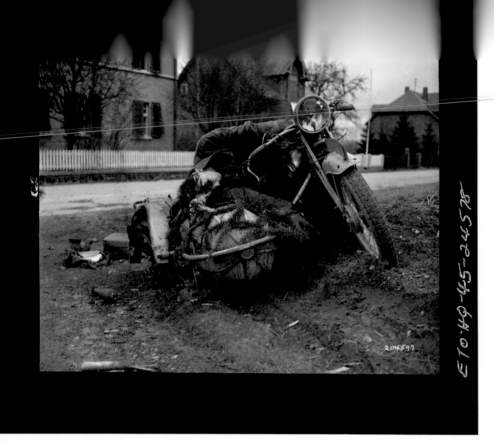

MARCH 29 WILLIAM KLUGER PHOTO

A German courier on a motorcycle could not flee from the town of Haiger fast enough when the 104th Infantry Division of the First Army moved into central Germany. Signal Corps photographers—like other soldiers—witnessed many last moments. Charles E. Sumners of the 166th watched as a wounded GI stumbled toward him during the last winter of the war. "His body was full of shrapnel, and he was saying, 'No, God, not me. Not me, God, not me.'" He died two or three minutes later, Sumners wrote. "I still remember those words, and they will always be with me."

RIGHT: These fourteen-year-old boys, pulled into Germany's war effort, were captured by U.S. forces in Giessen, also in central Germany. The one on the right has his coat buttoned in the wrong holes. Signal Corps photographer Robert Hopkins called the final remnants of Adolf Hitler's army "Germany's last human resource." Wrote photographer Arthur Herz of the 166th, "The Nazis were scraping the very bottom of their manpower barrel."

MARCH 29 WILLIAM J. TOMKO PHOTO (166TH

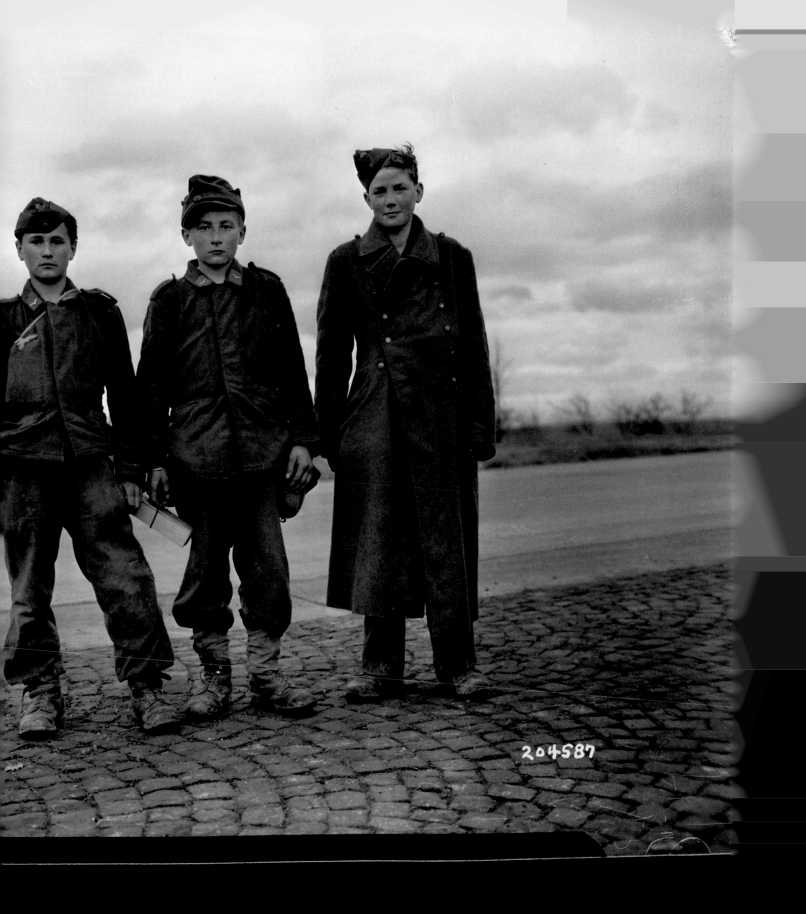

204587

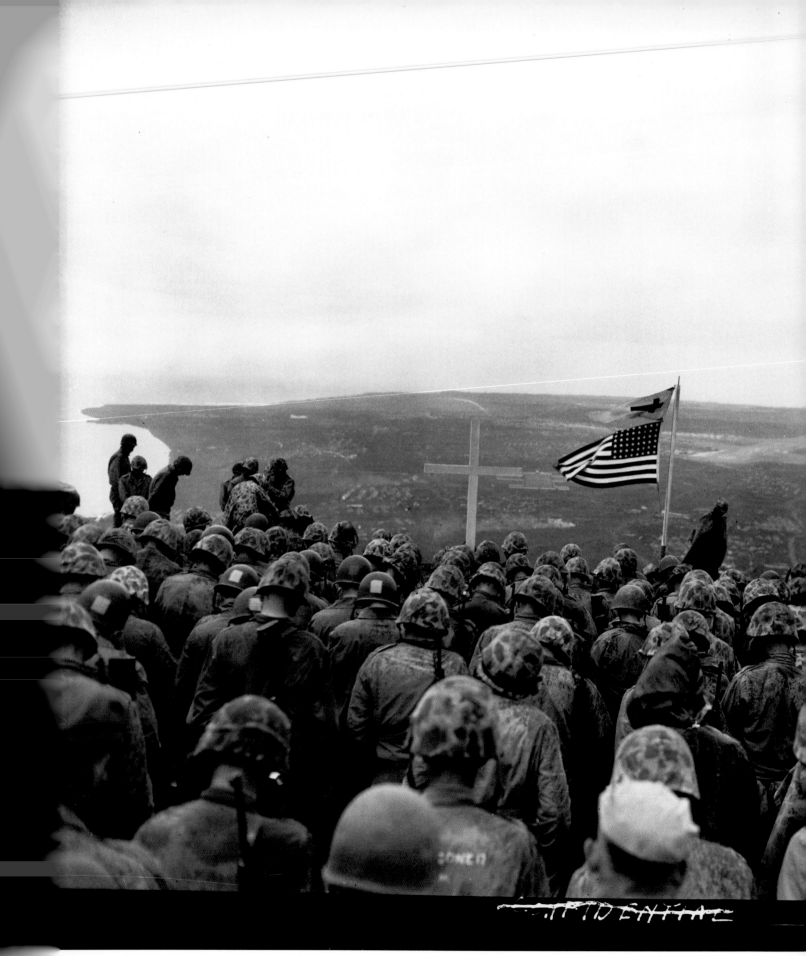

204795

-45-2852

One of the most prominent sites of the entire war was Mount Suribachi on the island of Iwo Jima, about 750 miles directly south of Tokyo. Marines took the Japanese-held island in February and March 1945, after bitter fighting in which most of the defenders fought to the death. "This was a bitter, desolate, godforsaken island," wrote Edward Steichen, who served with the Signal Corps in World War I and headed a special naval photographic unit in World War II. "We needed desperately to take it in order to shorten the Guam-Tokyo air trip in case the old B-29s ran out of fuel—it was a fifteen-hour nonstop flight and a troubled plane could make it in twelve if we had the airstrip on Iwo."

Here, atop Suribachi, soldiers attend an Easter service led by chaplain Alvin O. Martin. Another Iwo Jima chaplain, E. Gage Hotaling, kept a diary of his time on the island, including the grim work of interring the dead. "The majority of men we buried were killed by shrapnel rather than bullets," Hotaling wrote. "Shrapnel has terrific force and literally tears a man to pieces, leaving gaping holes in the head or arms or legs or belly, or else tearing them off completely. Some of the men we buried were not even identifiable, as they had been so torn to pieces that there were only 15 or 20 pounds of body left and it was buried in a cardboard box."

Prisoners of war are among the slave laborers preparing a meal behind barbed wire at this German camp in Moosheide, northern Germany, having survived a system that demanded large work forces and steadily consumed them. Slave laborers were ravaged by malnutrition and disease, with high death rates. While German prison camps displayed signs reading *"Arbeit macht frei"* (Work sets you free), the Nazis' aims were quite the opposite. They intended to take over "inferior" nations and turn their people into slaves, as explicitly stated by SS leader Heinrich Himmler in 1942: "The war will have no meaning if, twenty years hence, we have not undertaken a totally German settlement of the occupied territories. . . . If we do not fill our camps full with slaves . . . [to] build our cities, our towns, our farmsteads, we will not have the money after the long years of war in order to furnish the settlements in such a fashion that truly German men can live in them and can take root in the first generation."

Liberating former prisoners was a moving experience for all involved. "Ran smack into 1,200 former POWs coming through lines, all Russian, Yugoslavs, French, Italians, and Serbs who crashed the gate at a prison hospital," the 163rd Signal Photo Company reported. "Most of the men were definitely hospital cases. Some were emotionally unstable, some of them hardly able to walk from lack of proper care. Yugoslavs were the best faring of the group—all with long mustaches—all very happy. French were all a dazed, overjoyed group."

APRIL 3 RALPH PAIK PHOTO (168TH)

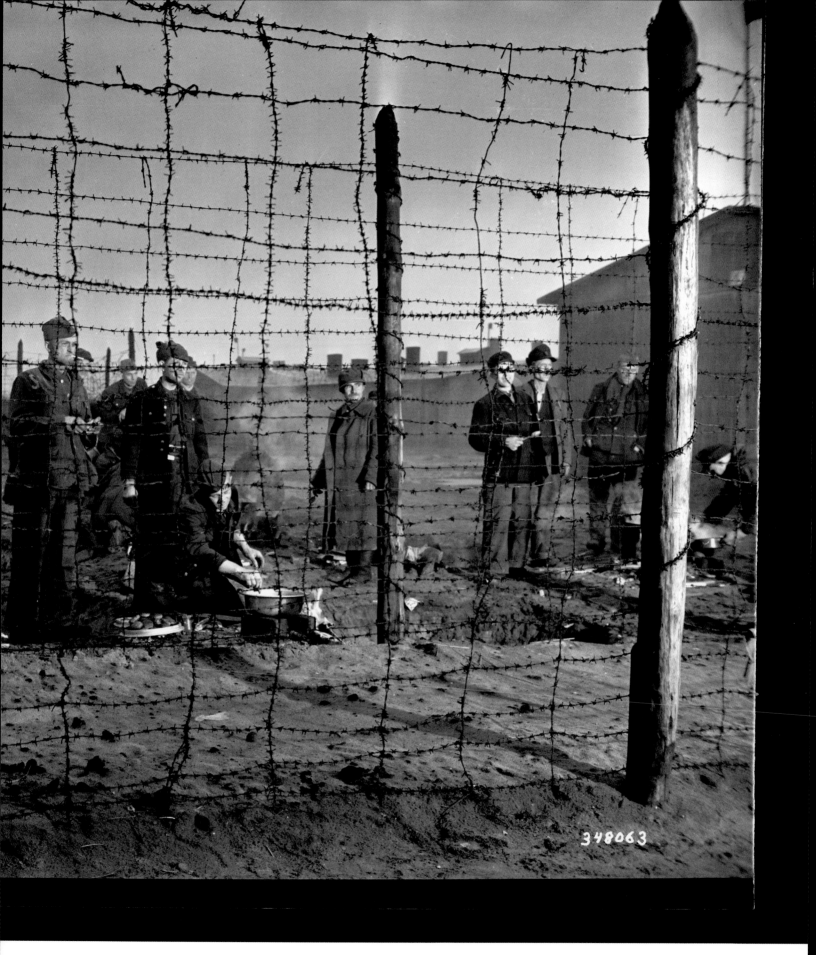

348063

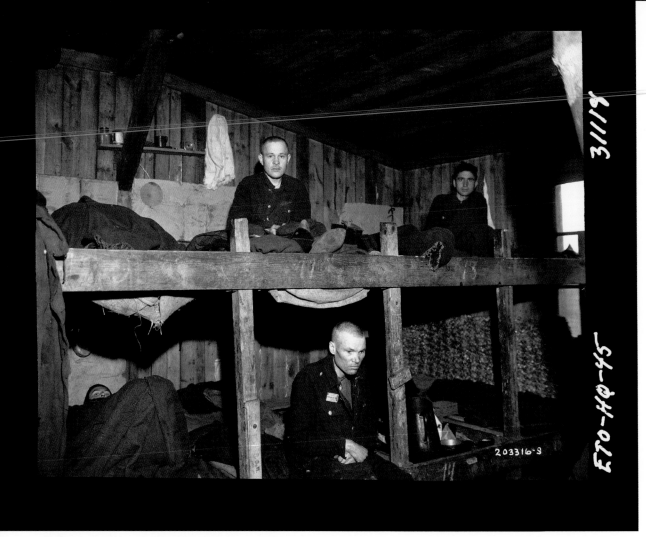

APRIL 7 J. MALAN HELSOP PHOTO (167TH)

Soviet prisoners with tuberculosis were kept in a barracks at a prisoner of war camp in Germany that was liberated by the First Army. Before the war, Germany had one of the world's lowest rates of tuberculosis mortality, but the rate doubled as Europe was plunged into conflict. Crowded and unsanitary conditions at concentration camps and among slave laborers helped spread the disease.

RIGHT: While U.S. forces had already witnessed many of the horrors of Nazism, they would soon come across mind-boggling atrocities. The first Nazi concentration camp they encountered was Ohrdruf, a sub-camp of Buchenwald. Eric Wiesenhutter of the 166th wrote: "The first thing I noticed on reaching the camp was the odor; they had used lots of lime, but unless a body is buried within a week it takes more than lime to preserve it. The first sight that greeted me was forty men sprawled in death. They had been murderously machine-gunned as they waited for their marching orders."

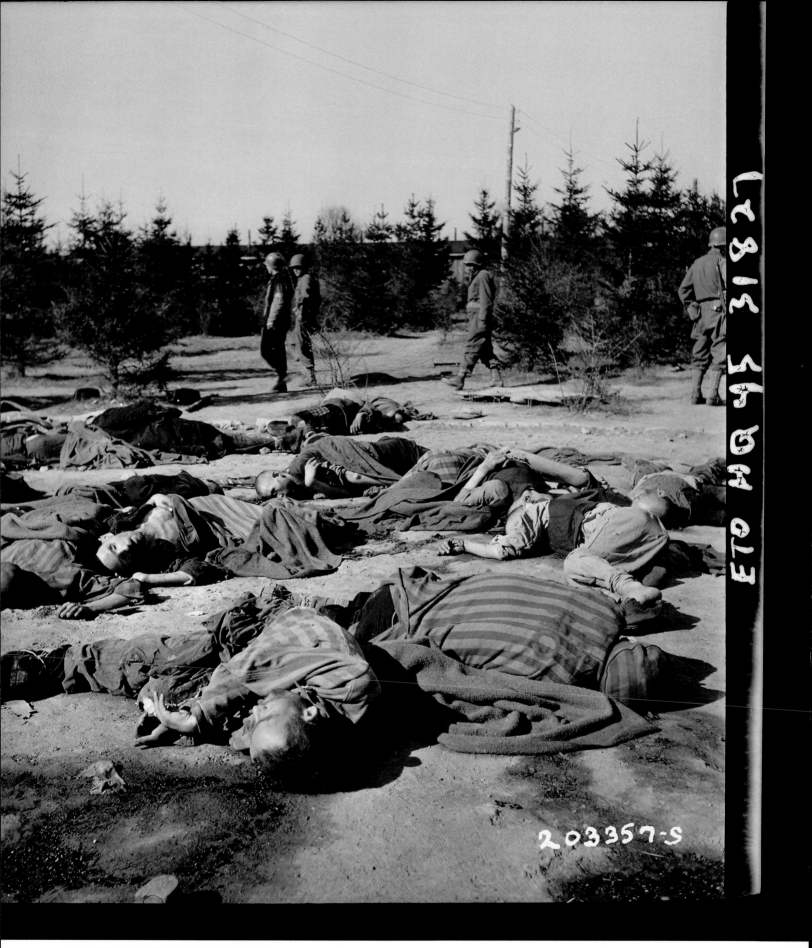

"I had experienced many grim sights in combat. I took more pictures than I can remember. But the best picture was the one I didn't take. I was about to photograph a group of inmates who obviously didn't have more than thirty minutes to live. I just couldn't bear to see the look in their eyes. So, I lowered my camera and simply walked away."

Robert Stubenrauch
163rd Signal Photographic
Company, on Dachau

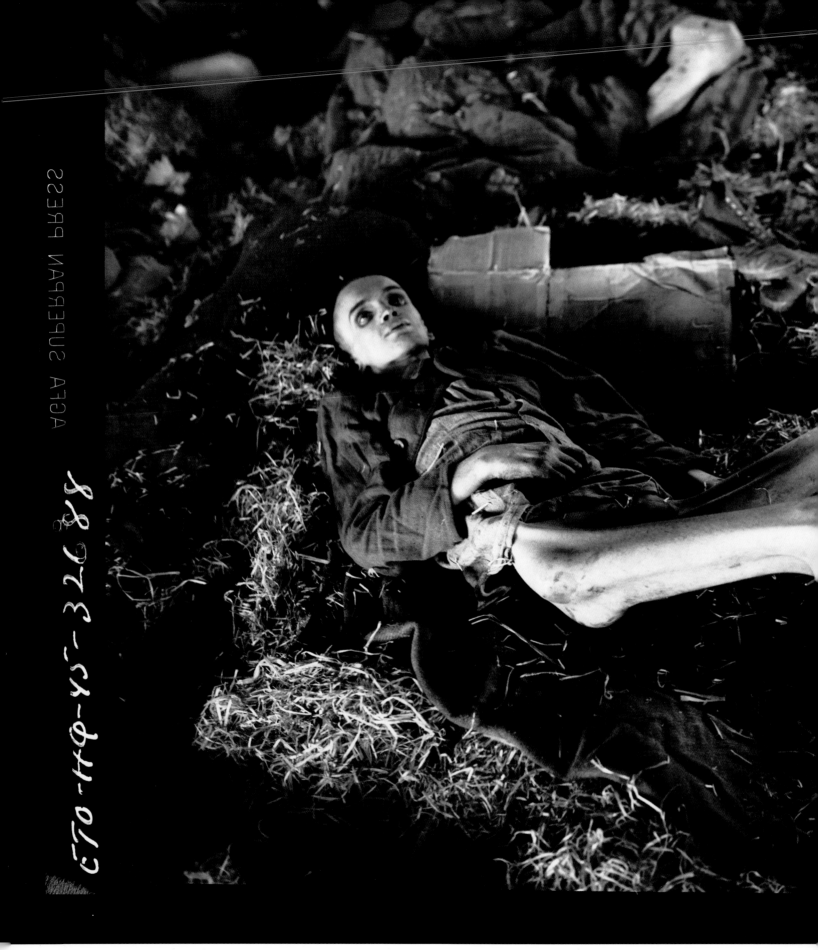

APRIL 11 HAROLD ROBERTS PHOTO (165TH)

APRIL 12 CLYDE M. PLETCHER PHOTO

A military police officer guards a prominent prisoner, Franz von Papen, after his capture in Hirschberg, Germany. Von Papen served as Germany's chancellor for a few months before Adolf Hitler's rise to power. He persuaded Germany's elderly president, Paul von Hindenburg, to give the chancellorship to Hitler, thinking that the Nazis could be placated and controlled. Instead, Hitler used the appointment to seize total power. Von Papen had a second key role, as ambassador to Austria when Hitler annexed that country. Upon his capture, von Papen told Allied interrogators that German men feared being shipped to the Soviet Union as slave laborers after the war as part of a "secret agreement" with the other Allies. Tried for war crimes after Germany fell, von Papen was acquitted, but he was later sentenced to eight years by a German court. He was released early—in 1949.

LEFT: Prisoners were worked to death at the Mittelbau-Dora camp near Nordhausen, Germany, a notorious facility where slave laborers built V-2 rockets in an underground factory. The supreme Allied commander General Dwight D. Eisenhower wanted the Nazis' atrocities documented. He wrote his wife, Mamie, "I never dreamed that such cruelty, bestiality and savagery could really exist in this world!"

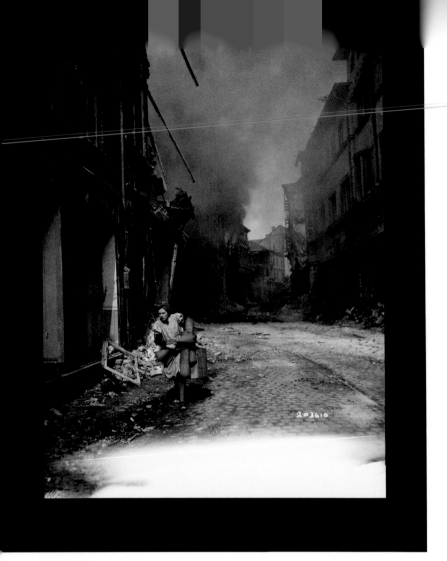

APRIL 13

A woman flees with a few possessions from burning buildings in Siegburg, Germany, just east of the Rhine River. Fighting in towns with civilians posed a particular challenge. Walter Rosenblum and Joseph Bowen of the 163rd wrote about the takeover of the town of Gemunden am Main: "The whole position was complicated by the many civilians who were driven into the streets by the burning buildings. A vigorous firefight began that lasted for several hours. It was a real nightmare. Burning buildings, guns firing, civilians running madly through the streets."

RIGHT: A soldier of the 100th Infantry Division, Seventh Army, takes a lonely walk through desolate and devastated Heilbronn, in southwestern Germany, once an important road and rail center. Aside from their destruction, Siegburg and Heilbronn had another thing in common: synagogues in both cities had been torched on Kristallnacht, or the Night of the Broken Glass, just seven years earlier, when terrorism against Germany's Jews reached especially vicious heights.

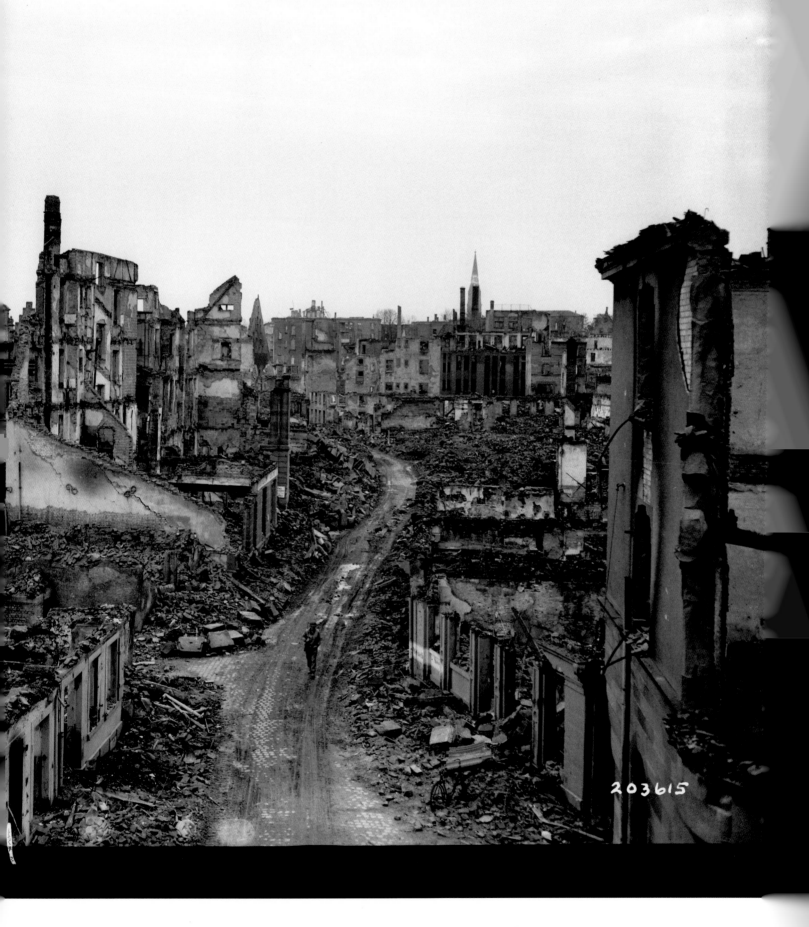

203615

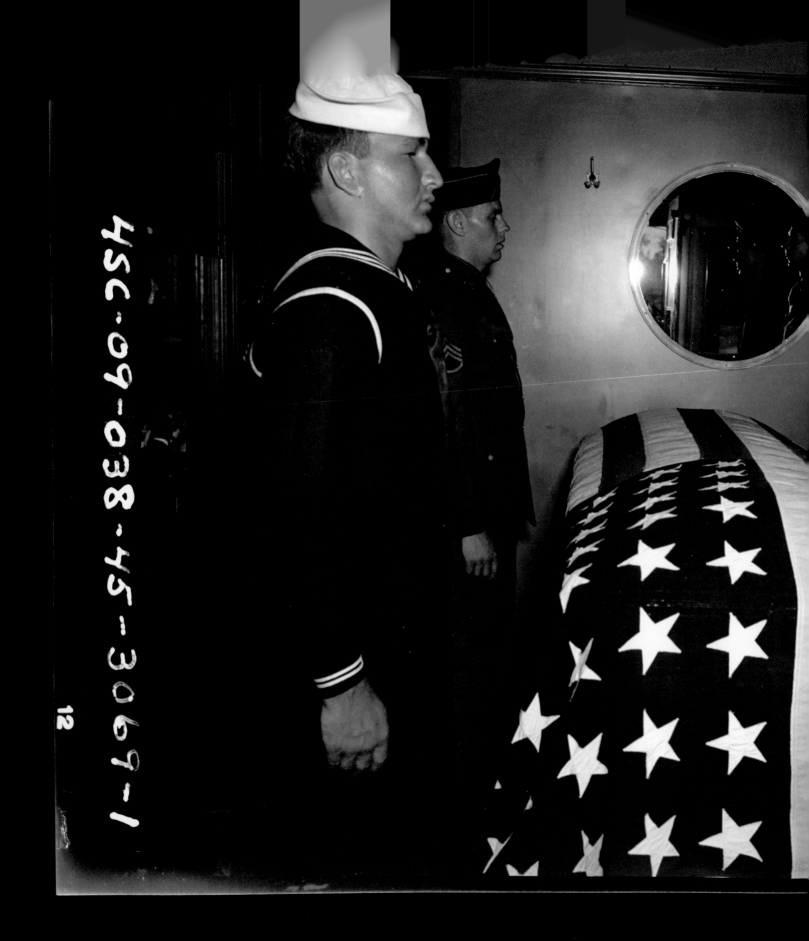

APRIL 13 PHILIP J. CHARLESON PHOTO

209083

An honor guard stands with the flag-draped casket of President Franklin D. Roosevelt after his death at his retreat in Warm Springs, Georgia. The last car of a special train would take it to Washington, D.C. An artist was painting a portrait of FDR when the president complained of a headache and excused himself. Hours later he was dead from a stroke.

When the Nazis heard the news, they celebrated; propaganda chief Joseph Goebbels ordered his staff to bring out the best champagne. He telephoned Hitler in his bunker near the ruins of the Reichstag parliament building and told him, "Fate has laid low your greatest enemy."

Signal Corps photographer Robert Hopkins, son of Roosevelt advisor Harry Hopkins, had photographed the president at diplomatic conferences in Casablanca, Cairo, and Tehran in 1943, and in Yalta just two months before FDR's fatal cerebral hemorrhage. Hopkins was in Paris when his photographs from Yalta appeared in newspapers and magazines. "It was gratifying to see them," he recalled, "because I rarely saw the product of my labors while I was overseas. At the same time, the photos reminded me of what the world had just lost."

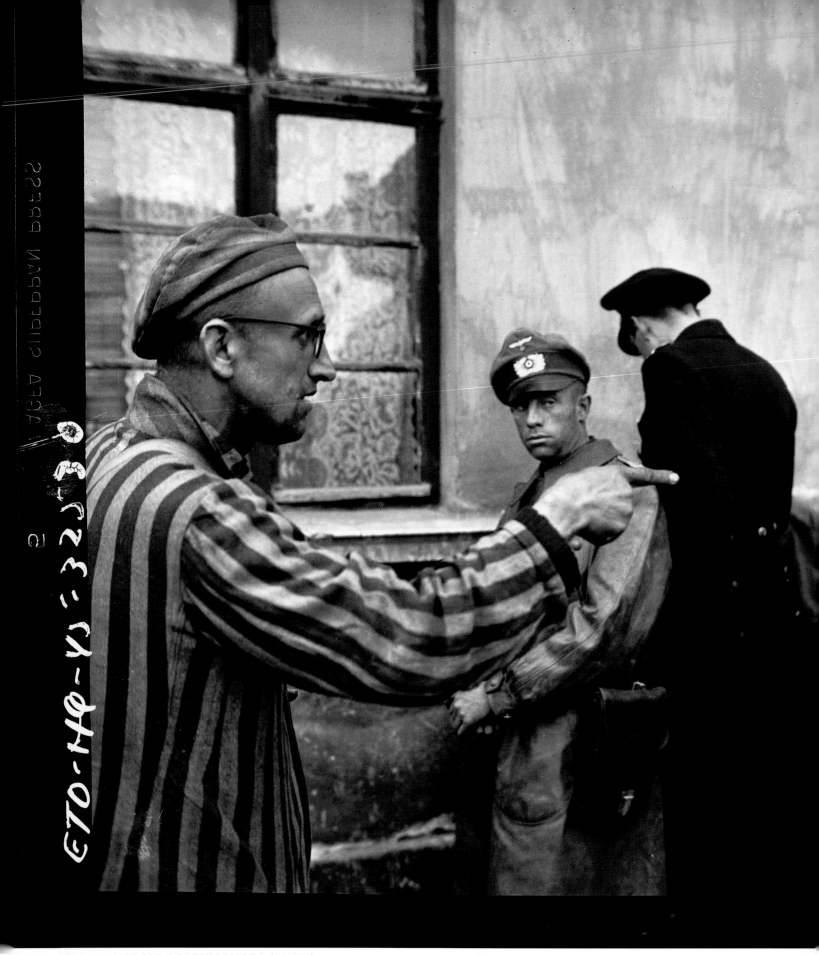

APRIL 14 **HAROLD ROBERTS PHOTO (165TH)**

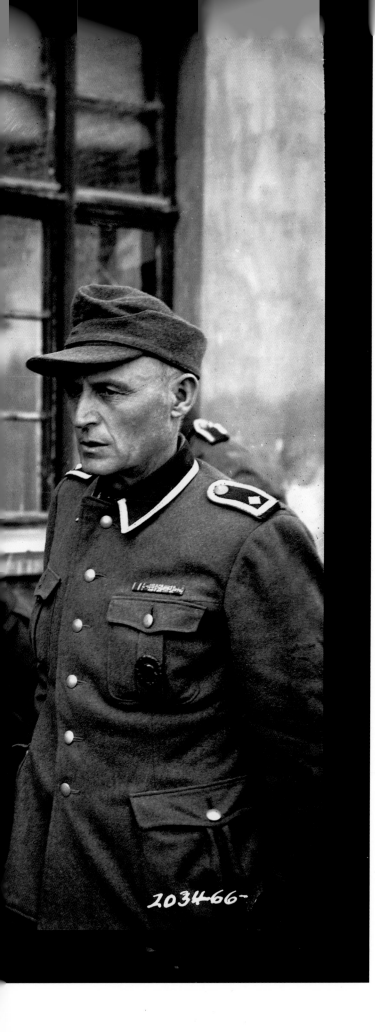

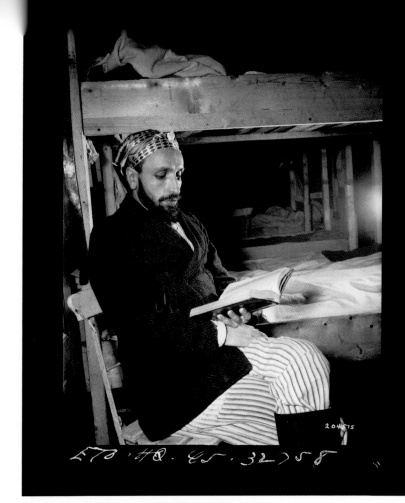

APRIL 15 HENRY GASIEWICZ PHOTO (165TH)

Muslim cleric Zini Czechodorow, described in the Army Signal Corps caption as a "Mohammedan priest," reads the Quran at a German prison hospital in Naumburg, in central Germany. Czechodorow was among the many prisoners from the Soviet Union.

LEFT: A Soviet slave laborer liberated by the First Army points out a German guard who brutalized prisoners at the Buchenwald concentration camp. Harold Roberts of the 163rd Signal Photo Company later told his family that he missed an even better image because his camera required him to change the film holder between shots. Roberts's wife, Barbara, explained to a local newspaper, "Hal shot [the photograph with] a big 4-by-5 camera that had slides in it. In those days, that's what they gave them. He said he shot that picture and the very next thing—he said he missed the best picture in the world—that slave laborer socked the Nazi guard in the face."

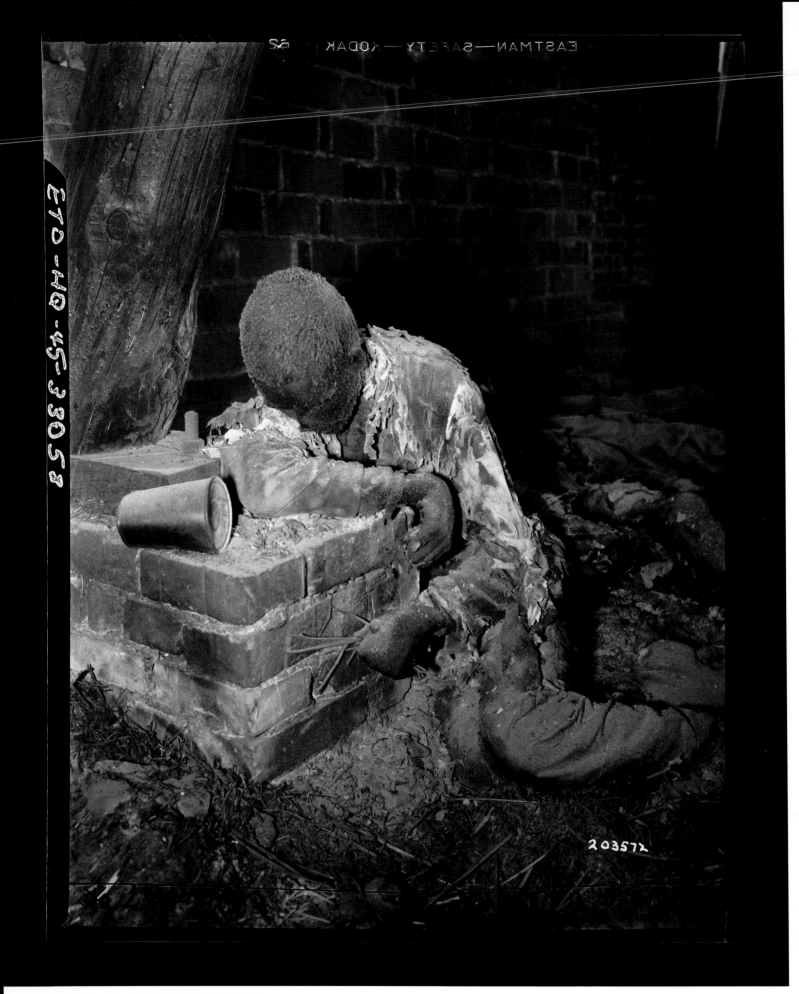

EASTMAN — SAFETY — KODAK 62

ETO-HQ-45-3058

203572

APRIL 16 E.R. ALLEN PHOTO (168TH)

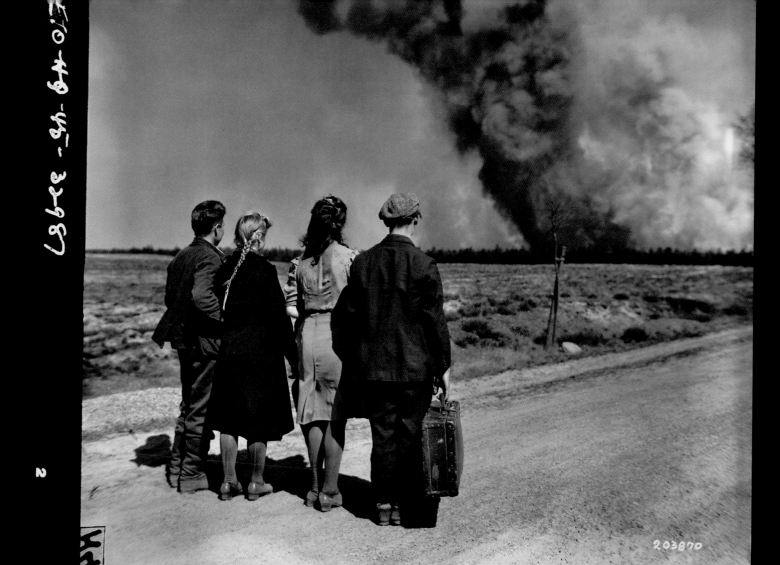

APRIL 16 N. SPERRY PHOTO (168TH)

German civilians watch a forest fire near Ziemendorf (now part of Arendsee) in northern Germany, caused by American tracer bullets used to rout out German soldiers.

LEFT: Frozen in an awful moment are the ashen remains of a prisoner murdered by the Nazis. SS troops set fire to a large barn on the outskirts of Gardelegen, in northern Germany, that was full of Soviet, French, Polish, and Jewish prisoners. Those who desperately burrowed under the walls of the burning barn to escape were shot by the SS. The Gardelegen massacre shocked American troops, who discovered more than 1,000 bodies in the barn and nearby. Said one GI: "I never was so sure before of exactly what I was fighting for. Before this you would have said those stories were propaganda, but now you know they weren't. There are the bodies and all those guys are dead."

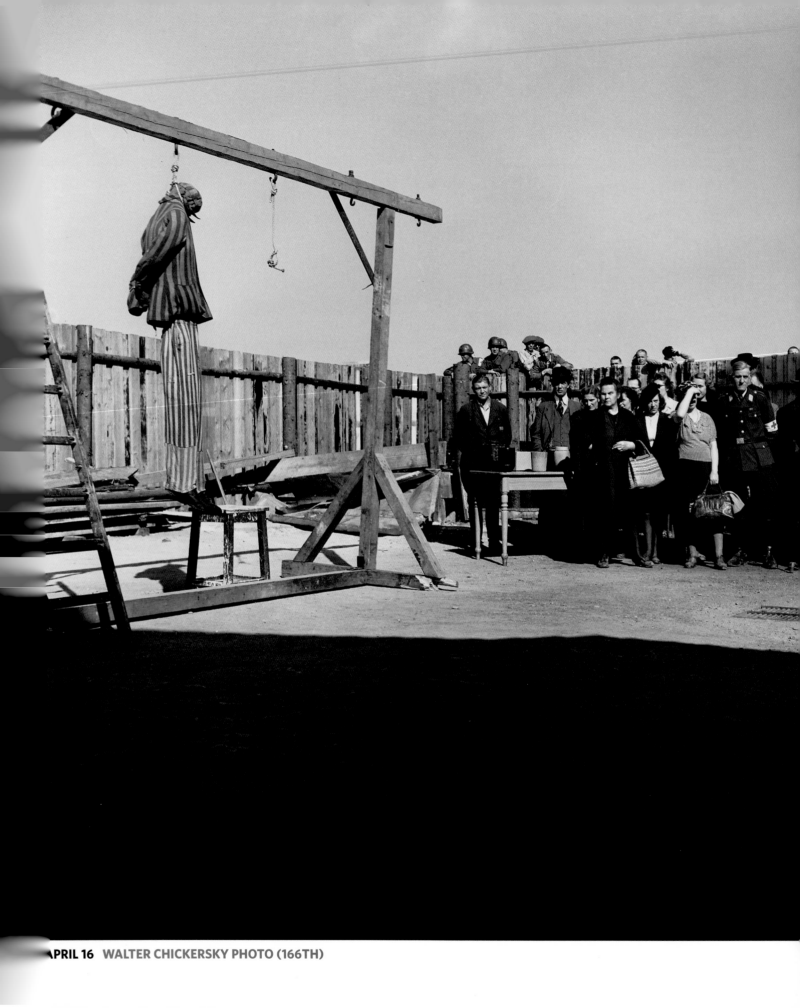

APRIL 16 WALTER CHICKERSKY PHOTO (166TH)

203585

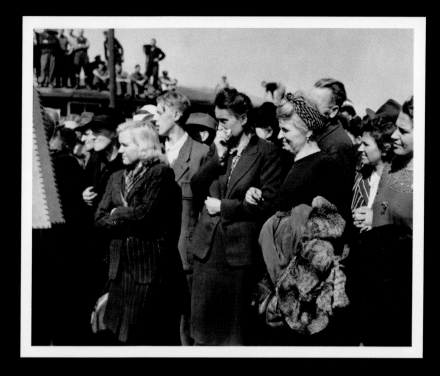

APRIL 16 WALTER CHICKERSKY PHOTO (166TH)

When the Nazis built their concentration camp near Weimar, in central Germany, local authorities didn't want to be associated with it. So instead of calling it the Weimar camp, they named it Buchenwald—German for "beech forest." By the time Allied troops arrived as liberators, Buchenwald and its sub-camps formed the largest prison network in the Nazi system, with about 112,000 inmates. An estimated 60,000 prisoners died at Buchenwald, including the man shown here hanging from a hook. Among the survivors: Elie Wiesel, who would later win the Nobel Peace Prize. Appalled authorities ordered the townspeople of Weimar to visit the camp "to give them a firsthand knowledge of the infamy of their own government," as General Patton put it. After viewing the grisly scene, the mayor of Weimar and his wife killed themselves.

"The German civilians had to have known what was going on, because you could smell those camps for miles before you reached them," wrote Charles E. Sumners of the 166th. "You could always tell when you were getting near one of these areas by the stench. The odor of a dead decaying human being has a different, distinctive smell from any other smell I have ever encountered. But once you have smelled it, you will never forget it as long as you live."

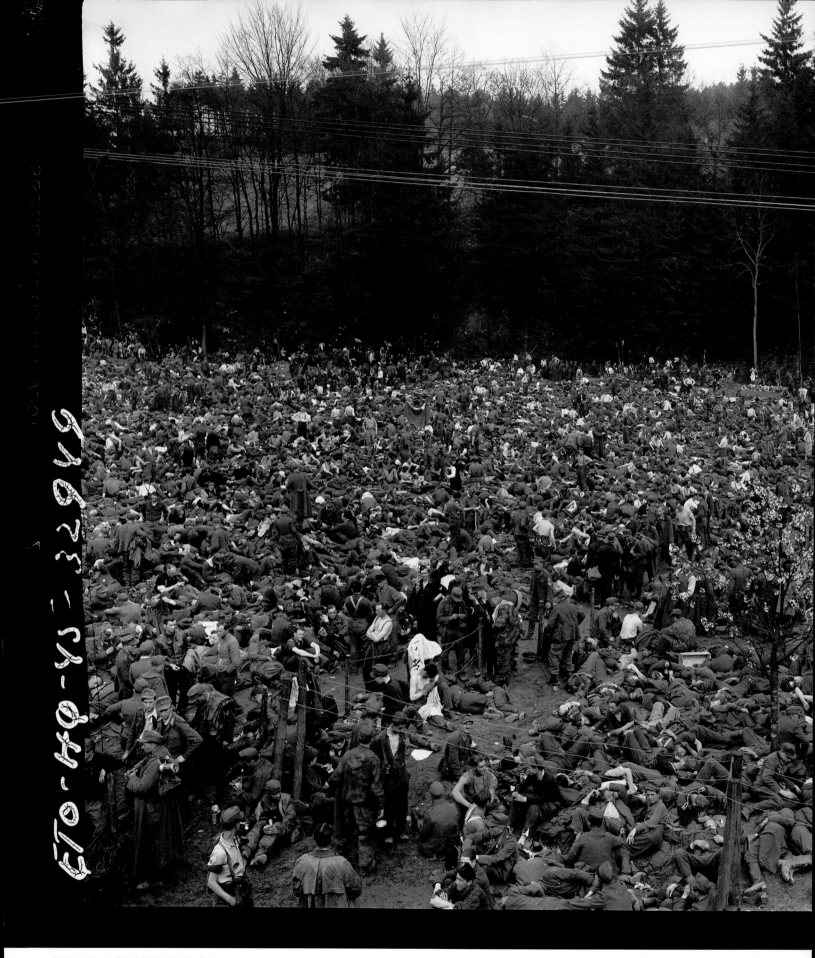

APRIL 17 LEO MOORE PHOTO (165TH)

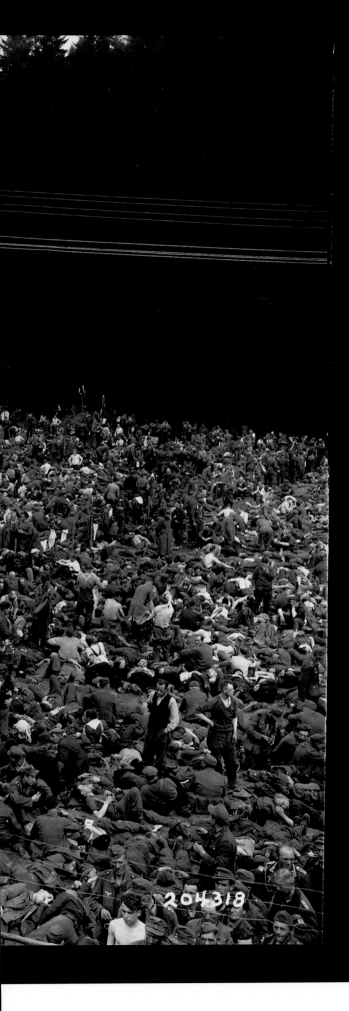

"By the time the Rhine River was crossed by the Allied troops, it was quite evident that Germany had been defeated, and the remaining action would be one of mopping up the routed enemy troops," wrote Billy A. Newhouse of the 166th Signal Photo Company. Not much more battle photography was possible, he wrote. "Orders came down to be on the lookout for subjects of interest which could not be photographed outside of Germany proper. Among these subjects were the Concentration and Prisoner of War camps."

The surrender of German forces trapped in the Ruhr Pocket in western Germany led to the creation of a huge prisoner of war camp near Gummersbach that held at least 50,000 German soldiers. Conditions were grim, with no food or water for days on end. GIs with machine guns were posted on the heights overlooking the valley where the prisoners were kept, while more guards patrolled with guns and clubs. U.S. troops, who were seeing and hearing more and more details about the Nazis' atrocities toward Jews and foreign prisoners, had little sympathy for captured members of the German Wehrmacht.

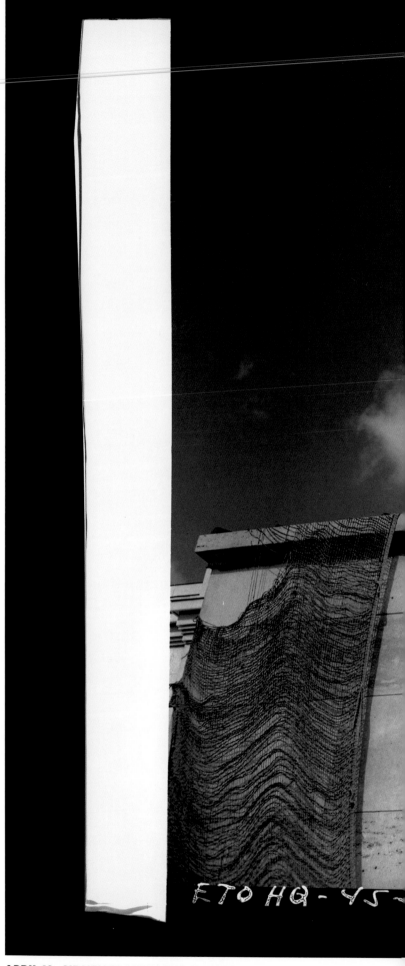

Harold Hershey of the 163rd Signal Photo Company mimics Hitler, using a comb for a mustache, at the Nazi Party Congress Stadium in Nuremberg. "Of all the pictures I've taken, that one probably got the most exposure," said Sidney Blau, who took the picture of his partner. The photo was Blau's idea. Hershey protested at first because he thought it was too corny.

The stadium, featuring a gilded copper swastika, had once been the site of Hitler's grandest speeches to huge throngs, as captured in Leni Riefenstahl's film *Triumph of the Will*. A U.S. Army map of Nuremberg included this guidance: "In view of its ranking position as Nazi Circus Town, its importance cannot be exaggerated."

The occasionally lighthearted attitude of the soldier photographers belied the danger surrounding the taking of Nuremberg. "Under the leadership of Julius Streicher, dictator of the Nuremberg laws, several thousand *Volkssturm* troops defended the city," wrote Harry Miller of the 166th Signal Photo Company. "The fighting was heavy for four days and nights; it was house-to-house and street-to-street battle. As the 80th [Infantry Division] advanced further into the city, it became apparent that Julius Streicher had led his Nazi Volkssturm into a mass suicide, as the streets were littered with dead Germans."

APRIL 19 SIDNEY BLAU PHOTO (163RD)

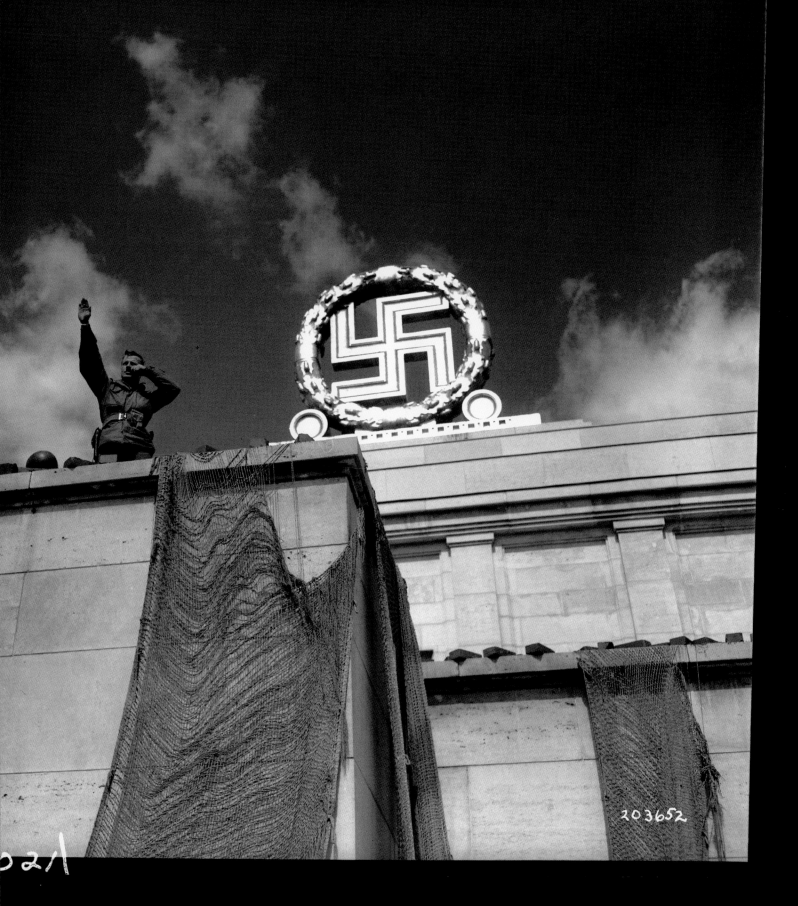

203652

021

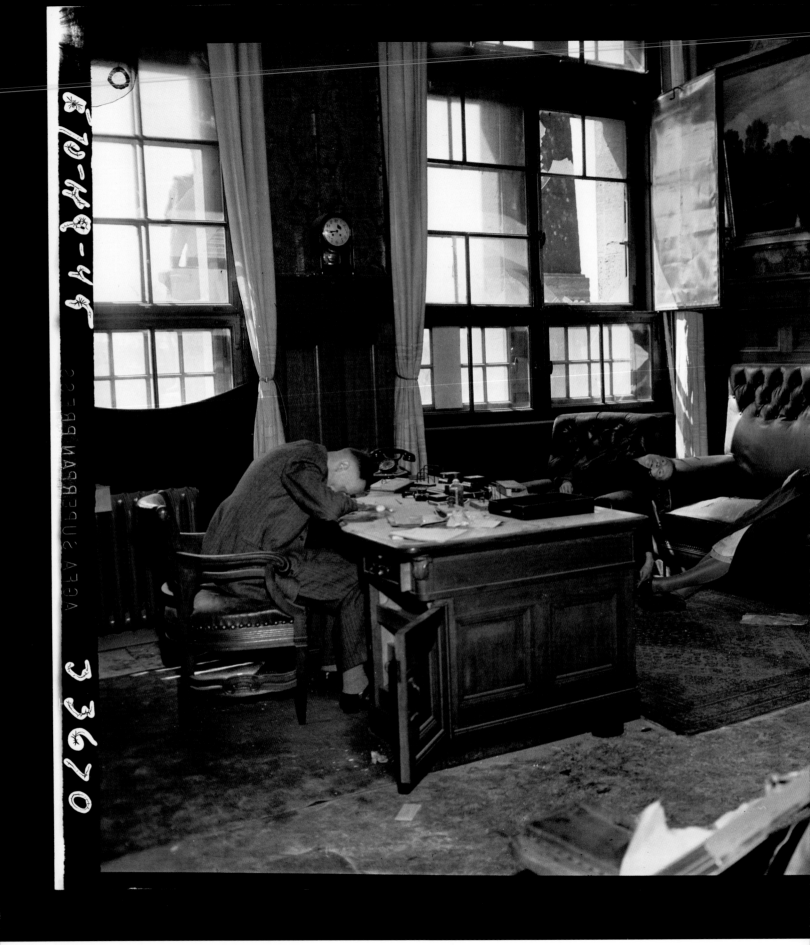

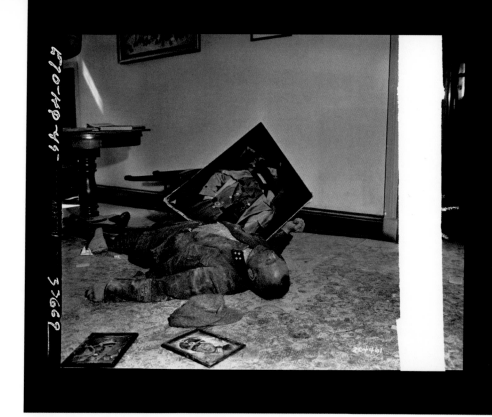

APRIL 20 J. MALAN HESLOP PHOTO (167TH)

For many Nazi Party members, the collapse of the dictatorship was the end of their world. Kurt Walter Donicke, general of the Volkssturm militia, lies dead next to a torn picture of Hitler after committing suicide at Leipzig's city hall, about 100 miles south of Berlin.

LEFT: The deputy mayor of Leipzig, Ernst Kurt Lisso; his wife, Renate; and his daughter, Regina, took cyanide in his office. Lisso had his Nazi Party card at his elbow when he was found. His daughter is wearing an armband for the German Red Cross. Such drastic measures may have been fueled by Nazi propagandists' descriptions of the barbarity of their enemies, particularly the Soviets. But even surrender to First Army soldiers was too much for the Lissos to contemplate.

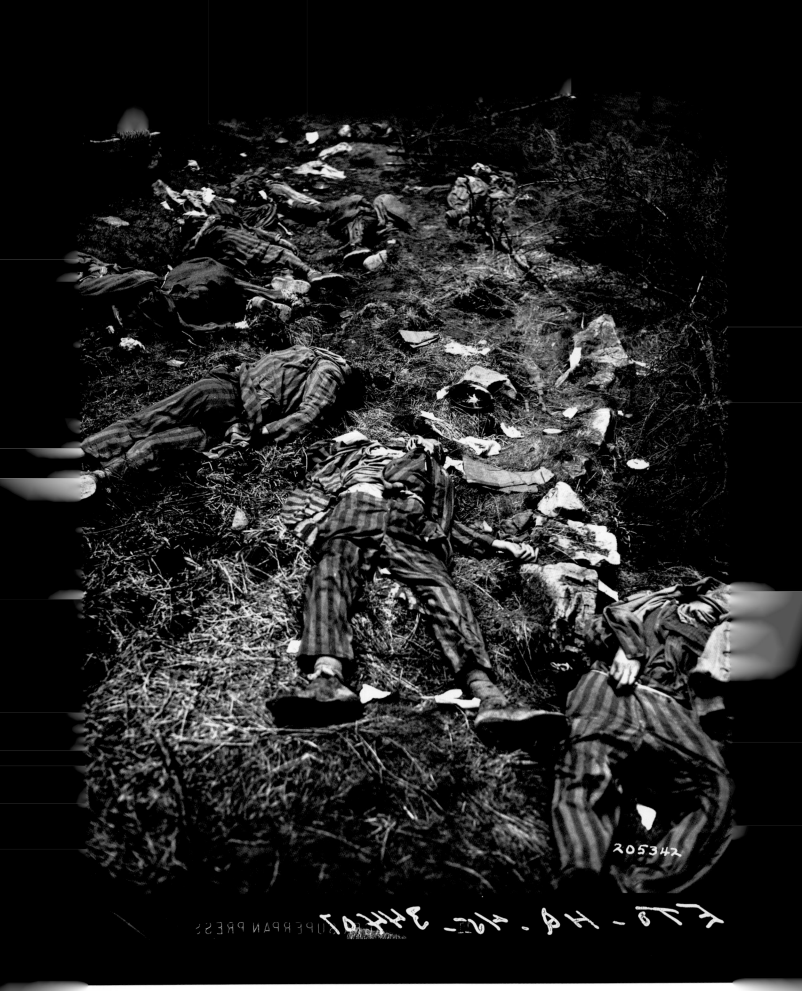

205342

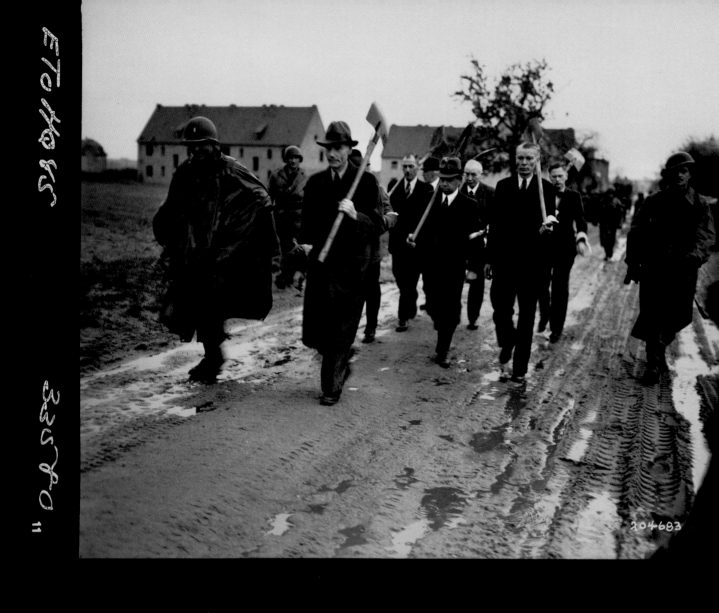

APRIL 21 JOSEF VON STROHEIM PHOTO (168TH)

Villagers in Gardelegen, Germany, site of the shocking atrocity in which prisoners were herded into a barn that was then set afire, are marched by GIs to a site where some victims of the massacre had been hastily buried in a mass grave. The townspeople dug up the bodies and reburied them individually.

LEFT: Soldiers of the First Army came across Soviet, Italian, and French prisoners who had been taken to the Braunlage Forest and shot in the head by the Germans. What Signal Corps photographers witnessed was overwhelming. Wrote Ted Sizer of the 166th: "It was a front seat in the most dramatic kind of theater you could imagine."

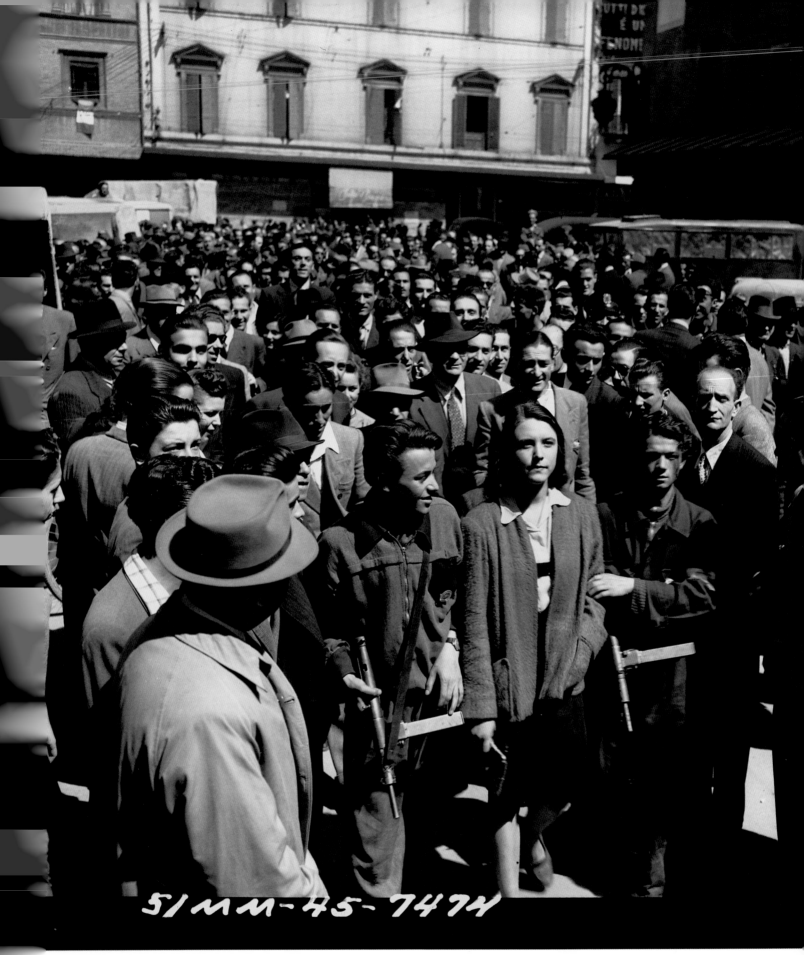

51MM-45-7474

APRIL 23 DANIEL P. PHILLIPS PHOTO (196TH)

208472

As American and Polish troops entered Bologna, Italy, they encountered a city engulfed in retribution. Bologna had been a welcoming place for fascists led by Benito Mussolini, but there were anti-fascist Bolognese as well. When the Italian military disbanded in 1943, soldiers in Bologna were offered civilian clothes in exchange for their weapons. Those arms went to the partisans who confronted the Italian fascists and Germans. After the German army withdrew from the city in April 1945, partisans rounded up suspected fascist collaborators, executing several. The Allies tried to quell the violence by ordering partisans to turn in their weapons.

This photo, taken in a Bolognese square, shows partisans with a woman who is a suspected collaborator. Her fate is unknown.

Foto-Facto, newspaper of the 163rd Signal Photographic Company

" **The war hurts most when it hits home. The news of thousands killed will not affect us as much as the death of just one soldier we know personally.**"

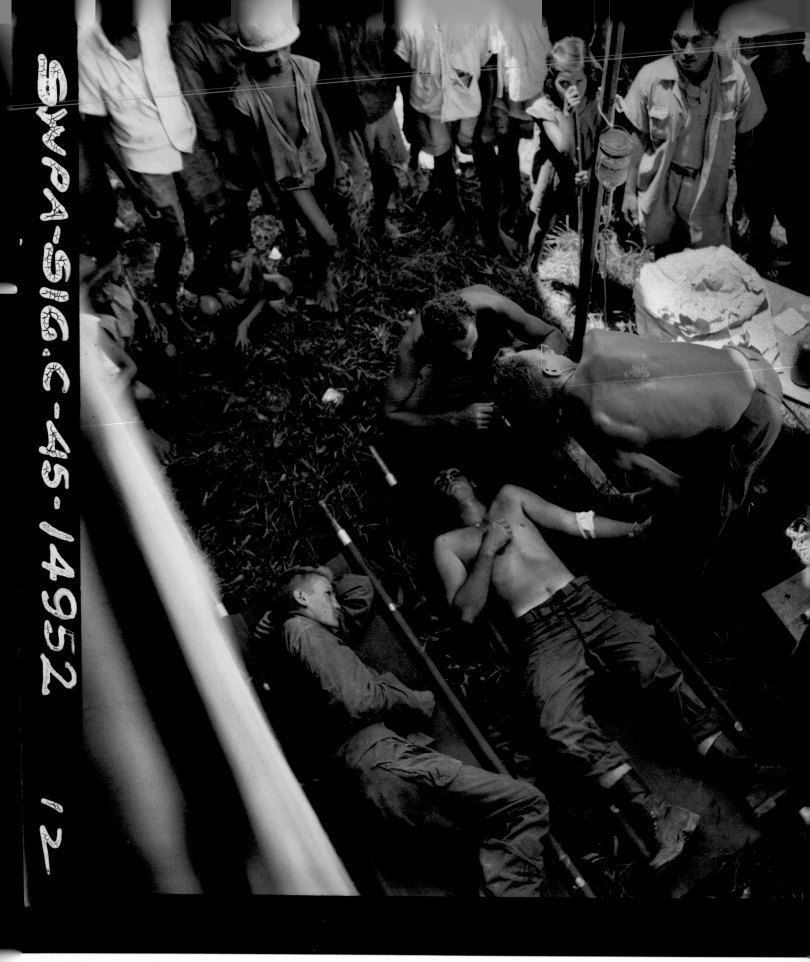

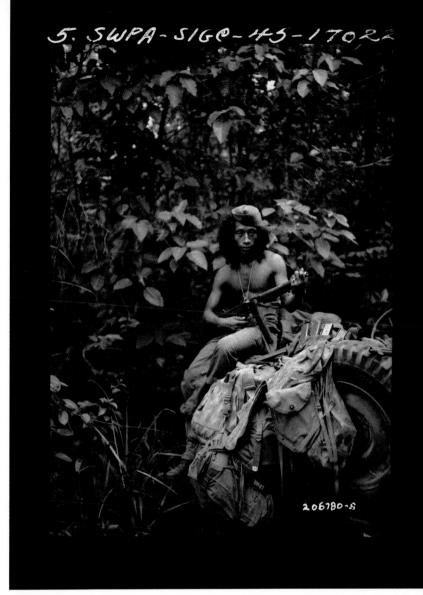

APRIL 25

Amicedo Farola, one of the Filipino guerrilla fighters who battled the Japanese after they took over the Philippines early in the war, sits on the back of a jeep with his Thompson submachine gun on the southern island of Mindanao. The Signal Corps caption said Farola "has more Japanese kills to his credit than he will admit to strangers."

LEFT: Private First Class Owen G.M. Crumb, of Stamford, New York, receives a saline solution transfusion to treat heat exhaustion at Katidtuan, also on Mindanao. Joseph Zinni was with the 166th, half a world away from Mindanao, but he knew well the life of a ground trooper: "A civilian could never fully understand or imagine what the 'doughboy' really goes through. . . . But it'll suffice to say that neither pictures nor words can describe the fears, discomforts, loneliness and hardships that the poor infantryman has to go through."

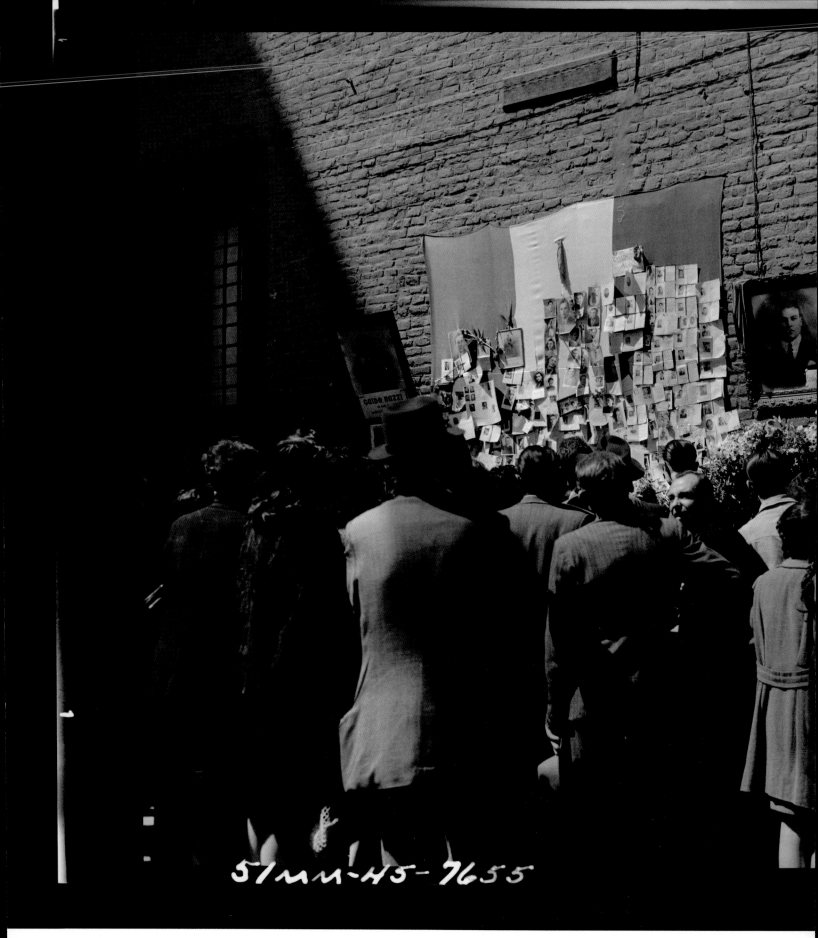

51mm-H5-7655

207380

4-484-45/AD-45-34
207247

APRIL 26

Mrs. Fred Prokopanoff and her daughter Annie return to Atka Island in the Aleutians three years after the Aleuts were removed and held in incarceration camps by U.S. authorities when the Japanese invaded the remote island chain, which is now part of the state of Alaska. Atka is the site of a wrecked B-24 Liberator bomber that was downed by bad weather in 1942 and is part of a national monument.

LEFT: Italians gaze at photos of missing people—many of them presumed victims of Benito Mussolini's regime—at Bologna's Piazza Maggiore, also known as Piazza Vittorio Emanuele II. The display began with mothers who went to the city center with photos of their missing sons, searching for information on their whereabouts. The mothers created a "photographic wall," and the practice spread to other Italian towns.

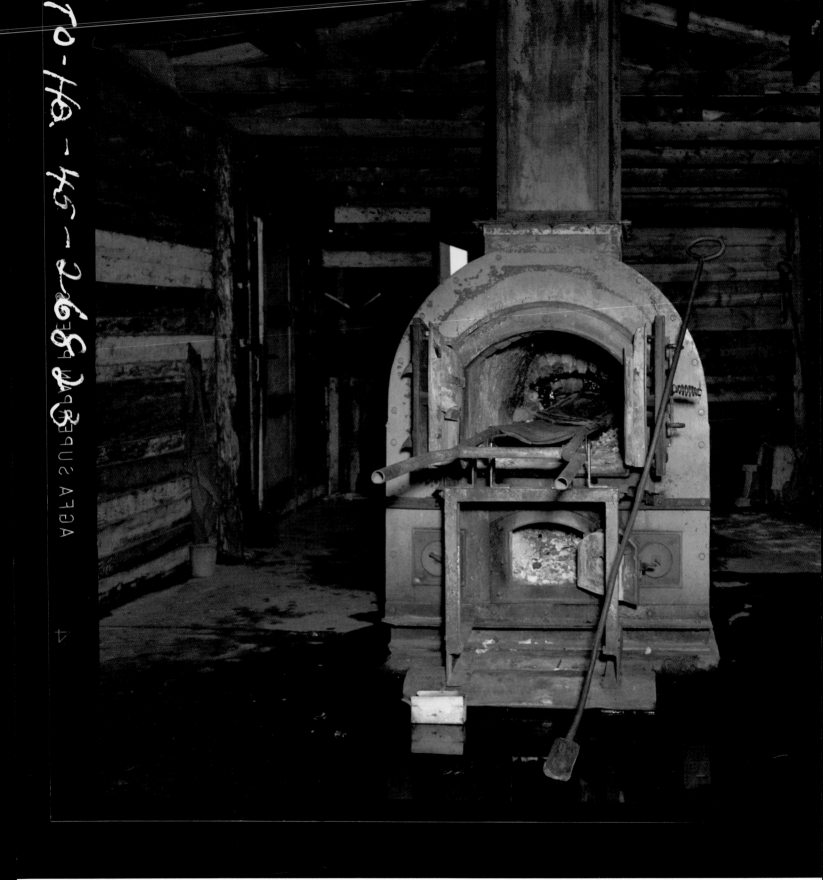

APRIL 28 LAWRENCE D. GWIN PHOTO (167TH)

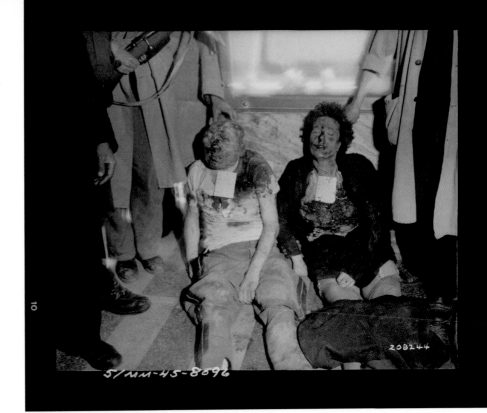

APRIL 28 JOHN T. MASON PHOTO (196TH)

For some of Europe's fascists, brutality was turned against them. By late April, the German army in Italy was trying to negotiate a surrender to Allied troops and the country was in a state of insurrection. Benito Mussolini, deposed as Italy's dictator, tried unsuccessfully to flee to Switzerland and was captured by partisans and held in a farmhouse in Giulino di Mezzegra. A group of men came to the farm and promised to take Mussolini to freedom. He and his mistress, Clara Petacci, joined them, only to be taken to a nearby stone wall and shot to death. Their bodies were beaten and hung upside down from a metal girder above an Esso gasoline station near Milan's Piazzale Loreto.

LEFT: The crematorium at Bergen-Belsen, where human beings were turned to ash. Anne Frank died there.

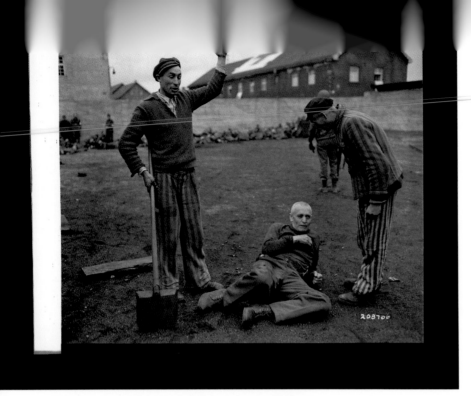

APRIL 29 ARLAND B. MUSSER PHOTO (163RD)

Survivors of the Dachau concentration camp, newly liberated, insult a former SS guard after knocking him to the ground. Many guards were beaten, and one American soldier lent his rifle to the prisoners, allowing them to fatally shoot two guards. "There was all this shooting going on," Signal Corps photographer Philip Drell recalled. "Guards were being pursued, shot and beaten to death. It was an awful situation."

RIGHT: The Nazis' cruelty at Dachau so enraged American troops that they committed their own war crimes. Shown here is the aftermath of the notorious Dachau coal-yard shooting, in which GIs killed at least 17 captured SS guards. A U.S. military investigation found that American troops led dozens of SS guards into the yard, lined them up against a wall, and set up a machine gun. When a belt of ammunition was loaded into the machine gun and the lead round was fed into the chamber, some of the Germans panicked and moved toward the Americans, who fired with the machine gun and other firearms. Some American medics refused to treat the wounded SS men. Walter Rosenblum of the 163rd, who was working alongside photographer Arland B. Musser, filmed the scene, but the footage was destroyed. He received a note from Signal Corps Major Fred Fox: "A portion of this coverage was not screened due to censorship and laboratory difficulties." Rosenblum could not understand why his film was destroyed and Musser's photos were printed. A U.S. Army inspector general recommended charges against several soldiers involved in the shooting, but nothing came of it.

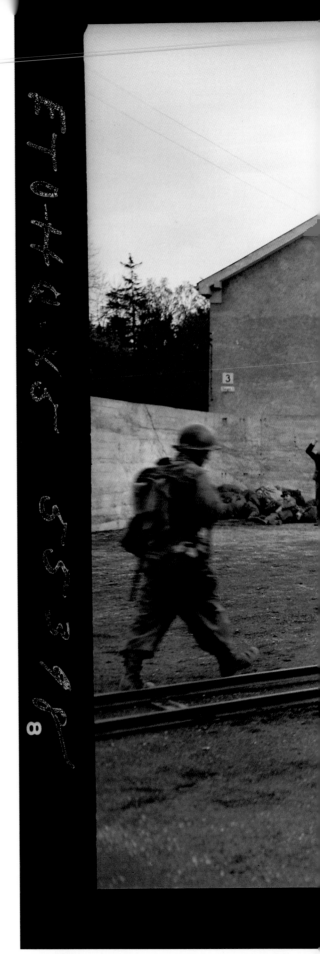

APRIL 29 ARLAND B. MUSSER PHOTO (163RD)

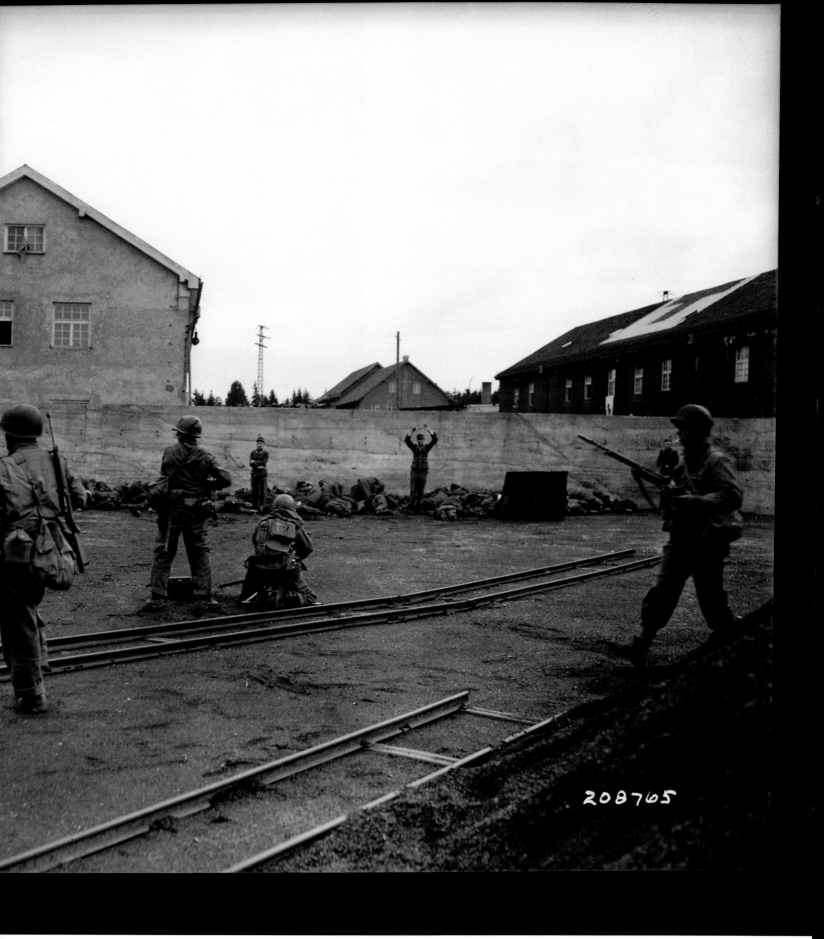

208765

APRIL 29

The body of this Jewish concentration camp inmate, with a bullet hole in his head from an SS guard's gun, was among those unearthed when citizens of Neunburg vorm Wald, Germany, were forced to dig up camp victims who had been shot in the woods and buried in a common grave as Allied forces approached.

RIGHT: Neunberg residents built the boxes and hauled about 120 massacre victims out of the mass grave so they could be buried in the city cemetery. American chaplains said prayers. Eric Wiesenhutter of the 166th recalled, "At the appointed hour, and with cameras already emplaced at strategic points to record each step of the proceedings, four men of the town stepped forward, grasped an open coffin and began the two-mile trek to the scene of the crime. Eventually there were no men left to carry bodies, and the women and girls of the town were enlisted to also make the trip to the grave, secure a body, place it in the crudely made coffin, and again, with a person at each corner of the coffin, make the trip back to town and through the lined streets, and then to the . . . cemetery, where a ceremony would be held."

He continued: "Several men and women quailed at the proceedings, fainted away, or otherwise would have quit but the program was kept moving. It was a strange and ghastly sight to see a two-mile-long procession of groups of five people, one of them in an uncovered coffin, dead of an unjust and horrible death, the other four in file over a main road and through the town to the cemetery."

APRIL 29 WENDELL N. HUSTEAD PHOTO (166TH)

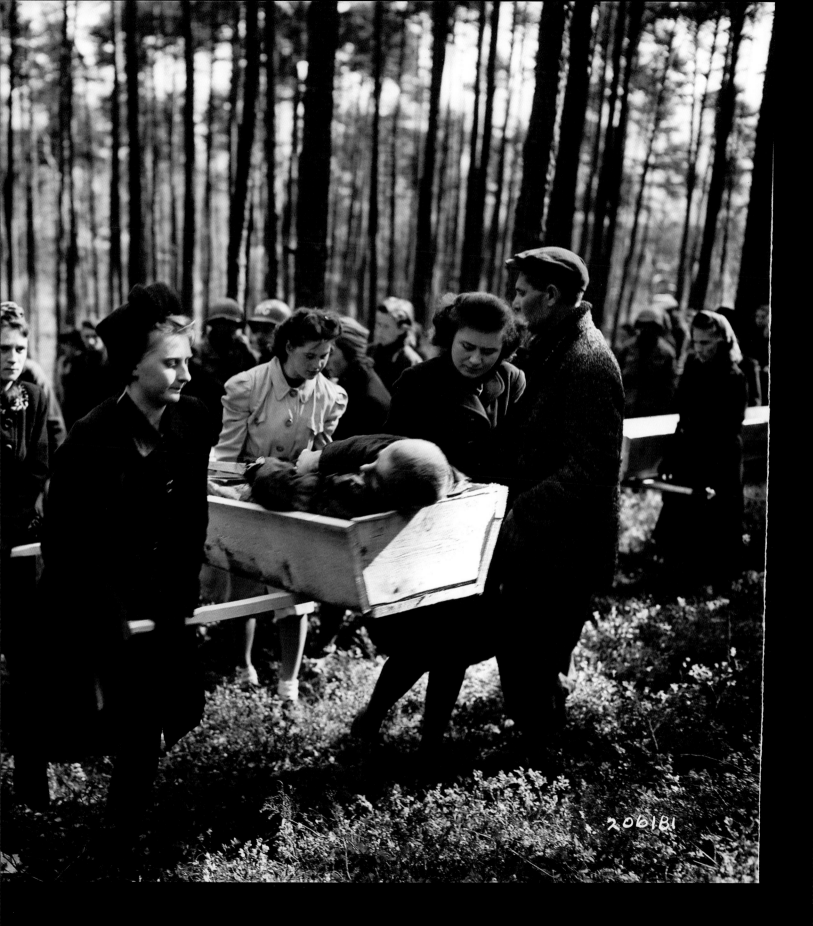

A Mormon chaplain with the U.S. Army's XXIV Corps presides over a marriage ceremony between a captured Japanese first lieutenant and an Okinawa nurse on the Japanese island of Okinawa. The wedding of an enemy prisoner was "a ceremony perhaps unparalleled in American military history," according to the Associated Press, which explained: "Lovers for several months, the couple was found in a cave on April 28. They had been there since April 22, when the officer and the girl, tired of war, decided to hide, await the arrival of the Americans and hope for the best." The bridesmaid, standing behind the Japanese nurse, was an English-speaking Hawaiian. A GI with an accordion played wedding music.

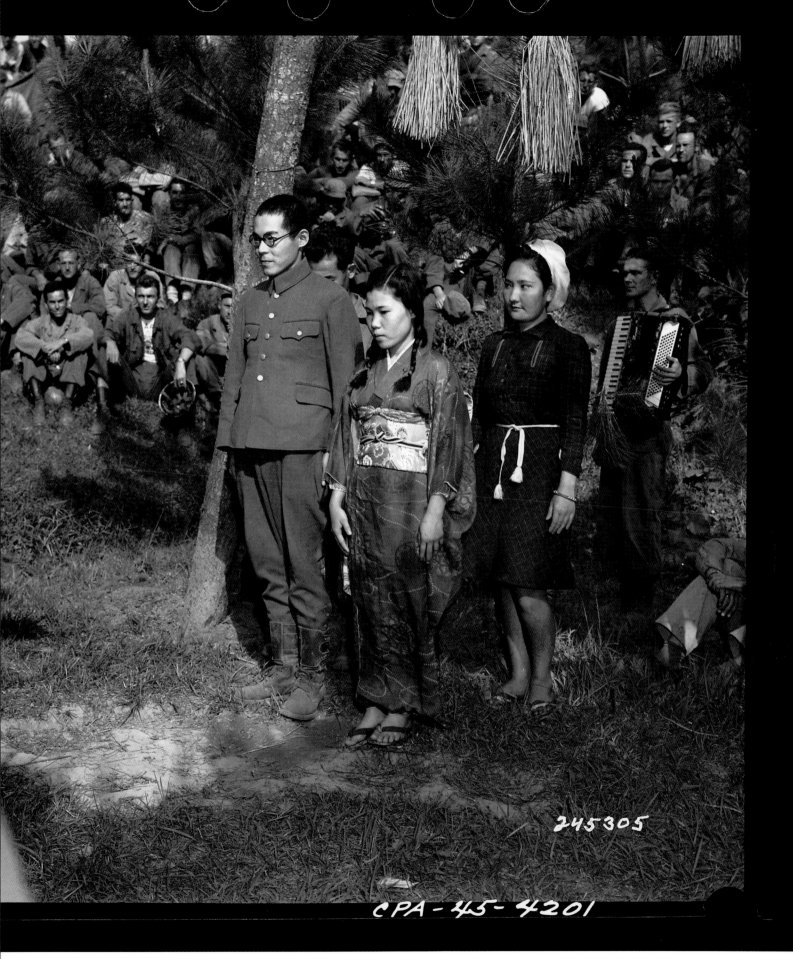

245305

CPA-45-4201

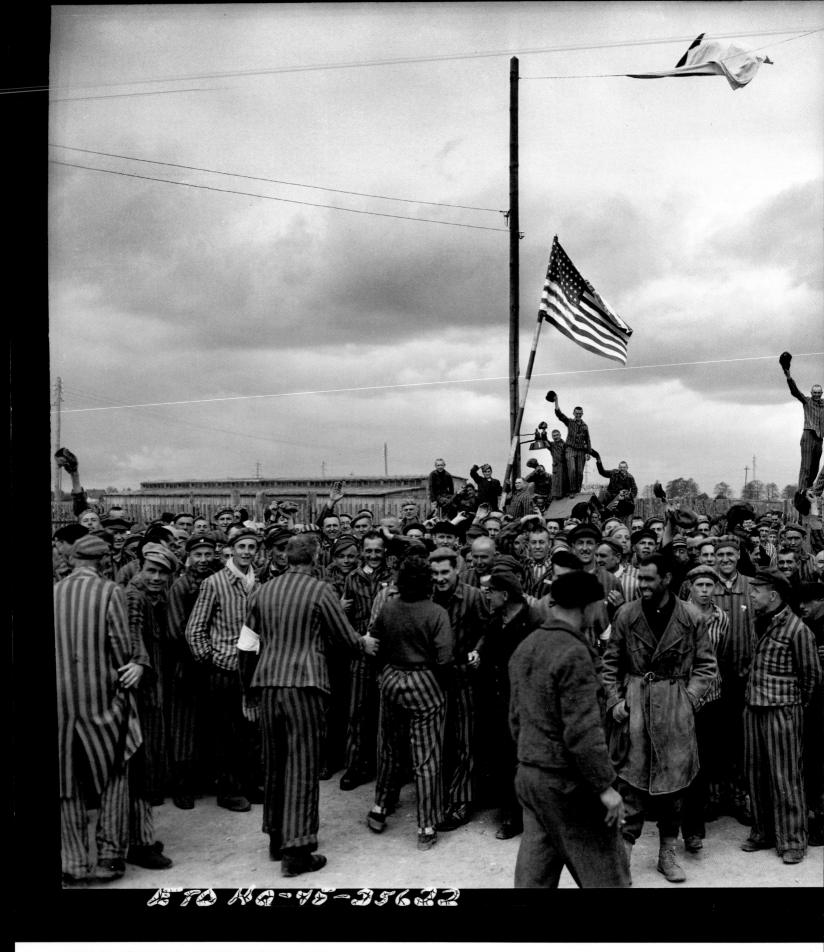

APRIL 30 ARLAND B. MUSSER PHOTO (163RD)

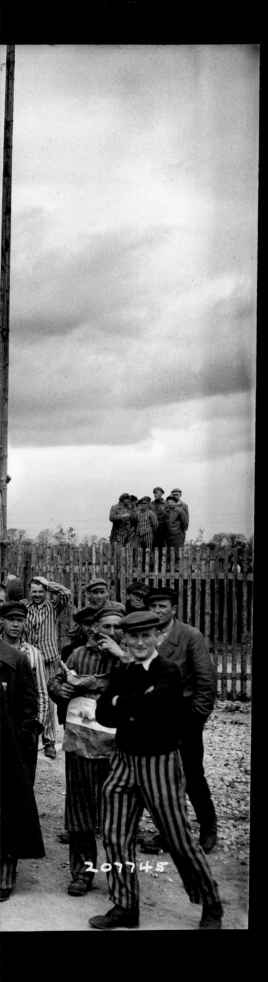

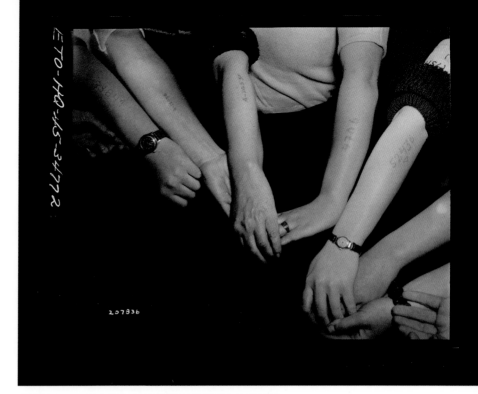

APRIL 30 HAROLD ROBERTS PHOTO (163RD)

Jewish women show their tattooed numbers after Germans left them behind at Mehltheuer (now part of Rosenbach, Germany) when the Eighty-Seventh Infantry Division moved in.

LEFT: When the Seventh Army troops liberated 30,000 prisoners at the Dachau concentration camp, the first instinct of the survivors was to rush the gates to leave the camp. But of course, it was important for them to stay put and receive incoming food and medical care. Lieutenant William Cowling wrote to his family about the wild throng of celebrating inmates. "They were dirty, starved skeletons with torn tattered clothes and they screamed and hollered and cried," he said. "They ran up . . . grabbed us and tossed us into the air screaming at the top of their lungs." Here, a day after the arrival of U.S. troops, the survivors of Dachau pose for a photograph, with the American flag prominently displayed.

Before leaving Paris, photographer Robert Hopkins started to see photos of the camps being printed in the Signal Corps labs. "No words could describe it," he said. "Only the photographs could effectively attest to this Nazi infamy."

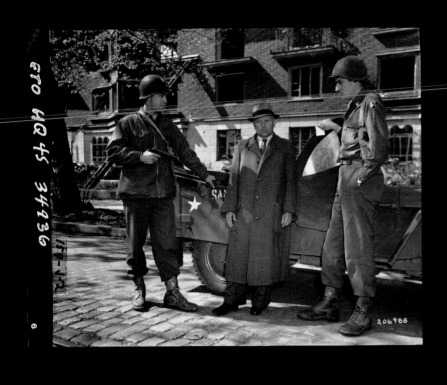

MAY 1 ROLAND OXTON PHOTO (198TH)

A man identified by a Signal Corps photographer as German Colonel Willie Schmidt is in the custody of Lieutenant Robert Benoy (*left*) of Owosso, Michigan, and Staff Sergeant Ralph Lubow of New York City. The caption stated that Schmidt was notorious for his persecution of the Jews and had switched into civilian clothes in an unsuccessful attempt to evade capture in Dusseldorf.

RIGHT: A train car holds the bodies of prisoners after a massacre by SS troops with machine guns in Seeshaupt, in southern Germany. The image of train cars containing bodies was remembered by several Signal Corps photographers, including Philip Drell, who arrived at Dachau. "The first thing we saw [was] the train," he told the USC Shoah Foundation's Institute for Visual History and Education. "It was along a siding. We opened up a door and a body rolled out into a sitting position right at the edge of the train." Drell said the train had about 40 cars and held 3,000 bodies. "We made a whole series of photographs of the bodies in the train," he recalled. "There were some guards next to it who were shot immediately."

MAY 1 ALBERT GRETZ PHOTO (163RD)

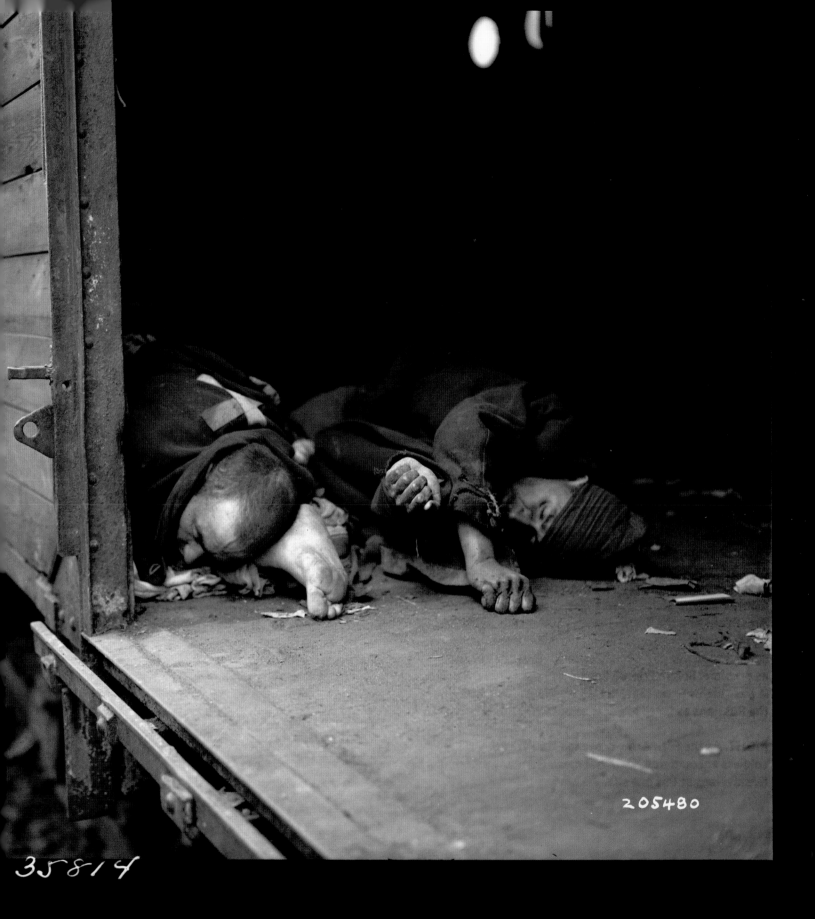

205480

35814

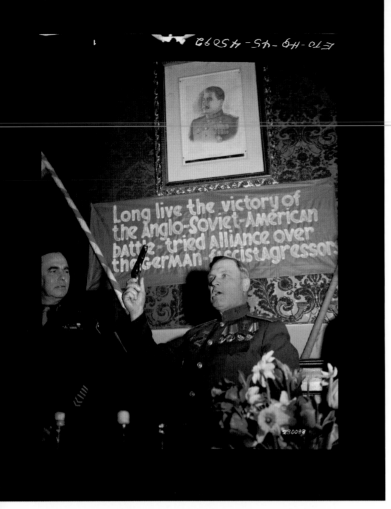

MAY 2 RICHARD G. THOMPSON PHOTO (163RD)

One week after Soviet and American troops met at the Elbe River in eastern Germany, Red Army General Filipp Cherokmanov presents a pistol as a gift to U.S. Major General Raymond S. McLain of the Ninth Army in Wittenberg, Germany, beneath a portrait of Soviet dictator Joseph Stalin. By this time, it was clear to the Americans and the British that the Soviet Union would be their postwar adversary, and the Allies were racing against each other to occupy as much German territory as possible. British Prime Minister Winston Churchill said it was "highly important that we should shake hands with the Russians as far to the east as possible."

RIGHT: As the Fifth Army drove the Germans out of Italy, soldiers encountered a reminder that Germans had shot five civilians at this one site.

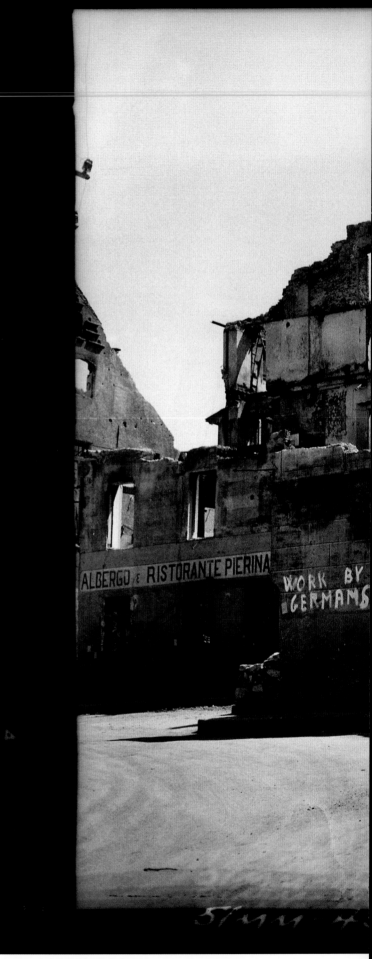

MAY 2 JAY B. LEVITON PHOTO (196TH)

HERE FIVE OF OUR
CITIZENS SHOT
BY GERMANS DIED.
WE WILL REMEMBER
IT!

EPURAZIONE

WELCOME TO THE ALLIED!
OUR COUNTRY THANKS YOU FOR
THE PRECIOUS HELP YOU HAVE GIVEN
TO OUR BRAVE PATRIOTS!

209631

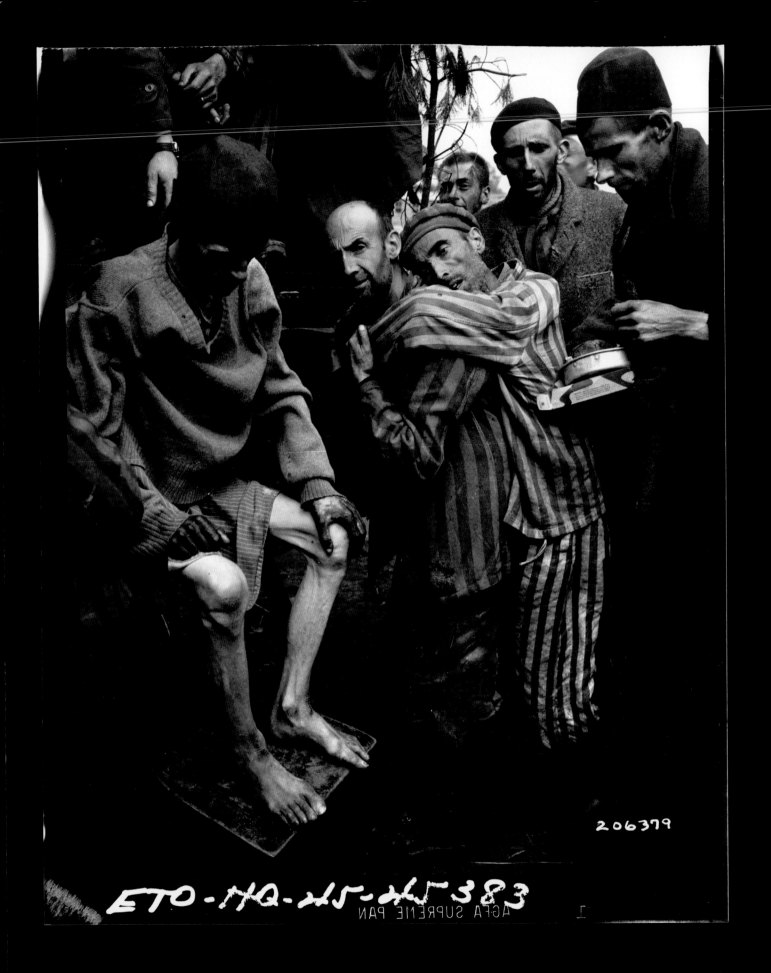

206379

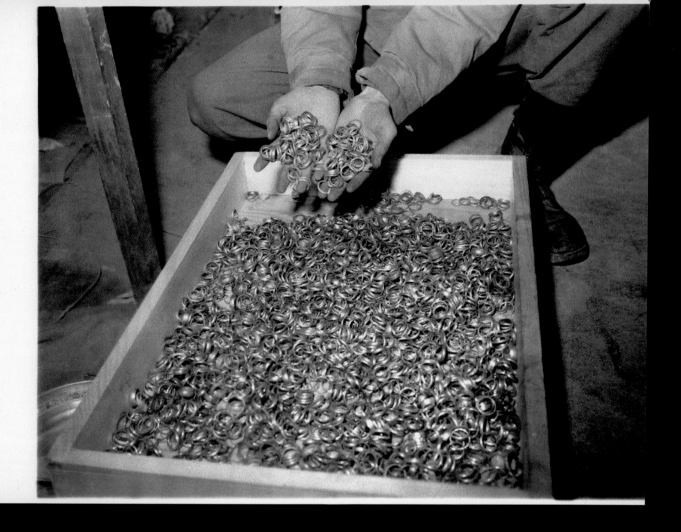

MAY 5 HAROLD ROBERTS PHOTO (165TH)

The rings stolen from the Nazis' victims were among the valuables found in a cave near the Buchenwald concentration camp outside Weimar, Germany. Other loot in the cave included watches, precious stones, eyeglasses, and gold teeth. "We were hardened by years of combat," said Walter Halloran of the 165th Signal Photo Company, who photographed Buchenwald. "But nothing, nothing prepared us for the brutality—the sights, sounds and smells—we found there."

LEFT: Starving prisoners are removed from the newly liberated Woebbelin concentration camp in northern Germany so they can be treated at a U.S. field hospital. The man carrying a fellow inmate has been partially identified by the United States Holocaust Memorial Museum as a political prisoner named Aliende, but no more is known about him. Conditions were so ghastly at Woebbelin that cases of cannibalism were reported.

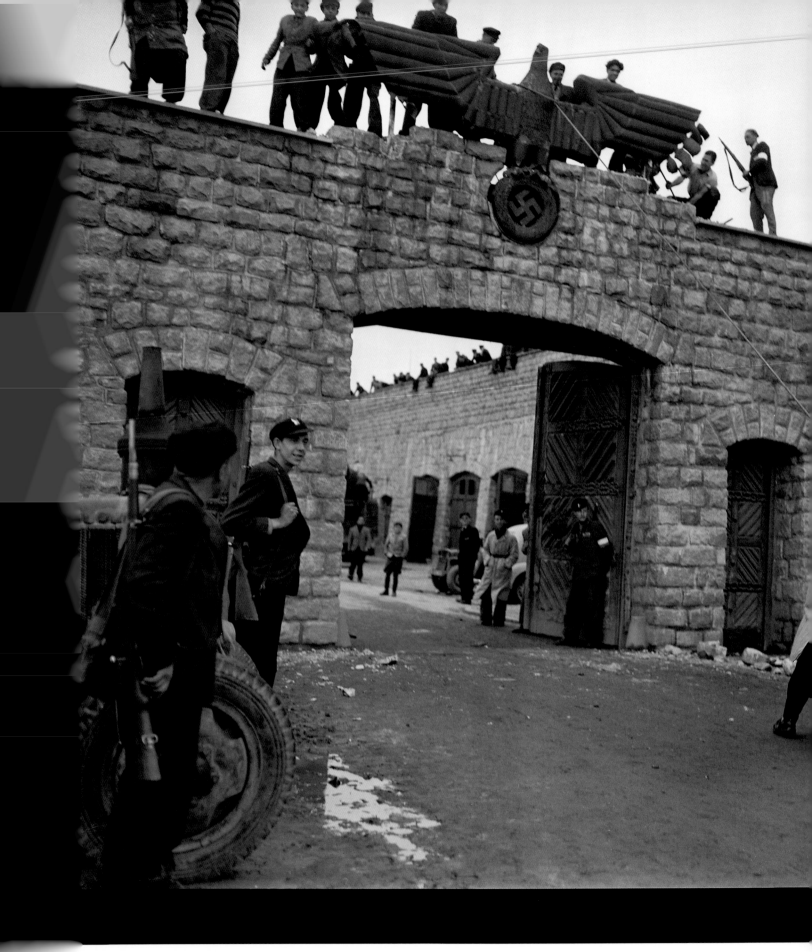

206399

MAY 7

At SHAEF—the Supreme Headquarters, Allied Expeditionary Force—a British officer leads a Nazi delegation into the meeting at Reims, France, where the Germans agreed to surrender effective the next day, May 8. German General Alfred Jodl (*center*), who signed the surrender documents, would be convicted of war crimes and meet the hangman in October 1946.

LEFT: Liberated prisoners at the Mauthausen concentration camp pull down the Nazi eagle at the entrance to the notorious facility on the banks of the Danube River near Linz, Austria, about 30 miles east of the border with Germany. More than 100,000 people died at Mauthausen, where prisoners worked in a granite quarry, carrying heavy stone blocks along a route that became known as "the stairs of death." Only a few of Mauthausen's inmates were Jews. The camp held a variety of enemies of the Nazis, including Polish political prisoners, gypsies, homosexuals, Soviet POWs, and even anti-fascist activists from Spain. One of Mauthausen's survivors was Simon Wiesenthal, a Polish Jew who would become world famous as a Nazi hunter for decades to come.

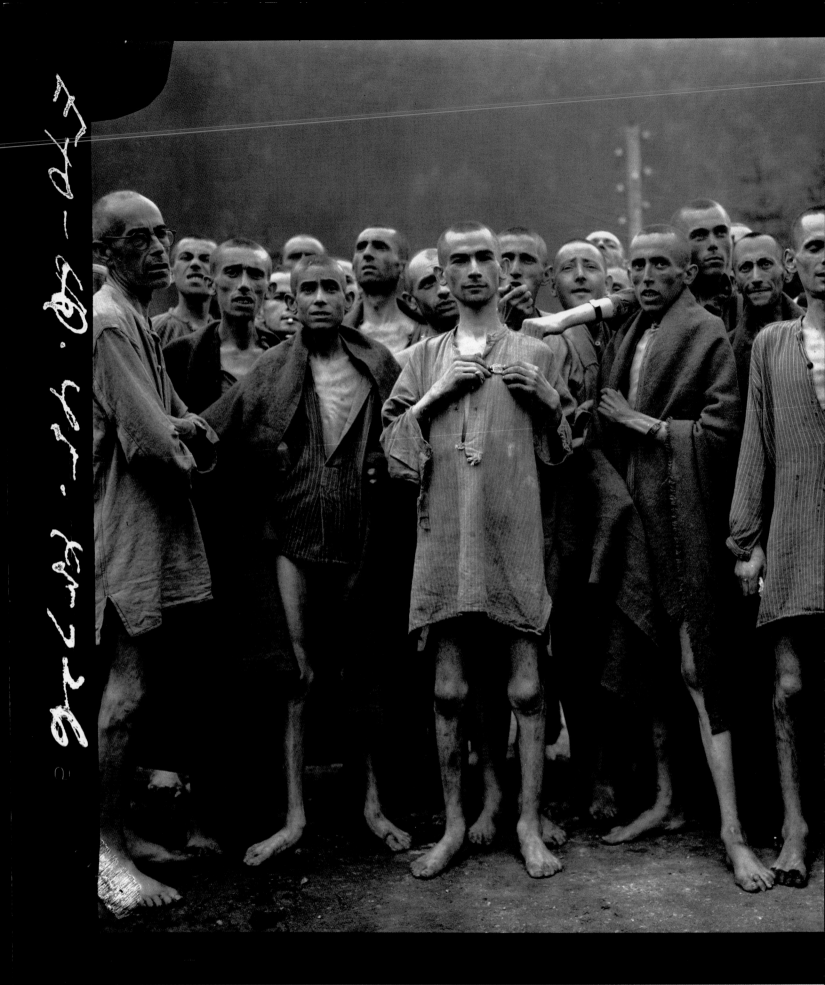

MAY 7 ARNOLD E. SAMUELSON PHOTO (167TH)

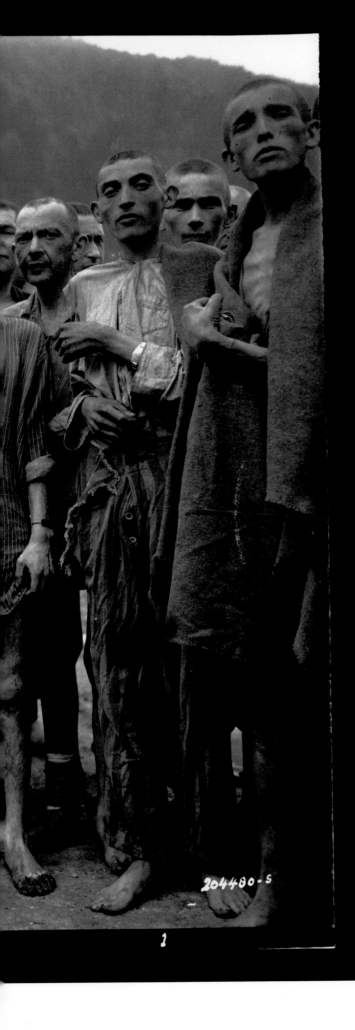

204480-5

A remarkable dignity shines through in this photo of the survivors of Ebensee, a sub-camp of Mauthausen in the Austrian Alps. The slave laborers of the Ebensee camp worked at a secret V-2 missile facility in a complex of tunnels in the mountains. The SS had fled the camp a day before the U.S. Army's arrival, leaving Volkssturm militia to watch about 20,000 starving prisoners. The soldiers on the lead tank approached the camp's entrance, took a rifle away from one of the Volkssturm, and smashed it over the turret of the American tank. That inspired a cheer from the prisoners behind the electrified, barbed-wire fences.

"One thing I've learned from photography is that all people are the same and need the same kind of respect," wrote Walter Rosenblum of the 163rd. "We are all human beings of the same kind and the same variety. And people have the same aspirations, the same needs, the same desires, to have a family, to have children who they could help to live decent lives, eat properly, build a life doing something of consequence. . . . Photography is like writing a love letter, only it's in terms of a photograph, rather than a written document."

Charles E. Sumners
166th Signal Photographic Company

"Sometimes people ask, 'Why does God allow war?' I don't know the answer to this, but war is a terrible thing, sometimes a necessary thing, that dramatically affects everybody involved. Sometimes war has meaning, and sometimes it has none. However, there is one constant: those who suffer the most have nothing to gain from its outcome and had nothing to do with starting it."

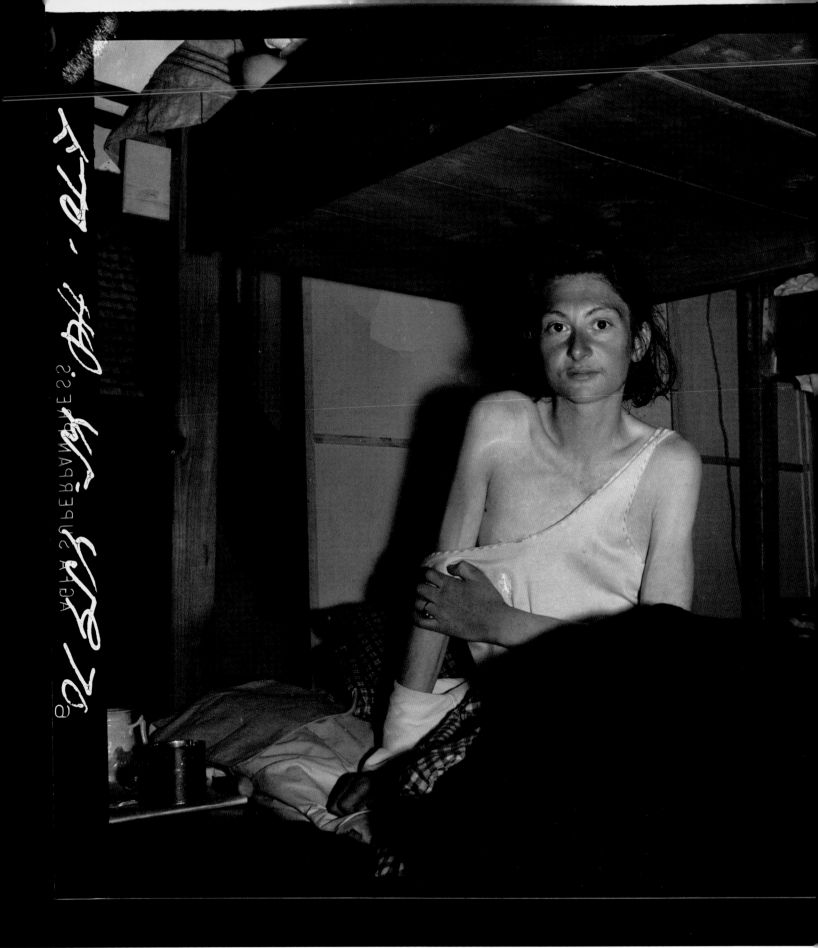

206093

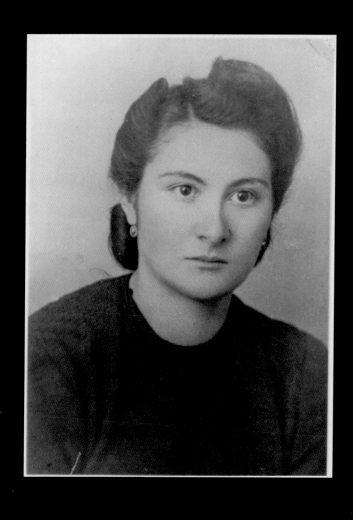

MAY 8 R.J. SCHNEIDER PHOTO (166TH)

As the Germans retreated, they often took their prisoners with them on long, grueling marches in which many died. Twenty-two-year-old Amelie Mary Reichmann was with a group of female slave laborers forced to walk about 18 miles a day for 30 days and fed only soup. Deaths steadily thinned the group. In early May, Germans left about 150 of them to die in a barn in Volary, Czechoslovakia, but members of the U.S. Army found them in time. Captain Aaron Cahan, a medical officer, recalled: "One thing that surprised me when we entered this barn is that I thought we had a group of old men lying and spread about and would at this time have judged that their ages ranged between fifty and sixty years. I was surprised and shocked when I asked one of these girls how old she was and she said seventeen, when to me she appeared to be no less than fifty." Reichmann was photographed during her recovery, and she gave the Signal Corps a portrait she carried showing her before her captivity. In 1994, Reichmann and her husband were preparing for a gathering to mark the fiftieth anniversary of the Volary liberation, and they visited the National Archives to look through photographs. That is where she reunited with her pre-captivity portrait and saw the Signal Corps' picture of her for the first time.

MAY 8 RACHLINE PHOTO

Two enduring European symbols, Paris's Arc de Triomphe and London's Big Ben, glow as the Allies celebrate V-E Day on May 8. Signal Corps photographer Robert Hopkins recalled, "The City of London tried to turn on the streetlights which had been off since the beginning of the Blitz, but birds had built their nests in them and the lights did not go on again as Londoners fervently hoped they would." Elizabeth Davey Velen, an American working in military intelligence with the Office of Strategic Services in Paris, wrote about the scene outside her apartment: "People were emerging from homes, listening and lingering. . . . Suddenly just below us a fountain that had been dormant since France fell in June 1940 burbled up into the air. . . . As we watched, spellbound, the Arc de Triomphe . . . was flooded with light." Jacob Harris of the 163rd wrote: "A dying war today tapered off into an anti-climactic announcement, at 12:01 a.m., that set off a symphony of firing." Gordon Frye, also of the 163rd, wrote to his parents, "Amen—it's over, over here!! Believe me, it is hard to realize—but it is finished—thank the Good Lord for bringing me safely through."

206422

MAY 8 SIDNEY SILVERMAN PHOTO

206905

E TO HQ-45-38676

11

MAY 9 CLIFFORD BELL PHOTO (163RD)

Members of the Allied forces walk on a Nazi flag as they ascend the steps of the Fuhrerbau, Hitler's former headquarters in Munich. The building is most famous as the site of the prewar agreement in which Hitler strong-armed Britain, France, and Italy into forcing Czechoslovakia to cede the Sudetenland to Germany. British Prime Minister Neville Chamberlain famously said the agreement would bring "peace in our time," but instead it became a symbol for futile appeasement of a dictator. Many valuable works of art were kept at the Fuhrerbau during the war. After its SS guards fled, as many as 650 pieces were looted. Today, the building is used by Munich's University of Music and Performing Arts.

RIGHT: Hermann Goering, called "Hermann the Vermin" by the 163rd, poses in front of the Texas flag at a castle in Kitzbuhel, Austria, after his capture. Goering, commander of the Luftwaffe, the German air force, was allowed to take a hot bath and was the guest of two U.S. generals for meals—treatment that caused a furor. The supreme Allied commander General Eisenhower issued an order that "senior German officers will be given only minimum essential accommodations."

264

MAY 9 HYMAN PHOTO

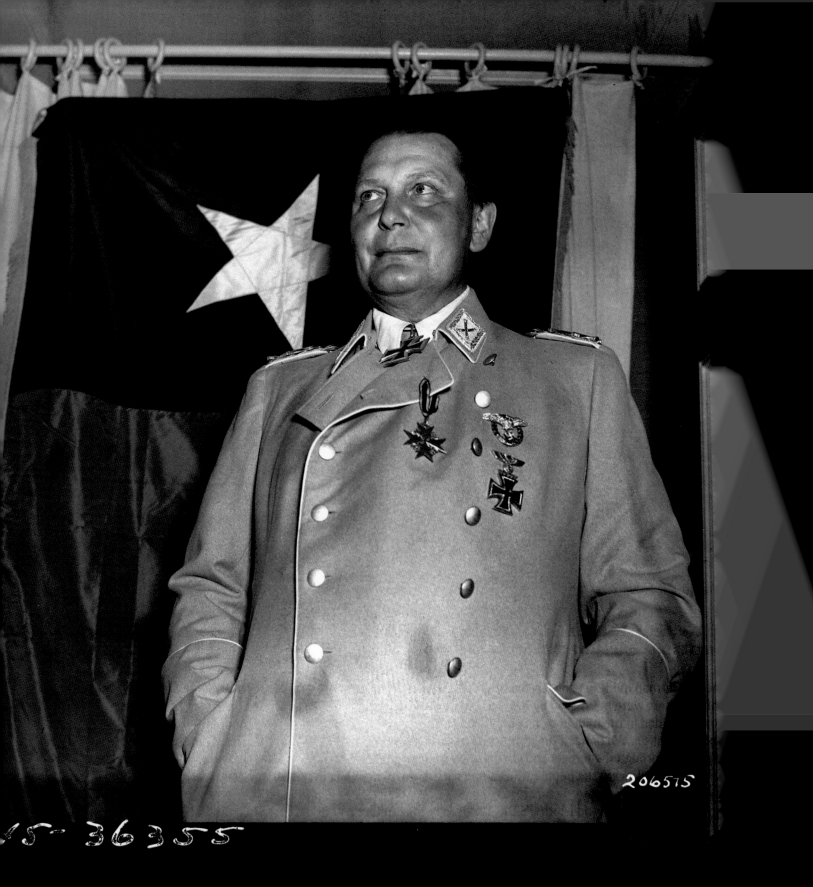

206575

15- 36355

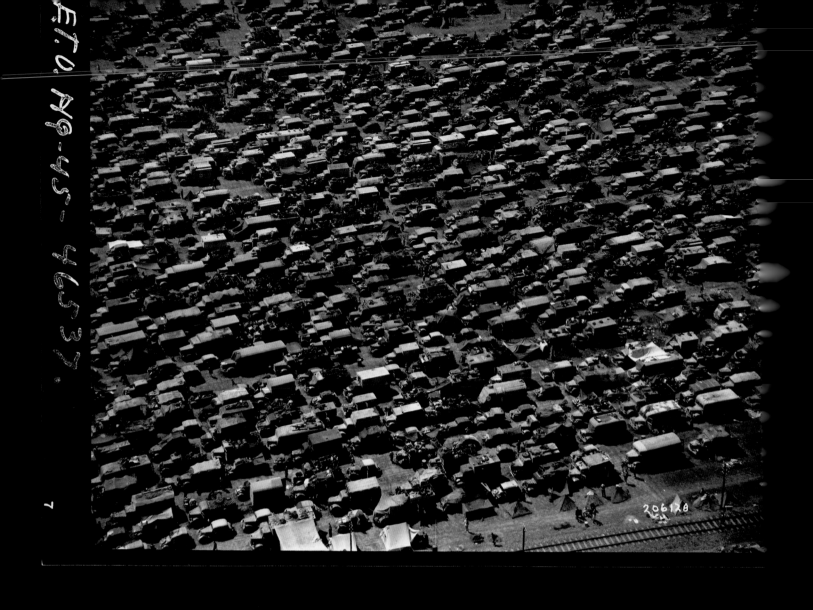

MAY 12 WALTER D. MacDONALD PHOTO (167TH)

A huge fleet of German military vehicles, under U.S. Army guard in Liezen, Austria, survived the war. Signal Corps photographers were impressed by the German roadways. William Tomko of the 166th wrote, "These are six-lane roads, divided in the middle by a twenty-foot strip. The curves and grading were made for high-speed, uninterrupted travel. . . . We noticed the absence of advertising signs along the route, the beauty of the road curving gracefully through the forests and valleys, over bridges and near peaceful towns. We admired them, and felt disgust and anger toward the people who turned such creative capacity into killing and destruction."

RIGHT: American soldiers attend Mother's Day services in the remnants of St. Michael's Cathedral in Coventry, England, where a 1940 bombing devastated much of the city center, including this medieval church where composer George Frideric Handel once played the organ. The West Midlands city was a legitimate military target, with factories producing motorcycles and aircraft engines. Townspeople had considered painting "Kirche" (German for "church") on the cathedral's roof in hopes it would be spared. The church's ruins remain standing today as a monument to British sacrifice.

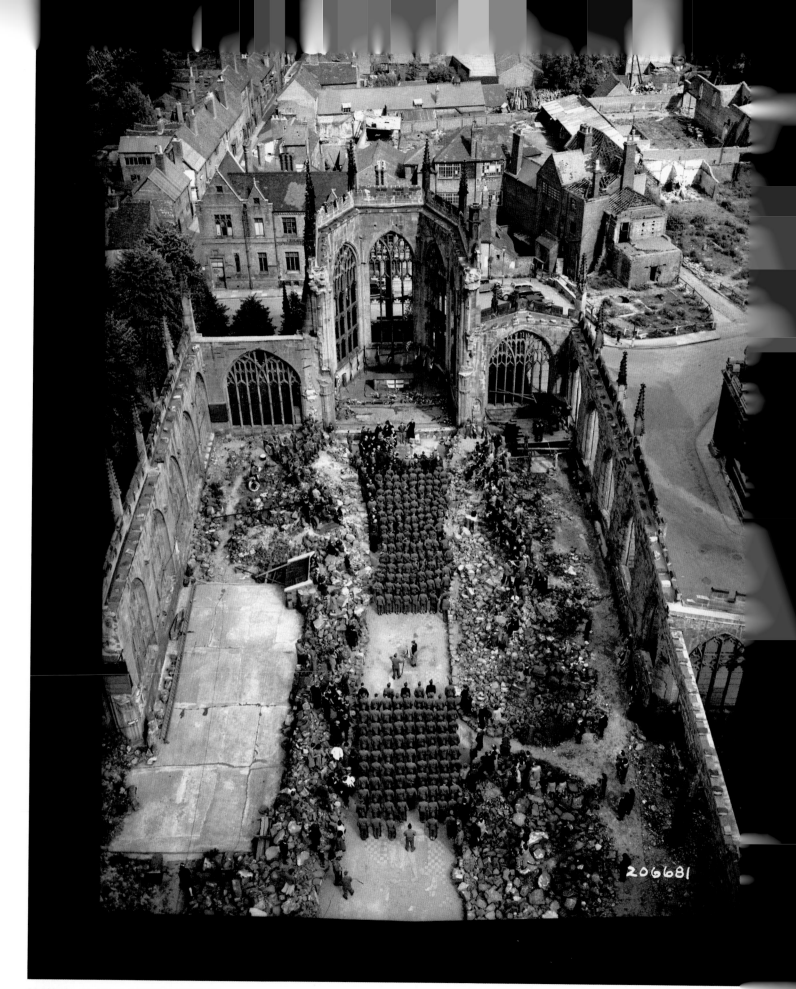

206681

MAY 12 ALAN R. CISSNA PHOTO

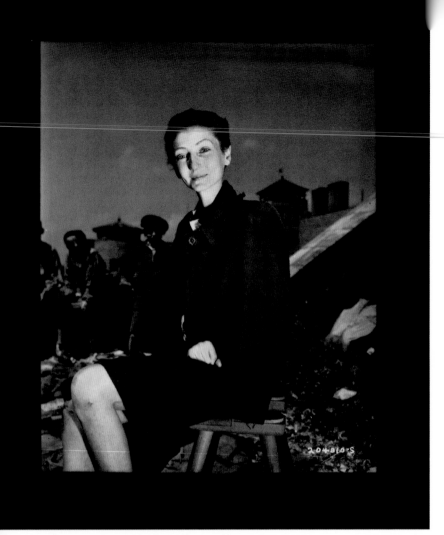

MAY 12 IGNATIUS GALLO PHOTO

Hungarian Jewish stage actress Livia Nador somehow retains her ebullient expression despite her ordeal in Gusen, a sub-camp of Mauthausen.

RIGHT: Americans assess a battlefield full of Japanese dead after a banzai charge near the Maramas air strip on Mindanao in the Philippines. The Japanese banzai charge—a mass frontal assault—was named after what Japanese soldiers would shout as they ran toward the enemy: *"Tenno heika banzai"* (Long live the emperor). These tactics had been effective for the Japanese in past conflicts, but during fighting with the Americans in the Pacific, it was usually the option of last resort and tactically ineffective. The banzai charge fit into the mentality fostered by Japanese leaders that soldiers should fight to the end and never surrender.

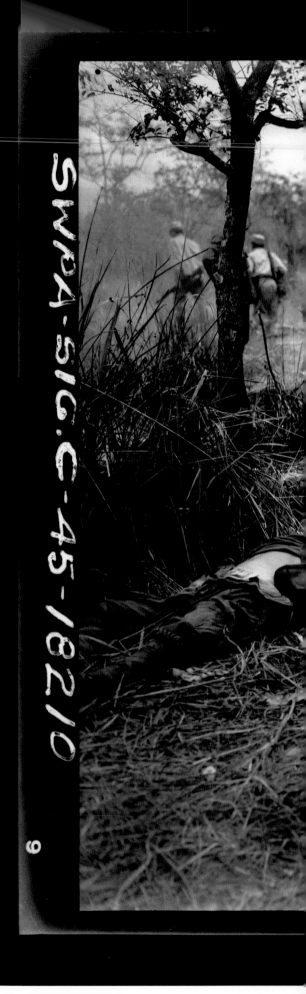

MAY 15 MURPHY PHOTO

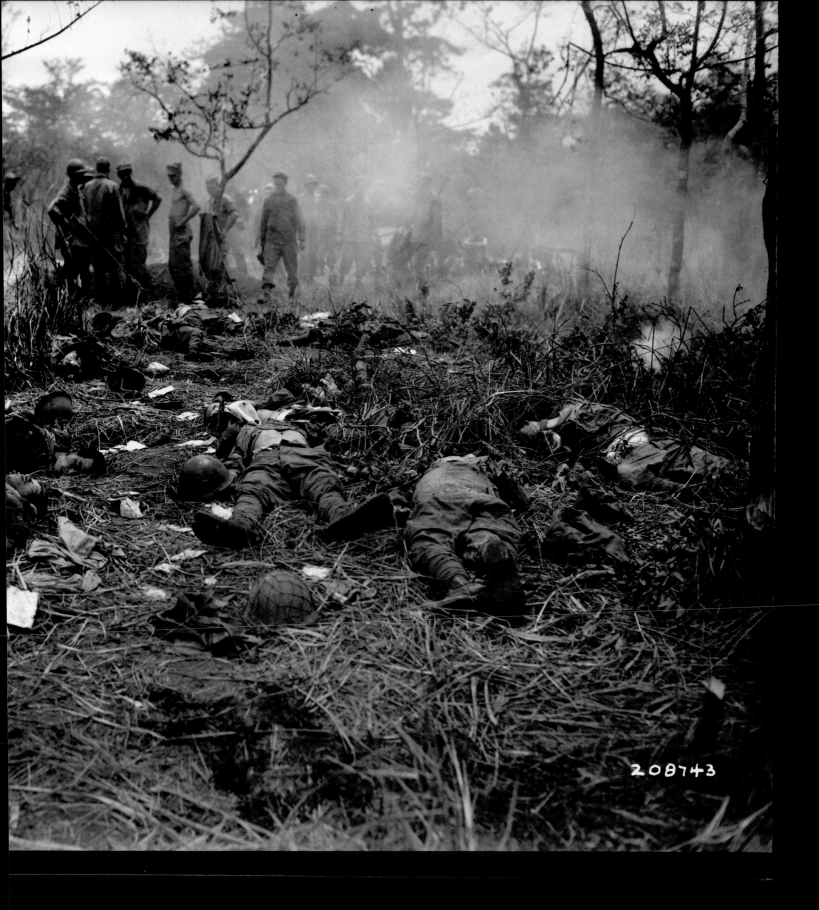

208743

MAY 15 CHESTER G. RUSBAR PHOTO (196TH)

Nazi SS leader Heinrich Himmler, who presided over the "Final Solution" to exterminate the Jews, went into hiding as the Allies advanced, but his wife and daughter, Margarete Boden Himmler and Gudrun Himmler (*above*), were taken into custody in Bolzano, Italy. When the U.S. Army Signal Corps reached the Himmlers' summer home, its *Foto-Facto* newspaper reported: "Heinrich the Hangman was evidently a teetotaler, or else the boys of the 36th Div. are gentlemen looters, and didn't leave any empty bottles around to hurt late visitors' feelings." Himmler hid in northern Germany, shaving his mustache and wearing an eye patch. He posed as a sergeant in a demobilized company, then switched to civilian clothes. A Soviet unit detained Himmler and turned him over to the British for questioning, but they remained unaware of his identity. When another detainee recognized Himmler, the SS leader assumed he would be identified and decided to come clean. As he was being searched, a doctor noticed something in his mouth and tried to pull it out. Himmler chomped on him, pulled his hand away, and bit into the object—a lethal vial of cyanide.

RIGHT: Even children were not spared from facing up to Germany's atrocities. Here a mother and son near Nammering, in eastern Germany, gather at the body of one of 800 Soviets, Poles, and Czechs exhumed from a mass grave.

MAY 17 EDWARD DELFER PHOTO (166TH)

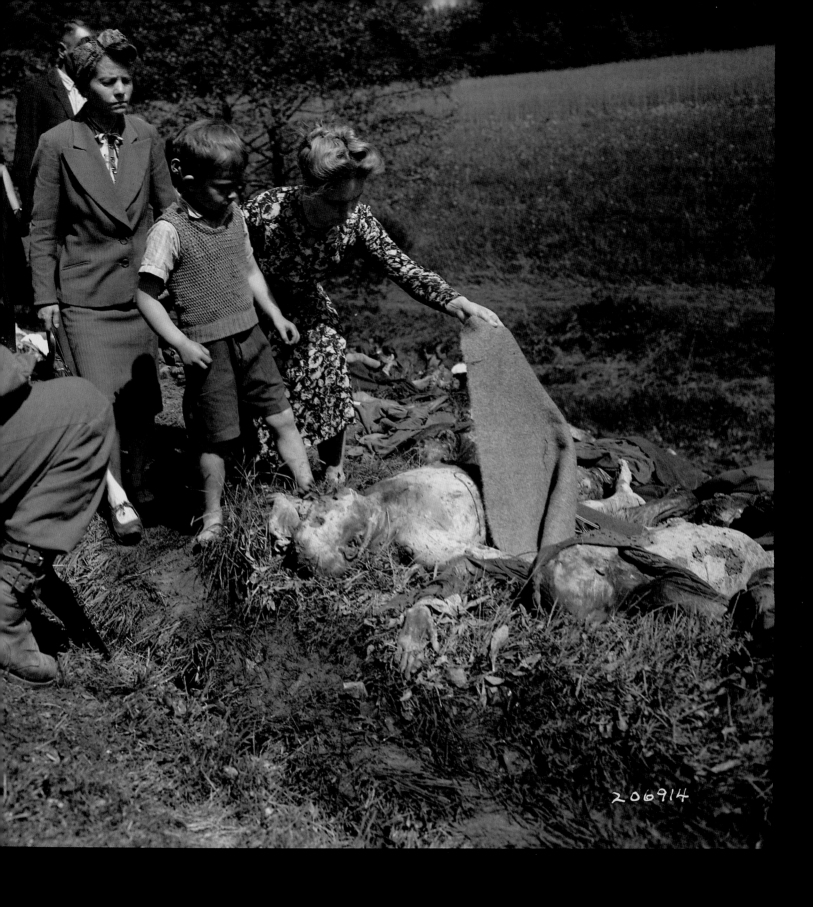

206914

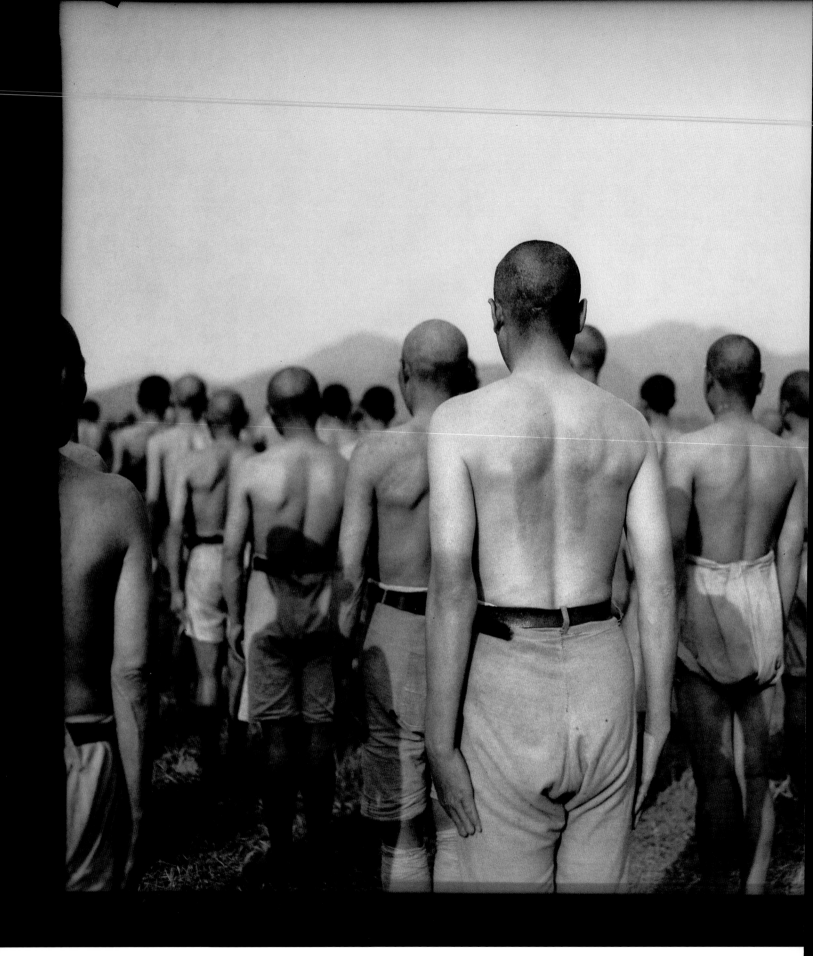

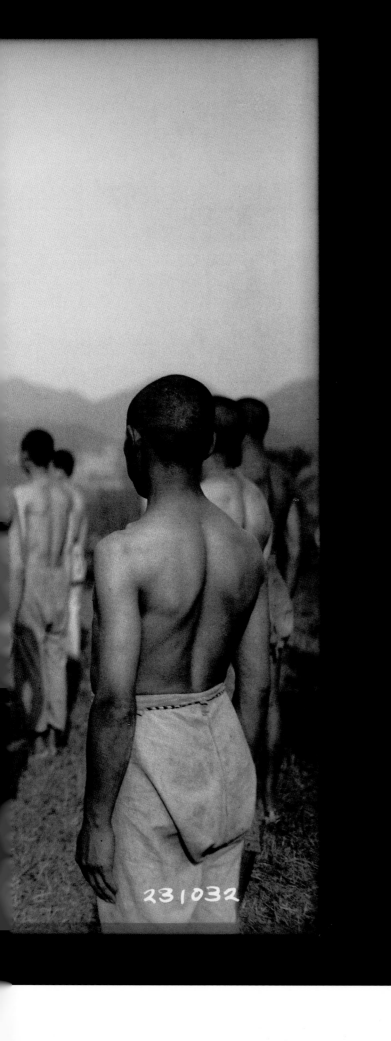

231032

Chinese leader Chiang Kai-shek had a fighting force of more than four million men, the largest army in the world. But professionalism, supplies, and training were far less plentiful. Early in the war, most Chinese soldiers had no boots, and only one in five had a blanket. The United States spent considerable resources helping the Chinese become a credible threat to the Japanese, but the Chinese forces never reached an effectiveness to match their numbers.

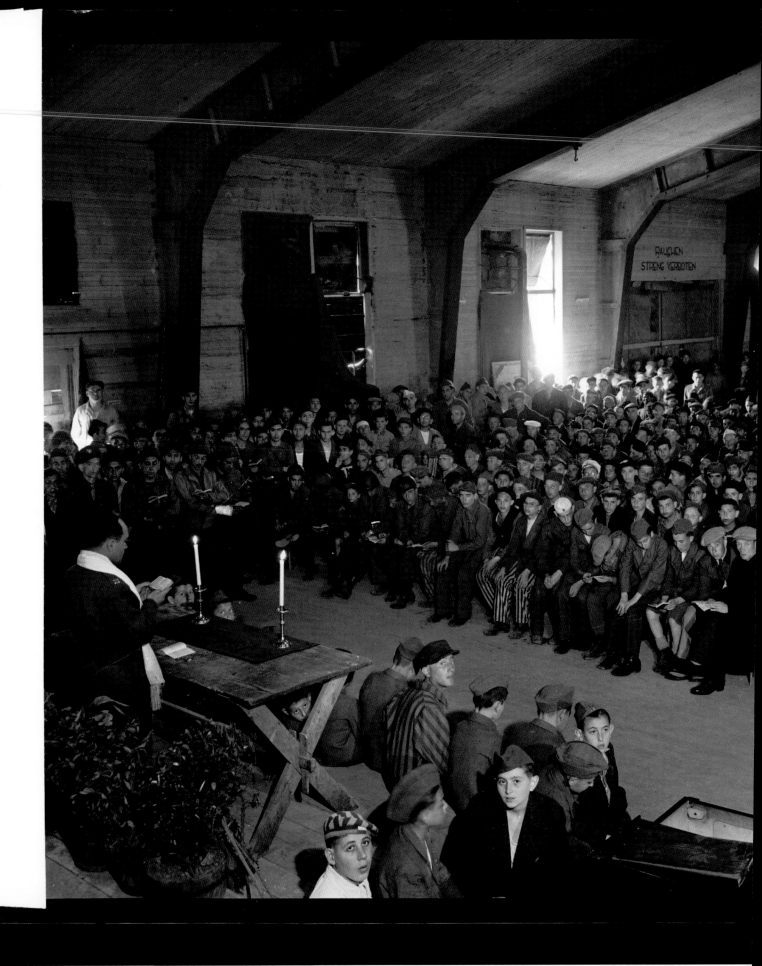

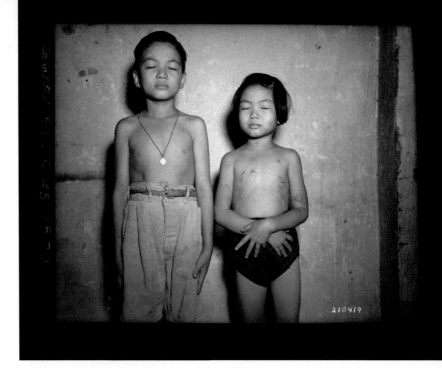

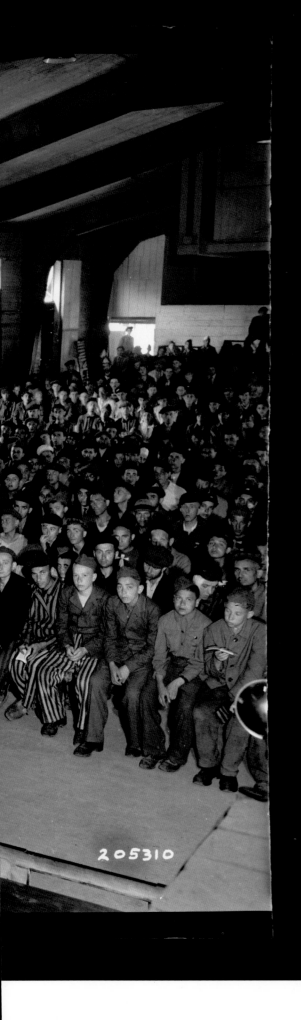

MAY 19 DIPAOLA PHOTO

Six-year-old Elisa Ang was bayoneted by the Japanese in Los Baños in the province of Laguna, Philippines, south of Manila. She and her brother were the only members of their family to survive; 19 others were killed. Three months earlier, Los Baños was the site of a daring raid in which United States and Filipino forces rescued more than 2,000 civilians, most of them American, from a Japanese internment camp.

LEFT: At the Buchenwald concentration camp, Rabbi Herschel Schacter presides over services for Shavuot, the holiday when Jews celebrate God giving them the Torah. As the Jewish chaplain for the Eighth Corps of the U.S. Third Army, Schacter helped liberate the camp, going from barracks to barracks telling the inmates they were free. In an interview with author Joseph Preil decades later, he recalled the prisoners looking at him with "incredulous eyes" and asking: "Is it true? Is it really true? Is the war over? Does the world know what happened to us? Where do we go from here?" Yet Schacter found that witnesses to the horror rarely discussed it until many years had passed. "Nobody talked about the Holocaust immediately," he said. "This is one of the remarkable phenomena. For years, when all these memories were so vivid in my mind, I had nobody to tell it to. Nobody asked. Nobody heard. Nobody spoke. The first ten years, the survivors never talked."

The atrocities they witnessed likely affected Jewish photographers. In the spring of 1945, the 163rd Signal Photo Company's newpaper *Foto-Facto* mentioned that "Irving Katz, Yale J. Lapidus, and R.C. Lingley took personal interest in covering Passover services."

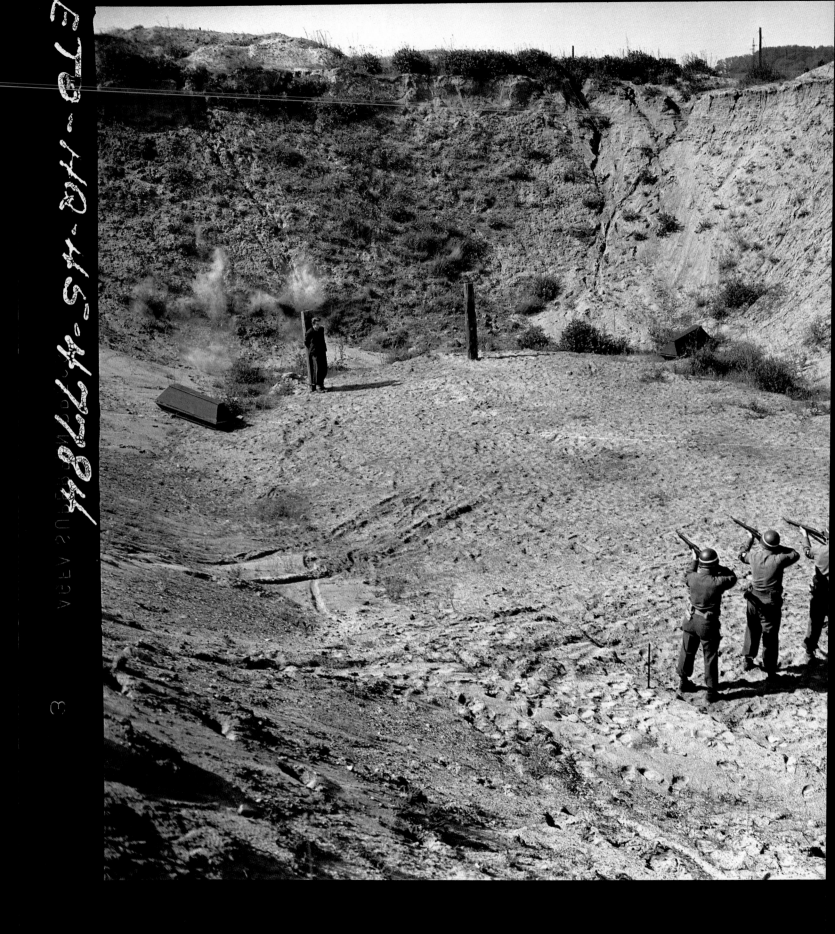

JUNE 1 **WILLIAM NORBIE PHOTO (165TH)**

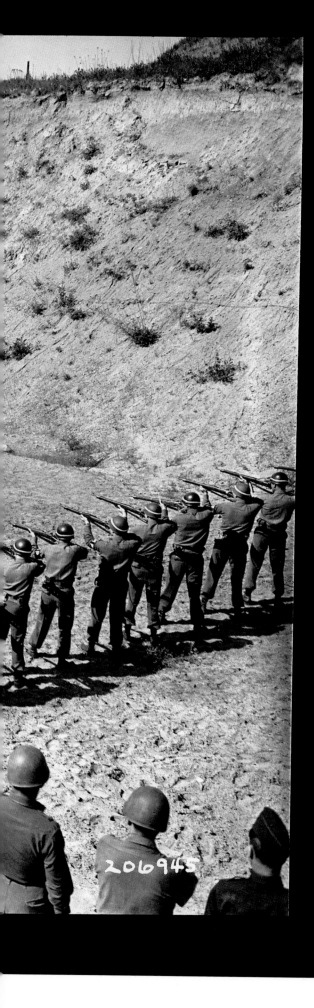

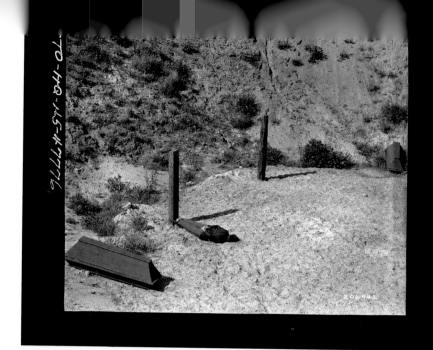

JUNE 1 J.A. JONES PHOTO (165TH)

Twenty-four days after the end of the war in Europe, a Ninth Army military police firing squad executes a sixteen-year-old boy named Heinz Petry, convicted of espionage. A member of the Hitler Youth, Petry was recruited by the SS into a guerrilla group called the Werewolves that was intended to continue the fight for Nazism even after the surrender. Petry and a fellow Werewolf named Josef Schorner were tried for espionage by a U.S. military court and sentenced to death. The court clearly wanted to make examples out of them, declaring: "You will pay the supreme penalty for your offenses so that the German people will know that we intend to use whatever force is necessary to eradicate completely the blight of German militarism and the Nazi ideology from the face of the Earth." Such executions went on as long as 18 months after the war, when two former Hitler Youth members were killed because they had stockpiled weapons in the woods. The occupying forces tried to further their propaganda by showing executions of Werewolves in newsreels at movie theaters. At one showing, about 100 Germans walked out.

The Signal Corps photographers in Europe were kept busy, even after V-E Day. "In one day I shot a wedding, a firing squad execution of German spies, and a visit by General Eisenhower," wrote Russell Grant of the 166th.

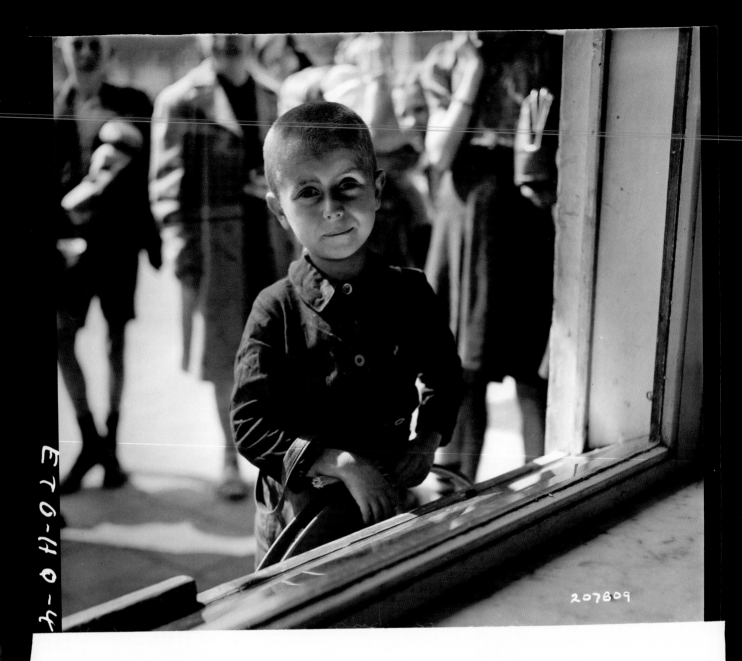

207809

11

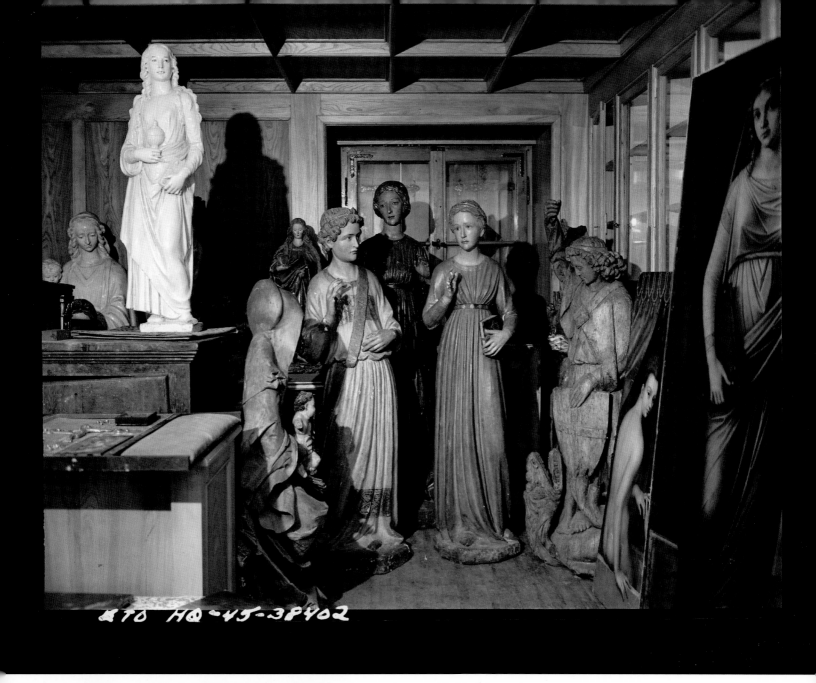

ATO HQ-45-38402

JUNE 9 JOSEPH A. BOWEN PHOTO (163RD)

Priceless artwork stolen by Nazi leader Hermann Goering was stored near Berchtesgaden, where it was organized and assessed. Goering amassed about 1,400 paintings and drawings, plus 250 sculptures and 168 tapestries. Questioned by Allied interrogators, Goering put it this way: "During a war, everybody loots a little bit." He went on to admit: "Perhaps one of my weaknesses has been that I love to be surrounded by luxury and that I am so artistic in temperament that masterpieces make me feel alive and glowing inside."

LEFT: A boy looks through a window in the Dutch city of Rotterdam, which suffered deeply during the war. Early on, in May 1940, German bombers obliterated the city center, leaving 40,000 civilians dead. The Rotterdam bombing set a precedent that would lead to later bombings of urban areas, with civilians rarely spared.

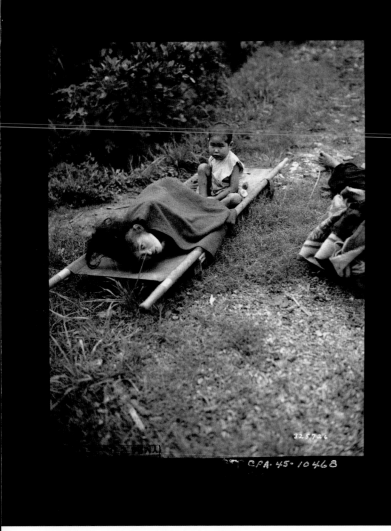

JUNE 12 CLAUDE BIGELOW PHOTO

The Battle of Okinawa was the last major battle in the Pacific before the dropping of atomic bombs put an end to the war. The U.S. military's strategy was to seize the island and use it as a steppingstone to the rest of Japan. The Japanese strategy was to make that seizure time-consuming, to give the mainland more time to prepare for the inevitable invasion. Japanese authorities arranged the evacuation of some civilians, but many remained. The United States dropped leaflets that urged civilians to wear white and stay away from military units. But the fighting was devastating for noncombatants, as these two photographs show. Some civilians found safety in caves, but as the fighting went badly for the Japanese, soldiers sometimes evicted civilians from the caves so they could hide there themselves. More than 100,000 civilians may have died in the battle.

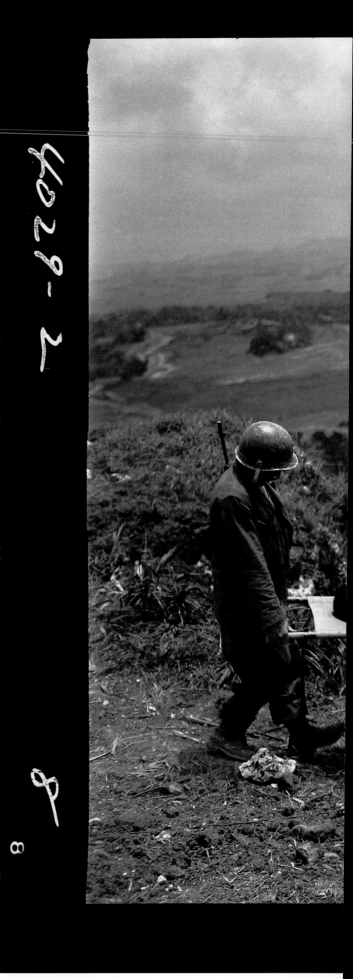

JUNE 13 JONES PHOTO

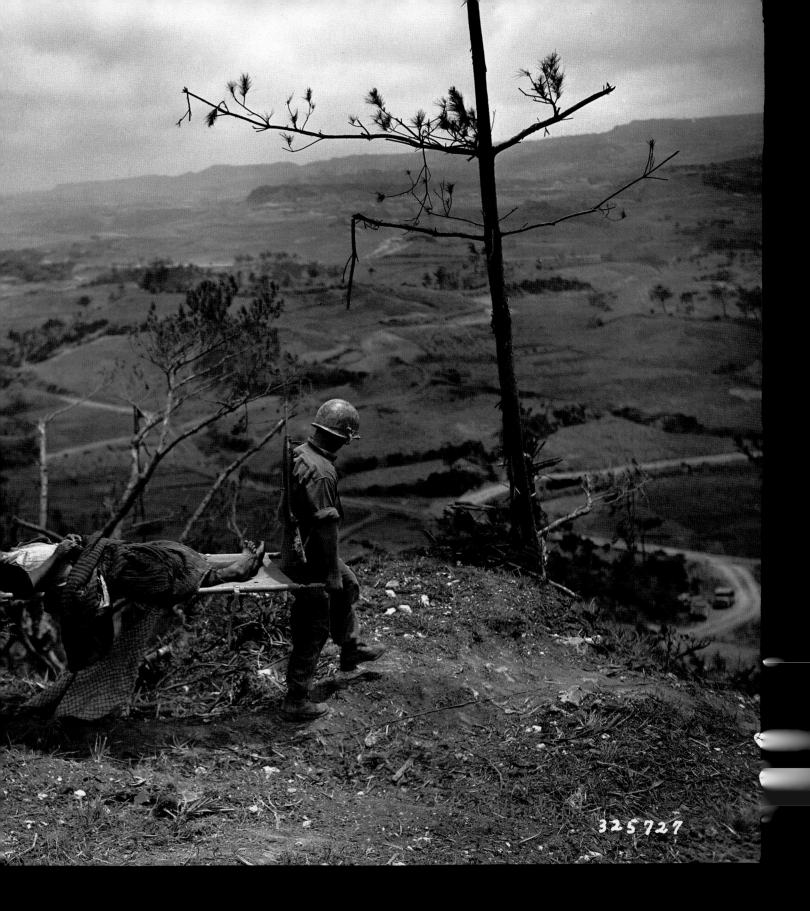

325727

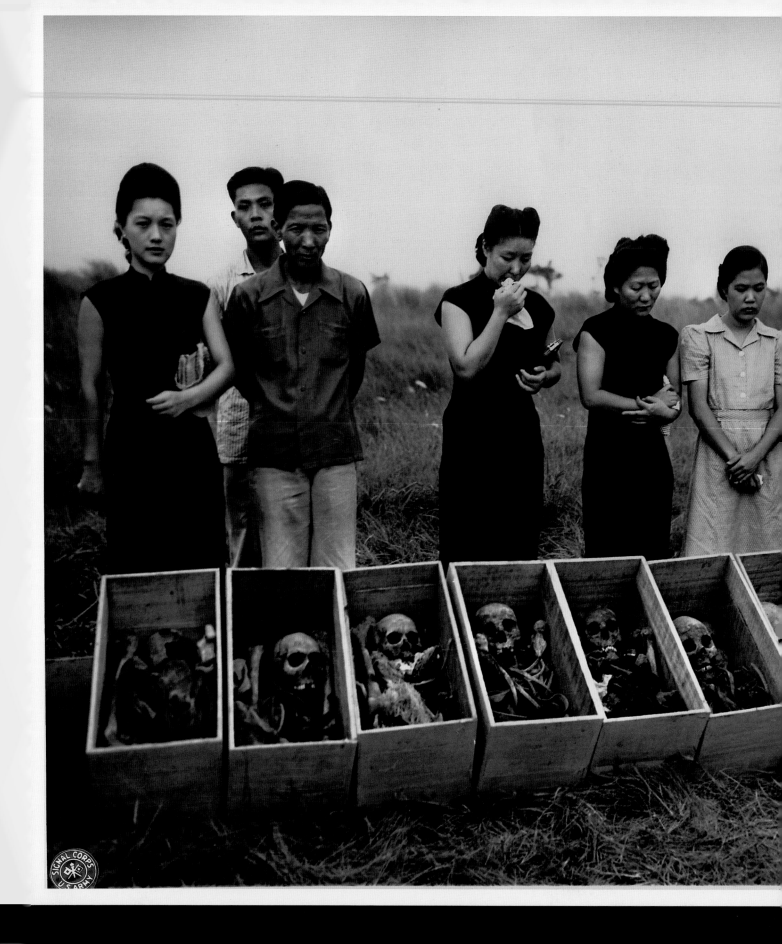

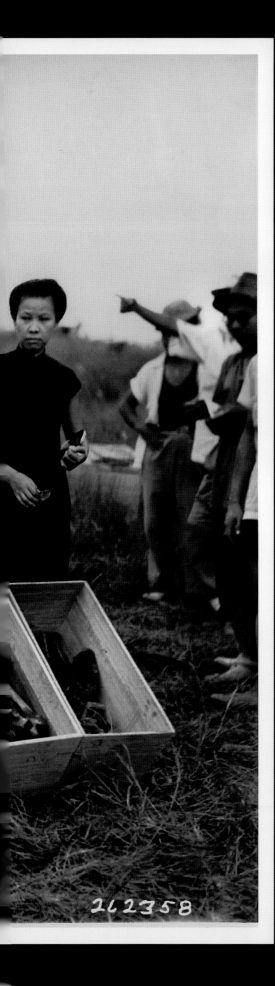

The relatives of Chinese diplomats executed by the Japanese in the Philippines stand with their remains after the Allies had retaken the islands. At the far left is Shirley Wang, who travelled to the Philippines to marry her fiancé, consular official Jimmy Wang, just before the United States went to war with Japan in 1941. The other women in black are (*from left*) the widows of consulate staffers Shiao, Yao, and Mok. The family of Consul General Clarence Kuangson Young, who also was slain, had left for the United States before this photo was taken. Young's widow, Juliana Koo, wrote a memoir decades later recounting what had befallen the Chinese diplomats.

Just before Japan's conquest of the Philippines, the United States offered to take the Chinese staff off the island, but they stayed to support the 100,000 ethnic Chinese there. The consulate collected donations from the islands' Chinese to help fund China's war effort against Japan, and shipped that money out of the Philippines before the Japanese arrived. The diplomats also arranged for the destruction of a shipload of Chinese currency so the invaders could not seize it. The Japanese, furious that the consulate had kept the cash out of their hands, demanded that Consul General Young obtain a huge amount of money from the islands' Chinese nationals. He refused. All eight members of the Chinese consular staff were taken to a cemetery and shot. Juliana Koo helped the diplomats' families throughout the war, and none knew for sure that their loved ones were dead until after the islands were retaken in 1945. The Japanese captain whose soldiers killed the consular staff was tried and executed after the war.

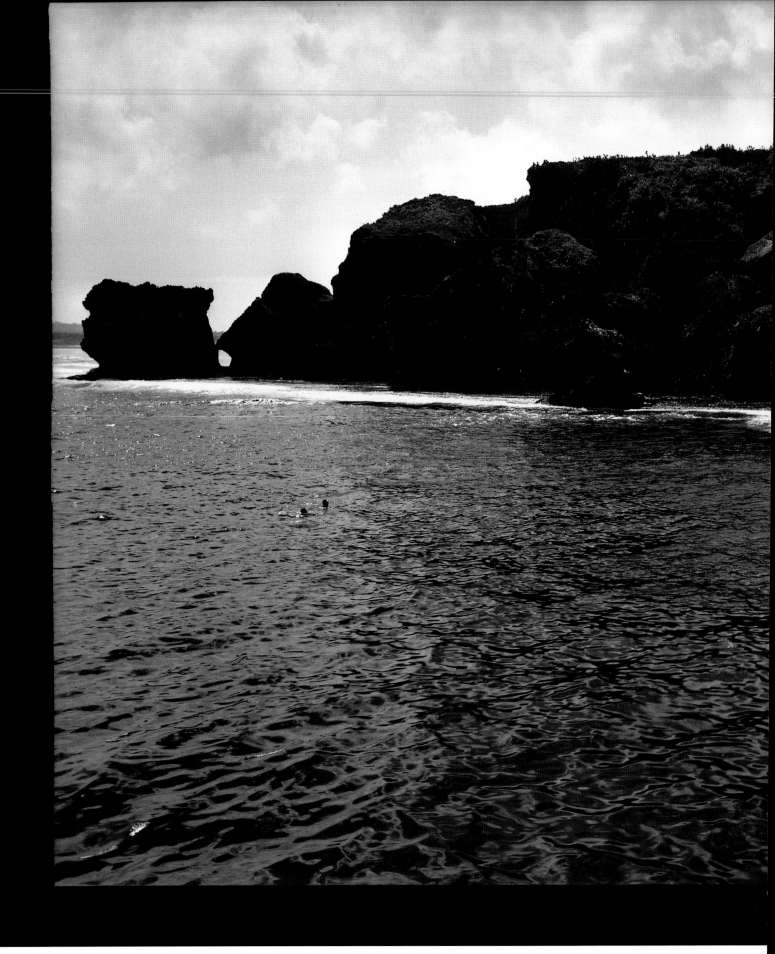

5

209300

A·45·10475

The Battle of Okinawa, the bloodiest battle in the Pacific, lasted almost three months—until the last pockets of resistance ceased on June 21, 1945. The next day, a few Japanese soldiers on the southern tip of Okinawa swam out to a U.S. ship to surrender. Loudspeakers from ships offshore implored the enemy to give up: "Japanese soldiers, you fought well and proudly for the cause of Japan, but now the issue of victory or defeat has been decided. To continue the battle is meaningless. We will guarantee your lives. Please come down to the beach and swim out to us."

The Japanese weren't the only ones taking a swim as the fighting waned. On the Okinawan island of Tokashiki, where about 300 Japanese soldiers refused to surrender, the Japanese commander offered to let U.S. soldiers swim on the beaches without being attacked if they would avoid the Japanese camped in the hills. It was only after American authorities gave the commander a copy of the Imperial surrender announcement months later that he agreed to lay down his weapons. He told the Americans he could have held out for 10 more years.

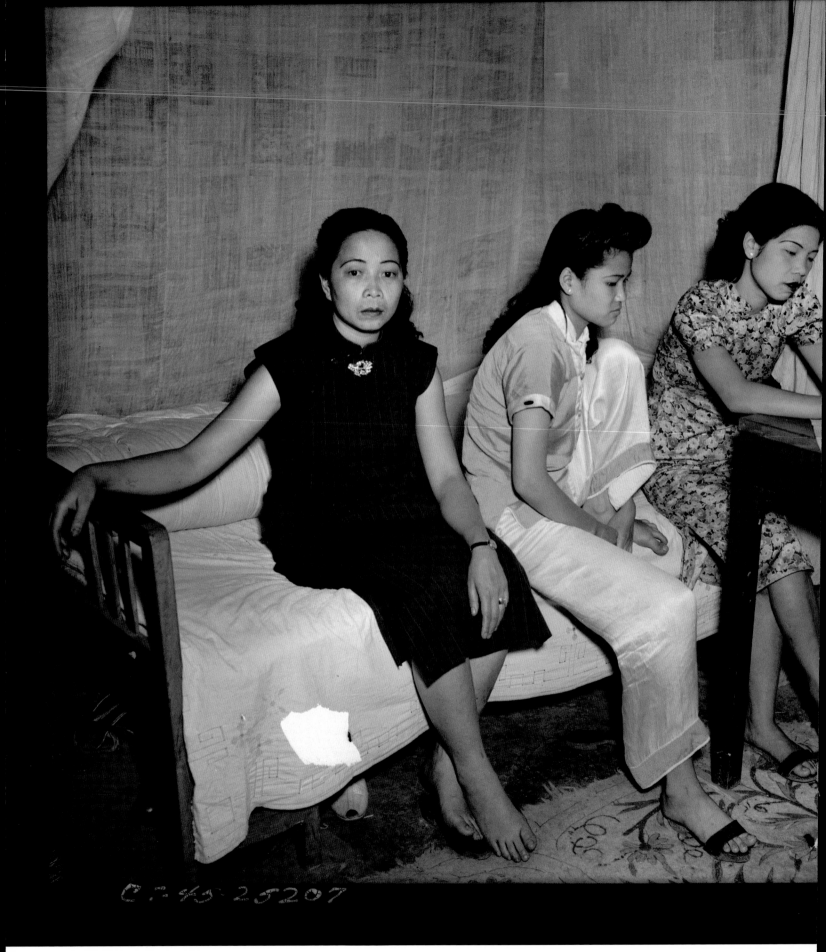

These women, identified as prostitutes, lived in a bustling red-light district in Kunming, China, that was notorious for venereal disease. It was so notorious, in fact, that the commander of a Chinese-American air force unit brought in 12 healthy prostitutes from India to service his men. But that tactic was ultimately vetoed by the commander's higher-ups. Japanese coercion of women into prostitution was rampant in Korea, China, and the Philippines. After the Rape of Nanking in 1937, in which Japanese soldiers committed mass sexual assaults against Chinese women, the Japanese set up "recreation centers" or "comfort stations" to control the sexual activities of their troops. In Korea, the Japanese promised women high-paying jobs in war industries or as laundry workers or cooks, then trapped them into prostitution.

Other women were kidnapped into sex slavery during the war. Some Japanese believed a superstition that sex before battle would provide a shield against injury. And there was the thinking—common in other nations' armies as well—that men should have an opportunity to experience sexual intercourse before facing death. The "comfort women" issue remains heated seven decades after the war. It was 2015 before South Korea received an official apology from Japan and the countries agreed not to criticize each other over the issue. But in 2018, Filipinos erected a statue in memory of the nation's comfort women, and the Japanese government complained.

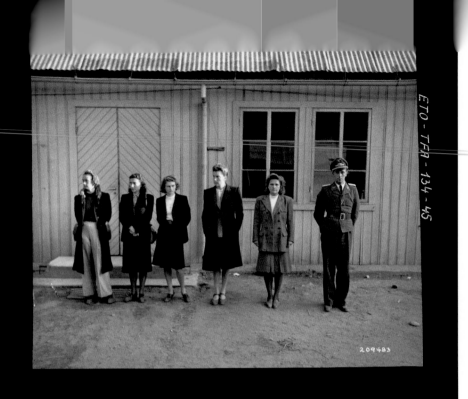

JUNE 23

Five women and a German officer were suspected of war crimes and "screened from the ranks" by Allied investigators in Oslo, Norway. The end of World War II in Europe set off a hunt for collaborators outside Axis nations: in addition to Norway, thousands were suspected in Belgium, Czechoslovakia, France, Greece, Hungary, the Netherlands, Poland, the Soviet Union, the United Kingdom, and Yugoslavia.

RIGHT: An informer who is hooded to conceal his identity is escorted past surrendered German troops in the hope that he can identify SS members in Norway. Members of the SS were treated more harshly than regular troops after the war because they were more likely to have committed atrocities. Norwegians were determined to identify and punish Nazi collaborators, including Prime Minister Vidkun Quisling, who had set up a puppet government. Quisling was tried and executed by a firing squad along with about 50 others who carried out his orders. About 46,000 Norwegians were tried as suspected collaborators. Quisling has endured as a symbol of treason to the extent that the lowercase word "quisling" describes a traitor who collaborates with enemies occupying their country.

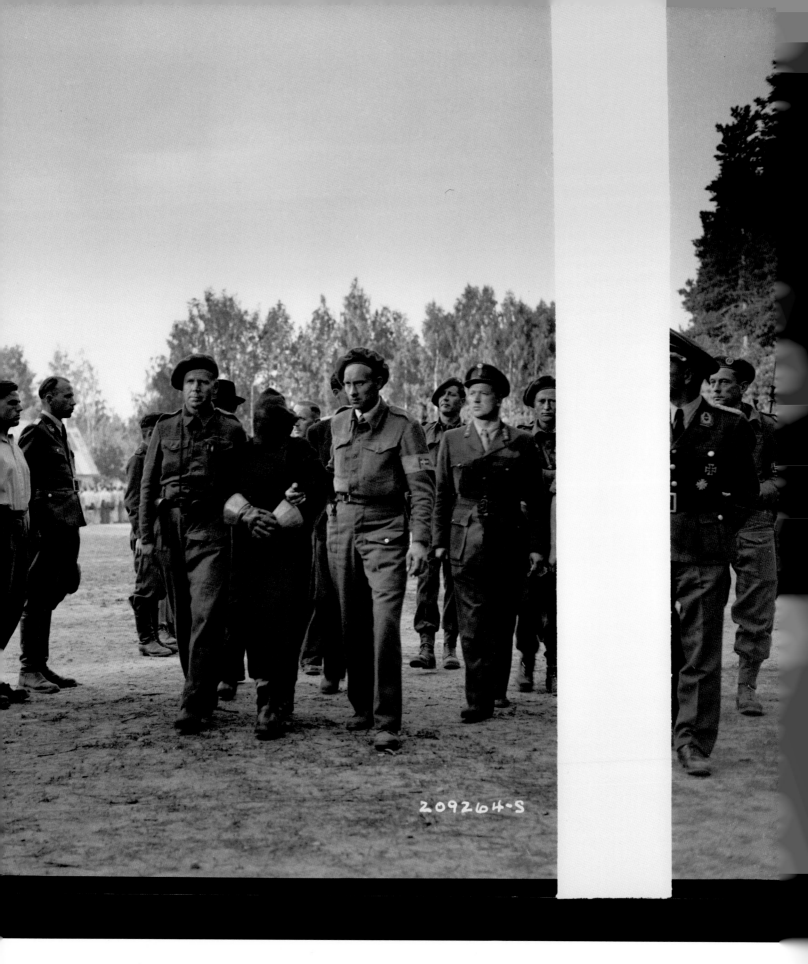

209264-S

SWPA-SIG-45-1972 5

JULY 1 GAETANO FAILLACE PHOTO

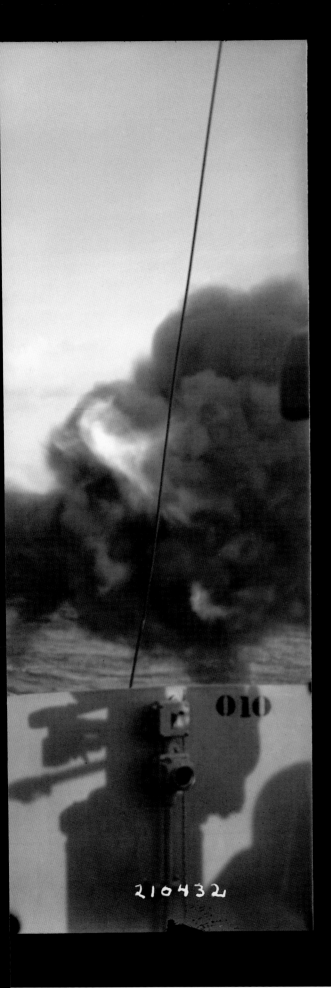

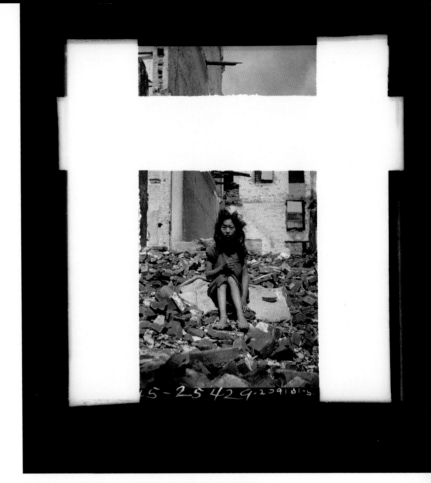

JULY 1 **BARNEY ROSSET PHOTO (164TH)**

A woman sits on a pile of rubble in Liuzhou, China, which had changed hands twice in the previous nine months of fighting. The site of a U.S.-Chinese airfield for long-range bombers, Liuzhou had been captured by the Japanese in November 1944 and was retaken by the Allies in late June 1945.

LEFT: General MacArthur, aboard the light cruiser USS *Cleveland,* watches Australian forces assault Balikpapan on the island of Borneo. It was the last major amphibious attack of World War II. Most of the well-known photography from U.S. ships in the Pacific was done by Edward Steichen's Naval Aviation Photographic Unit. Steichen, a renowned photographer recruited by the U.S. Navy at age 62, said: "I had gradually come to believe that if a real image of war could be photographed and presented to the world, it might make a contribution toward ending the specter of war."

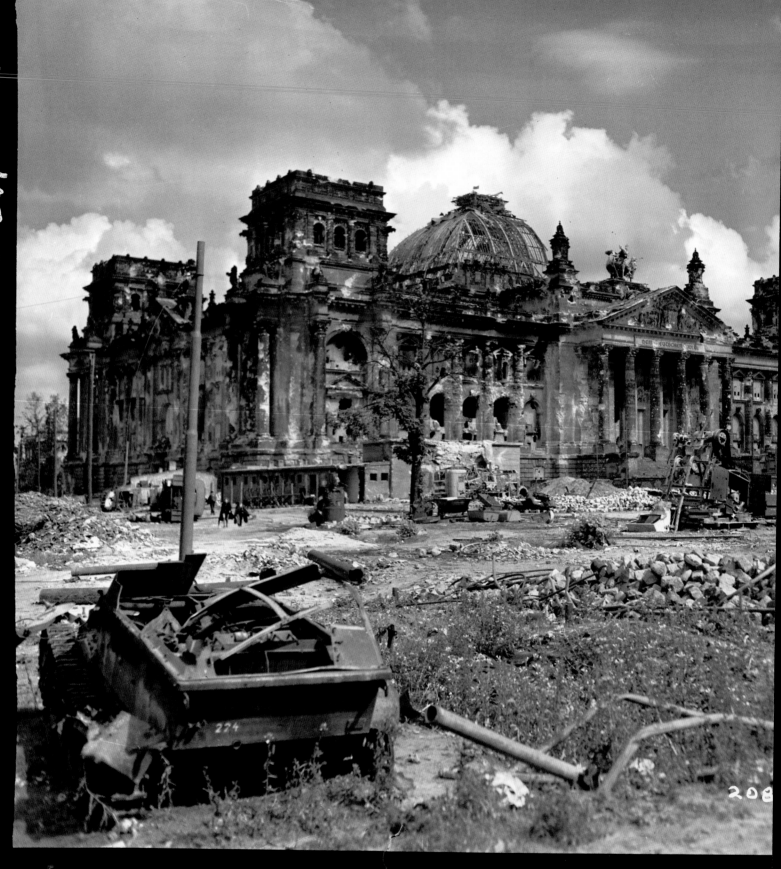

208

JULY 7

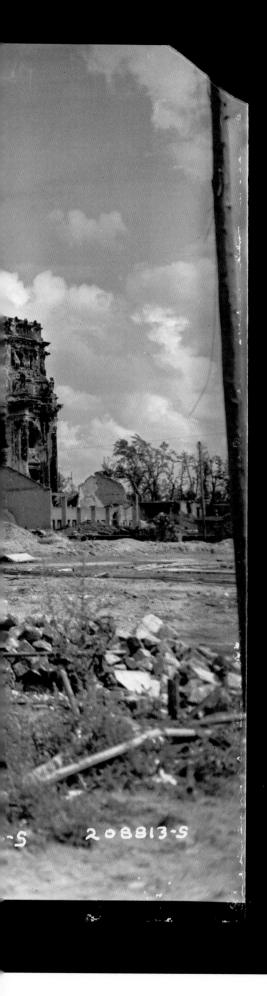

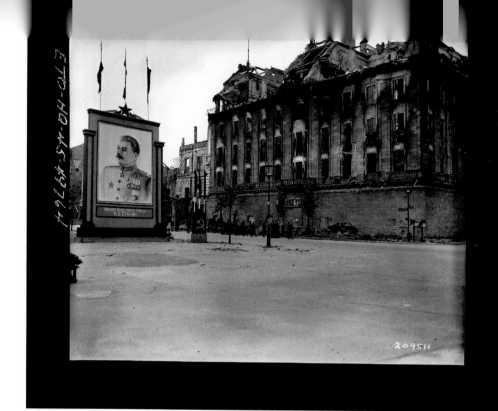

JULY 7 PETER J. PETRONY PHOTO (165TH)

Berlin was the biggest prize as the Allies brought down Hitler's regime, and the Soviets won the race against the Americans and the British to reach the German capital first. With the Allies fast approaching, Berlin residents joked that optimists were learning English and pessimists were learning Russian. The SS had no such gallows humor: when residents put out white flags as a signal to the Red Army, SS teams went to their homes and shot them. Soon, though, the Soviets were in control and dictator Joseph Stalin's picture was displayed in front of the Hotel Adlon (*above*), one of the most famous hotels in Europe. Before Berlin fell, Hitler committed suicide in his bunker under the Reich Chancellery, close to the ruins of the Reichstag building (*left*). That building, once the home of Germany's parliament, was a sad landmark to Hitler's rise. It burned in a 1933 arson fire that the Nazi leader used as a pretext to suspend civil rights and consolidate his power.

Germany was divided into Soviet, American, British, and French zones of occupation, and Berlin—in the Soviet zone—was further split into what became known as West Berlin, controlled by the western Allies, and East Berlin, controlled by the Soviet Union. By July 1945, the heavily bombed city was, in the words of *New York Times* reporter Anne O'Hare McCormick, "a graveyard." Wrote one Berlin resident, "They bombed the hell out of us. There is nothing left to destroy here."

210214

N-39082

8

JULY 8 ROBERT F. WATKINS PHOTO

JULY 10

Jewish refugees at a transit camp in Aversa, Italy, dance as they await transportation to Palestine, where the state of Israel would be founded three years later. "As matters now stand, we appear to be treating the Jews as the Nazis treated them except that we do not exterminate them," wrote attorney Earl G. Harrison, who studied displaced persons camps for the U.S. government in 1945. "They are in concentration camps in large numbers under our military guard instead of SS troops." Jews who survived their imprisonment in Germany were confronted with a new problem regarding resettlement. International relief officials initially refused to consider them a distinct national group and intended to send the Polish Jews back to Poland, for example, whether they wanted to go or not. Only a concerted pressure campaign altered that policy, allowing many European Jews to migrate to Palestine.

LEFT: A girl and her brother inspect their wrecked home in the southern German city of Augsburg, site of a Messerschmitt aircraft factory.

209279

A meeting room set up for the Potsdam postwar conference features the flags of the Big Three—the United States, the Soviet Union, and the United Kingdom. The conference was held at Cecilienhof, home of Crown Prince Wilhelm, in Potsdam, Germany. This was Joseph Stalin's first meeting with a U.S. president since the death of Franklin Roosevelt and the succession of Harry Truman, who was more suspicious of Soviet postwar motives than Roosevelt had been. Truman told Stalin that the United States had developed "a new weapon of unusual destructive force," but he didn't disclose details about what would soon be commonly known as the atomic bomb. Stalin pretended to be only mildly interested in Truman's revelation. In fact, he was deeply concerned, according to later revelations by Soviet officials. But he wasn't surprised: the Soviets had spies in the U.S. atomic program.

Thirteen days later, the Potsdam Declaration called for Japan to surrender unconditionally or suffer "prompt and utter destruction." The document—signed by the United States, the United Kingdom, and China, but not signed by the Soviet Union, which was not at war with Japan—read: "The time has come for Japan to decide whether she will continue to be controlled by those self-willed militaristic advisers whose unintelligent calculations have brought the Empire of Japan to the threshold of annihilation, or whether she will follow the path to reason."

JULY 13 M. SCHNEIWEISS PHOTO

Two weapons that would influence the global politics and warfare of the second half of the twentieth century were used in the waning days of World War II. Napalm, developed at Harvard University in 1942, was a form of jellied gasoline whose name is a combination of two of its ingredients, naphthenate and palm oil. Here it is shown being dropped on Japanese troops at Kinangan in the Philippines. About 14,000 tons of napalm were used in World War II, about 32,000 in the Korean War, and nearly 400,000 during the Vietnam War, when napalm became a household word.

RIGHT: The first test explosion of an atomic bomb took place under top-secret conditions in the New Mexico desert. Code-named Trinity, the bomb lit up the sky at 5:29 a.m. Navy pilot John R. Lugo was flying a transport plane near Albuquerque en route to the West Coast when the blast occurred. "My first impression was, like, the sun was coming up in the south. What a ball of fire! It was so bright it lit up the cockpit of the plane." Lugo radioed authorities but got no explanation, just a bit of advice: "Don't fly south."

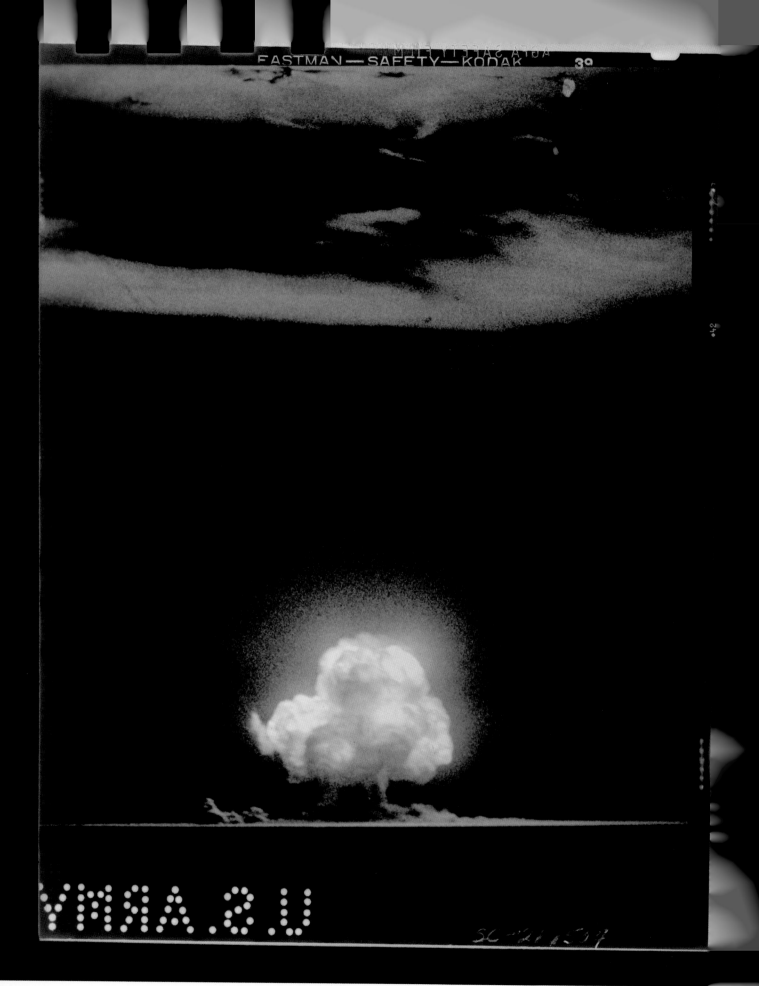

EASTMAN — SAFETY — KODAK 39

JULY 16

"On the way down we passed through such completely destroyed cities as Frankfurt, Nuremberg and, of course, Munich. Sometimes we had to wait while bulldozers cleared a path through the piles of rubble. The devastation caused by our bombers was horrendous and we thought it would take Germany at least one hundred years to dig out of that mess."

Eric Wiesenhutter
166th Signal Photographic
Company

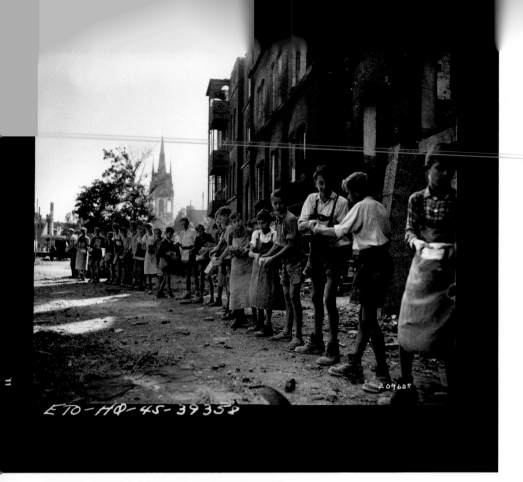

JULY 18 YALE J. LAPIDUS PHOTO (163RD)

Schoolboys pass bricks hand-to-hand for use in rebuilding their school, Kepler Mittelschule, damaged by Allied bombers in Ulm, Germany. Bombs shattered the resolve of 70 million Germans. "Its main psychological effects were defeatism, fear, hopelessness, fatalism, and apathy," the U.S. Strategic Bombing Survey concluded in its two-volume report *The Effects of Strategic Bombing on German Morale.* An estimated 305,000 German civilians were killed during bombing raids and 780,000 were injured. More than 1.8 million homes were destroyed and almost 5 million civilians were evacuated. "There was no German civilian who did not experience hardship or suffering as a result of bombing," the report stated.

RIGHT: In a 25-minute period on December 17, 1944, British Lancaster bombers dropped more than 1,400 tons of bombs on Ulm, a city near the Swiss border. The main targets were two large truck factories, rail facilities, and barracks. But Ulm's city center was also devastated. One major building spared was Ulm's cathedral, from which this photo of the devastation was taken.

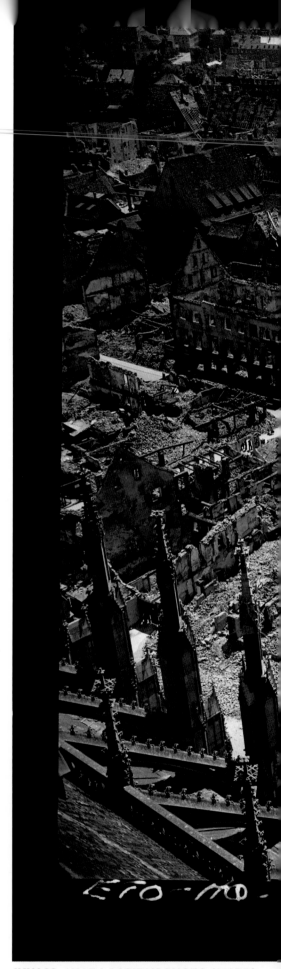

JULY 22 YALE J. LAPIDUS PHOTO (163RD)

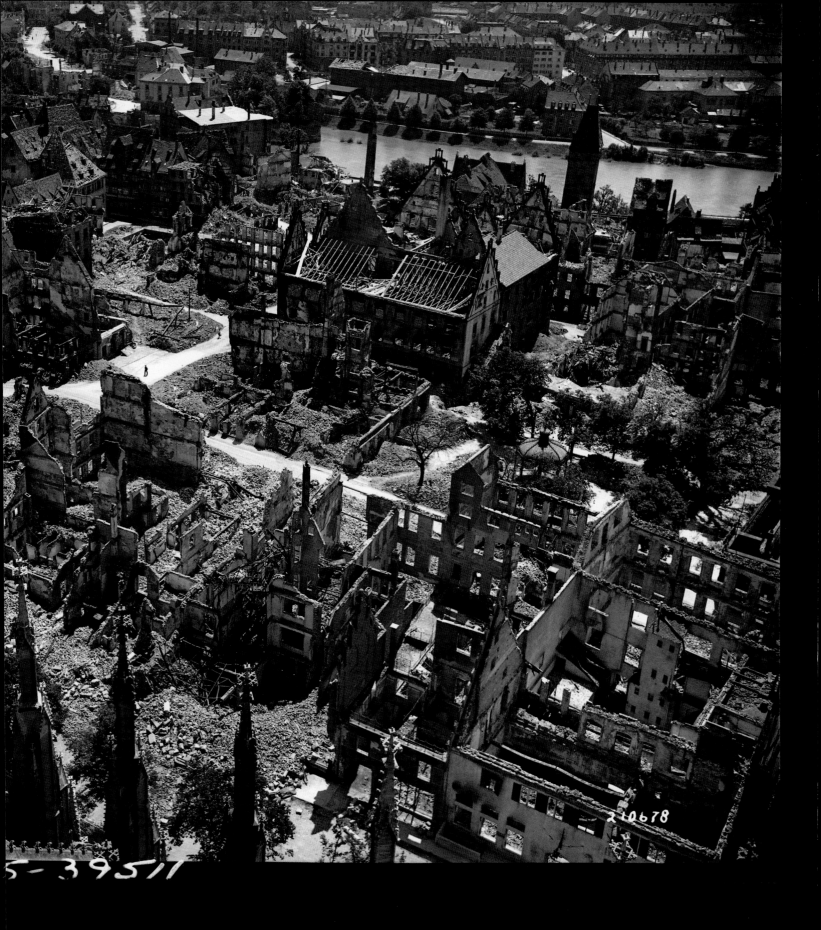

JULY 22 THURSTON PHOTO

Wounded Chinese soldiers convalesce at an American-run portable surgical hospital in Lungshen, attended by medical worker Homer Bartram of Fort Gay, West Virginia. The soldiers were wounded in fighting to retake Kweilin, a Chinese city captured by the Japanese army months earlier. Another soldier involved in the Kweilin offensive as a combat liaison officer, Second Lieutenant Phil Saunders, wrote a letter to his wife at the time: "The courage and guts of these poor, sick, dirty, hungry Chinese soldiers is something wonderful. . . . If they are wounded or sick, the chances of recovery for them is above 2 percent, yet they will keep going night and day until they are told to stop. It's just impossible to describe what I've seen in the last few weeks, one minute you see mankind at its worst and the next at its best."

RIGHT: Crosses mark the cost of war at a military cemetery in Guam. As in World War I, the government did not release photographs of dead GIs at the start of World War II. But in 1943, President Roosevelt and the War Department agreed that the public should be able to see photographic images of dying and dead soldiers so they would better understand the reality of war. In September 1943, *Life* published a photo by war correspondent George Strock that showed the bodies of GIs washed up on Buna Beach in New Guinea. The magazine defended its decision by stating, "The reason is that words are never enough."

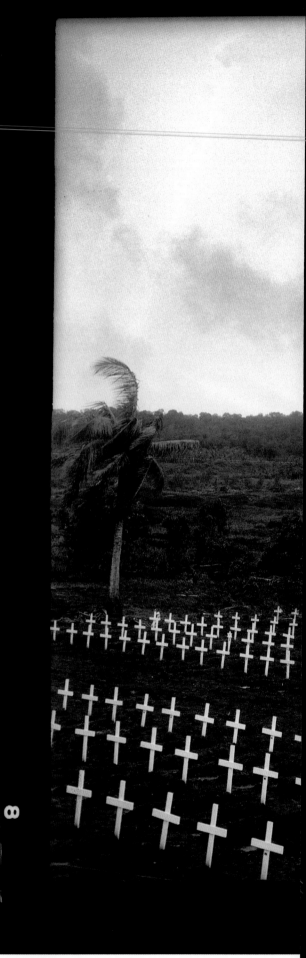

AUGUST 2

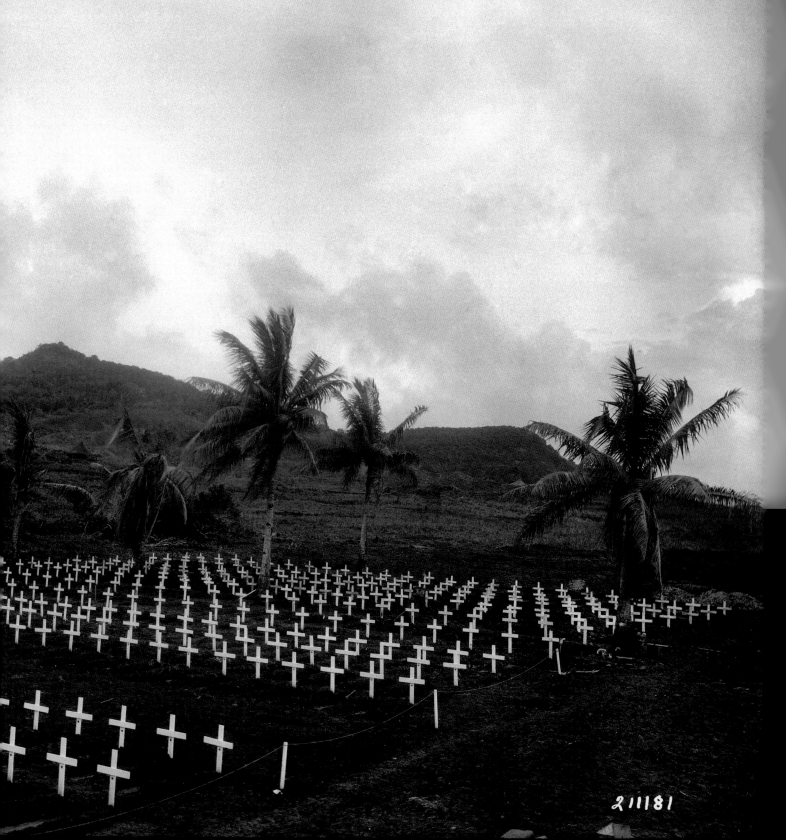

211181

CPA-44-7833

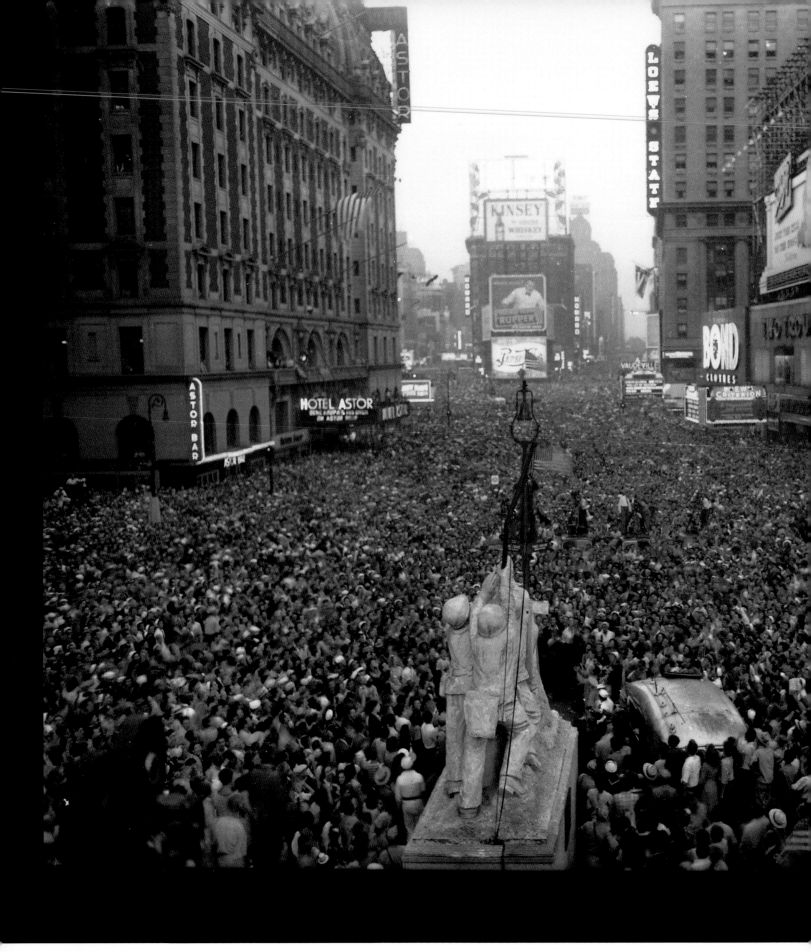

AUGUST 10 **FRED L. TONNE PHOTO**

American soldiers and British women march through London's Piccadilly Circus after hearing news on the radio that the Japanese had surrendered, ending World War II. For Signal Corps photographers and other GIs, thoughts turned to coming home. The 163rd's *Foto-Facto* wrote about service members returning to their children: "They're going to be awfully nice to come home to even though some of them might at first say, 'Who is that man, Mama?'"

LEFT: A throng celebrates at New York City's Times Square. In Japan, the official announcement came from Japan's Emperor Hirohito in a radio speech, the first time ever that he had spoken directly to the public. To be technical, Hirohito's address wasn't completely direct. He recorded his message on a phonograph record that was played for broadcast. Some members of Japan's military tried to seize the record to prevent the announcement, raiding the royal palace but failing to find it. The record was smuggled out of the palace in a laundry basket and taken to a radio station, where the military dissidents tried again to seize it. They failed, and Hirohito's declaration was broadcast, ending a war that killed an estimated 60 million people worldwide.

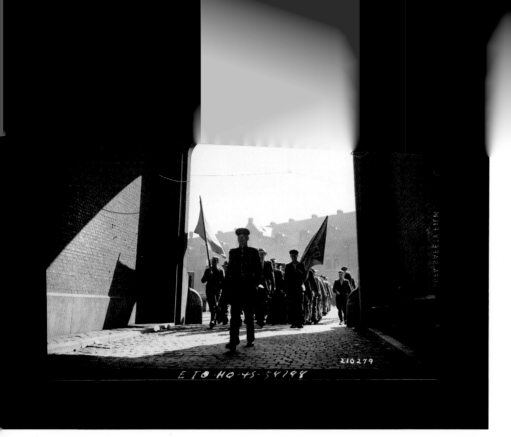

AUGUST 12

Led by a Red Army officer, a group of Soviet displaced persons marches toward a train that will take them from Belgium to Soviet-held territory in Germany. The Germans' mistreatment of Soviet citizens in their custody was well known. About six million Soviet soldiers were taken prisoner during the war, and only one million survived. According to historian David Stafford, there were another million soldiers from Soviet states who had joined the Nazis against the Red Army. Those who were suspected of having anti-communist sympathies—especially those who had fought alongside the Nazis—were summarily executed by the Soviets.

RIGHT: The Rockettes of Radio City Music Hall in New York City perform at Camp Chicago, a U.S. Army redeployment center near Laon in northern France. Many of the GIs at Camp Chicago were waiting to be sent back to the States. Their impatience was mixed with boredom. Soldiers lived in a vast neighborhood of six-man tents, playing cards, organizing sports, and going to the camp theater for movies. Charles E. Sumners, waiting in Bavaria to return with others in the 166th, would go deer hunting with a Thompson submachine gun and fishing with hand grenades. "We would see some fish, throw a grenade into the stream and jump behind a tree as it went off. You must remember that these were men that had been in combat for a long time."

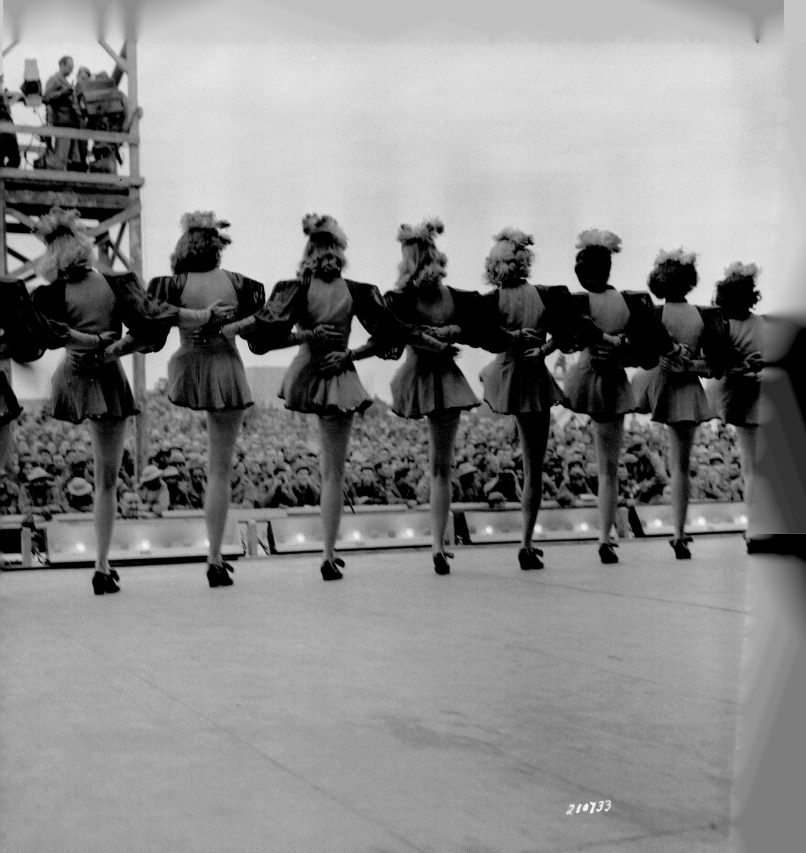

210733

ETO-HQ-45 60367

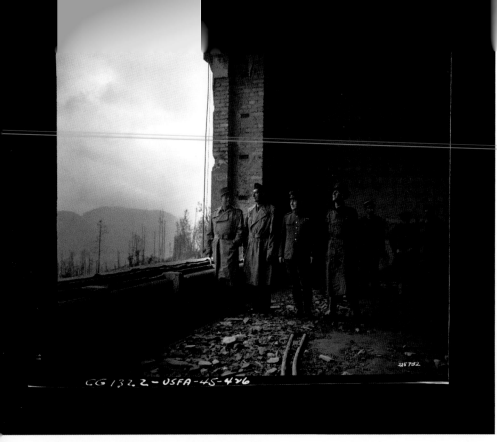

High-ranking Allied officers admire the view from the observation tower at Hitler's home at Berchtesgaden. They are (*from left*) French Lieutenant General Emile Marie Bethouart, U.S. General Mark Clark, Soviet Colonel-General Alexis Zheltov, and British Lieutenant General Richard McCreery. The American and British generals developed a lack of admiration for each other based on their efforts to dislodge the Germans from Italy. Clark called McCreery "a washout . . . a feather duster type," while McCreery said he had just two problems, and "one was Mark Clark."

RIGHT: Propaganda leaflet dropping like this operation by B-25s over China was stepped up in the war's waning months. About 4.2 million leaflets were dropped in June 1945, with both Japanese invaders and Chinese civilians as targets. The drop shown here came during the interlude between the Japanese surrender announcement and the formal ceremony, when the Allies were concerned that some Japanese combatants might refuse to put down their weapons. And with Japan's surrender, the civil war between Chinese communists and the U.S.-backed Chinese nationalists would heat up, reaching its conclusion with a communist victory in 1948.

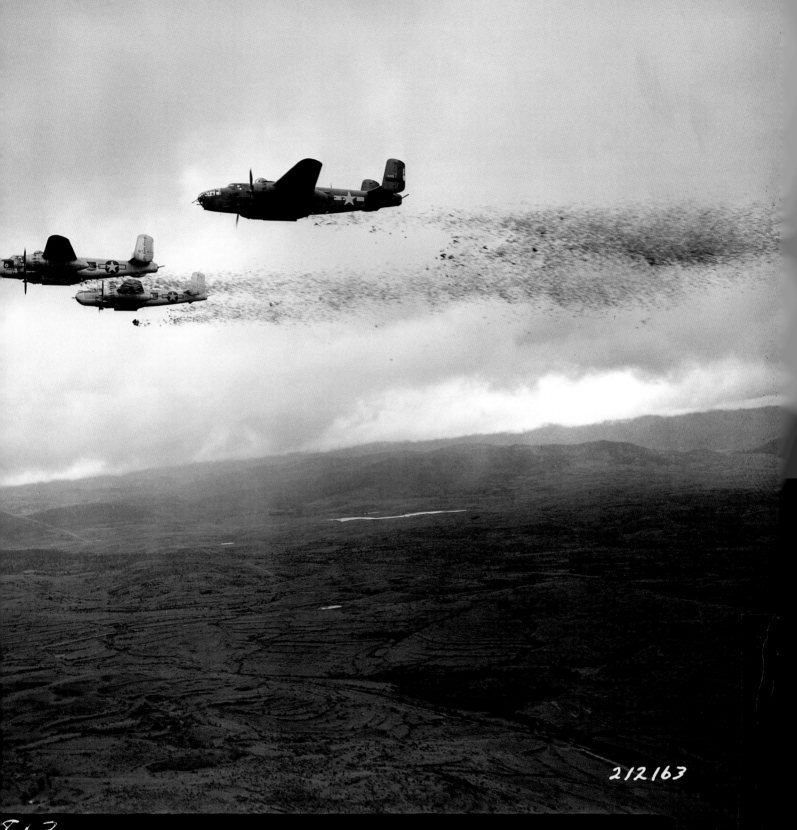

212163

813

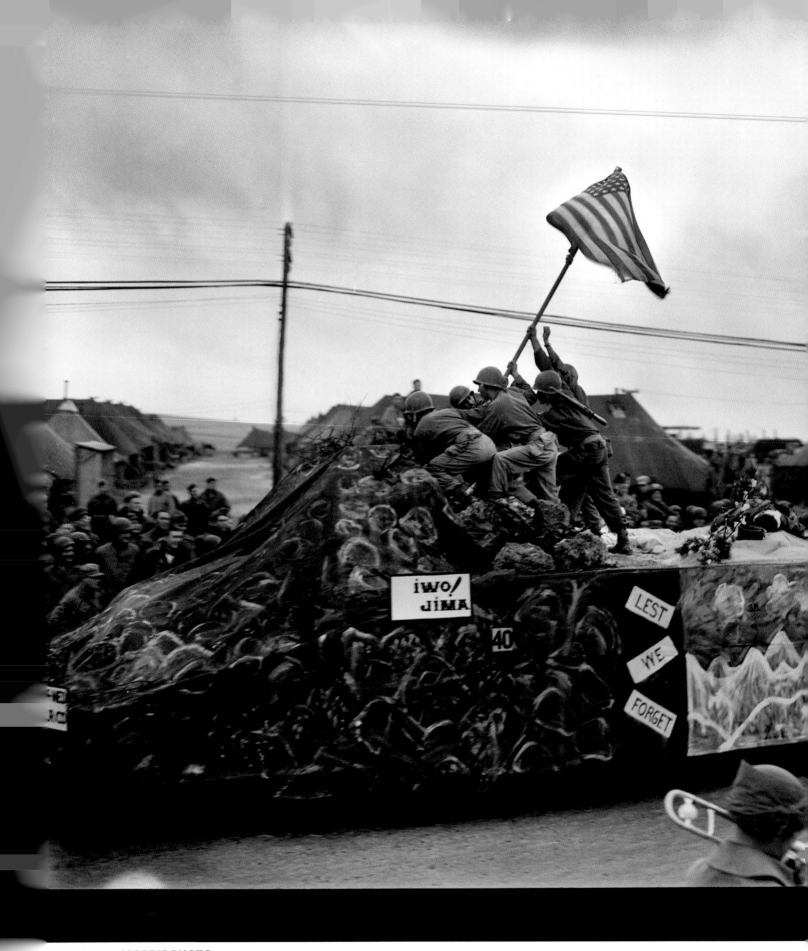

iwo/
jima

LEST
WE
FORGET

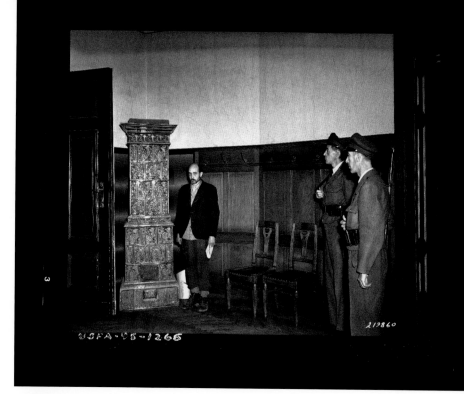

AUGUST

Maximillian Grabner, an SS officer who ran the political department at the Auschwitz death camp, awaits interrogation in Vienna, Austria. Grabner cultivated a fearsome reputation in the camp, ordering summary executions and herding prisoners into the gas chambers. He ran the infamous Block Eleven torture center and regularly cleared out the camp's hospital, sending the sick to the gas chamber. A "dusting off," he called it. In a statement after his capture, he said: "I only took part in the murder of 3 million people out of consideration for my family. I was never an anti-Semite and would still claim today that every person has the right to life." The authorities were unimpressed; Grabner was put to death.

LEFT: This parade float depicting the flag-raising atop Iwo Jima's Mount Suribachi won first place during months-late Mardi Gras festivities at Camp New Orleans, an army redeployment center near Reims, France. The float is based on the Iwo Jima photograph taken by Joe Rosenthal, a war correspondent who worked alongside military photographers. Rosenthal's photo has withstood decades of criticism because it actually shows the second raising of Old Glory, not the first raising with a smaller flag. Upon seeing the photo, Associated Press photo editor John Bodkin proclaimed, "Here's one for all time!" He was right.

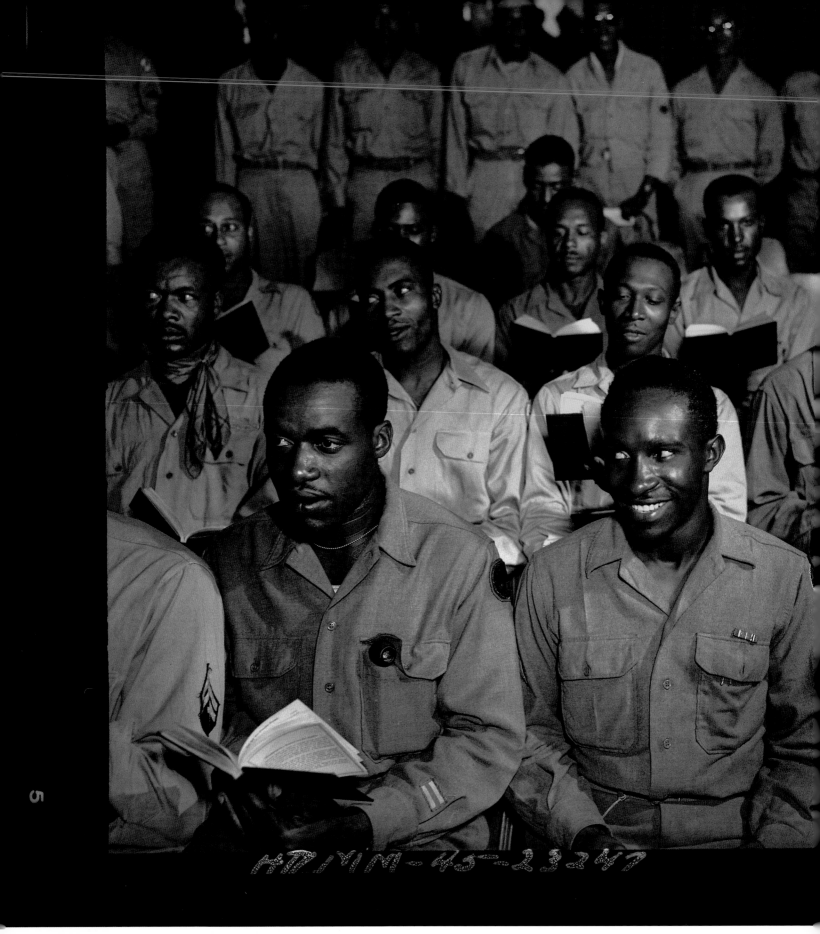

5

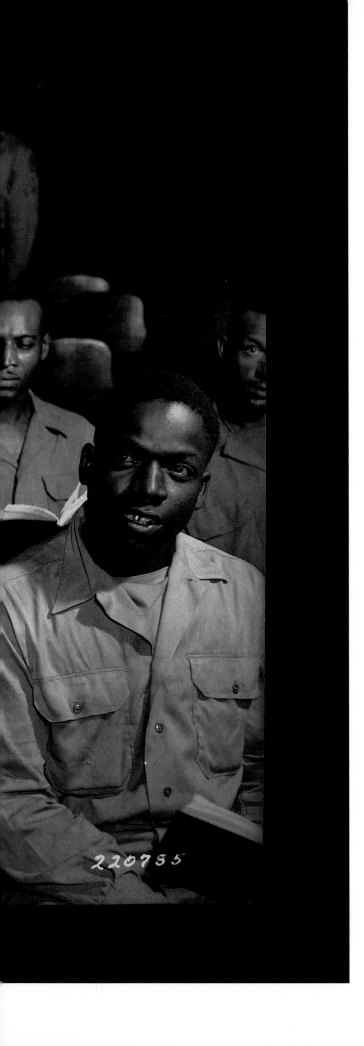

African Americans represented 8.7 percent of the Army's personnel in World War II, but few were ordered into combat because of racial prejudice in official circles and the nation at large. The draft was segregated, military units were segregated, and even the Red Cross's blood banks were segregated. It seems that no Signal Corps photographers were African Americans. At least one Japanese American, photographer Yoichi Okamoto, served in the Signal Corps during the war.

Secretary of War Henry Stimson admitted in his diary that the U.S. Army set its literacy standards to keep out blacks, and he also believed strongly that there could be only one mission—winning the war. Racial reforms should wait until later. "What these foolish leaders of the colored race are seeking is at the bottom social equality," Stimson wrote. Pressure from African Americans paid off when President Harry Truman officially desegregated the armed forces in 1948. Here, soldiers attend a religious service at the Imperial Red Cross Club in Livorno, Italy.

Charles Rosario Restifo
161st Signal Photographic
Company

" Japanese were dazed and in a state of confusion, running, crying, wailing. They displayed many burns and blisters. Some were carrying umbrellas against the drizzly rain. The ground was wet. Many dead. We took our movies and photos."

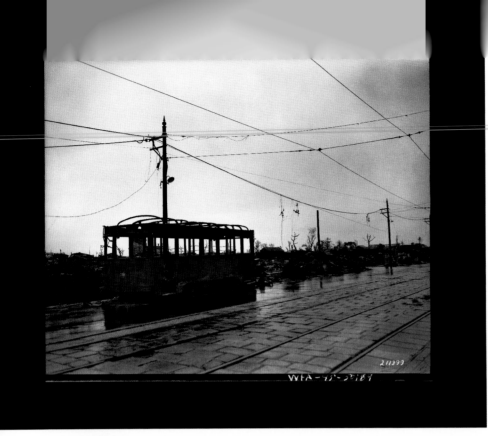

SEPTEMBER 1

Nearly 3 million Japanese soldiers and civilians were killed in the war, with almost 9 million more left homeless. Postwar Japan had an apocalyptic atmosphere, with morale shattered, food in short supply, and many cities demolished by Allied bombings. In Tokyo, 65 percent of all homes were destroyed, and shantytowns sprang up. "Tokyo, the first war casualty I've seen, is a devastated, immodest mess, but the silence is what gets me most; no honks, yells, clangs—none of the stuff you hate in a town but come to expect," wrote U.S. Navy Lieutenant Sherwood R. Moran, one of the first American witnesses.

Shown here are two scenes from Yokohama, a port city of more than one million. It was nearly destroyed by a massive bombing raid in May 1945, when about 450 B-29s dropped more than 2,500 tons of incendiary bombs, laying waste to almost nine square miles of the city. An American bombing analyst looked at the results and concluded that no further attack was necessary. As a wartime publication put it, "The parts left over were not worth bombs."

SEPTEMBER 1 KROGER PHOTO

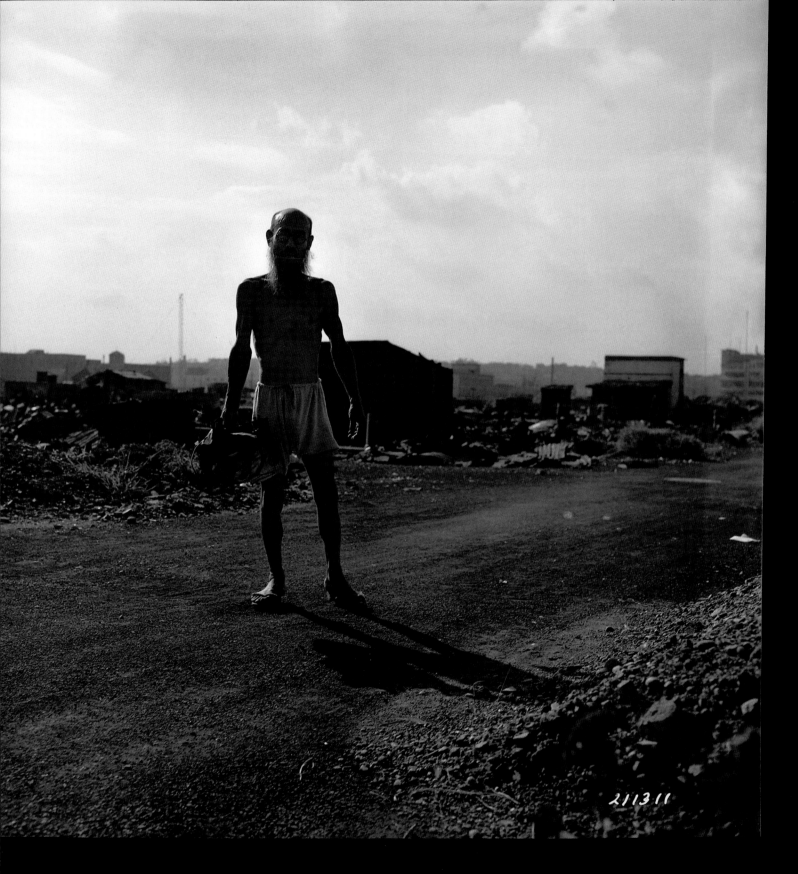
211311

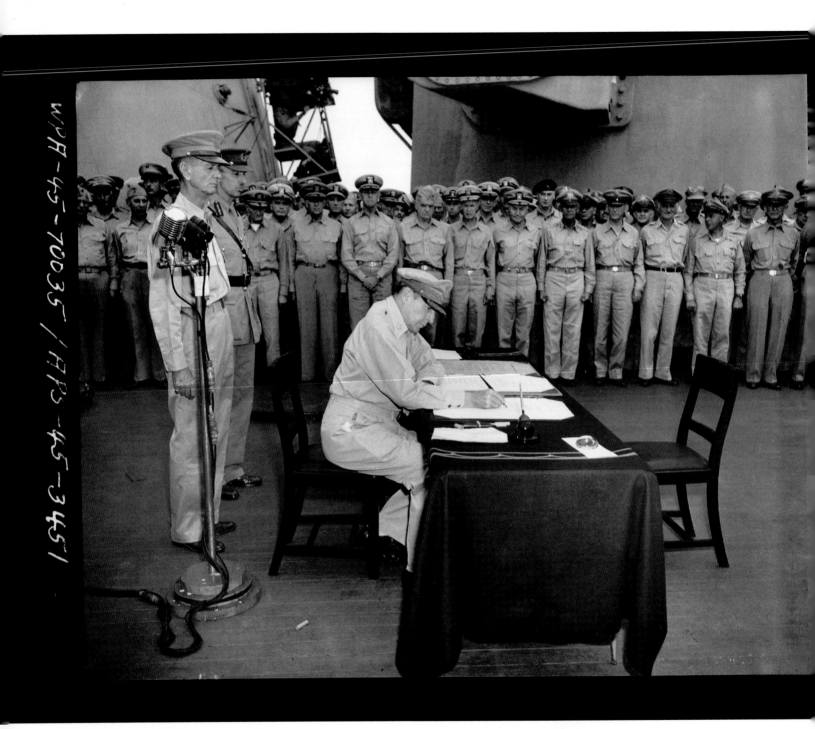

SEPTEMBER 2 GLENN W. EVE PHOTO

About two weeks after Emperor Hirohito announced his nation's surrender, formal papers were signed on the deck of the battleship USS *Missouri* in Tokyo Bay. U.S. General Douglas MacArthur puts his signature to the document as U.S. Lieutenant General Jonathan Wainwright (*left*) and British Lieutenant General A.E. Percival stand behind him. The two Japanese leaders in the front row signed the surrender document—Foreign Minister Mamoru Shigemitsu, on behalf on the government, and General Yoshijiro Umezu, representing the armed forces. The Americans stage-managed and rehearsed for the event carefully. Planners made sure that the eight U.S. servicemen whom the Japanese would walk past were all over six feet tall, supposedly demonstrating superiority.

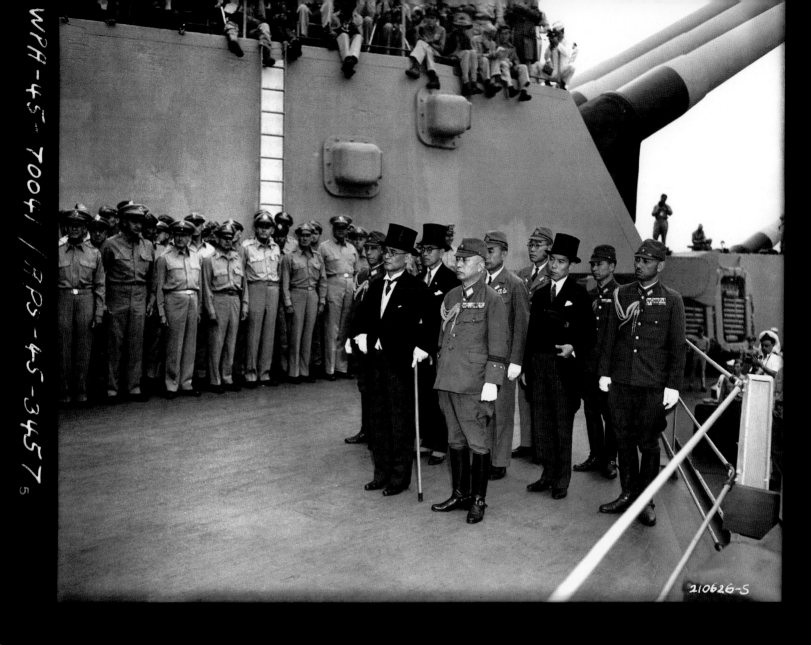

Signing the surrender document, MacArthur warned: "If we do not now devise some greater and more equitable system, Armageddon will be at our door. The problem basically is theological, and involves a spiritual recrudescence [revival] and improvement of human character that will synchronize with our almost matchless advance in science, art, literature, and all material and cultural developments of the past two thousand years. It must be of the spirit if we are to save the flesh."

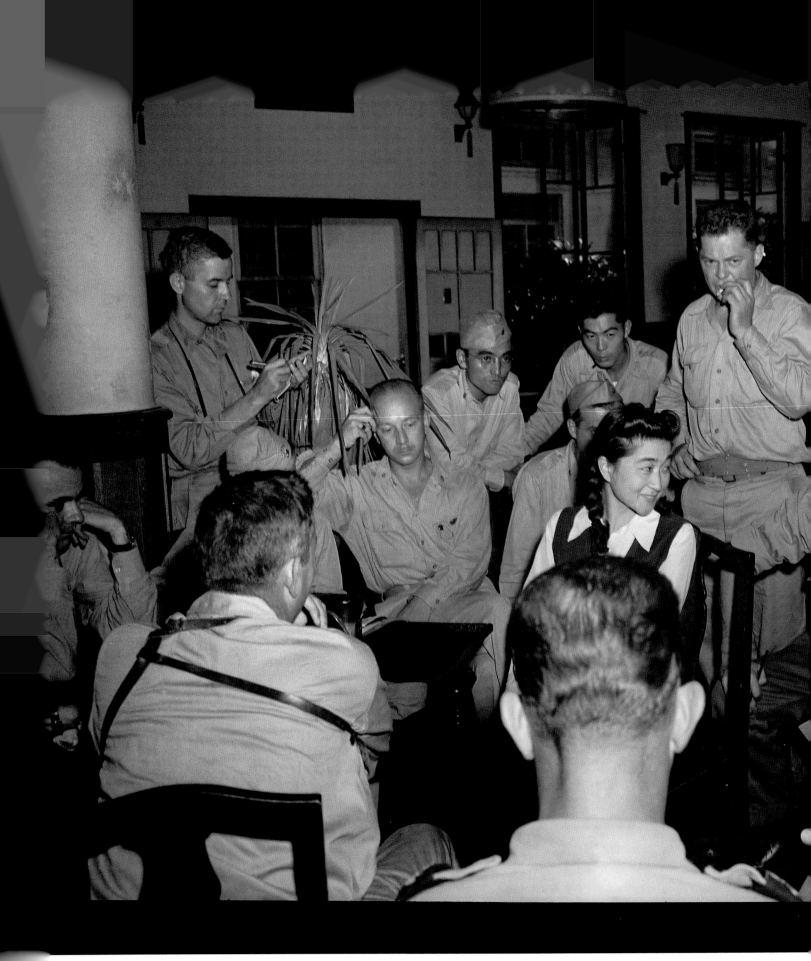

211323

Iva Toguri d'Aquino would have been wiser to say "no comment" instead of talking to journalists at a Yokohama hotel. When d'Aquino was identified as infamous Japanese radio propagandist Tokyo Rose, her life was turned upside down. Born in Los Angeles to Japanese immigrant parents, d'Aquino graduated from the University of California, Los Angeles, and took a trip to Japan, either to visit an ailing aunt or to study medicine (she told it both ways). After war broke out and she was stuck in Japan, she took a job as a radio announcer on a Japanese propaganda show.

D'Aquino was among several women who made broadcasts aimed at American soldiers, and the troops called them "Tokyo Rose" collectively. D'Aquino never used that moniker, appearing on the air as "Orphan Ann." Some believe that the Tokyo Rose broadcasts actually helped American morale, but d'Aquino's postwar publicity prompted the FBI and the army to take her into custody and launch an investigation. Lacking much evidence about what she had actually broadcast, they freed her without charges in 1946. But two years later, complaints by newspaper columnist Walter Winchell and others led the government to take another look. D'Aquino was charged with treason, convicted, and sent to prison. She served six years and then relocated to a quiet life in Chicago, running a grocery store and gift shop. In 1977, President Gerald Ford issued a pardon.

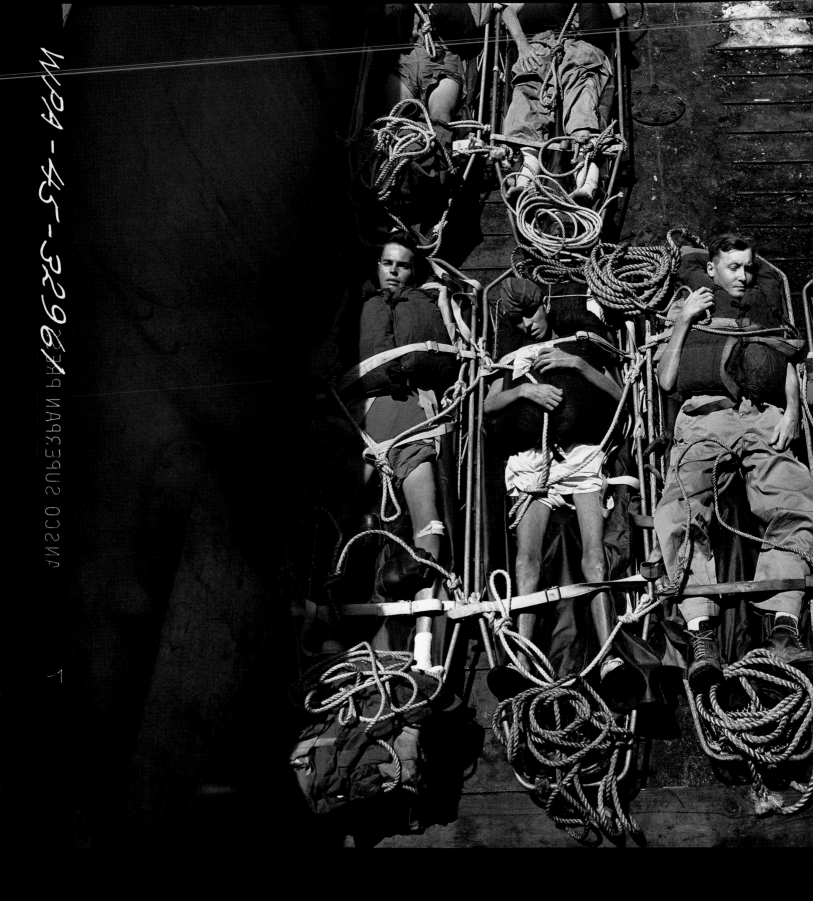

American, British, and Australian soldiers in need of medical treatment lie in litters in a landing craft after being lowered from an aircraft carrier in the Pacific. In some parts of the Pacific theater, malaria caused more suffering and death than combat. The standard drug to treat malaria, quinine, was in short supply, with the Japanese controlling many areas where the raw material for quinine was produced. So Atabrine, a recently discovered substitute for quinine, was often used instead. Another medical advance may have had an even greater impact during the war: penicillin. Some chemists of the era viewed the antibiotic as an "extract of fungi" more akin to witchcraft than medicine, but its effectiveness against infections made it a major lifesaver. By D-Day, Allied doctors had produced 100,000 units to support the invading forces.

Halfway across the world, Signal Corps photographers made their way home. It took Eric Weisenhutter of the 166th nine days to cross the Atlantic with other GIs. "As we proceeded up the Hudson River we were greeted by bells, whistles, and sirens from various sources along the shoreline," he wrote. The ship tied up at a military facility north of New York City for disembarkation. "Practically everybody kneeled down and kissed the ground."

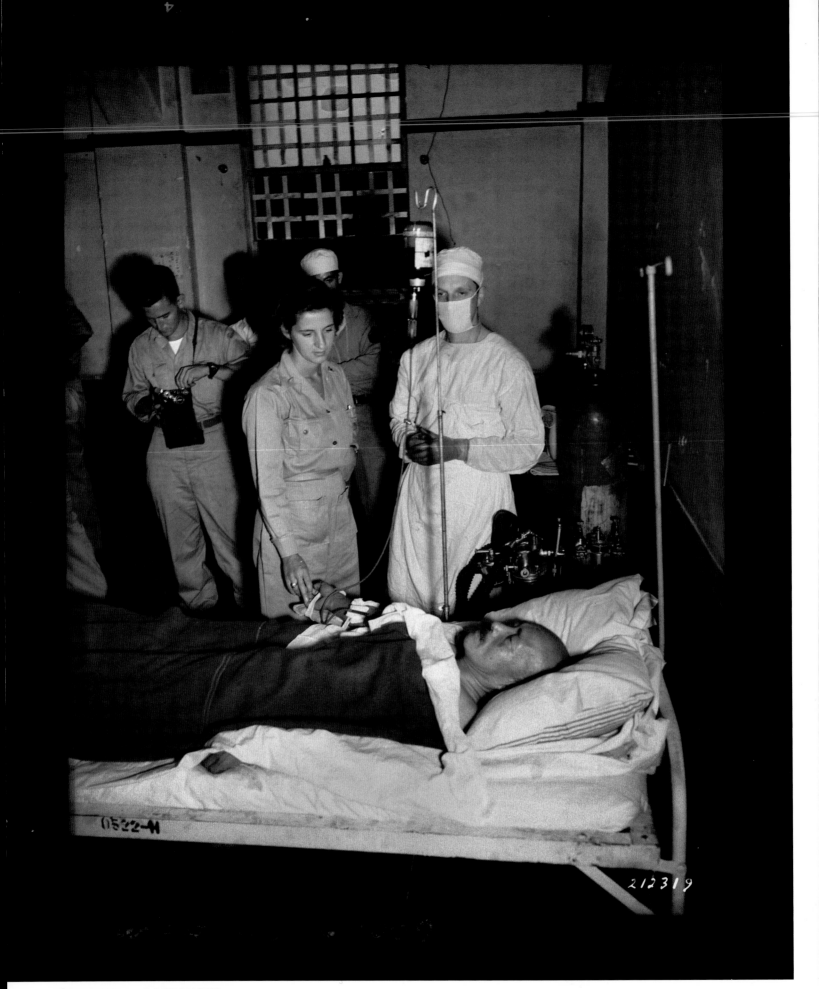

SEPTEMBER 12 CAMP PHOTO

The first Signal Corps photographer reached Hiroshima a month after the dropping of the first atomic bomb. "We flew to Hiroshima and took photos," wrote Charles Restifo of the 161st. "The city was still smoldering, charred to the ground from the fires that devastated it after the actual bombing. An occasional wall remained of a huge city." The attack killed about 70,000 people right away, and the death toll doubled by year's end because of a new and mysterious illness: radiation sickness. Survivors desperately needed medical care, yet the blast had destroyed four of Hiroshima's hospitals, killing all the staff and patients. Three other hospitals were badly damaged, including the Red Cross Hospital shown here, where the bomb's radiation was so powerful that it exposed X-ray film in the concrete basement. The hospital was soon back in operation serving the many victims, including this man suffering burns.

LEFT: Hideki Tojo, a symbol of Japanese militarism who headed the nation's government for most of the war, is watched in a Tokyo-area hospital after a suicide attempt. Tojo had marked the location of his heart with a crayon and then shot himself there, piercing a lung but missing the heart. Nurse Rebecca Schmidt of Long Green, Maryland, and a Canadian doctor, Captain Roy Gold, oversaw his blood transfusion. The Japanese public was embarrassed by Tojo's botched suicide, especially since he rejected the traditional Japanese method of hara-kiri with a sword or knife and instead used "a pistol like a foreigner," as one diarist put it. After nursing Tojo back to health, the Allies put him on trial for war crimes and hanged him in 1948.

SEPTEMBER

While Japan was reeling from devastation and defeat, America's home front was filled with optimism and confidence. Shown here are residents of the atomic boomtown of Oak Ridge, Tennessee, where uranium for atomic bombs was processed. The top-secret town was created in a thinly populated area west of Knoxville, and grew from 3,000 residents in 1942 to nearly 75,000 three years later. Despite being surrounded by guard towers and barbed wire, the town projected an all-American ambience, featuring a soda fountain at the Thrifty Drug Store and Ferris wheel rides for the kids. These photos were part of a 14-picture series called "The Townspeople of Oak Ridge."

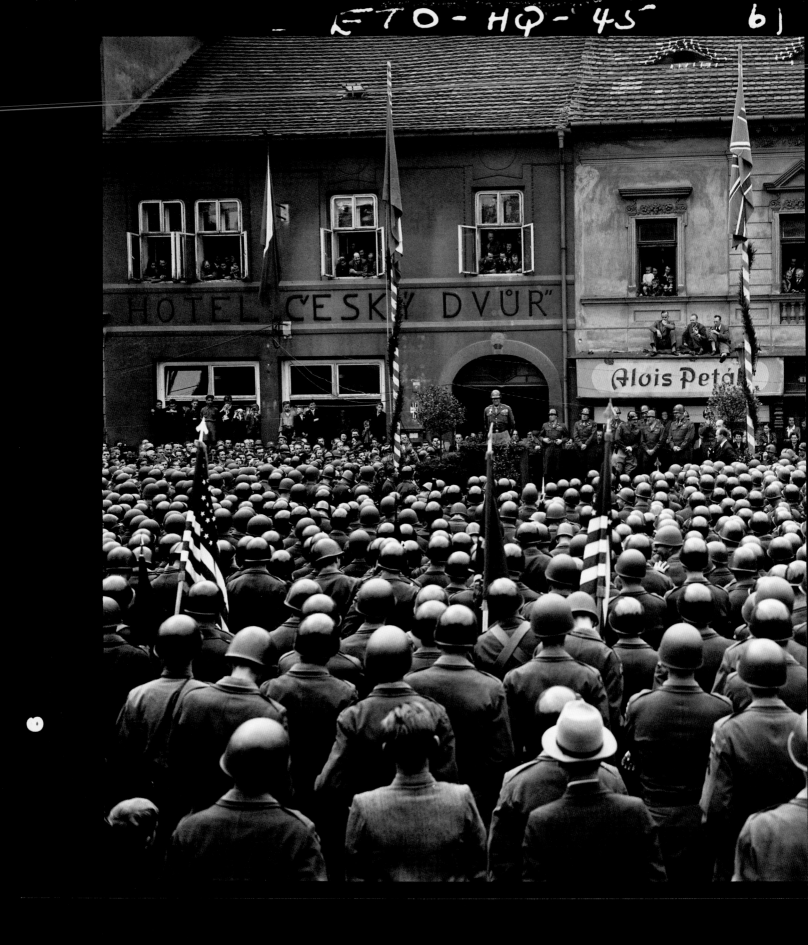

SEPTEMBER 14 WILLIAM NORBIE PHOTO (165TH)

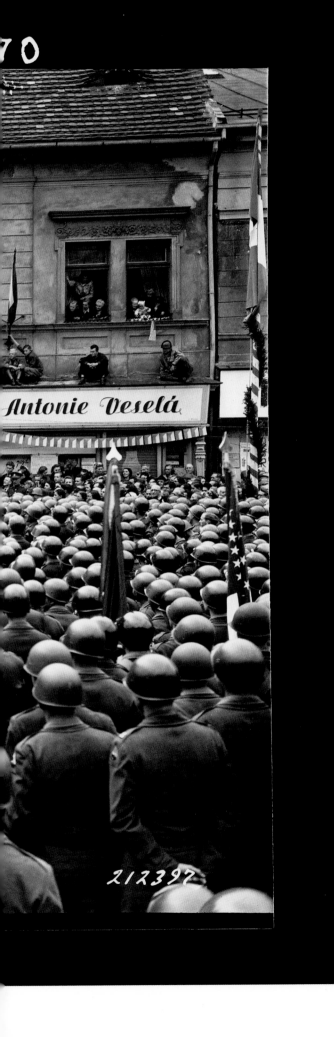

General Patton bids farewell to the troops of the Eighth Armored Division, who are preparing to leave Rokycany, Czechoslovakia, to return to the United States. Patton's troops had linked up with the Red Army in western Czechoslovakia, and various conflicts had arisen in Rokycany between the supposed allies from the United States and the Soviet Union. Patton was famously contemptuous of the Soviets, and wrote in his diary a month earlier: "We can no more understand a Russian than a Chinaman or a Japanese, and from what I have seen of them, I have no particular desire to understand them, except to ascertain how much lead or iron it takes to kill them. . . . The Russian has no regard for human life and is an all-out son of bitch, barbarian, and chronic drunk."

The 166th Signal Photographic Company was informally known as Patton's Cameramen since it followed the general's troops through Europe. Russell Grant, who served as Patton's personal photographer late in the war, said Patton considered himself a photographer, and often gave Grant instructions—no, make that orders—on how to take pictures. Patton used his own Contax camera to photograph the Buchenwald concentration camp, and insisted that his own pictures were every bit as good as Grant's. "Yes, sir," the photographer replied.

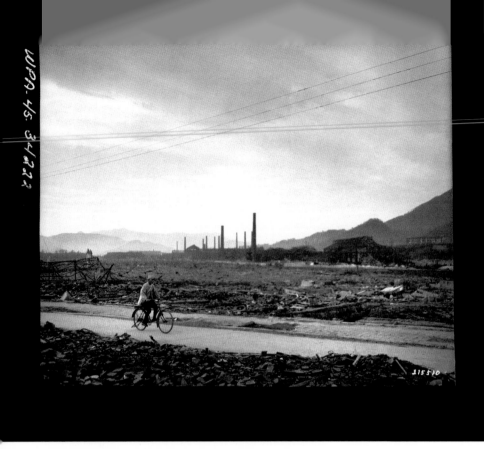

SEPTEMBER 16 GEORGE H. WOLINSKY PHOTO

Some have argued that the atomic bombing of Hiroshima was unnecessary, and even more think that about Nagasaki, which was attacked three days later. But even after the dawn of the nuclear age, Japanese leaders failed to send clear signals to the Allies that they were prepared to surrender. After Hiroshima, President Harry Truman announced the atomic bomb to the world, and American forces dropped leaflets on Japanese cities declaring: "We are in possession of the most destructive explosive devised by man." Yet the Japanese government kept its public largely in the dark. The *Nippon Times* had written about "a new type of bomb," but media were banned from using the word "atomic" until two days after the Nagasaki attack. Here, a man bicycles through the Mitsubishi Iron and Steel Works, a war-related installation in Nagasaki. The bomb fell close to the plant, leaving only twisted steel girders and chimneys.

RIGHT: A train carries Australian prisoners of war away from the devastation of Nagasaki. Twenty-four Aussies who were captured and used as slave laborers by Mitsubishi survived the bombing. British and American POWs also survived. An Australian warrant officer, Jack Johnson, recalled that the light from the explosion was "like a photographer's magnesium flash." Ten days later, their Japanese captors told them that the war was over. Allied planes dropped food to the POWs to sustain them until they could be brought out.

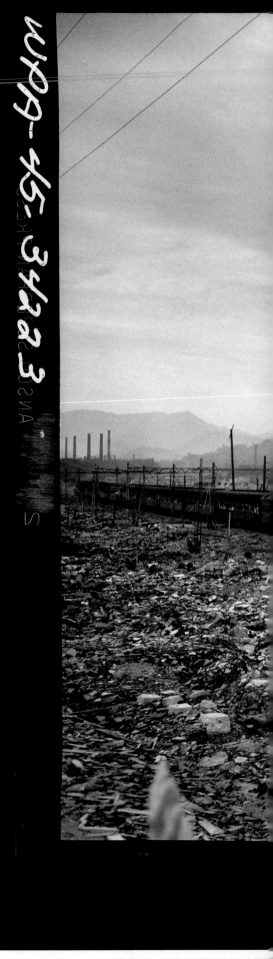

SEPTEMBER 16 GEORGE H. WOLINSKY PHOTO

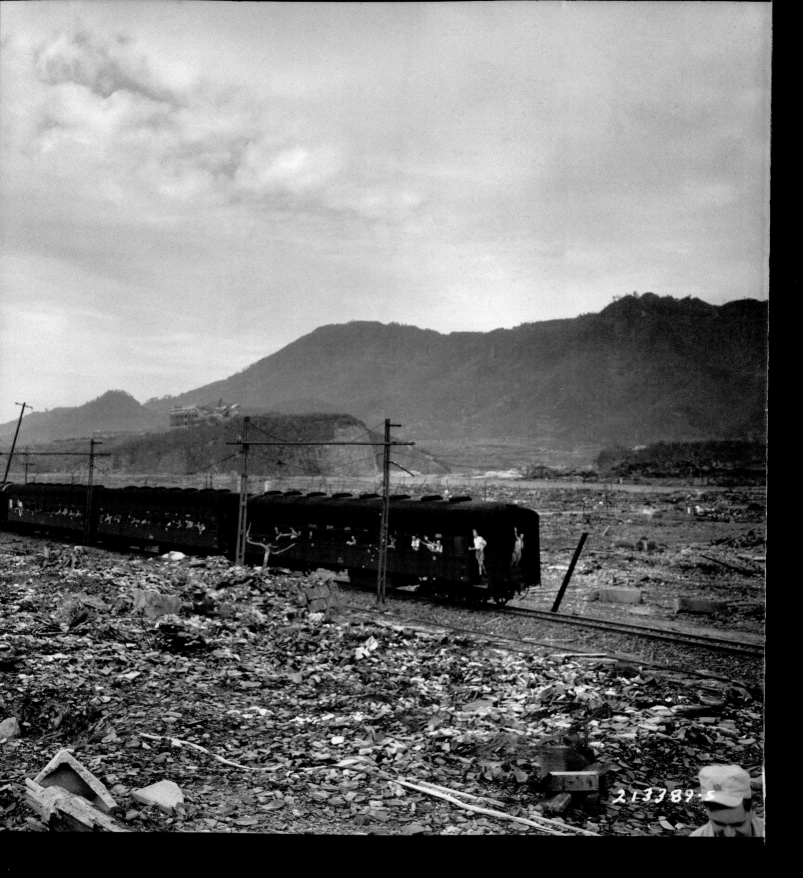

213389-5

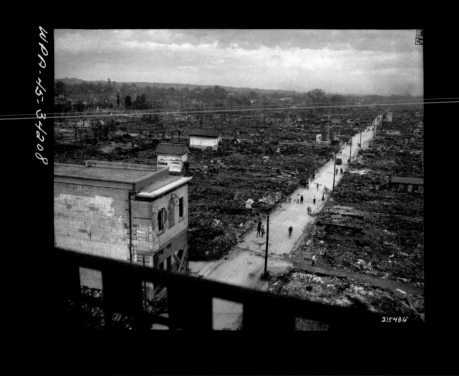

SEPTEMBER 16 WINSTON PHOTO

The shocking new weapon that destroyed Hiroshima and Nagasaki overshadowed the comparable destruction wrought in other cities by conventional bombing. Shown here is Sendai, where B-29s leveled the city center in a July raid. After that attack, General Jimmy Doolittle said, "Japan eventually will be a nation without cities—a nomadic people." The atomic bomb brought the end of the war before Doolittle's prediction could come true.

RIGHT: Children give a "V for victory" sign to a passing jeep on a street in Sendai. Charles Restifo of the 161st, one of the first Signal Corps photographers to arrive in Japan, said the U.S. relief effort started immediately. "A few days after my visit, bulldozers flown in by the U.S. Army were clearing the land and rubble. The army had gathered the survivors into tents. Generators were giving power and food was made available. The mighty power of the USA was about to care for and treat the very persons they had bombed and who had bombed us in Pearl Harbor."

SEPTEMBER 20 WINSTON PHOTO

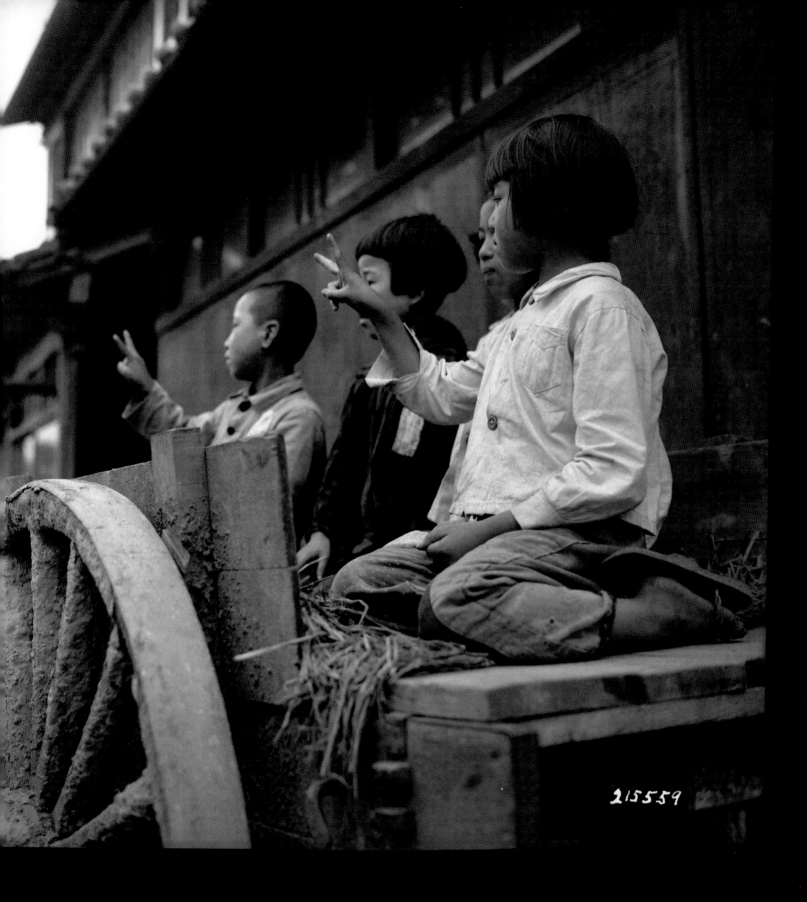
215559

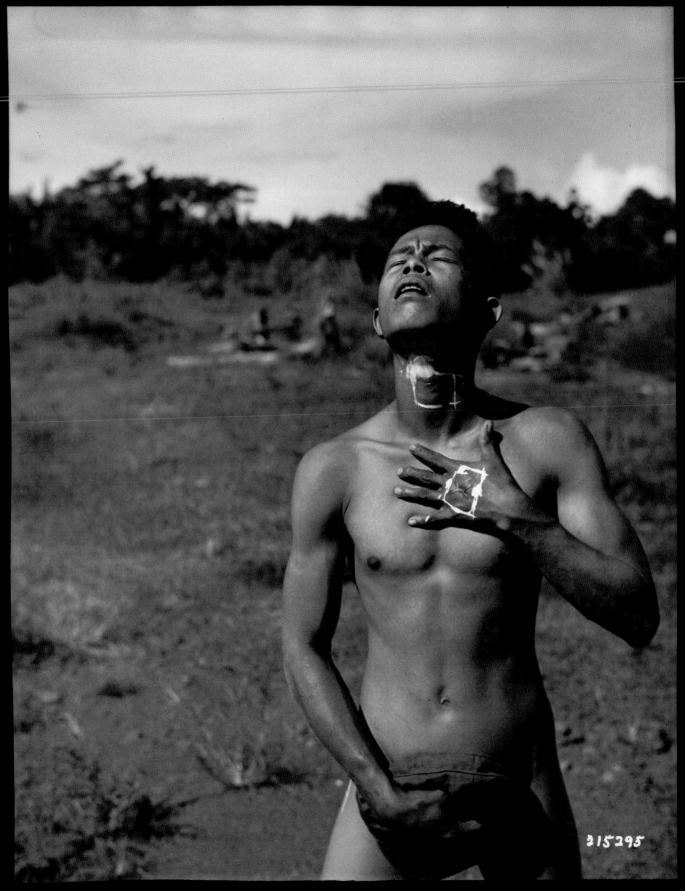

215295

WRA-LE-34357

SEPTEMBER 25 WILSON PHOTO

Five men pose after surviving a harrowing Japanese atrocity. They were thrown into a well in Lipa, Philippines, by Japanese soldiers who then shot into the hole.

FAR LEFT: Eusebio Linatok shows his bayonet wounds at the hands of Japanese soldiers in Lipa. The Japanese commander at the time, Tomoyuki Yamashita, known as the Tiger of Malaya, was the first Japanese defendant tried by the Allies for war crimes—and his case set a controversial standard for how other cases would be handled. Yamashita was held responsible for acts of cruelty by his soldiers even when there was no allegation that he had ordered the action or even knew about it. Yamashita told an interviewer that his command was as big as MacArthur's. "How could I tell if some of my soldiers misbehaved themselves? . . . The charges are completely new to me. If they had happened and I had known about them, I would have punished the wrongdoers severely. But in war someone has to lose. What I am really being charged with is losing the war." Yamashita was hanged.

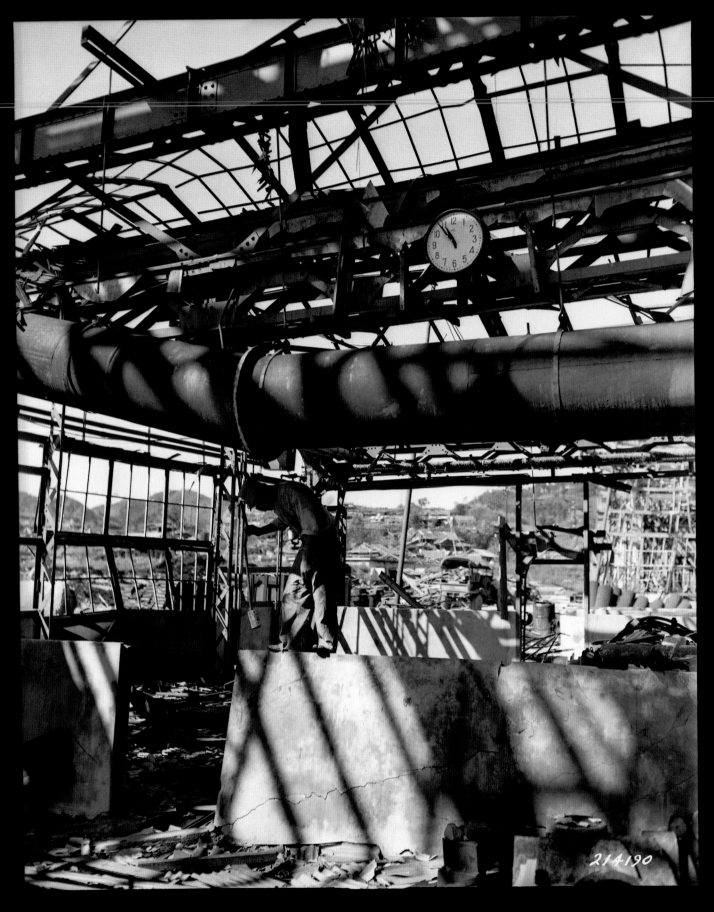

WPA-45-60396

9

214190

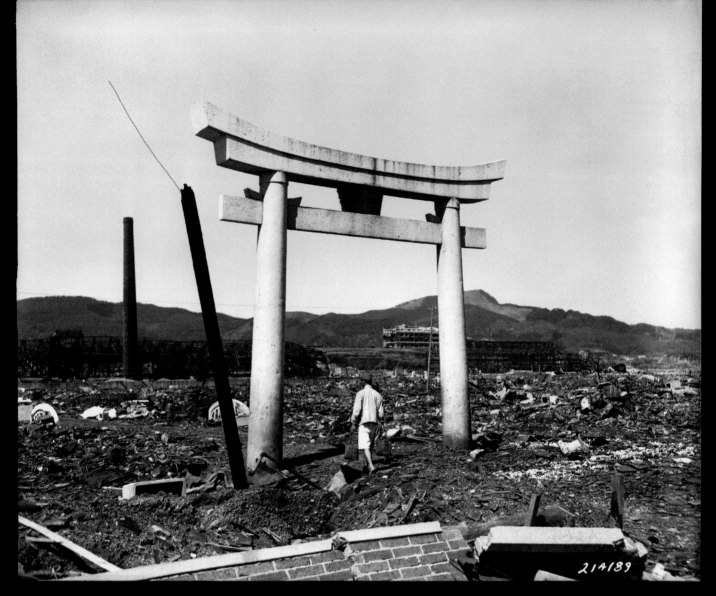

214189

SEPTEMBER 29 KINGSLEY R. FALL PHOTO

Nagasaki suffered its terrible fate because of bad luck: the primary target for the second atomic bomb, Kokura, was obscured by clouds, so the B-29 crew proceeded to the secondary target, Nagasaki. A torii—but not the Shinto temple that was behind it—has survived the Nagasaki blast.

LEFT: A man examines the remnants of a Nagasaki factory that was damaged by the bomb. The clock above him stopped at the moment of the explosion. That clock was either running a little slow or the blast jarred the clock's minute hand—the officially logged time of the explosion was 11:02 a.m. The Nagasaki bomb was nearly twice as powerful as the Hiroshima device, but the blast killed fewer people initially because the city's hills contained its force. By year's end, the death toll reached as high as 80,000, including radiation-related deaths.

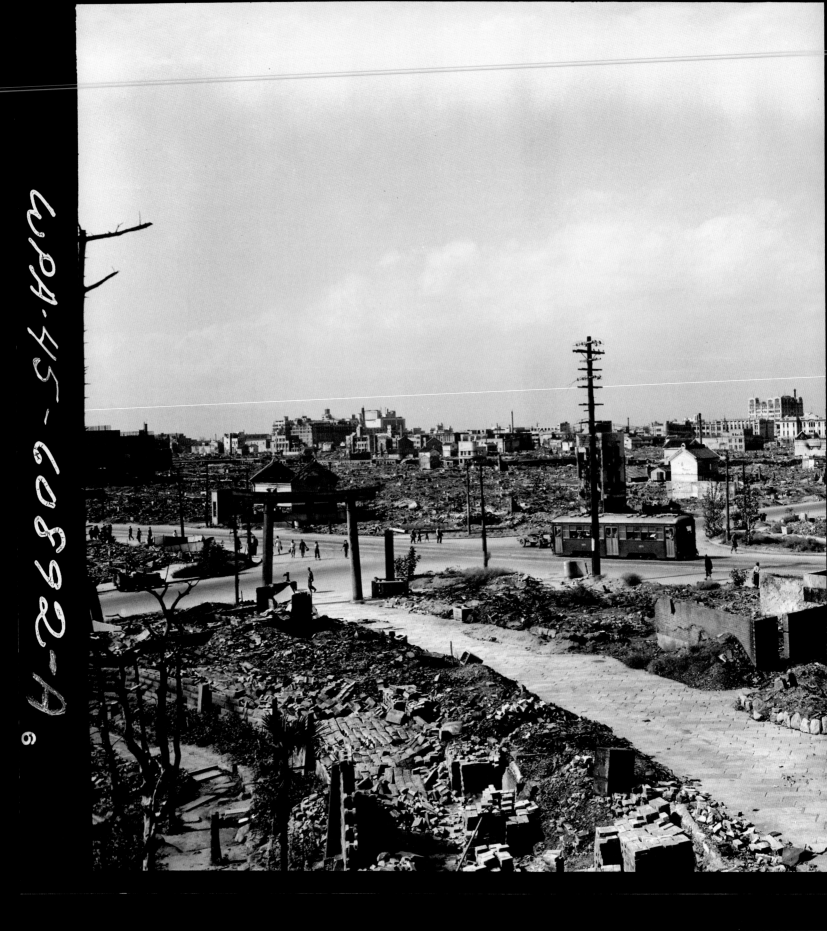

SEPTEMBER 30 HRICIK PHOTO

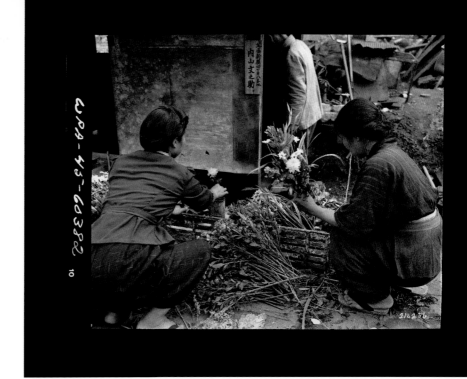

OCTOBER 1 A. ROSEN PHOTO

Amid the tin and iron that were once Japanese homes, Japanese women arrange flower bouquets to sell on the streets of Tokyo. Economic desperation was everywhere, with hundreds of starvation deaths documented in large cities. A girls' magazine featured articles headlined "How to Eat Acorns" and "Let's Catch Grasshoppers." The grasshoppers offered vital protein.

LEFT: About 57 percent of the homes were uninhabitable in Osaka, shown here. Even after Hiroshima and Nagasaki, the conventional bombing campaign against Japan was unrelenting, as the Japanese and Americans negotiated the terms of a surrender. In the last five days of the war, about 1,000 B-29s caused such devastation that an estimated 15,000 people died.

In 1946, the Manhattan Engineer District Investigating Group issued a report on the two atomic bombs. It concluded, "We have discussed among ourselves the ethics of the use of the bomb. Some consider it in the same category as poison gas and were against its use on a civil population. Others were of the view that in total war, as carried on in Japan, there was no difference between civilians and soldiers, and that the bomb itself was an effective force tending to end the bloodshed, warning Japan to surrender and thus to avoid total destruction."

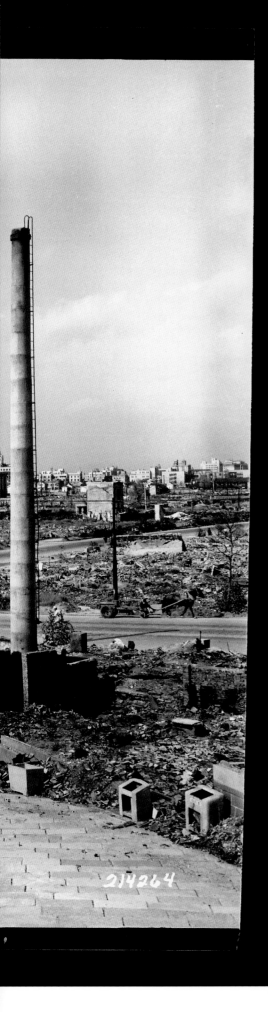

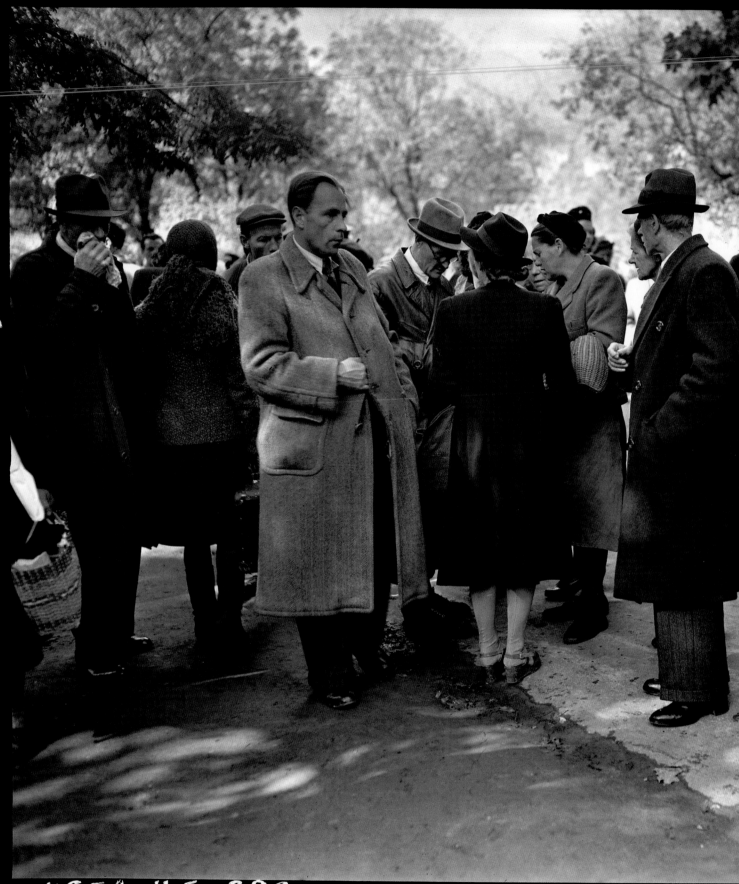

OCTOBER 2 LOUIS WEINTRAUB PHOTO

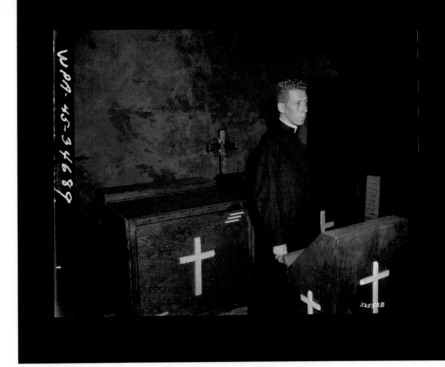

OCTOBER 2 NATHANIEL NORMAN MILGROM PHOTO

Father Cornelio Tenus, a Catholic missionary from the Netherlands, stands before an altar built by the soldiers of the 4168th quartermaster depot in Manila. Tenus was a missionary in Pangue, Philippines, who was captured by the Japanese. When freed, he became the quartermasters' chaplain.

LEFT: The black market is open for business at the Karlsplatz in Vienna, Austria. The shortage of goods and the imposition of price controls meant that many products were unavailable for purchase using ration coupons. They could be acquired on the black market for exponentially higher prices. A loaf of dark bread, for example, was about 75 times more expensive on the black market than under legal price controls. Wine was 10 times costlier. The most sought-after items, cigarettes and cigarette-lighter flints, became their own kind of currency. One flint was worth six smokes. The black-market scene in Austria was so rife with intrigue that it became the subject of a popular 1949 movie, *The Third Man,* starring Orson Welles.

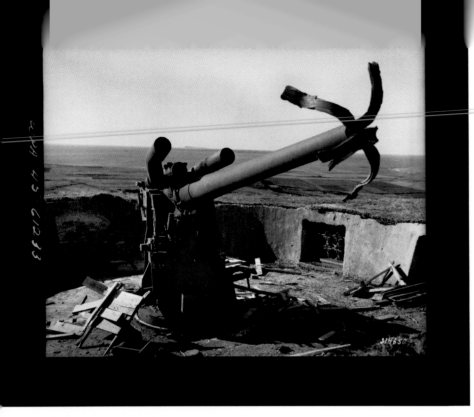

OCTOBER 3 ALBRIGHT PHOTO

A Japanese gun was spiked to prevent the advancing Allies from using it on Saishu-to, a large island west of the Japanese mainland. Saishu-to, a jumping-off spot for thirteenth-century Mongols in their assaults on Japan, was used by the Japanese in the twentieth century as both a naval base and a penal colony for Koreans. It sat along a possible island-hopping route as the Allies approached the Japanese mainland, but they went elsewhere. Saishu-to is now known as Jeju Island and is part of South Korea.

RIGHT: With Japan defeated and its leaders pledging to maintain strictly defensive forces, much of its military equipment became unnecessary. These confiscated rifles are arrayed at Taisho airfield in Osaka.

OCTOBER 5 HRICIK PHOTO

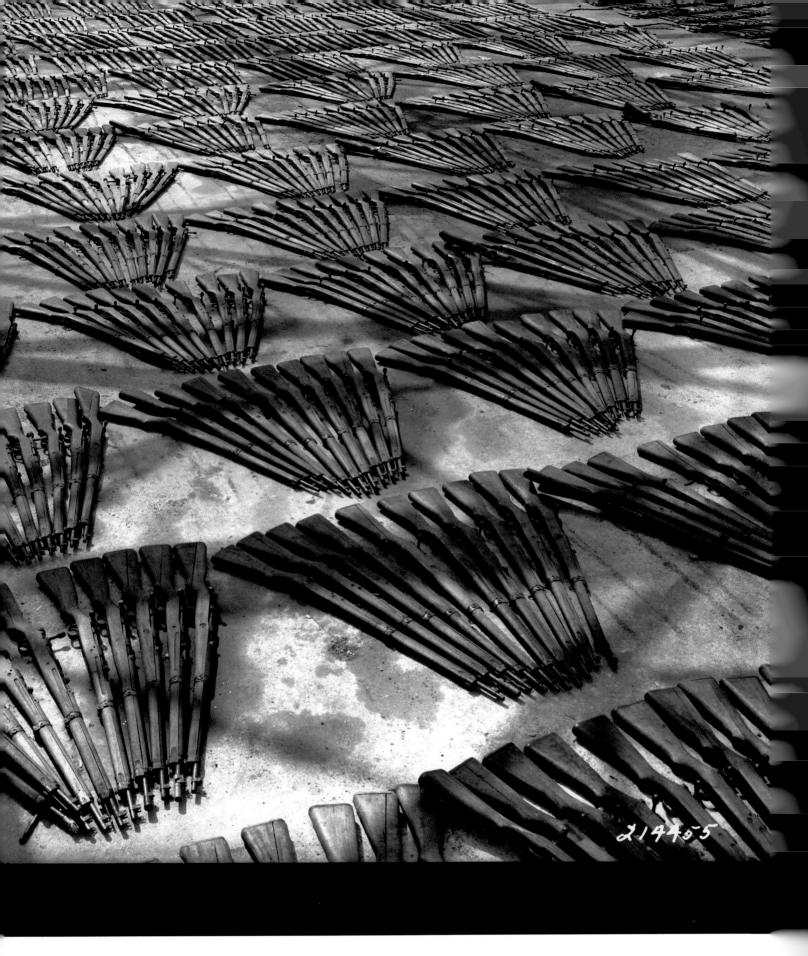

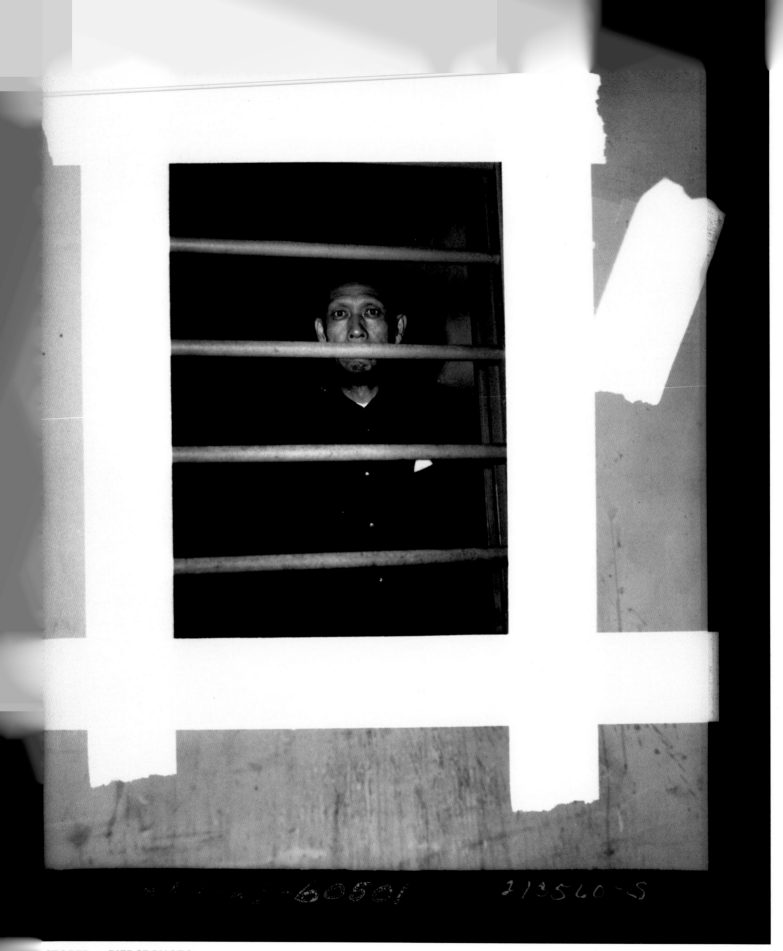

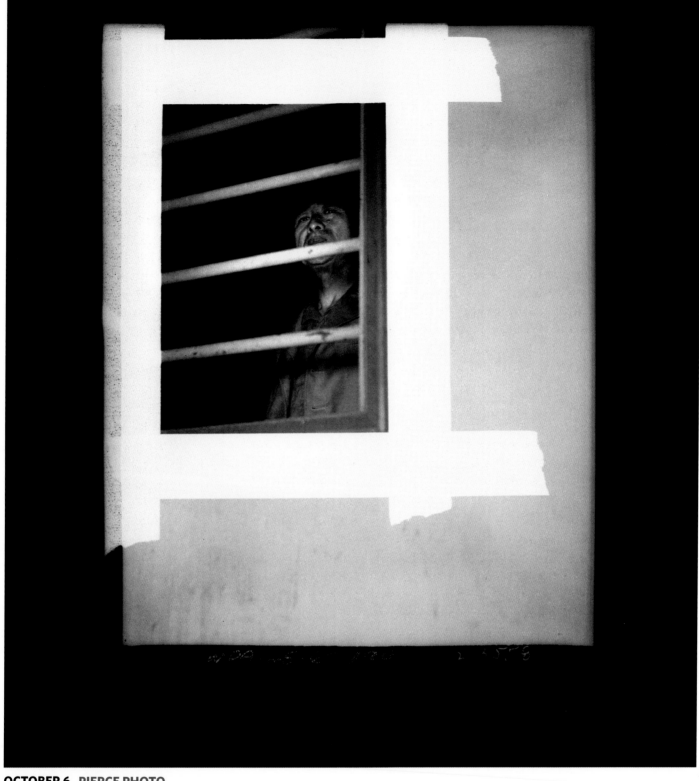

OCTOBER 6 PIERCE PHOTO

These two high-ranking Japanese, charged with war crimes, are held at Yokohama Prison as they await transfer to Omori prison camp. Admiral Shigetaro Shimada (*above*) and Sadaichi Suzuki (*left*), were members of the "Pearl Harbor cabinet"—the group of government officials who made the decision to launch the attack on the U.S. fleet at Pearl Harbor in 1941. General MacArthur, in charge of the occupation of Japan, ordered the arrest of Shimada and Suzuki on the same day that he shut down the Japanese general headquarters and imposed censorship on the country's newspapers and radio. The Associated Press cast the actions as "the sudden disclosure of the iron hand behind the velvet glove of occupation." Shimada and Suzuki received life sentences.

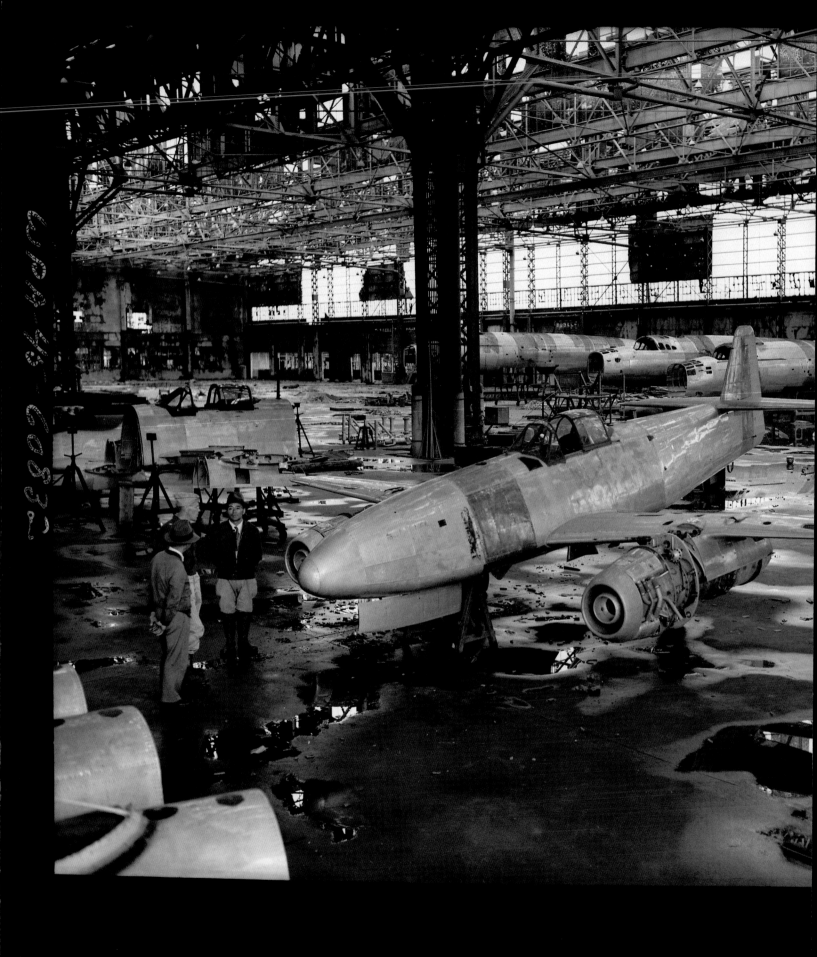

OCTOBER 6 CHAPMAN PHOTO

Advanced aircraft were in production in Japan in the waning days of the war, but never made it into combat. The long-range Renzan bomber, designed for a crew of 10, was found at the Nakajima company's plant in Koizumi. Only four prototypes had been constructed before production was suspended in June 1945.

LEFT: The Nakajima factory also was developing a jet fighter called the Kikka. The Kikka project began when a Japanese official witnessed testing of Germany's Messerschmitt Me 262 and sent enthusiastic reports home. The Kikka's first test flight occurred too late to help the Japanese cause—on August 7, between the Hiroshima and Nagasaki bombings.

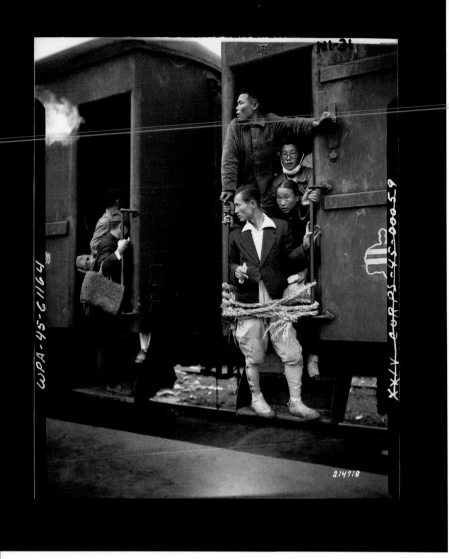

OCTOBER 8 WEBB PHOTO

Despite deep wounds from the war, a new Asia was emerging. Passengers ride a crowded train in Seoul, Korea, with a rope tied across the door to keep people from falling out. The defeat of Japan meant the liberation of Korea, which had been annexed by Japan in 1910. But just five years after the war's end, the Korean peninsula was riven by a new war between the South and the North, with the United States and China supporting the rivals.

RIGHT: Corporal John E. McCarron of Woodhaven, New York, hangs out with Japanese children after heavy rains in Tokyo. The Allied occupation of Japan was accompanied by changes in social, economic, and governmental structures that made the country a strong and vibrant democracy. The occupation officially ended in 1952, with Japan becoming a major U.S. ally.

OCTOBER 8 HAAS PHOTO

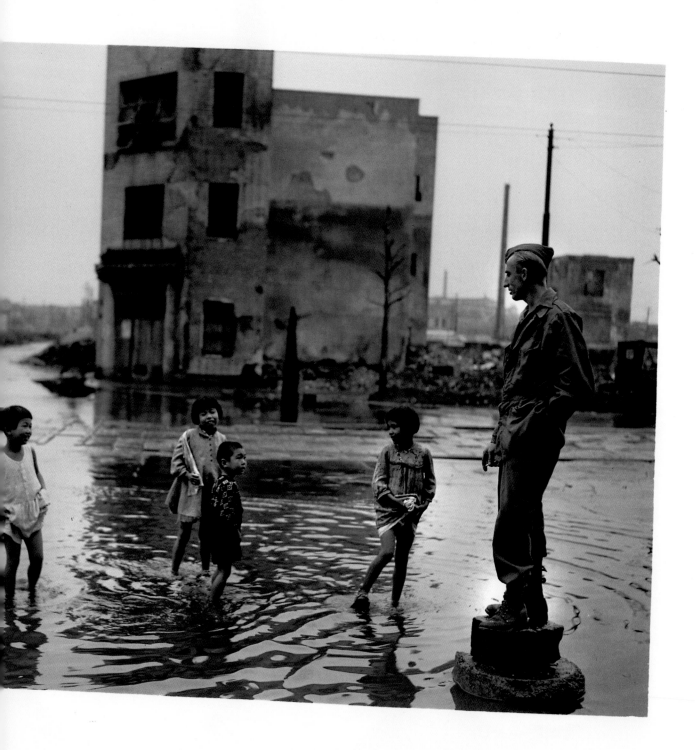

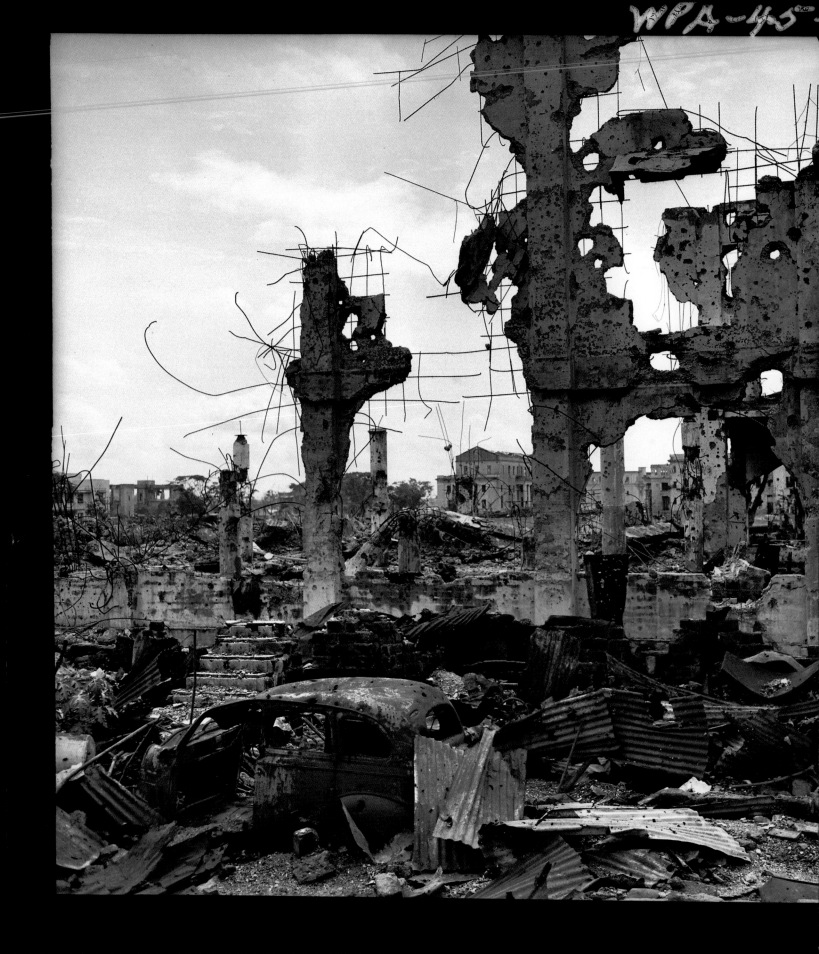

WPA-45

OCTOBER 8 **EDWARD SELIADY PHOTO (161ST)**

OCTOBER 9 ADAMS PHOTO

As part of the demilitarization of Japan, a component of explosives called picric acid is destroyed in Odawara. A booby trap used by Japanese troops during the war included two sake bottles filled with the acid.

LEFT: Manila was once known as "the Pearl of the Orient," but the fighting to retake the Philippine capital from the Japanese caused widespread wreckage in February 1945. When Allied forces landed in the Philippines, they expected the Japanese to abandon the capital and retreat, but instead the Japanese forced them to fight building to building. Shown here are the remnants of the YWCA building in Manila.

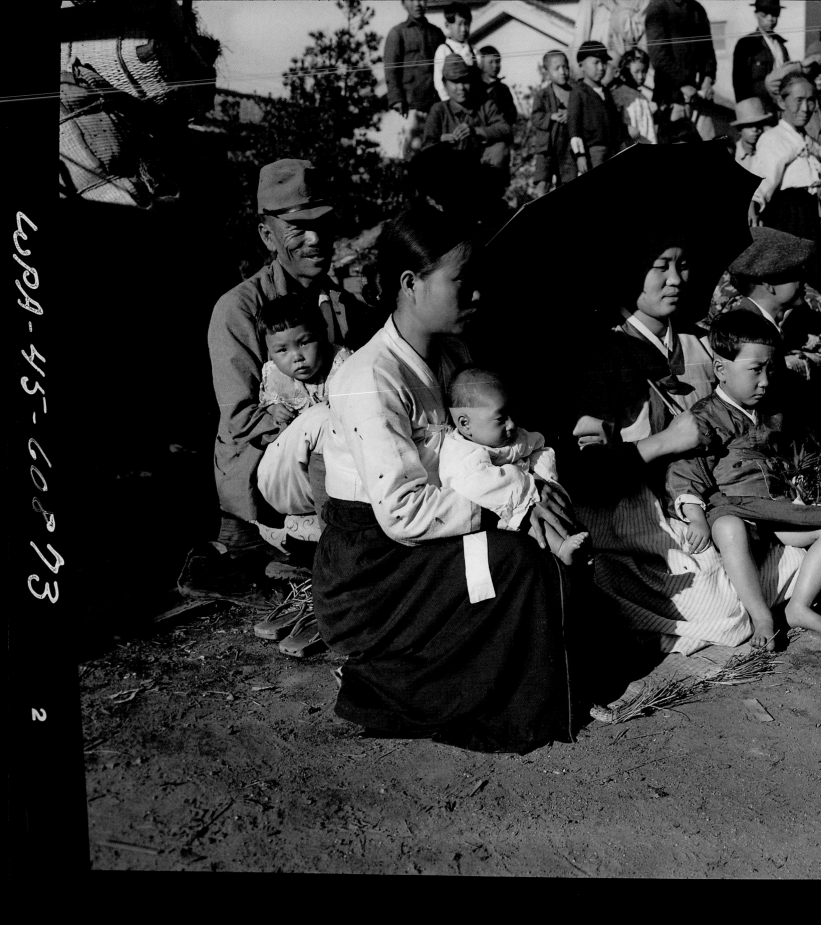

OCTOBER 13 WITTE PHOTO

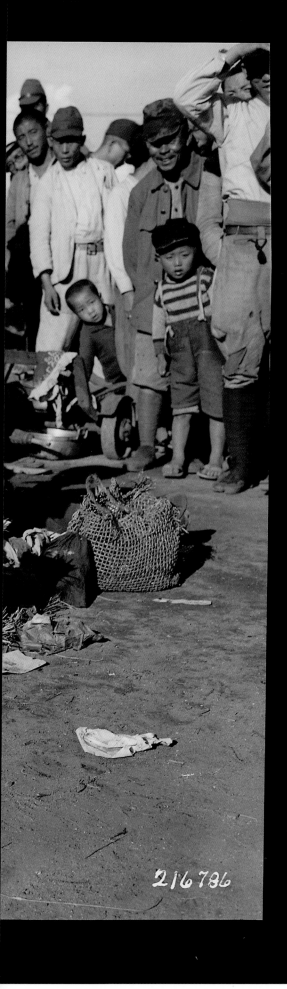

216786

OCTOBER 14 KLING PHOTO

Chinese soldiers who were prisoners of war flourish their flags in Osaka, Japan, as they await transportation home.

LEFT: Korean civilians who had been brought to Japan as laborers during the war found their homecoming delayed in Fukuoka on the island of Kyushu. There was no housing for them in the city, and some had waited there a month. Koreans, whose homeland had been a Japanese colony since 1910, often experienced discrimination. And they had suffered at least as much as the Japanese from the privations of war. More than 20,000 Korean workers and their families were among those killed at Hiroshima and Nagasaki.

OCTOBER 14 E.R. ALLEN PHOTO

The Feast of La Naval de Manila is an annual event marking the intervention of Our Lady of the Most Holy Rosary to ensure the victory of Spanish and Filipino naval forces against the invading Dutch in the seventeenth century. This procession at the University of Santo Tomas in Manila had a special significance as the first La Naval after liberation from Japanese invaders. During the occupation, Santo Tomas was used as a concentration camp for political prisoners, and some of them took part in the procession.

RIGHT: About 4,000 Germans marched to Mount Rechberg Church atop Mount Rechberg to express their thanks that prayers were answered and the town of Schwabisch Gmund was spared during Allied bombings.

The end of the war altered the work of Signal Corps photographers. "Victory had brought relief, but also a strange sense of depression," explained photographer Robert Stubenrauch's character in his autobiographical novel, *Cat Thirteen.* "Until this day, they had a long, well-established routine, the daily challenge, the constant movement, the hunt for pictures, the freedom to decide what to do, how to do it. That was all they knew."

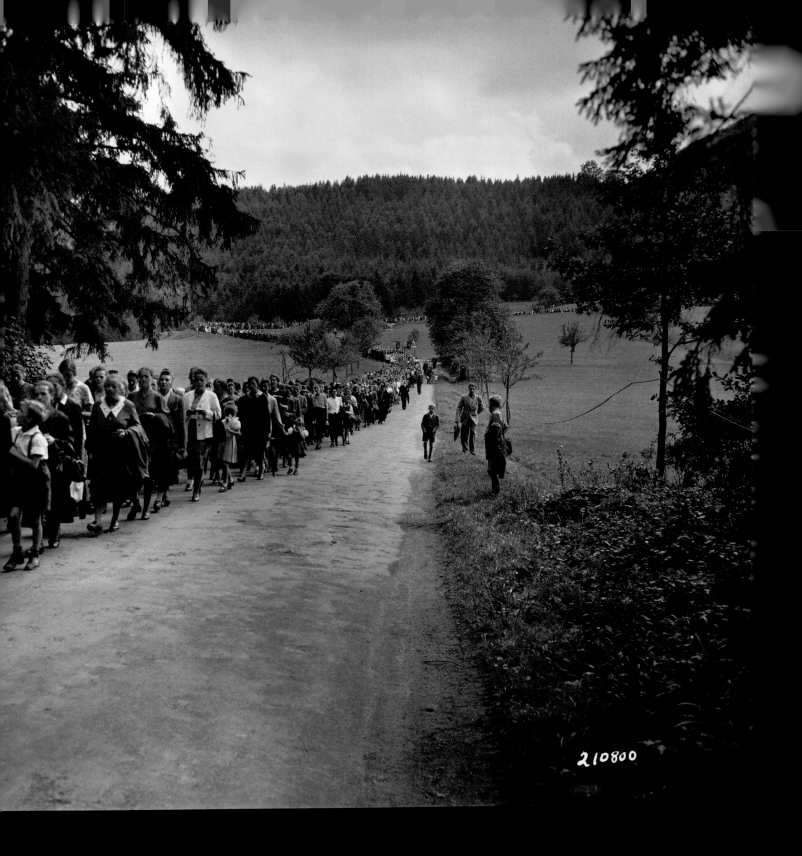

210800

OCTOBER 15 REYNOLDS PHOTO

OCTOBER 16 MUNN PHOTO

A specimen case in Japan shows the rodents of Formosa, an island south of Japan that the Imperial Japanese Army controlled during World War II. A few years later, Formosa became the haven for Chinese nationalists who lost the civil war against the communists. They called the island Taiwan.

LEFT: A ghastly scene was revealed in the Berlin subway system—a dead body hanging from a wire. As Berlin came under Allied air raids, many residents used the subway system for shelter. But when the Red Army closed in, authorities were afraid that Soviet troops would use the underground tunnels to get around defenses, and an order was given for SS troops to blow up a transit tunnel under the Landwehr Canal, flooding parts of the transit system. Even today, the disaster is shrouded in mystery—with the death estimates varying widely from 50 to 15,000.

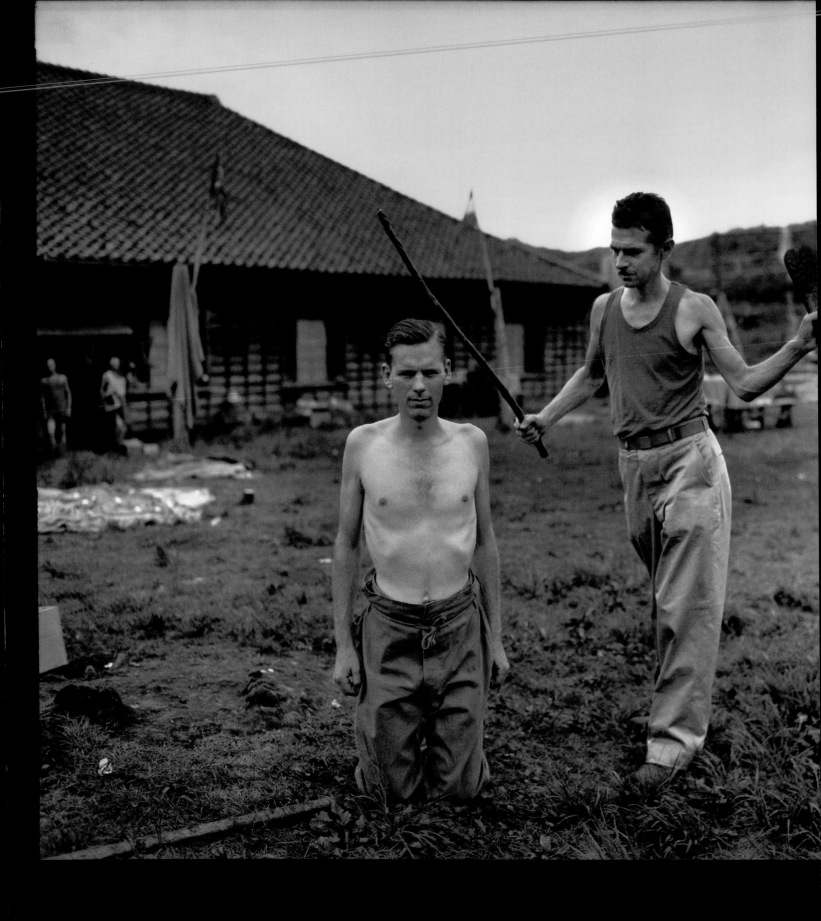

212149

212150-S

OCTOBER 24

Lieutenant Fred Garrett, a B-24 pilot from Oklahoma, lost a leg in a Japanese prison camp. Here he awaits transport to Yokohama by truck. Garrett's story was told in the best-selling book *Unbroken* by Laura Hillenbrand, about Olympic runner and prisoner of war Louis Zamperini. Garrett was shot down in the Pacific, suffered a compound ankle fracture in the crash, and floated 10 hours on a raft before the Japanese picked him up. Maggots infested his ankle, and the Japanese gave him a spinal anesthetic, leaving him conscious as they sawed his leg and then broke it off. They told him they were removing the whole leg, not just the foot and ankle, so that he could never fly a plane again. Garrett sought out Zamperini when they were put in the same Japanese prison camp.

LEFT: American officers demonstrate how they were abused by their Japanese captors. They were beaten on the head with bamboo poles and hit with a shoe for any "guilties" they committed.

NOVEMBER 2 FRISBIE PHOTO

American soldiers supervise German prisoners of war as they pile up sandbags to close off the entrance to an underground factory that made motor parts in Geislingen, Germany.

RIGHT: U.S. soldiers reenlist during a ceremony in Yokohama, bucking the trend in which many GIs wanted to get out of the service as quickly as possible with the war over. These troops are from the Americal Division, so named as shorthand for "American troops on New Caledonia," where the division was formed. Ultimately, the infantry division got a numerical designation—the Twenty-Third—but retained the name "Americal." Despite heroism on Guadalcanal and other World War II battlefields, the division's reputation was sullied because its soldiers committed the My Lai massacre of civilians during the Vietnam War. The Americal Division was deactivated in 1971.

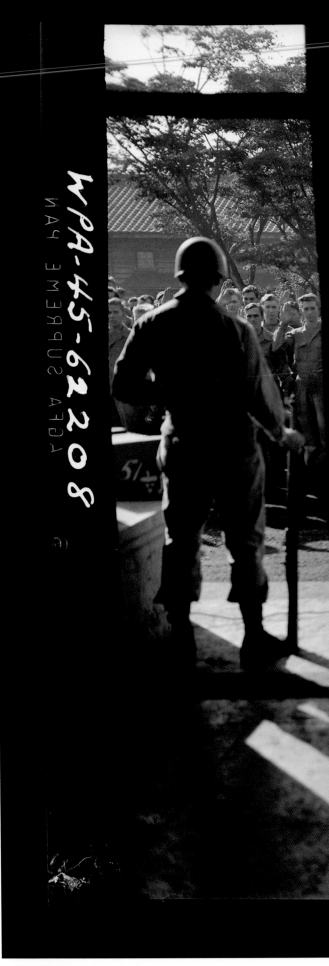

NOVEMBER 3

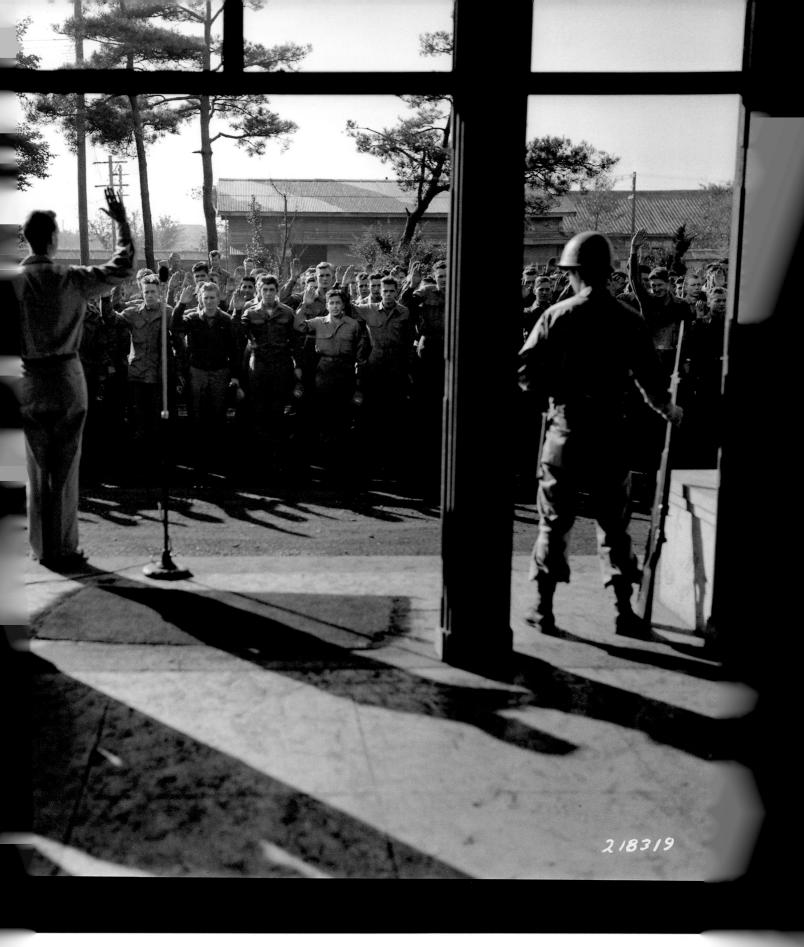

218319

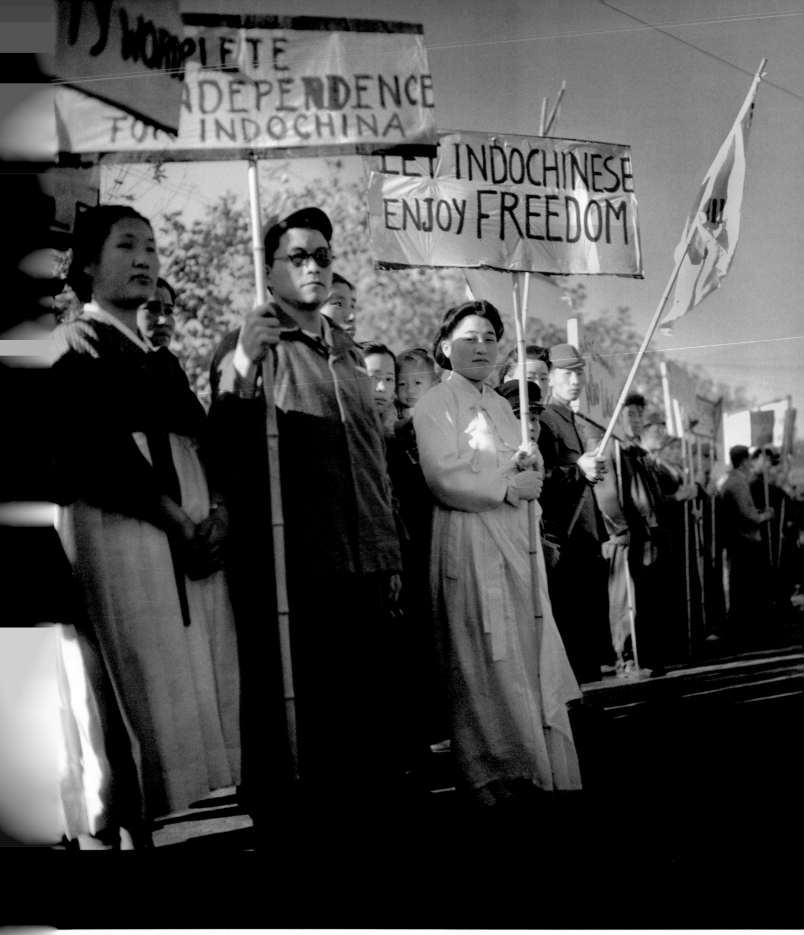

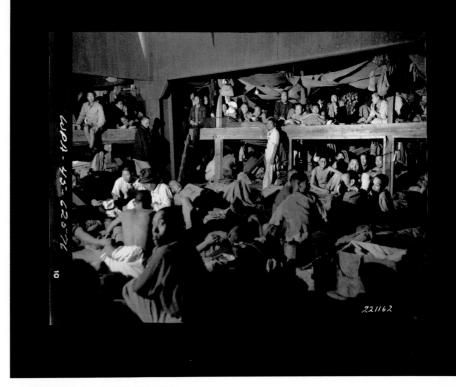

NOVEMBER 9 KOHN PHOTO

Chinese who were liberated from captivity crowd a ship called the *Enoshima Maru,* bound for China.

LEFT: Protesters gather outside General MacArthur's headquarters in Tokyo to urge postwar planners to support independence for Indochina. Counties in the region included Vietnam, which was occupied by France and then taken over by the Japanese. When the Japanese were defeated, the Vietnamese hoped to form an independent government, but the French went back in, followed by the Americans, leading to a rare military defeat for the United States.

222299

NOVEMBER 9 DEERING PHOTO

Graves prepared by the Japanese mark the places where American B-29 crewmen were buried.

LEFT: American airmen were held in this cell by the Japanese. The marks on the wall show the spots where the prisoners killed mosquitoes and other insects. Japanese leaders told their soldiers that honorable death was far preferable to humiliating surrender, and that attitude helps explain the Imperial Japanese Army's harsh treatment of Allied fighters who surrendered. About 27,000 Americans were taken prisoner by the Japanese, and 40 percent of them died, according to congressional research. Among Americans taken captive by the Germans, only 1 percent died.

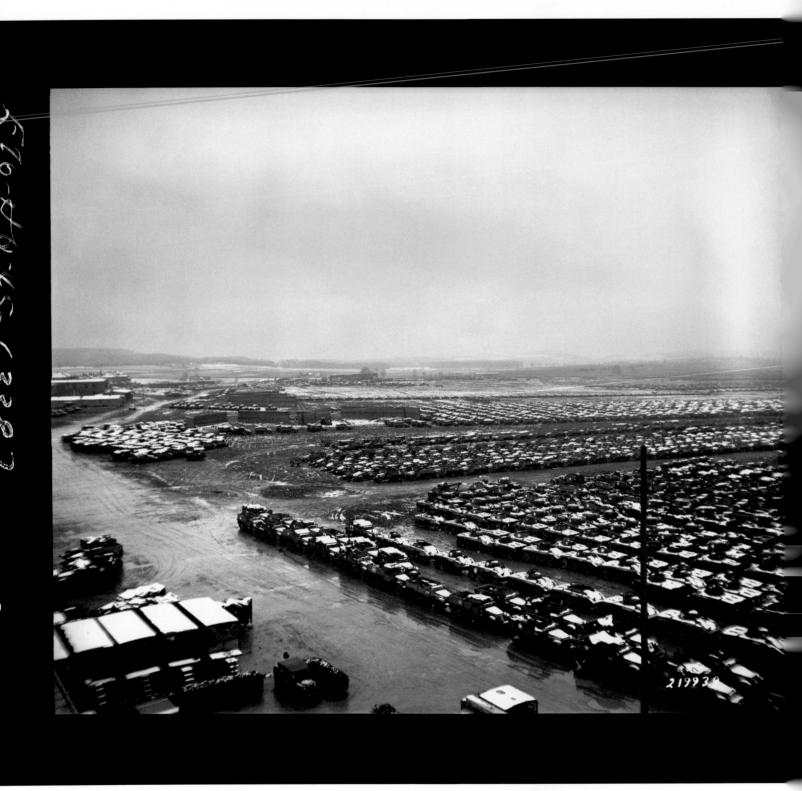

NOVEMBER 10 WILTON PHOTO

An enormous fleet of U.S. armored vehicles rests at Boblingen airfield near Stuttgart, Germany, after the long war. The airfield was created by the German military in World War I, closed after the German defeat, and reopened in the 1920s as a civilian airport. That's when the famed Graf Zeppelin landed at Boblingen in front of a crowd of 100,000. During World War II, Boblingen was a military airfield, a pilot training site, and a target for Allied bombers. When peace came, Boblingen served as a prisoner of war camp, a center for displaced persons, and a vehicle repair shop.

219940

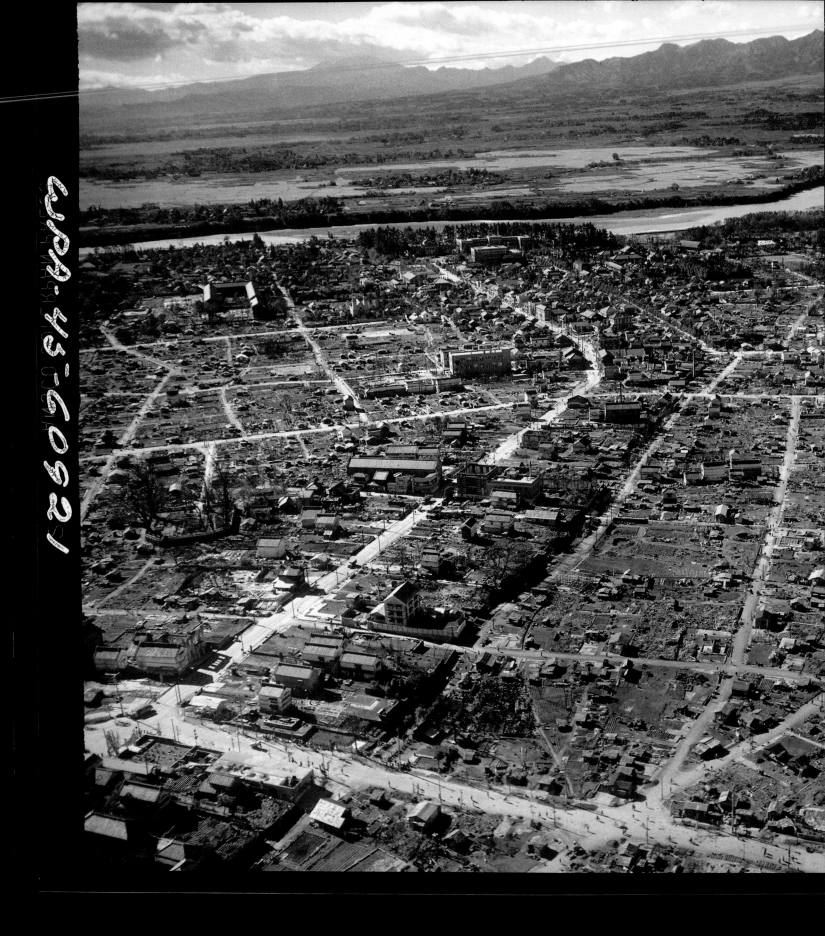

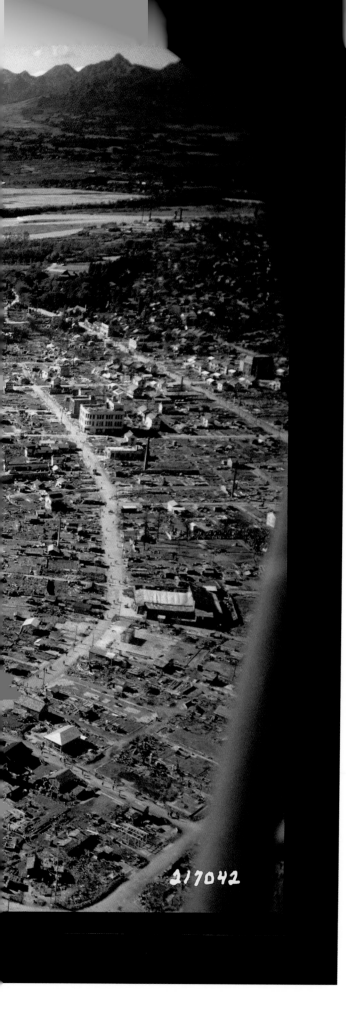

NOVEMBER 21 SPRINGLE PHOTO

While U.S. military censors had no problem showing American soldiers socializing with European women, they banned the release of this picture and others of Japanese women catering to American occupiers. It's not clear from the Signal Corps caption exactly what these women did at the Sapporo Club, but the Japanese had an organized and legal system in which businesses labeled as "restaurants" and "dance halls" might also serve as brothels for the occupation force. Some of those houses of prostitution resembled the comfort stations that the Japanese had set up for their own soldiers during the war. One notorious postwar brothel was the International Palace, which had a sort of assembly-line process in which GIs would drop off their shoes when they arrived, have relations with women, and pick up their newly shined shoes at the exit. These types of businesses embarrassed U.S. officials, who shut them down in 1946.

LEFT: The bombing of Maebashi, Japan, occurred a day before the atomic bomb fell on Hiroshima. More than 40 percent of Maebashi was destroyed.

NOVEMBER 21

A snapshot found in Frankfurt, Germany, shows Adolf Hitler, his wife-to-be Eva Braun, and a child named "Dachi."

LEFT: Found 6,000 miles away: a "predictor" machine used by the Japanese military to help anti-aircraft guns with targeting.

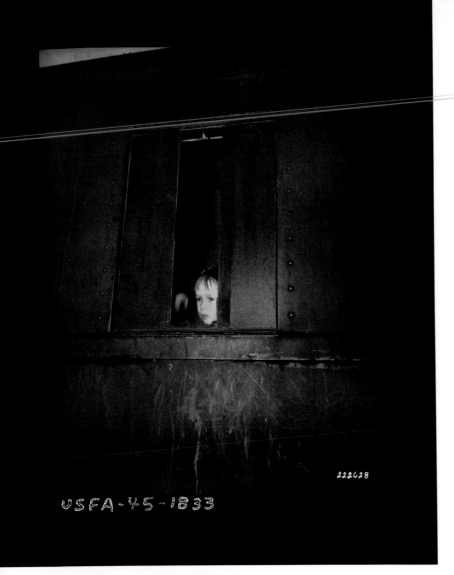

USFA-45-1833

222628

NOVEMBER 22 MANRY PHOTO

Amid hardships as the first winter after the fall of the Nazi regime approached, an Austrian boy was separated from his mother and sent by train from Vienna to Switzerland to be cared for.

RIGHT: Volunteers pass a box of donuts to children aboard a train headed to Switzerland. From 1945 to 1955, the Swiss Red Cross brought about 35,000 Austrian children to the city of Bern for three-month stays to relieve their malnutrition and poverty. Six decades later, 200 elderly Austrians who had been helped by the program returned for a ceremony in Bern to thank the Swiss.

USFA -5

NOVEMBER 22 ROBERT F. WATKINS PHOTO

222631

-1296

"Well, fascism has become a thing you can see and feel the burden of. It's no longer a newspaper headline. It's the real thing. You see men killed before your very eyes. You see the hate in the face of the Nazi soldier even while our medics are giving him first aid. . . . The brain isn't large enough to encompass all the suffering and hardships the Nazis have caused."

Walter Rosenblum
163rd Signal Photographic
Company

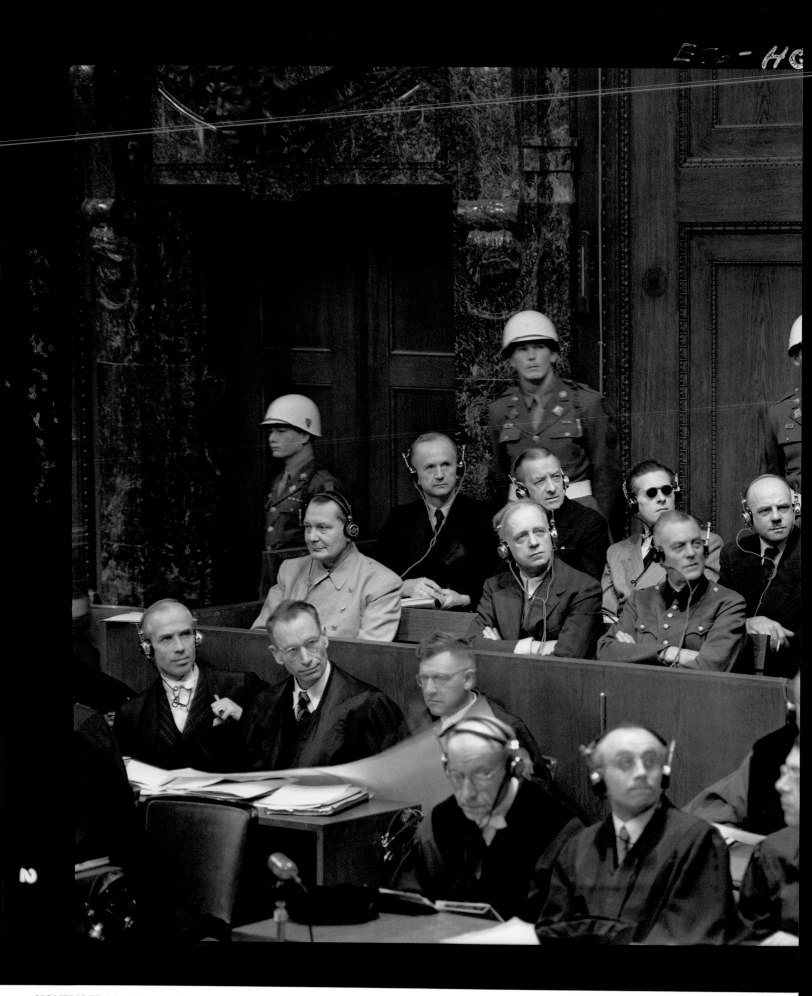

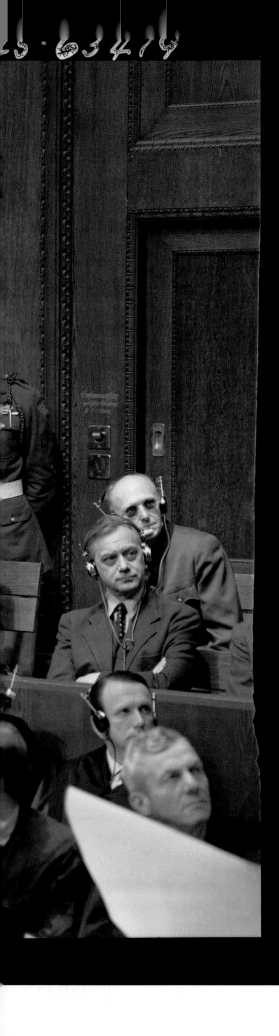

NOVEMBER 23 JOHN HEROD PHOTO

When the fighting stopped, some high-ranking Germans hoped to fade into the background as in past wars. But World War II atrocities were uniquely horrifying; the Allies were determined to hold the Nazis accountable. Shown reading a book is Rudolf Hess, the German deputy fuhrer who had taken a curious flight to Scotland in 1941 to try to talk peace with the British. They ignored his offer and imprisoned him. Held at the prison of the Palace of Justice in Nuremberg, Germany, the Nazi defendants were given "German rations"—the same meager food that civilians received. Hess was not pleased, writing the prison doctor: "I have been given a mass of egg which I cannot eat. Could I not be given instead more bread—even black bread—and some jam?"

LEFT: Among the Nazis on trial at Nuremburg were Luftwaffe boss Hermann Goering (in the light jacket and wearing earphones for a translation) and Foreign Minister Joachim von Ribbentrop (to Goering's left). Both Goering and von Ribbentrop were sentenced to death, while Hess got a life sentence. Taken to Spandau Prison in West Berlin, Hess died there in 1987 at age 93, an apparent suicide. The prison was immediately torn down so that it would not serve as a shrine to the Nazi movement.

NOVEMBER 24

Signal Corps photographers minutely documented the prison of the Palace of Justice—showing individual cells and former Nazis reading, smoking their pipes, and playing chess. Hermann Goering's writing table in his cell includes the Holy Bible, American Legion playing cards, photos of his family, American cigarettes, cigars, and wilted flowers. Not shown: the hidden cyanide capsule that Goering used to commit suicide hours before he was to be executed. Relations between the Soviets and the Americans were so bad at this point that the Soviets accused the Americans of giving Goering the cyanide. Twenty-two major Nazi figures were tried at Nuremburg, with 12 sentenced to death. The defendants, once so intimidating, inspired fear no more. "Observers remarked how utterly ordinary they appeared, these pale, tired figures in their ragged suits," wrote author Ian Buruma. Others who were accused of war crimes escaped capture and punishment, leading to decades of Nazi hunting worldwide. Fifteen years after the war, Israeli agents tracked down a key architect of the Holocaust, Adolf Eichmann, in Argentina. He was brought to Israel, tried, and executed.

RIGHT: A guard was posted in front of each cell door at the prison for the Palace of Justice. The cells of Rudolf Hess and Goering are at the far right.

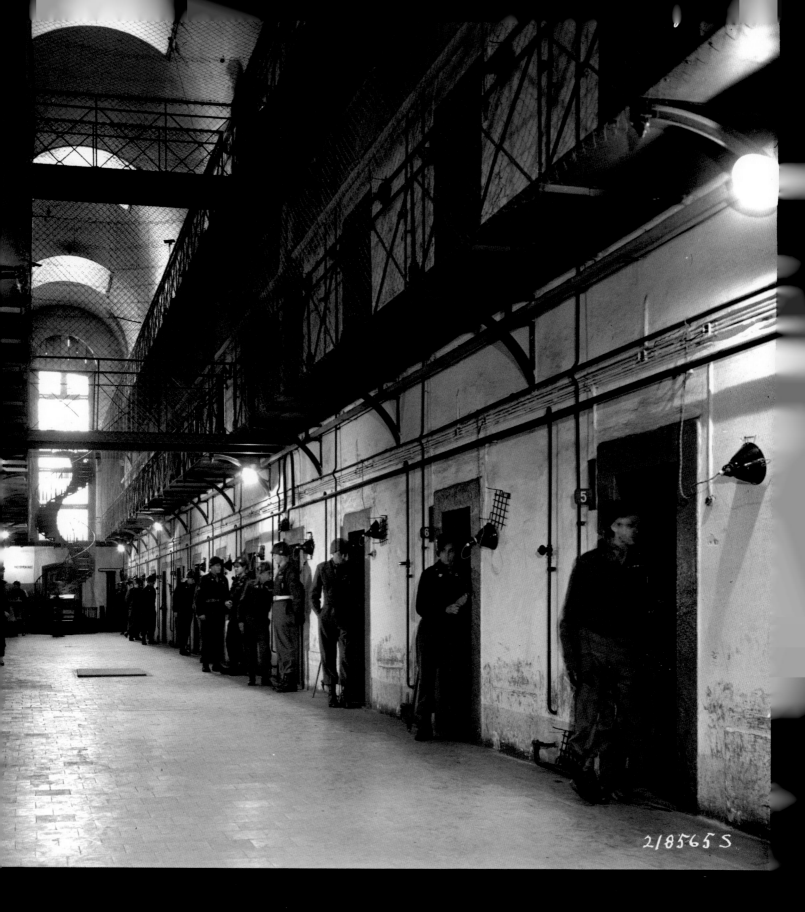

218565 S

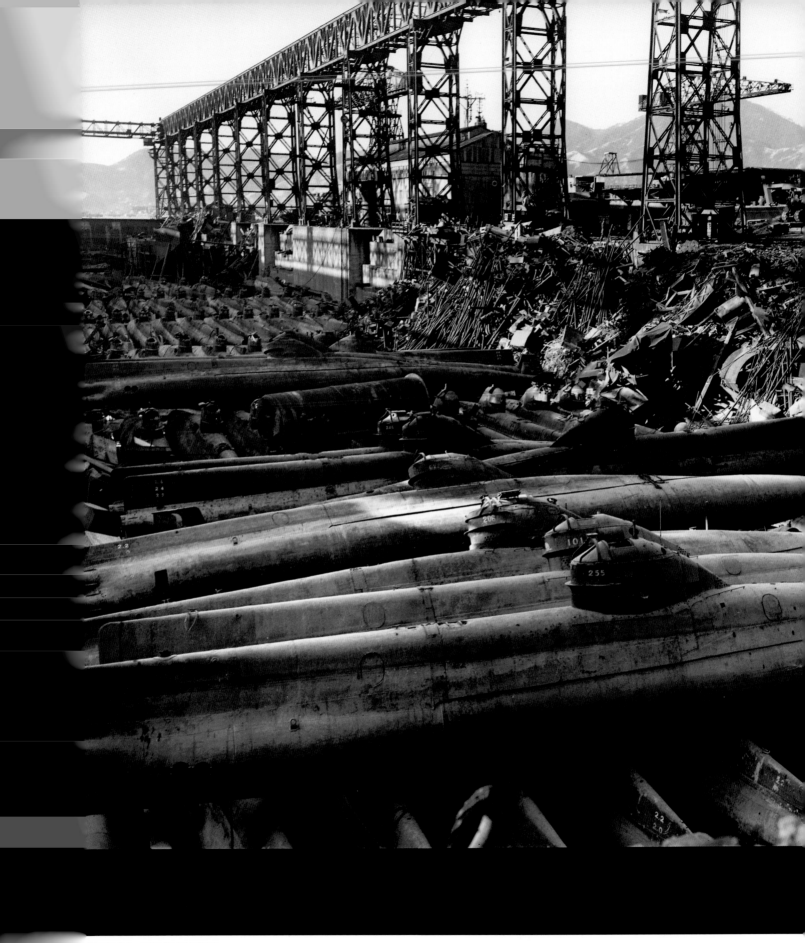

NOVEMBER 30

After years of building weapons, it was time to destroy them. Two cyclotrons and other equipment from the Japanese atomic program were dumped into Tokyo Bay off Yokohama. Japan was far behind the United States in its nuclear program, and some American scientists argued that the Japanese equipment could not be used to build a bomb. But American officials weren't taking any chances. About 350 tons of material was dumped, requiring two ships.

LEFT: A dry dock full of Japanese two-man subs was filled with scrap metal by engineers, who planned to pour salt water into the jumble of metal to corrode it and make the subs unusable.

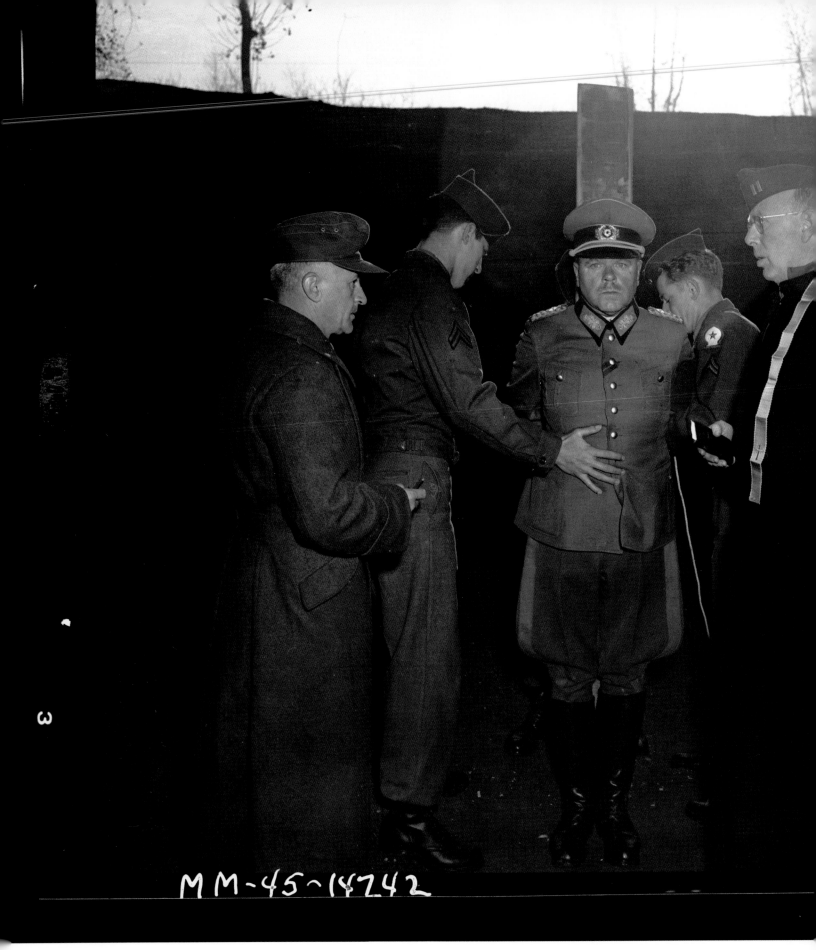

MM-45-18742

225295

MM-45-14751

DECEMBER 1 BLOMGREN PHOTO

LEFT: German General Anton Dostler is tied to a post before his execution by firing squad in Aversa, Italy. He had been found guilty of ordering the deaths of 15 American soldiers. The 15 men, on a commando mission to blow up an Italian railroad tunnel, were in uniform rather than in disguise, so their surrender should have been respected under the rules of war. Tried before an American tribunal, Dostler argued that Hitler had ordered all commandos be put to death, and that he would have been court-martialed if he had disobeyed. But the excuse of "just following orders" was not accepted after the war. At the execution site, the names of the victims were read to Dostler, and he shouted, *"Es lebe Deutschland!"* (Long live Germany!) before a 12-man firing squad did its work.

ABOVE: Dostler's body is hauled away.

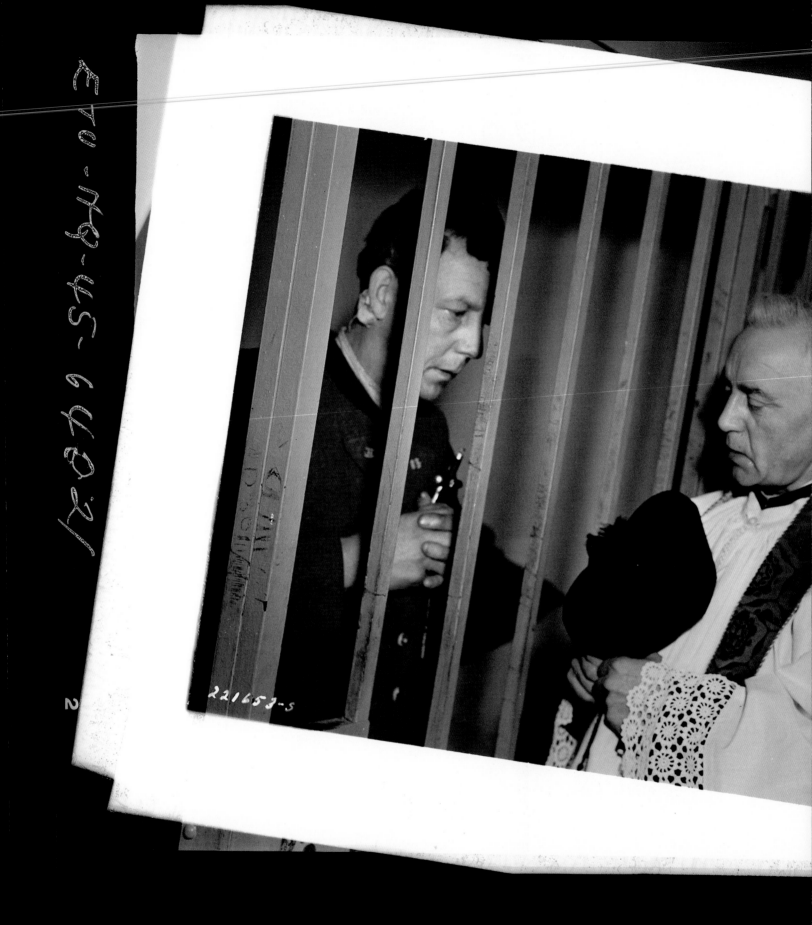

221653-5

Despite their despicable acts for a murderous regime, some Nazis considered themselves religiously devout. Franz Strasser, an Austrian Nazi, receives a blessing from Catholic priest Karl Morgenschweis at Landsberg Prison, west of Munich, as he awaits his execution by hanging. Strasser had accepted the surrender of five fliers from a downed American plane in Czechoslovakia, but then the airmen were shot, two of them by Strasser personally. At his trial, Strasser said the fliers were killed when they tried to escape, but a witness said otherwise. The *Chicago Tribune* report on the trial noted that after the death penalty was ordered, "Strasser picked up some cigarette butts in an ash tray and slipped them into the pocket of his coat."

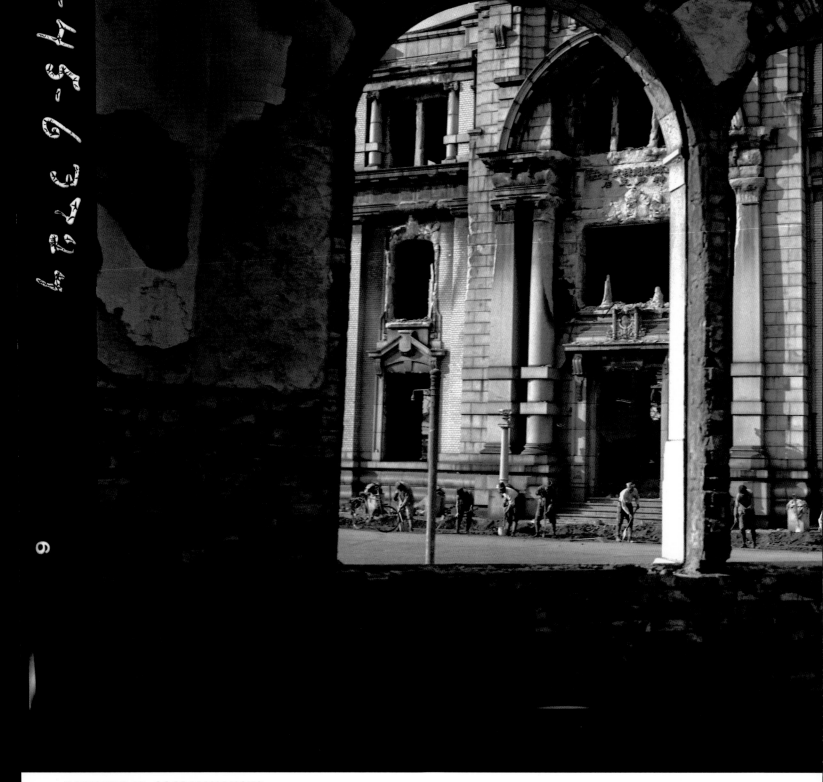

DECEMBER 17

Lieutenant Ivan Haselby (*right*) of Logansport, Indiana, and Captain Charles Sewell of Abilene, Texas, look over the dead body of Japan's former Prime Minister Prince Fumimaro Konoe after he was targeted by war crimes prosecutors and killed himself with cyanide rather than face arrest.

LEFT: This photo, taken from the inside of a bomb-damaged building in Kobe, shows Japanese civilians clearing debris. Kobe, Japan's sixth most populous city with a population of about one million, was battered in the last year of the war, with its many wooden buildings easily consumed by firebombs. In one March 1945 attack, three square miles of the city were demolished, with 8,000 people killed and 650,000 left homeless. Kobe "looked like a lake of white-hot metal," said Lieutenant Warren Aylesworthy of Empire, Michigan, who commanded a B-29. Yet the distance from the disaster allowed American news media to write with odd whimsy about the horror. An Associated Press story about Kobe burning for seven hours included an anecdote about Irish American crewmen hoping to celebrate St. Patrick's Day with four cans of beer left to cool in the camera hatch, only to find that the beer had fallen out and was "presumed in the hands of the enemy." A subhead read: "Japs Get Free Beer."

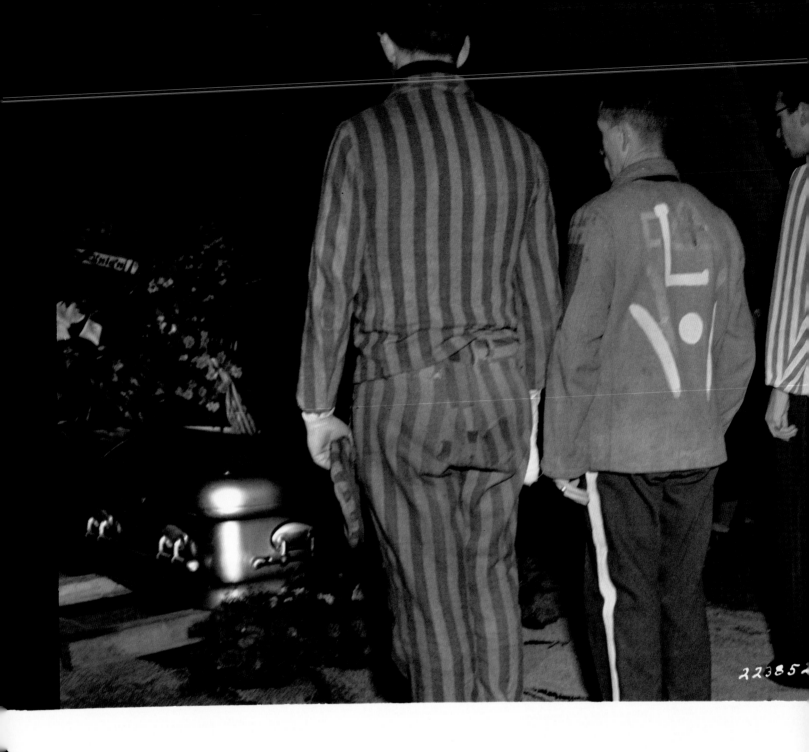

8

DECEMBER 24 RICHARD HOOD PHOTO

General George Patton, who survived so many desperate battles during the war, did not live long into the postwar era. He was on a pheasant hunting trip in Germany on December 9 when his car collided with an army truck and he suffered a broken neck. He died about two weeks later. Shown here are three men paying their respects at the general's casket. The three were members of the underground who helped downed Allied fliers but were ultimately captured and imprisoned at Dachau. They were grateful to Patton, whose army had liberated them from the infamous camp. Patton wanted to be buried at the U.S. Military Academy in West Point, New York, but military policy forbade service members who died overseas from being shipped home, and they would not make an exception for Patton. He was taken by train to the U.S. military cemetery in Hamm, Luxembourg, to be buried with his men.

Crime scene in Vienna. Like Berlin, postwar Vienna was divided into Soviet, American, British, and French zones. This is one of 17 photographs taken in late 1945 for the Vienna Area Command, which provided security in the U.S. sector. Vienna, like many cities bombed during the war, was in desperate need of food, fuel, clothing, and medical supplies. In a letter to the editor published on the last day of 1945 by the *Manchester Guardian,* John T. Stanley shared a plea from a friend in Vienna: "For goodness sake tell the people at home that the four powers will have to stop squabbling over trifles and try to stop this—it is only another way of having a Buchenwald." Allied officials reported they were "astonished and indignant" at how lax Vienna police and courts were in prosecuting Austrian Nazis. "Nazis of high standing are still reported to be running around freely, for the Austrian government so far has done little to aid in apprehending them," wrote the *New York Herald Tribune.*

For people in Vienna and around the world, the war's horror had been lifted, but the dawning of a new world brought its own threats of cruelty and death on an unimaginable scale. Signal Corps photographers remained in Vienna and throughout war-torn Europe and Asia recording the first years of the Cold War. And three-quarters of a century later, the human failures that brought us World War II remain well beyond our understanding.

William A. Avery
161st Signal Photographic Company

"I was just four calendar years older when I got out, but it seemed like a lifetime."

About the Photographers

Hundreds of soldiers worked as photographers for the U.S. Army Signal Corps during World War II. Based on our research and interviews, here are capsule profiles of some of the photographers whose work is featured in this book. Each profile includes page references to photos taken by that photographer. References to large photos that run across two pages include a dash.

Clifford Bell (1920–2013) took up photography at age 10 in San Antonio, Texas. He studied formally at the Ray School of Photography in Chicago before enlisting in the army in 1942. After the war, he purchased a banana plantation in Mexico that was wiped out by a hurricane, tried oil exploration, and worked with the Army Corps of Engineers. He also wrote the book *War through a Lens,* which documented his World War II experience. His niece Bobbi Farquar called Clifford a "free-spirited man." (Page 154)

Sidney Blau (1920–2007) was born in New York City. He learned photography at Brooklyn Technical High School, military skills in basic training, and how to stay alive during his first days of action in North Africa. That is where he met a British photographer who "told me when to duck and when to get the pictures." Blau moved to Sacramento, California, after the war. He worked briefly as a commercial photographer and for decades as a photoengraver for the *Sacramento Bee.* "I feel that every day I lived past World War II is a bonus," he told the Veterans History Project, "because I never really believed I would get through that." (Pages 114–115)

Joseph A. Bowen (1911–1970) was an employee at a photo studio in Philadelphia when he enlisted in 1943. After the war, he worked as a photographer for the Smithsonian Institution and resided in Falls Church, Virginia. (Page 169)

Philip J. Charleson (1925–2013) was woken in the middle of the night at Fort Benning, Georgia, to photograph Franklin Delano Roosevelt's funeral procession in Warm Springs. Charleson, then 19, used his best camera—a Speed Graphic—and brought plenty of film. "As luck would have it, I had two flash bulbs and two pieces of film left" when Roosevelt's casket was loaded onto a train, he later wrote. "As luck wouldn't have it, the first flash bulb was a dud and wouldn't go off." The second worked. After the war, Charleson worked for more than 60 years as a financial advisor in Chicago. He kept a darkroom in the basement of his suburban home. When he turned 80, his children gave him a Speed Graphic camera. (Pages 104–105)

Walter Chickersky (1924–2008) first served as a combat soldier and then as a soldier photographer during World War II. His obituary in the *Morning Call* in Allentown, Pennsylvania, noted that he was the first photographer to enter the Buchenwald concentration camp in Germany. After the war, he worked at Bethlehem Steel. (Pages 110–111)

Alan R. Cissna (1921–1979) was a photographer at the Dorchester Hotel's Hollywood Night Club in San Francisco when he registered for the draft. City directories indicate he was a sales manager in several California cities after the war. (Page 157)

Dwight Ellett (1917–2005) enlisted in 1941 and photographed in Belgium and Germany with the 165th Signal Photo Company. He was discharged at the end of the war and last lived in Hudson, Ohio. (Page 85)

Glenn W. Eve (1921–1994) worked on an experimental mobile photo lab built on a long semi-trailer truck for the Signal Corps in the Pacific. The lab was moved from New Guinea to the Philippines in 1945 and set up in Tokyo in August 1945. Before the war, Eve was an animator for the Walt Disney Company. Discovered at age 15 when he won a drawing contest, he dropped out of school to apprentice on *Fantasia.* "Disney did not re-hire him after the war and it broke his heart," wrote daughter Debra Eve. "He passed away in 1994, a broken man. I believe he suffered all his adult life from post-traumatic stress disorder." Glenn bequeathed his war photos to Debra, and said, "Do something with them." They sat in a box for decades, but she scanned them around 2010 and put them online. (Pages 210–211)

Gaetano Faillace (1904–1991) was a personal photographer of General Douglas MacArthur during World War II and the military occupation of Japan. Faillace was born in Italy and became a U.S. citizen in 1925. He lived in New York City when he enlisted and retired as a major. (Pages 54, 180–181)

Kingsley R. Fall (1908–1988) graduated from Dartmouth College in 1931, and joined the *Berkshire Evening Eagle* in Pittsfield, Massachusetts, the following year. He continued to work there after the war, later serving as managing editor. In May 1945, Fall wrote to the paper about the value of his photo work. He put down his camera during a firefight in the Philippines and picked up his sidearm, missing his chance to take a closeup photo of a Japanese soldier tossing a handmade bomb. "That was all that was needed to teach me once and for all that my weapon is a camera." (Pages 66–67, 228, 229)

Ralph Forney (1909–1968) took up photography at age 15, and worked for the *Ogden Standard-Examiner, Washington Herald,* and federal Resettlement Administration before enlisting. He also sold pictures to *Life* magazine. After the war, he moved to Hollywood and became a celebrity photographer, opening Hollywood Associated Photos. (Page 142)

Ignatius Gallo (1907–2004) enlisted in 1943 in New York City. He worked as a freelance photographer after the war and lived until age 97 in a suburb outside New York. (Page 158)

Henry Gasiewicz (1909–1964) photographed in Belgium and Germany with the 165th Signal Photo Company during the war. He was born in Centralia, Pennsylvania, and worked as a salesman before enlisting in 1944. (Page 107)

Sydney Greenberg (1919–2012) spent two years on China's southwestern border starting in 1943. He was embedded with the Chinese army, and traveled with General Chiang Kai-shek, leader of the Republic of China. After the war, Greenberg lived in New Canaan, Connecticut, where he worked as a justice of the peace and started the police department photography unit. He also ran a black-and-white darkroom in New York City. He lectured about his China experiences, but never returned to that country. Said son Philip, "He wanted the memories he had collected to remain undisturbed." (Page 39)

John Gutmann (1905–1998) was born in Breslau, Germany. He fled the Nazis in 1933 and settled in San Francisco, becoming a U.S. citizen in 1940. His early photographs of the United States—shot from an outsider's perspective—are filled with wonder and whimsy. "Using a Rolleiflex camera and shooting from the waist, he combines unusual angles, close cropping, and careful—almost classical—framing to create works that are as poetic as they are impactful," writes the International Center of Photography. Considered a master photographer, Gutmann approached his subjects as a press photographer and as an artist. "As a rule I do not like to explain my photographs," he later said. "I want my pictures to be read and explored." (Pages 52-53)

Jacob Harris (1908–1977) was born in Malmo, Sweden, and worked as a photographer for the Associated Press before enlisting. He was credited by *Popular Photography* as the first soldier to use the huge "Big Bertha" camera with a long telephoto lens in combat. Peter Maslowski, author of *Armed with Cameras,* said Harris also lugged his beloved violin through most of the war. (Page 81)

Arthur Herz (1921–2012) was born in Berlin, but left with his family in 1938 to avoid Nazi persecution. The Herzes moved first to Italy, then to England and Cuba. Arthur immigrated to Rochester, New York, to attend what would become the Rochester Institute of Technology. After unsuccessfully trying to join the Canadian Army and the U.S. Navy, he was drafted by the U.S. Army in 1942. He filed a petition for naturalization in 1943 while in training camp in South Carolina and was sent overseas in 1944. His ability to speak fluent German helped his company during the last year of the war. He later worked as a researcher for the Eastman Kodak Company. (Pages 64–65)

J. Malan Heslop (1923–2011) graduated from Utah State Agricultural College after the war and joined the photography staff of the *Deseret News* in Salt Lake City. He was later named the paper's managing editor. He served as a mission president, regional representative, and bishop for the Church of Jesus Christ of Latter-day Saints, and authored or coauthored more than a dozen books and plays. About 1,600 of Heslop's World War II photographs are online as part of the digital collection at Brigham Young University. (Pages 96, 116–117, 117)

Wendell N. Hustead (1912–2000) enlisted in 1943 in Greensburg, Pennsylvania. He photographed in Luxembourg and Germany during 1945 with the 166th Signal Photo Company. His tombstone reads: "Army Combat Photographer." (Pages 132–133)

Jack Kitzerow (1918–2002) owned and ran a photo retouching studio in Chicago after the war. Richard Smyth, who worked with him, recalled that Kitzerow kept a Luger in the office filing cabinet and owned a rope ladder because he was terrified by fire. Smyth said Kitzerow claimed he took the famous photograph of General Dwight D. Eisenhower addressing U.S. paratroopers in England just before D-Day. The photograph has never been credited. (Page 25)

Yale J. Lapidus (1919–2006) began his professional career at age 19 and joined the staff of *Life* magazine after the war, when he changed his name to Yale Joel. During his 25 years at *Life* he was known for his experimental work: creating pictures with infrared and antique cameras, extreme wide-angle lenses, and special lighting equipment. (Pages 12–13, 192, 192–193)

Joseph Lapine (1916–1977) enlisted in 1942 in Massachusetts and was sent overseas in early 1944. Lapine's landing craft was sunk before it reached the French coast, but he was rescued by GIs in a rubber raft. After the war, he worked as a reporter and photographer in Worcester, Massachusetts. (Page 62)

Edward Laudansky (born 1922) took part in the 1943 invasion of Makin Atoll in the Pacific's Gilbert Islands. "All this time my camera was my biggest worry," he wrote in the 1944 yearbook of Dorchester High School for Boys in Boston. He kept his camera over his head along with his combat pack. "I luckily kept them dry, but all the films I had in my pockets, my wallet, and the sixty-pound pack on my back were all soaked." (Page 8)

Clare Leipnitz (1921–1990), from Eau Claire, Wisconsin, was a linotype operator and staff photographer for the local *Leader* and *Telegram* before entering the military. He documented the building of the Ledo Road that made it possible to deliver supplies from India and Burma to China. (Page 49)

Jay B. Leviton (1923–2013) served two stints with the Signal Corps, and later moved to Atlanta to work as a commercial photographer. His 1956 photographs of Elvis Presley on a concert tour were published in the 1987 book *Elvis Close-Up.* "Apparently this was the last unrestricted access to Elvis," Leviton said. "Right after that, he went on the *Ed Sullivan Show* and became a national figure." (Pages 140–141)

James H. Lobnow (1922–2010) was working at Douglas Aircraft when he enlisted in 1942 in Los Angeles. He photographed in the China-Burma-India theater, and worked as an inspector after the war, according to city directories. (Page 52)

Frank Manwarren (1920–2010) developed an enthusiasm for landscapes during his Signal Corps years. "While in China, Frank was in the midst of misery," wrote David Barrett, a friend. "Soldiers were not only dying in combat, but falling to illness, including dysentery and malnutrition. Yet, in the midst of the horror of war, Frank noted that China was home to some of the most remarkable and beautiful rivers and waterscapes." Upon his return, Manwarren started constructing water sculptures and monuments. He built an island for Bush Gardens in Van Nuys, California; the grounds of the Japanese Pavilion at Epcot in Orlando, Florida; miles of shoreline along artificial lakes; and zoo habitats, according to the magazine *Landscape Architect*. He also had a long career as a Los Angeles Fire Department photographer. (Pages 162–163)

Francis Mayer (1907–1972) was one of the oldest Signal Corp photographers, enlisting at age 33. He was born in Pennsylvania and was working as a photographer when he joined the army. He died in California. (Pages 204–205)

Nathaniel Norman Milgrom (1921–2008) was born in Los Angeles, and was working for Universal Pictures when he enlisted in July 1942. After the war, he lived in Sherman Oaks, California. (Page 233)

Arland B. Musser (1910-1962), known for his photographs of the liberation of the Dachau concentration camp, opened a photo studio in Little Rock, Arkansas, after being discharged. He returned to his hometown of Decorah, Iowa, in 1948, and worked as a linotype operator for the *Decorah Posten,* a Norwegian-language newspaper. He and wife Barbara had four young children when he died. He was buried in Decorah.

(Pages 130, 130–131, 136–137)

James V. Naccarata (1920–2011) was born in New York and served as a combat photographer during World War II and the Korean War. He kept a book of war photos—brutal pictures of death and destruction—and didn't let his two boys look at it until they turned 18, said son Anthony. Naccarata started a photo business in New York after Korea and moved to California to work as a lithographer. He believed World War II was necessary to stop dictators. Said Anthony, "He was frustrated that people did not understand what a great sacrifice was made." (Pages 78–79)

William Norbie (1919–1995) was working at the Lockheed Aircraft Factory in Burbank, California, when he registered for the draft. He enlisted in July 1942 after three years of college. Norbie died in Missouri and was buried in the Missouri Veterans Cemetery. His tombstone notes he was a photographer for the 165th Signal Photographic Company. (Pages 166–167, 220–221)

Edward A. Norbuth (1918–1994) enlisted in November 1942 in Chicago and photographed in Belgium and Germany in 1945 with the 165th Signal Photo Company. He was discharged later that year and returned to his hometown. (Page 118)

Donald R. Ornitz (1920–1972) was called "the titan of the Hollywood photographers" by *Popular Photography* during his postwar career chronicling celebrities and models. His father, screenwriter and novelist Samuel Ornitz, was one of the Hollywood Ten blacklisted from work in Hollywood because they refused to testify before the House Un-American Activities Committee during the McCarthy era. Donald was called before the committee in 1959 and refused to answer questions about his affiliation with the Communist Party. One of his photos was chosen by Edward Steichen to be part of *The Family of Man,* the prestigious 1955 exhibit at New York's Museum of Modern Art that toured the world. (Pages 144–145)

Roland Oxton (1911–1984) was a photographer in Brookline, Massachusetts, when he enlisted in 1943. He shot for the Signal Corps in Europe and Japan. After the war, he worked as a newspaper photographer for Boston dailies, winning a 1979 Pulitzer Prize as part of a *Boston Herald American* team that covered a blizzard in eastern Massachusetts. Wrote Stanley Forman, who went on to win two more Pulitzers: "Rollie was the king of his era. He cruised the streets of Boston for parts of three decades, always there when it happened." (Page 138)

Ralph Paik (1913–1992) was born in Los Angeles and was working as a salesclerk when he enlisted in 1942. A Korean American, he was one of only a few photographers of Asian descent in the Signal Corps during World War II. (Pages 94–95, 214–215)

Charles Pearson (1920–2015), born in Texas, was working as a freelance photographer in Vancouver, British Columbia, when he enlisted. He served as a photographer and photo lab supervisor during the war. Later, he was a commercial photographer in Seattle, specializing in food and architectural photography. (Pages 86–87)

Louis W. Raczkowski (1913–1964) enlisted in 1942 in Syracuse, New York, and served in the China-Burma-India theater. He received the Bronze Star for his artillery action pictures. (Page 38)

Ernest E. Reshovsky (1921–1975) was born in Vienna, Austria. He became a U.S. citizen in 1946 and worked as a Los Angeles photojournalist after the war. His photographs were donated to the UCLA Library. On his tomb is inscribed: "I am a camera." (Page 76)

Harold Roberts (1918–2001) was exempt from the draft, according to his wife, Barbara, because he worked at a shipyard. But he enlisted in 1942. "He was Jewish. He heard what was going on and he wanted to do his part," she said. Roberts, who grew up in Boston, started his army career with the military police. In Europe, he was told the Signal

Corps needed photographers, and he volunteered. After the war, he worked briefly as a fashion photographer, but left to become a shipbroker. He seldom talked about the war but kept an album of photographs. "He came out pretty doggone normal," said Barbara. "He was very lucky." (Pages 100–101,106–107, 137, 143)

Barney Rosset (1922–2012) became a noted publisher and fighter for free speech. He purchased Grove Press for $3,000 in 1951, and created its *Evergreen Review* magazine. He introduced dozens of influential writers to American audiences, including Jean Genet and Eugene Ionesco, as well as Nobel Prize–winners Samuel Beckett and Pablo Neruda. He also led a legal battle to publish an uncensored version of D. H. Lawrence's novel *Lady Chatterley's Lover,* and later published Henry Miller's *Tropic of Cancer* and William S. Burroughs's *Naked Lunch.* In 2002, he showed a collection of his Signal Corps photographs at a New York art gallery. *The New York Times* headlined his obituary "The Man Who Made Publishing a High-Wire Act." (Page 181)

Chester G. Rusbar (1915–2015) was discharged on the day Japan surrendered. When he got home, he met Alice Murchio, sister of Signal Corps buddy Lou Murchio. Chester and Alice fell in love and married. Chester became a movie photographer, worked for Boeing, and documented the construction of NASA's first rockets, according to daughter Norma Rusbar. "He was a space nut," she said. He was also a pacifist. "He told me my whole life that war doesn't solve anything. He went because he felt like he was doing his job." Chester died at age 99 at his home in Covington, Louisiana. (Page 160)

Adrien J. Salvas (1914–2000) was a celebrity photographer in Miami Beach before the war, shooting Hollywood stars on vacation. Salvas got married a few months after his return from Europe. He worked as a photographer for local New Jersey newspapers until 1955, when he began a career as a liquor salesman. "He was funny, kind, and serious when

necessary," said son Adrien. "Always ready to help another person." (Pages 56, 57, 96–97)

Arnold E. Samuelson (1917–2002) grew up in Tacoma, Washington, and sold camera equipment for Eastman Kodak before his 1942 enlistment. He served briefly in the U.S. Army Air Corps before training to be a Signal Corps photographer. He seldom talked about his war experience afterward, but traveled to Austria in 1996 to find what remained of the Ebensee concentration camp. He returned the following year as an honored guest for the dedication of a permanent exhibit at the Ebensee Memorial. (Pages 146–147)

Charles B. Sellers (1913–1985) was born in Scotland, immigrated to the United States in 1923, and lived most of his life in Schenectady, New York. His photographs of everyday infantrymen appeared in newspapers across the country in 1945. He was discharged from the Signal Corps in 1946. (Pages 68, 69)

William Spangle (1914–1977) was working as a professional photographer when he enlisted in 1942. He photographed the fall of Germany with the 165th Signal Photo Company, and was discharged in 1945. (Page 70)

Robert Stubenrauch (1924–1998) published five books, including *CAT 13,* his autobiographical novel about his experience as a combat photographer. He lived in Canton, Ohio, and retired in 1985 as the head of corporate photographic operations for Goodyear Tire and Rubber. He also worked to restore Goodyear's Wingfoot Express, the jet-powered car that set a land speed record in the 1960s. (Pages 54–55)

Charles Tesser (1920–2004) opened a short-lived photo studio in New York, and then began a long career as a cameraman and engineer for NBC-TV, where he covered assassinations, the civil rights movement, Super Bowls, and Miss America pageants. He also worked on classic TV shows like Sid Caesar's *Your Show of Shows* and *The Perry Como Show.* In 2014, Tesser's son Lewis put together

In the Thick of Things, a book of his father's World War II photos. Charles focused his postwar photo work on taking color slides of his wife and kids. "All that was important to him was his family," Lewis said. "He didn't let little stuff bother him." (Page 44)

William J. Tomko (1919–2009) worked as an advertising director for Weatherhead Corporation in Ohio after World War II. He recalled watching Messerschmitt jets during the last days of the war. "We saw for the first time propeller-less airplanes, totally unheard of at that time, strafing us and machine-gunning our troops as we sped along the autobahn. This was Hitler's last secret weapon, and thank God, they were too few, too late." (Pages 90–91)

Josef von Stroheim (1922–2002) was born to movie royalty and grew up in Beverly Hills, California. The son of Hollywood actor and director Erich von Stroheim, Josef worked as a still photographer for Metro-Goldwyn-Mayer starting in 1939. He enlisted in 1942 and served in Europe and Japan. After the war, he returned to Los Angeles to work as a sound editor for dozens of TV shows and films, including *A Star Is Born* in 1976. (Page 119)

Louis Weintraub (1922–1991) was born in Montreal and raised in New York. He became a U.S. citizen in 1946. He worked as a picture editor for the government's Office of War Information and the Army Pictorial Service, which oversaw Signal Corps photo coverage. After the war, he opened a public relations firm and a picture service named Photo Communications Company. His 1944 photograph of GIs helping an exhausted comrade onto the Normandy shore became one of the most famous photographs of D-Day. (Pages 232–233)

George H. Wolinsky (1922–1977), a graduate of Brooklyn College, enlisted in October 1942 and served in the China-Burma-India theater. Taking pictures from an airplane, he covered the 1945 recapture of Corregidor Island in the Philippines. (Page 222, 222–223)

Acknowledgments

This book about the intrepid U.S. Army Signal Corps photographers took us all around the world. Granted, most of that travel was online, but the book has been an adventure since the day we arrived at the National Archives in College Park, Maryland, in 2017 and filled out our first reference service slip for Record Group 111. Since then, we've been following the photographs wherever they take us.

Sometimes it was to Colorado, where we tracked down the story behind our cover boy, Jack Pulliam. Despite how bad he looked on the night he was reunited with American troops, Pulliam went on to live a vital and healthy life. He passed away at age 68 in 1993. We contacted his son, Tim Pulliam, who sent us a 19-page manuscript written by Jack about his capture and escape from the Nazis. Tim's daughter Kristen Pulliam wrote, "Thank you for writing about my grandfather. He was truly one of a kind in my book."

Sometimes, we didn't need to travel at all. The medical officer who described what happened to the death-march women in Volary, Czechoslovakia, (page 151) is Aaron Cahan, father of coauthor Richard Cahan. He, too, was photographed by the Signal Corps as he gave aid to one of the survivors. We never would have found his photograph (SC-325738) with a simple name search because his name was misspelled on the caption sheet.

Scholarly thanks go to Peter Maslowski, whose father, Karl Maslowski, was a U.S. Army Air Forces photographer. Peter spent 16 years putting together *Armed with Cameras,* the bible on this subject. He interviewed 77 World War II photographers. Almost all were dead by the time we started—but their words and deeds will live forever because of his work. We were also helped by Ralph Butterfield of the 166th Signal Photographic Company, who was smart enough to gather 36 essays from his photo colleagues in 1945 as they waited in Camp New Orleans in northern France and reflected on their experiences. The essays became Butterfield's 1990 book *Patton's GI Photographers.*

All of the photographs and much of the written material were found in the National Archives. Thanks go to Holly Reed, who runs the Still Picture Branch and who answered all of our questions, and to the kind and ever-watchful Still Pix staff. We also looked through the records of every Signal Corps photo company at the archives.

Even though readers might think this book is about 1945, it is really about a timeless subject—human behavior. Nothing was more helpful in understanding the life of Signal Corps photographers than the personal recollections of Signal Corps photographers written in books or detailed in oral interviews. We found great insight in *War through a Lens* by Clifford Bell, *Darkness Visible* by Charles Eugene Sumners, and *CAT 13* by Robert Stubenrauch. Also helpful were interviews of Signal Corps photographers from the Veterans History Project, which can be found online.

Only a few photographers are still around to reflect on 1945. Journalist Lisa Reisman led us to Ira Lewis, who recalled in detail what it was like to be in Manila in 1945. The families of photographers were extremely helpful. David Edgren shared an interview of his father, Emil Edgren, about his experience in the European theater; Philip Greenberg sent us photographs and interviews of his father, Sydney Greenberg. Ruth Domb DeSantis, Debra Eve, Art Greenhaus, Susan Heymann, David Joel, Anthony Naccarato, David Manwarren, David Oxton, Barbara Roberts, Adrien J. Salvas, Barbara Salk, Lewis Tesser, and Michele Salvas Trabert shared memories of their beloved photographers. Also helping were Patrick Brion, Bill Musser, and Richard Smyth.

We paid a visit to Susan Rutberg, daughter of Jerry Rutberg, in San Francisco. She admits that her home is part shrine to her father, who passed away in 1965 when Susan was just about to leave for college. She has spent the past few decades trying to learn more about her father, scanning photographs he left behind and meeting with his colleagues, like Harold Hershey, who cried when they met.

Susan cries, too, when she explains why she has posted her father's World War II photographs online.

"I've been waiting my whole life to share what he saw with as many people as I could get to look because I think he had a beautiful eye for important historical events.

"Every time I look at one of Jerry's pictures, I feel like I'm seeing what he saw," she said. "It brings me closer to

knowing him."

Several people helped us solve mysteries surrounding the photographs.

We were fortunate to track down Genevieve Young, who spent the war in the Japanese-occupied Philippines and whose father, Chinese Consul General Clarence Kuangson Young, was executed by the Japanese there. Genevieve helped her mother, Juliana (Mrs. V. K. Wellington) Koo, produce an autobiography, *My Story,* which tells the harrowing story of those times. Genevieve and her mother had left the Philippines for the United States just a few months before the photo was taken of grieving Chinese relatives (pages 172-173), so her mother was not in the picture. But Genevieve helped us identify the people in the photograph. She told us she had never seen the photo before we showed it to her.

We received help from scholars to identify the Soviet general pictured during a meet-up celebration with the Americans (page 140). The original captions by Signal Corps soldier photographers vary widely in accuracy, and we soon figured out that this one was just plain wrong. So we reached out to several historians familiar with the Soviet Union to see whether they knew the general's name. Professors Margaret Peacock of the University of Alabama, Laura McEnaney of Whittier College, and Martin Sherwin at George Mason University offered assistance. Sherwin made the key connection for us when he sent our query to Russian Academy of Sciences member Natalia Tarasova, who consulted historians at Mendeleev University in Moscow. Mendeleev's Alexandre P. Zhukov and Natalia Denisova identified the general as Filipp Cherokmanov.

John C. McManus, a history professor at Missouri University of Science and Technology, was a generous provider of information on the liberation of the Dachau concentration camp. His book *Hell before Their Very Eyes* is an impressive achievement in scholarship and a riveting read.

Christopher E. Mauriello, a history professor at Salem State University in Massachusetts and director of the Center for Holocaust and Genocide Studies, helped us with information on the Allies' practice of forcing German citizens to face up to their government's atrocities. His book *Forced Confrontation: The Politics of Dead Bodies in Germany at the End of World War II* is a significant work on that topic.

Mick Broderick, associate professor of media analysis at Murdoch University in Western Australia, helped us understand the significance of the photograph showing a train carrying Australian prisoners of war from Nagasaki (pages 222-223).

The public libraries in Skokie and Evanston, Illinois, were vital resources. In addition, Paul W. Grasmehr, reference coordinator at the Pritzker Military Museum and Library in Chicago, offered advice.

Special thanks to copy editor Mary Klein, who has stood by us since the start and pushed us to be as clear and precise as possible.

Signal Corps aficionados Hunter Miertschin, Chad Phillips, and Tom Sullivan helped review parts of our manuscript. Also helpful was Ivan Yee-Gwan Lo of Vintage Camera Lab.

Most important, we would like to recognize our families. Thanks to the Cahans: Cate Cahan; Elie, Caleb, Maddie, and Millie Burroughs; Claire Cahan, Schuyler and Evergreen Cahan Smith; Aaron, Valerie, and Peter Cahan; and Glenn Cahan. Also, the Jacobs: Lisa Jacob; Maureen, Greg, Malcolm, and Brendan Etter; and Katherine Jacob. And the Williamses: Karen Burke, and Caedan and Christopher Jinks.

Tatsu Aoki, of Asian Improv Arts Midwest, is our fiscal sponsor, and we appreciate his support for so many years.

Jonathan Logan and the Jonathan Logan Family Foundation provided the resources and trust to make this project possible. Jon understands that lessons of World War II are relevant in efforts toward social justice today. He shares our belief in the need to face the true cost of war and pursue lasting peace.

Sources

Abzug, Robert H. *Inside the Vicious Heart: Americans and the Liberation of Nazi Concentration Camps.* New York: Oxford University Press, 1985.

Allen, Michael Thad. *The Business of Genocide: The SS, Slave Labor, and the Concentration Camps.* Chapel Hill: University of North Carolina Press, 2002.

Ambrose, Stephen E. *Citizen Soldiers: The U.S. Army from the Beaches of Normandy to the Surrender of Germany.* London: Simon & Schuster, 1997.

Appleman, Roy Edgar, James Burns, Russell A. Gugeler, John Stevens, and Harry J. Maloney. *Okinawa: The Last Battle.* New York: Skyhorse Publishing, 2011.

Architects' Journal, vol. 108. Architectural Press Limited, 1948.

Associated Press. "350 B-29s Bomb Kyushu, Shikoku Factory Cities." *Chicago Tribune*, July 27, 1945.

Associated Press. "Kobe Burns for 7 Hours after Record B-29 Raid." *Chicago Tribune*, March 18, 1945.

Associated Press. "Wedding on Okinawa: Army Chaplain Marries Captive and Native Nurse." *New York Times*, May 1, 1945, 11.

Associated Press. "MacArthur Clamps Iron Glove over Japanese People." *Miami (Oklahoma) Daily News-Record*, September 11, 1945.

Axelrod, Alan. *The Real History of the Cold War: A New Look at the Past.* New York: Sterling, 2009.

Barkley, Alben William. *Atrocities and Other Conditions in Concentration Camps in Germany.* Washington, D.C.: U.S. Government Printing Office, 1945.

Barnouw, Dagmar. *Germany 1945: Views of War and Violence.* Bloomington: Indiana University Press, 2008.

Beevor, Antony. *The Fall of Berlin 1945.* New York: Viking, 2002.

Beevor, Antony. *The Second World War.* New York: Little, Brown, 2012.

Bell, Clifford. *War through a Lens: A Combat Team Photographer Looks at World War II.* Colorado Springs: Tell Your Story Books, 2017.

Beyond Victor's Justice? The Tokyo War Crimes Trial Revisited. Edited by Yuki Tanaka, Timothy L. H. McCormack, and Gerry Simpson. Leiden, Belgium: Nijhoff, 2011.

Biddiscombe, Perry. *The Last Nazis: SS Werewolf Guerrilla Resistance in Europe 1944–1947.* Stroud, UK: Tempus, 2006.

Boomhower, Ray E., and John A. Bushemi. *One Shot: The World War II Photography of John A. Bushemi.* Indianapolis: Indiana Historical Society Press, 2004.

Boot, Chris. *Great Photographers of World War II.* New York: Crescent Books, 1994.

Borch, Fred. *For Military Merit: Recipients of the Purple Heart.* Annapolis, Md.: Naval Institute Press, 2010.

Bracker, Milton. "U.S. Firing Squad Executes Dostler." *New York Times*, December 2, 1945.

Buruma, Ian. *Year Zero: A History of 1945.* New York: Penguin Books, 2014.

Butterfield, Ralph. *Patton's GI Photographers.* Ames: Iowa State University Press, 1992.

Caddick-Adams, Peter. *Snow & Steel: The Battle of the Bulge, 1944–45.* New York: Oxford University Press, 2015.

Calloway, Donald H. *Champions of the Rosary: The History and Heroes of a Spiritual Weapon.* Stockbridge, Mass.: Marian Press, 2016.

Calloway, Larry. "N.M. Gave Birth to Atomic Bomb." *Albuquerque Journal*, September 19, 1999.

Capa, Robert. *Slightly Out of Focus.* New York: Modern Library, 2001.

CBI Roundup, vol. III, no. 20. "Mercy L-1 Up a Tree: GIs Rescue Four Injured Men." Dehli, India, January 25, 1945.

Caughey, John Hart. *The Letters and Diaries of Colonel John Hart Caughey, 1944–1945: With Wedemeyer in World War II China.* Edited by Roger B. Jeans. Lanham, Md.: Rowman & Littlefield, 2011.

Chickering, Roger, Stig Forster, and Bernd Greiner. *A World at Total War: Global Conflict and the Politics of Destruction, 1937–1945.* Washington, D.C.: German Historical Institute, 2010.

Cohn, Gordon, and Ivan J. Houston. *Black Warriors: The Buffalo Soldiers of World War II: Memories of the Only Negro Infantry Division to Fight in Europe during World War II.* New York: iUniverse, 2009.

Colley, David P. *Seeing the War: The Stories behind the Famous Photographs of World War II.* Lebanon, N.H.: ForeEdge, an imprint of University Press of New England, 2015.

Crawford, Steve. *The U.S. Army in World War II: The Stories behind the Photos.* Washington, D.C.: Potomac Books, 2007.

Crew, David F. *Bodies and Ruins: Imagining the Bombing of Germany, 1945 to the Present.* Ann Arbor: University of Michigan Press, 2017.

Cronin, Francis D. *Under the Southern Cross: The Saga of the Americal Division.* Combat Forces Press, 1981.

Dancocks, Daniel George. *The D-Day Dodgers: The Canadians in Italy, 1943–1945.* Toronto, Canada: McClelland & Stewart, 1990.

Douhet, Giulio. *The Command of the Air.* Washington, D.C.: Office of Air Force History, 1983.

Dower, John W. *Embracing Defeat: Japan in the Wake of World War II.* New York: W. W. Norton, 1999.

Droke, Maxwell. *Good-by to G.I.: How to Be a Successful Civilian.* New York: Abingdon-Cokesbury, 1945.

Dronfield, Jeremy. *The Stone Crusher: The True Story of a Father and Son's Fight for Survival in Auschwitz.* Chicago: Chicago Review Press, 2018.

Duncan, David Douglas, and John Gunther. *Nomad: A Photographic Odyssey.* New York: Holt Rinehart Winston, 1966.

Dyreborg, Erik. *The Captured Ones: American Prisoners of War in Germany, 1944–1945.* New York: iUniverse, 2006.

Erlandson, Robert A. "She Nursed a War Criminal." *Baltimore Sun*, October 15, 1995.

Feifer, George. *The Battle of Okinawa: The Blood and the Bomb.* Guilford, Conn.: Lyons Press, 2001.

Fleming, Malcolm, and James H. Madison. *From War to Peace in 1945 Germany: A GI's Experience.* Bloomington: Indiana University Press, 2016.

Foot, John. *Italy's Divided Memory.* Basingstoke, UK: Palgrave Macmillan, 2009.

Francillon, René J. *Japanese Aircraft of the Pacific War.* Annapolis, Md.: Naval Institute Press, 1995.

Freedman, Jean R. *Whistling in the Dark: Memory and Culture in Wartime London.* Lexington: University Press of Kentucky, 2015.

Freeman, Lindsey A. *Longing for the Bomb: Oak Ridge and Atomic Nostalgia.* Chapel Hill: University of North Carolina Press, 2015.

Friedrich, Jorg. *The Fire: The Bombing of Germany, 1940–1945.* New York: Columbia University Press, 2008.

Gagnon, Dawn. "Photographer's Legacy Alive in WWII Photos." *Bangor Daily News,* July 31, 2009.

Gayford, Martin. "Cracking the Case of the Nazis' Stolen Art." *London Daily Telegraph,* November 9, 2013.

Giangreco, D. M. *Hell to Pay: Operation DOWNFALL and the Invasion of Japan, 1945–1947.* Annapolis, Md.: Naval Institute Press, 2009.

Goldensohn, Leon. *The Nuremberg Interviews: An American Psychiatrist's Conversations with the Defendants and Witnesses.* London: Pimlico, 2006.

Goldhagen, Daniel Jonah. *Hitler's Willing Executioners: Ordinary Germans and the Holocaust.* New York: Alfred A. Knopf, 1998.

Goldstein, Richard. "Obituary: American Convicted as 'Tokyo Rose.'" *New York Times,* September 27, 2006.

"The Good Old Days": The Holocaust as Seen by Its Perpetrators and Bystanders. Edited by Ernst Klee, Willi Dressen, and Volker Riess. New York: Konecky & Konecky, 1991.

Gosling, F. G. *The Manhattan Project: Making the Atomic Bomb.* Washington, D.C.: Office of History and Heritage Resources, Executive Secretariat, Office of Management, Department of Energy, 2010.

Gruhzit-Hoyt, Olga. *They Also Served: American Women in World War II.* New York: Birch Lane Press, 1995.

Hager, Thomas. *The Demon under the Microscope: From Battlefield Hospitals to Nazi Labs, One Doctor's Heroic Search for the World's First Miracle Drug.* New York: Harmony Books, 2006.

Hagerman, Bert, and Herbert C. Banks. *17th Airborne Division Association.* Paducah, Ky.: Turner, 1999.

Ham, Paul. *Hiroshima Nagasaki: The Real Story of the Atomic Bombings and Their Aftermath.* New York: Thomas Dunne Books, St. Martin's Press, 2011.

Hane, Mikiso. *Modern Japan: A Historical Survey.* Boulder, Colo.: Westview Press, 2015.

Hanson, Victor Davis. *The Soul of Battle: From Ancient Times to the Present Day, How Three Great Liberators Vanquished Tyranny.* New York: Free Press, 1999.

Harvard Magazine. "Like Garlic or Burning Matches." May–June 2013.

Heller, Jonathan. *War and Conflict: Selected Images from the National Archives.* Washington, D.C.: National Archives and Records Administration, 1990.

Hewitt, Kenneth. "Place Annihilation: Area Bombing and the Fate of Urban Places." *Annals of the Association of American Geographers* 73, no. 2 (June 1983).

Hickley, Catherine. "Painting Looted from Hitler to be Auctioned in Cologne." *Art Newspaper,* November 14, 2017.

Hicks, George. *The Comfort Women: Japan's Brutal Regime of Enforced Prostitution in the Second World War.* New York: W. W. Norton, 1995.

Hillenbrand, Laura. *Unbroken: A World War II Story of Survival, Resilience, and Redemption.* New York: Random House, 2010.

Hirsh, Michael. *The Liberators: America's Witnesses to the Holocaust.* New York: Random House, 2010.

Hirshson, Stanley P. *General Patton: A Soldier's Life.* New York: HarperCollins, 2002.

Holocaust Testimonies: European Survivors and American Liberators in New Jersey. Edited by Joseph J. Preil. New Brunswick, N.J.: Rutgers University Press, 2001. Preil's interview with Rabbi Herschel Schacter took place December 9, 1993.

Hopkins, Robert. *Witness to History: Recollections of a World War II Photographer.* Seattle, Wash.: Castle Pacific, 2002.

Jackson, Robert H. *Trial of War Criminals; Documents.* Washington, D.C.: U.S. Government Printing Office, 1945.

Jarvie, Jenny. "A Look Inside the WWII Surrender Ceremony: 'My Job Was to Make Sure We Did Not Screw Up.'" *Los Angeles Times,* September 2, 2015.

Kaiser, Hilary. *French War Brides in America: An Oral History.* Westport, Conn.: Praeger Publishers, 2008.

Kearn, David W., Jr. *Great Power Security Cooperation: Arms Control and the Challenge of Technological Change.* Lanham, Md.: Lexington Books, 2012.

Kershaw, Alex. *The Longest Winter: The Battle of the Bulge and the Epic Story of World War II's Most Decorated Platoon.* New York: Da Capo, 2007.

King, Benjamin, and Timothy Kutta. *Impact: The History of Germany's V-Weapons in World War II.* Cambridge, Mass.: Da Capo, 2003.

King, Martin, and Ken Johnson. *Warriors of the 106th: The Last Infantry Division of World War II.* Philadelphia, Pa.: Casemate, 2017.

Koo, Juliana (Mrs. V. K. Wellington), with Genevieve Young. *My Story.* Iceland: Oddi Printing, 2008.

Kravis, Irving B. "Prices and Wages in the Austrian Economy, 1938–47." *Bulletin of the United States Bureau of Labor Statistics,* no. 934, 1948.

Kristof, Nicholas D. "Kokura, Japan: Bypassed by A-Bomb." *New York Times,* August 7, 1995.

Ledig, Elfi. *Munich.* London: Dorling Kindersley, 2018.

Lehne, Inge, and Lonnie Johnson. *Vienna, the Past in the Present: A Historical Survey.* Vienna: Österreichischer Bundesverlag, 1985.

Liddell Hart, B. H. *History of the Second World War.* New York: B. P. Putnam's Sons, 1970.

Life magazine. "Snafu Suicide: Tojo Makes an Ignominious Mess of Traditional Honorable Death." September 24, 1945.

Loddenkemper, Robert, and Nikolaus Konietzko. "Tuberculosis in Germany Before, During and After World War II." In *Tuberculosis and War: Lessons Learned from World War II,* edited by John F. Murray and Robert Loddenkemper. Basel, Switz.: Karger, 2018.

Longerich, Peter. *Goebbels: A Biography.* New York: Random House, 2015.

Lowe, Keith. *Savage Continent: Europe in the Aftermath of World War II.* New York: St. Martin's Press, 2012.

MacArthur, Brian. "The Gates of Hell Were Opening . . . We Were Free." *Times of London,* August 10, 2005.

MacDonogh, Giles. *After the Reich: The Brutal History of the Allied Occupation.* New York: Basic Books, 2007.

Maser, Werner. *Nuremberg: A Nation on Trial.* Translated by Richard Barry. New York: Charles Scribner's Sons, 1979.

Maslowski, Peter. *Armed with Cameras: The American Military Photographers of World War II.* New York: Free Press, 1993.

Mauriello, Christopher E. *Forced Confrontation: The Politics of Dead Bodies in Germany at the End of World War II.* Lanham, Md.: Lexington Books, 2017.

McCurry, Justin. "'Tokyo Rose' Dies at 90." *Guardian,* September 27, 2006.

McDonough, Jimmy. *Big Bosoms and Square Jaws: The Biography of Russ Meyer, King of the Sex Film.* London: Vintage, 2006.

McEnery, Captain Kevin T. *The XIV Corps Battle for Manila; February 1945.* Pickle Partners Publishing, 2015.

McGlade, Fred. *The History of the British Army Film & Photographic Unit in the Second World War.* Solihull, UK: Helion, 2010.

McGuire, Phillip. "Desegregation of the Armed Forces: Black Leadership, Protest and World War II." *Journal of Negro History* 68, no. 2 (Spring 1983).

McKinney, Debra. "WWII Wreck Part of New National Monument." *Anchorage Daily News*, December 28, 2008.

McManus, John C. *Hell Before Their Very Eyes: American Soldiers Liberate Concentration Camps in Germany, April 1945.* Baltimore, Md.: Johns Hopkins University Press, 2015.

McNab, Chris. *The Flamethrower.* Osprey Publishing, 2015.

Menaugh, John A. "Island Hopping Offers Way to Reach Enemy." *Chicago Tribune*, December 17, 1944.

Miller, Gabriel. *William Wyler: The Life and Films of Hollywood's Most Celebrated Director.* Lexington: University Press of Kentucky, 2013.

Moeller, Susan D. *Shooting War: Photography and the American Experience of Combat.* New York: Basic Books, 1987.

Morgan, Philip. *The Fall of Mussolini: Italy, the Italians, and the Second World War.* Oxford: Oxford University Press, 2007.

Mountcastle, John W. *Flame On: U.S. Incendiary Weapons, 1918–1945.* Mechanicsburg, Pa.: Stackpole, 1999.

New York Times. "300 Burned Alive by Retreating SS." April 2, 1945.

Nordyke, Phil. *Four Stars of Valor: The Combat History of the 505th Parachute Infantry Regiment in World War II.* St. Paul, Minn.: Zenith Press, 2006.

O'Connell, Edmund Burke, Julie Whitman Jones, and Thomas J. Sullivan Jr. *The Last Farewell: A Journey of the Heart.* Xlibris, 2006.

O'Hare, Mick. "Myths and Reality of the Nazi Space Rocket." *New Scientist*, September 3, 2014.

Ohler, Norman. *Blitzed: Drugs in the Third Reich.* Boston: Houghton Mifflin Harcourt, 2017.

Orange County Register. "Holocaust Survivor and Soldier Forever Linked." November 4, 2005.

Osmańczyk, Edmund Jan. *Encyclopedia of the United Nations and International Agreements: A to F.* Edited by Anthony Mango. New York: Routledge, 2003.

Palmer, David. "Hiroshima and Nagasaki: Living under the Shadow of the Bomb." *Sydney Morning Herald,* August 5, 2015.

Piccigallo, Philip R. *The Japanese on Trial: Allied War Crimes Operations in the East, 1945–1951.* Austin: University of Texas Press, 1979.

Plating, John D. *The Hump: America's Strategy for Keeping China in World War II.* College Station: Texas A&M University Press, 2011.

Polmar, Norman, and Thomas B. Allen. *World War II: The Encyclopedia of the War Years, 1941–1945.* Mineola, N.Y.: Dover Publications, 2012.

Redding, Tony. *Bombing Germany: The Final Phase; The Destruction of Pforzhelm and the Closing Months of Bomber Command's War.* Barnsley, UK: Pen & Sword Aviation, 2015.

Rees, Laurence. *Auschwitz: A New History.* New York: Public Affairs, 2005.

Riding, Alan. *And the Show Went On: Cultural Life in Nazi-Occupied Paris.* London: Duckworth, 2011.

Roeder, George H. *The Censored War: American Visual Experience during World War Two.* New Haven, Conn.: Yale University Press, 1993.

Rosen, David M. *Child Soldiers in the Western Imagination: From Patriots to Victims.* New Brunswick, N.J.: Rutgers University Press, 2015.

Rosenblum, Walter, Daniel V. Allentuck, and Manuela Fugenzi. *They Fight with Cameras: Walter Rosenblum in World War II from D-Day to Dachau.* Roma: Postcart, 2014.

Rostker, Bernard D. *Providing for the Casualties of War: The American Experience through World War II.* New Haven, Conn.: Yale University Press, 2010.

Rottman, Gordon L. *World War II Axis Booby Traps and Sabotage Tactics.* Oxford, UK: Osprey Publishing, 2011.

The Routledge History of Genocide. Edited by Cathie Carmichael and Richard C. Maguire. New York: Routledge, 2015.

Ryan, Cornelius. *The Last Battle.* New York: Simon & Schuster, 1994.

SAGE Encyclopedia of War: Social Science Perspectives. Edited by Paul Joseph. Thousand Oaks, Calif.: SAGE Publications, 2017.

Samuel, Henry. "Hermann Goering's 'Full Catalogue' of Looted Nazi Art Published for First Time." *London Daily Telegraph*, September 30, 2015.

Sandler, Stanley. *World War II in the Pacific: An Encyclopedia.* New York: Garland Publishing, 2001.

Schrijvers, Peter. *The Unknown Dead: Civilians in the Battle of the Bulge.* Lexington: University Press of Kentucky, 2005.

Schultz, Sigrid. "Austrian Must Die for Killing Two Fliers." *Chicago Tribune*, August 25, 1945.

Sellier, Andre. *A History of the Dora Camp: The Story of the Nazi Slave Labor Camp that Secretly Manufactured V-2 Rockets.* Chicago: Ivan R. Dee, 2003.

Sharon, Jeremy. "Delegation from Siegburg Meets Holocaust Survivor." *Jerusalem Post*, September 8, 2011.

Shirer, William L. *The Rise and Fall of the Third Reich.* New York: Simon and Schuster, 1960.

Shtemenko, S. M, translated by Guy Daniels. *The Last Six Months: Russia's Final Battles with Hitler's Armies in World War II.* Garden City, N.Y.: Doubleday, 1977.

Signal Corps Army Pictorial Service in World War II (1 September 1939–15 August 1945). 1945.

Smith, Stephen C. *From St. Vith to Victory: 218 (Gold Coast) Squadron and the Campaign against Nazi Germany.* Barnsley, UK: Pen & Sword Aviation, 2015.

Snape, Michael. *God and Uncle Sam: Religion and America's Armed Forces in World War II.* Woodbridge, UK: Boydell Press, 2015.

Stafford, David. *Endgame, 1945: The Missing Final Chapter of World War II.* New York: Little, Brown, 2007.

Steere, Edward, and Thayer M. Boardman. *Final Disposition of World War II Dead, 1945–51.* Washington, D.C.: Historical Branch, Office of the Quartermaster General, 1957.

Steichen, Edward, and Tom Maloney. *U.S. Navy War Photographs: Pearl Harbor to Tokyo Bay.* New York: Bonanza Books, 1984.

Stephens, James R. *Camera Soldiers: The Philippine Odyssey.* United States: Booksurge, 2007.

Stubenrauch, Robert. *CAT Thirteen: An Autobiographical Novel of a Combat Photographer in World War II.* Bloomington, Ind.: AuthorHouse, 2004.

Sumners, Charles Eugene, and Ann Sumners. *Darkness Visible: Memoir of a World War II Combat Photographer.* Jefferson, N.C.: McFarland, 2002.

Sun, Jeremi. *Henry Kissinger and the American Century.* Cambridge, Mass.: Belknap Press of Harvard University Press, 2008.

Survey of War Damage in the Philippines. Report of the Special Investigating Mission Sent to the Philippines in June 1945. Washington, D.C.: U.S. Government Printing Office, 1945.

Taylor, Frederick. *Coventry: November 14, 1940.* New York: Bloomsbury, 2015.

Taylor, Frederick. *Exorcising Hitler: The Occupation and Denazification of Germany.* London: Bloomsbury Press, 2011.

Terkel, Studs. *The Good War: An Oral History of World War II.* New York: New Press, 1997.

The Atomic Bombings of Hiroshima and Nagasaki, by the Manhattan Engineer District. 1946.

The Effects of Strategic Bombing on German Morale. 2 vols. Washington, D.C.: U.S. Strategic Bombing Survey, Morale Division, 1946.

Thompson, George Raynor, and Dixie R. Harris. *The Signal Corps: The Outcome (mid-1943 through 1945).* Washington, D.C.: Center of Military History, U.S. Army, 2008.

Tompkins, Peter. *Italy Betrayed.* New York: Simon and Schuster, 1966.

Tucker, Anne, Will Michels, and Natalie Zelt. *War/Photography: Images of Armed Conflict and Its Aftermath.* Houston: Museum of Fine Arts, 2012.

Van Ells, Mark David. *To Hear Only Thunder Again: America's World War II Veterans Come Home.* Lanham, Md.: Lexington Books, 2001.

Wainstock, Dennis. *The Decision to Drop the Atomic Bomb: Hiroshima and Nagasaki, August 1945.* New York: Enigma Books, 2010.

Wallis, Dave, Gene Ebele, and John L. Roberts. *Saga of the Seventh: The Odyssey of Five Combat Cameramen during World War II Who Composed the 7th Combat Assignment Unit of the 168th Signal Photo Company.* Pine Bluff, Ark.: Delta Press, 1995.

Weatherford, Doris. *American Women during World War II: An Encyclopedia.* New York: Routledge, 2010.

Webster, Donovan. *The Burma Road: The Epic Story of the China-Burma-India Theater in World War II.* New York: Farrar, Straus and Giroux, 2003.

Werrell, Kenneth. *Blankets of Fire: U.S. Bombers over Japan during World War II.* Washington D.C.: Smithsonian Institution Press, 1996.

Wiesen, S. Jonathan. *Creating the Nazi Marketplace: Commerce and Consumption in the Third Reich.* Cambridge: Cambridge University Press, 2011.

Wilhelm, Maria de Blasio. *The Other Italy: The Italian Resistance in World War II.* New York: Norton, 1988.

Wilson, Stephen L. *Advising Chiang's Army: An American Soldier's World War II Experience in China.* Minneapolis, Minn.: Mill City Press, 2016.

World War II in Europe: An Encyclopedia. Edited by David T. Zabecki. New York: Garland, 1999.

World War II in the Pacific: An Encyclopedia. Edited by Stanley Sandler. New York: Garland, 2001.

Wright, Gordon. *The Ordeal of Total War: 1939–1945.* New York: Harper & Row, 1968.

Young, Peter. *A Short History of World War II, 1939–1945.* New York: Cromwell, 1966.

Yamazaki, Toyoko. *Two Homelands.* Honolulu: University of Hawaii Press, 2007.

Zaloga, Steven J. *V-2 Ballistic Missile 1942–52.* N.p.: Osprey Publishing, n.d.

Zobel, James W. *MacArthur: The Supreme Commander at War in the Pacific.* Mechanicsburg, Pa.: Stackpole Books, 2015.

WEBSITES

American Veterans Center: http://americanveteranscenter.org

Ancestry: http://ancestry.com

Asia-Pacific Journal: Japan Focus: https://apjjf.org

Battle of Manila: http://battleofmanila.org

BBC: http://www.bbc.com

Flanders Today: http://www.flanderstoday.eu

HathiTrust: http://hathitrust.org

Hawai'i Nisei: http://nisei.hawaii.edu

Library of Congress: http://loc.gov

Military History Online: https://www.militaryhistoryonline.com

National Archives and Records Administration: http://archives.gov

New York Times: http://nytimes.com

Portraits of War: https://portraitofwar.com

Project Gutenberg: http://gutenberg.org

Rare Historical Photos: https://rarehistoricalphotos.com

Reuters: https://www.reuters.com

Swissinfo: https://www.swissinfo.ch

Time magazine: http://time.com

Traces of Evil: http://www.tracesofevil.com

Trial International: https://trialinternational.org

United Nations Educational, Scientific and Cultural Organization: https://whc.unesco.org

United States Holocaust Memorial Museum: https://www.ushmm.org

Warfare History Network: http://warfarehistorynetwork.com

Washington Post: https://www.washingtonpost.com

Wikimedia Commons: https://commons.wikimedia.org

Wikipedia: http://wikipedia.com

Wisconsin Veterans Museum Research Center: https://www.wisvetsmuseum.com

Name Index

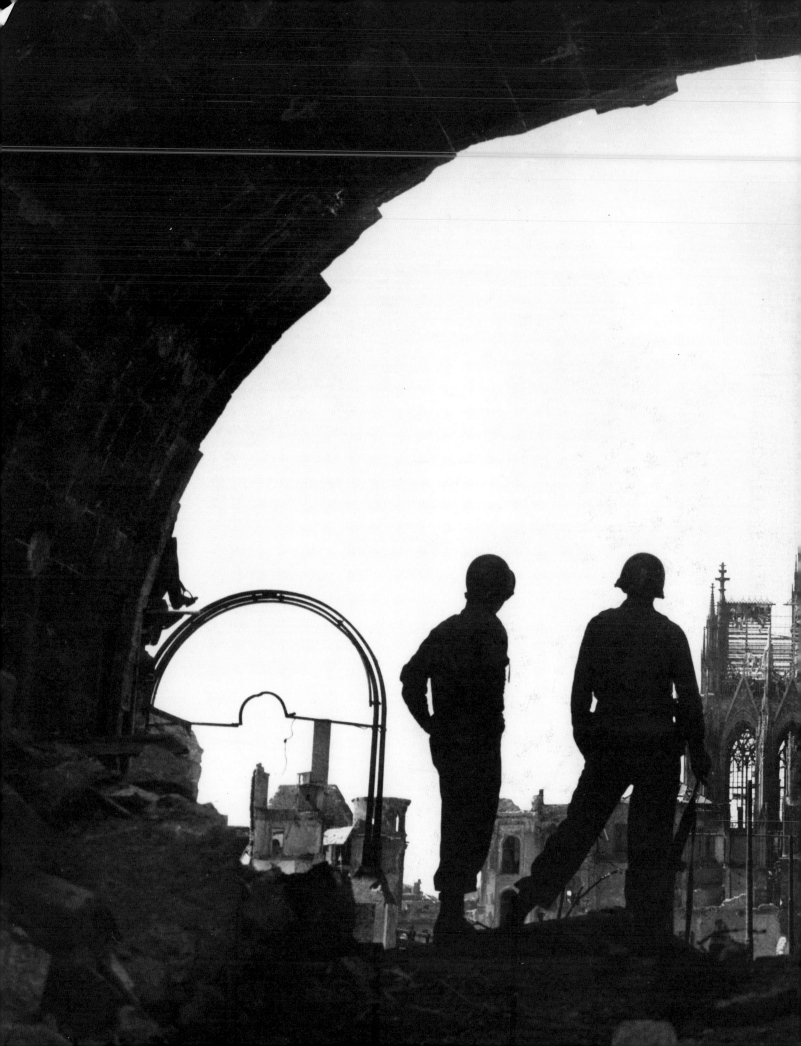